CW00685456

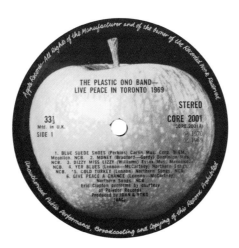

THE PLASTIC ONO BAND—
LIVE PEACE IN TORONTO 1969

STEREO

CORE 2001
(CORE 2001 A)

℗ 1970
© 1969

33⅓
Mfd. in U.K.
SIDE 1

1. BLUE SUEDE SHOES (Perkins) Carlin Mus. Corp. BIEM.
Mecolico. NCB. 2. MONEY (Bradford—Gordy) Dominion Mus.
NCB. 3. DIZZY MISS LIZZY (Williams) Essex Mus. Mecolico.
NCB. 4. YER BLUES (Lennon—McCartney) Northern Songs.
NCB. *5. COLD TURKEY (Lennon) Northern Songs. NCB.
6. GIVE PEACE A CHANCE (Lennon—McCartney)
Northern Songs. NCB
Eric Clapton performs by courtesy
of Polydor Records.
Produced by JOHN & YOKO
ISAC.

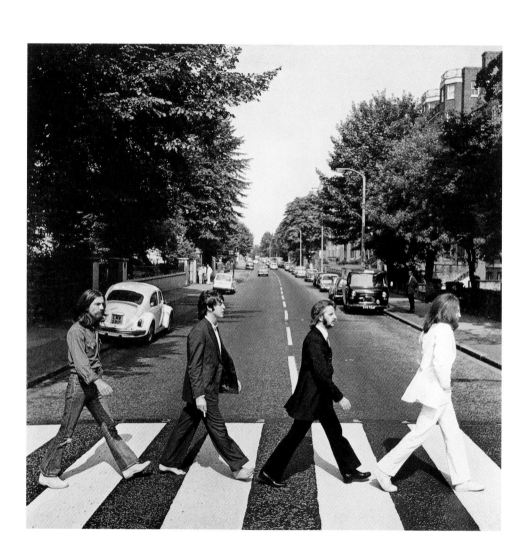

ROBBIE BUSCH
JONATHAN KIRBY
ED. JULIUS WIEDEMANN

ROCK
COVERS

TASCHEN

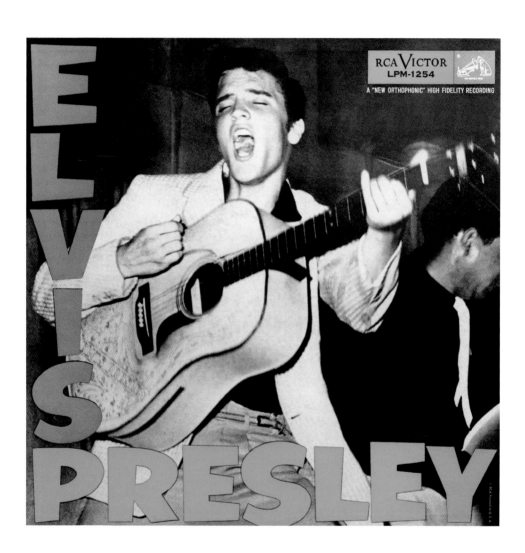

INTRODUCTION
BY ROBBIE BUSCH & JONATHAN KIRBY
6

INTERVIEWS
HENRY DILTZ
16

VAUGHAN OLIVER
28

RECORD COVERS
38

COLLECTORS' TOP-10 LISTS
490

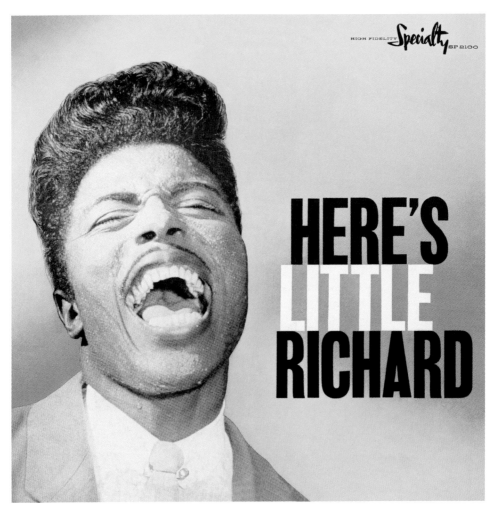

HIGH FIDELITY *Specialty* SP 2100

HERE'S LITTLE RICHARD

LITTLE RICHARD

artist LITTLE RICHARD
title HERE'S LITTLE
RICHARD
year 1957
label SPECIALTY
design THADD ROARK,
PAUL HARTLEY
photo GLOBE

page 2

THE BEATLES

artist THE BEATLES
title ABBEY ROAD
year 1969
label APPLE
design JOHN KOSH
photo IAIN MACMILLAN

page 4

ELVIS PRESLEY

artist ELVIS PRESLEY
title ELVIS PRESLEY
year 1956
label RCA VICTOR
photo WILLIAM V. "RED"
ROBERTSON

WHAT IS IT TO ROCK?

By Robbie Busch & Jonathan Kirby

What you hold in your hands is a book of rock covers, culled from the collections of a couple of obsessive vinyl addicts and reaching over a half century backwards into the past, peering wide-eyed at the first upright steps taken by the now ubiquitous genre. We do not pretend there are not better or differently focused collections. Is it *the* book on rock covers? Could there ever be such a volume? We contend that if you asked the question, "What is the greatest rock record of all time?" to 100 different people, you would get 100 different answers. For almost every cover in this book, a case could be made for an entirely different jacket, comprising an entirely different graphic, that when pasted on to paper stock and stuffed with a vinyl platter, could topple any number of entries within this volume—perhaps even by the same band. It could be that you prefer an artist's debut to their sophomore effort, or maybe you lean towards the solo work of the bass player from a momentarily fractured group. Such debates have proliferated within rock circles since the birth of the power chord, and it is probably this very passion that has led you here.

The last time we saw Kurt Cobain was at Castaic Lake Natural Amphitheater in Valencia, California on Saturday September 26, 1992: he shuffled on stage with his acoustic guitar, sandwiched between Sonic Youth and Mudhoney, to perform one song, solo. It was his version of Leadbelly's "In the Pines," known to Nirvana fans as "Where Did You Sleep Last Night?" Clearly rock owes its life to the blues. Love and pain mingled in the shadow of the devil at Robert Johnson's crossroads to bear witness and lay bare the swagger and mythology of rock with one bottleneck slide on a high E. Johnson's induction to the 27 club only cemented the lore of a live-fast, die-young mentality that may not be the healthiest, but is certainly an unfortunate cornerstone of rock. And while Cobain decided, "it's better to burn out than to fade away," there are plenty of second and third acts in the history of rock 'n' roll to prove him fatefully wrong.

Rock ('n' Roll) is here to stay. Or was it here all along? It's hard to imagine that such an instinctively primal form of music hasn't existed since the dawn of time. It's easy to envision cavemen banging bones on animal hides in cacophonous rapture and Beethoven rockin' at his piano, wig flying in a haze of powder and sweat. Would he roll over at the amplified madness that was to come or would he grab a stool and jam out with a wild barrelhouse blues riff?

R&B pompadoured screamers, zit-popping rockabilly dreamers, freaks, geeks, rabble-rousing hip-shakers, girl-chasers, surfers, greasers, "is that what you call music?!" teeny-boppers, Jewish folk singers, Christian head-bangers, snot-nosed punks, loud-mouthed drunks, pill-poppers, bobby-soxers, stoners, loners, hippie dippy

schemers, mods, skins, Krautrockers, genre-bending electrode-twisting avant-robotic creators, gong-banging glam-lovers, inventive pacific mothers, hair metal, black metal, Nü metal, steel pedal, Rickenbacker, Gibson, Les Paul, Fender, Stratocaster on fire, duckwalking, windmilling, violin bowing, shoegazing, skate-blazing, east coast, west coast, flannel on your back and fish bones on your chest, new wave, no wave, indie, goth, not even wearing undies rockin' out with only a sock, intergalactic spacemen looking for the future from fragments of the past and what's coming next will be the true test of what is, was and will rock.

The world of rock is filled with winners who became losers and vice versa. Because what is rock music besides a battle of the bands-turned-bar brawl between hillbillies and heshers, punks and preps, weekend warriors and Wicca, all fighting off kilter, sometimes opposing, battles with rock as their call to arms? Whether the guitar of your heart has flames on it or a peace sign, we tried to make a book that would suit most seasoned rockers.

While delineations are difficult to make, we tried to fulfill one of four perspectives with each cover chosen. The first: to present classic albums that we felt were imperative to a book forged in the name of rock. There were thousands of choices drawn from our collections and months of debates while we shifted through our other criteria to come up with the final selections.

Our second yardstick was more esoteric: we would strive to include rarities and obscurities that could be appreciated by even the most finicky collector. Some of these are privately pressed works shrouded in mystery, some are from foreign countries, demonstrating rock's ability to stomp its foot and caterwaul in any language, and some are alternative pressings of well-known albums that keep collectors salivating and chasing the dragon of elusive vinyl dreams into the darkest corners of collectordom.

Thirdly, we wanted to celebrate images that we felt were stand-alone works of art, visually stunning regardless of the music encapsulated. The ability of the record cover to help transport the listener to the right station is a well-stoked fire. But what happens when the tunes don't hold up to the presentation? How many times have you held a record in your hands and marveled at the insane detail, naïve genius or just plain coolness of the

"A seemingly universal sentiment felt by the individuals forever linked to these covers was the enriched importance that even the most mundane image can have when paired with a phenomenal recording."

art, but couldn't justify the purchase for the cover alone? Hopefully we can fill the void for you here with a few choice images. And finally, to include covers with good background stories associated with them. To mine these nuggets of rock lore, we went directly to the photographers, illustrators and recording artists, and oftentimes we discovered far more ore than we had anticipated. We discovered both close friends and skilled professionals at the drawing-boards of this book's championed covers. We found musicians forced to concoct their own creations, and bands too far removed from the industry innards to offer a clue as to how their corresponding cover came to be.

A seemingly universal sentiment felt by the individuals forever linked to these covers was the enriched importance that even the most mundane image can have when paired with a phenomenal recording. Old-timers lament the unavailability of computers, not realizing their often crude results are exactly what the young guns sought to mimic when the time came to order their own jackets—photographers whose Polaroid moments went from ordinary to extraordinary, and illustrators whose doodles were forever deemed masterpieces due to the bright moments tucked inside. It is truly hard to imagine one's favorite record without mentally conjuring up the cover art.

The selection process was made even more difficult by more than one existential debate centered on defining rock, and more controversially, identifying what isn't rock. Where does the trajectory of a Little Richard fan veer toward Elvis instead of James Brown? There are certainly shades of gray. But of all the reasons to love rock music, the medium's malleability tops the list. Whether you consider it a deviation of rhythm and blues, country, or folk, rock 'n' roll music followed a long and winding path to get to where it is today, and we have to honor that tenacity. To omit sub-divisions and permutations like Krautrock, gothic rock, folk or pop, would be to strip rock of its triumphs, to say nothing of doom-wop, friendcore, trike-a-billy, steed

"The pump is primed and those three chords open a door to another dimension where the young rebel in all of us holds up his lighter for one last encore."

metal and other genres we just made up... just this moment! And new rock phyla are being created all the time. Rock's ability to suit the trends of the time, the tastes of the public, and conform to the abilities of its architects has kept the art form alive and relevant all these years. And the reason is because every couple of years another group, idiot, or visionary comes along, and like a son defying his father, tries to prove to the world that everybody's doing it all wrong.

The pump is primed and those three chords open a door to another dimension where the young rebel in all of us holds up his lighter for one last encore. And we're happy to play air drums with you, if only to ensure that lunatics will be arguing about what rock is for centuries to come.

WAS IST DRAN AM ROCK?

Von Robbie Busch & Jonathan Kirby

Sie halten ein Buch über Rockcover in Händen – gesammelt von obsessiven Vinyl-Junkies –, das über ein halbes Jahrhundert in die Vergangenheit zurückreicht und mit großen Augen die ersten aufrechten Schritte dieses heute allgegenwärtigen Genres beobachtet. Wir wollen hier nicht so tun, als gäbe es keine bessere Sammlung oder keine mit anderem Schwerpunkt, oder behaupten, dass, wenn man 100 verschiedenen Leuten die Frage „Welches ist die großartigste Rockplatte aller Zeiten?" stellt, nicht 100 verschiedene Antworten bekäme. Für beinahe jedes Cover in diesem Buch gilt: Man hätte auch ein völlig anderes nehmen können, eines mit ganz anderer grafischer Gestaltung, und wenn das dann gedruckt, zu einer Hülle gefaltet und mit einer Vinylscheibe gefüllt wird, dann würde es vielleicht viele Beiträge in diesem Buch ausstechen – vielleicht sogar solche derselben Band. Es kann sein, dass Sie das Debüt eines Künstlers seinem Zweitwerk vorziehen oder eher dem Solowerk eines Bassisten von einer momentan zersplitterten Gruppe zugeneigt sind. Solche Debatten wogen in den Rockzirkeln seit Erfindung der Powerchords, und wahrscheinlich ist es auch genau diese Leidenschaft, warum Sie dieses Buch überhaupt in die Hand genommen haben.

Kurt Cobain sahen wir zum letzten Mal im kalifornischen Valencia im Castaic Lake Natural Amphitheater am 26. September 1992. Er schlurfte mit seiner akustischen Gitarre auf die Bühne und gab, zwischen Sonic Youth und Mudhoney gequetscht, solo einen Song zum Besten. Es war seine Version von „In the Pines" von Leadbelly, Nirvana-Fans bekannt als „Where Did You Sleep Last Night?". Ganz klar: Rock verdankt sein Leben dem Blues. Liebe und Schmerz mischten sich im Schatten des Teufels, um an Robert Johnsons Weggabelung Zeugnis abzulegen und mit einem scharfen Bottleneck Slide auf der hohen E-Saite die Prahlerei und den Mythos des Rock zu enthüllen. Johnsons Aufnahme in den Club 27 zementierte nur die Mär der „Live fast, die young"-Mentalität – vielleicht nicht die gesündeste, aber sicherlich ein Eckstein des Rock, ein unseliger noch dazu. Und während Kurt Cobain sein Leben mit den Worten beschloss: „It's better to burn out than to fade away", gibt es eine Menge zweiter und dritter Akte in der Geschichte des Rock 'n' Roll, die Cobain schicksalhaft widerlegen.

Rock ('n' Roll) wird es immer geben. Und war er eigentlich schon immer da? Man kann sich nur schwer vorstellen, dass es eine derart instinktive und ursprüngliche Form der Musik nicht schon seit Anbeginn gab. Es fällt leicht, sich Höhlenmenschen auszumalen, die völlig entrückt in kakophonischer Begeisterung mit Knochen auf Tierfelle eindreschen, oder Beethoven, wie er am Piano rockt und seine Perücke in einer Wolke aus Puder und Schweiß schüttelt. Hätte er sich vom elektrisch verstärkten Irrsinn abgewendet, der in der Zukunft wartete, oder hätte er sich einen Hocker geschnappt und wäre mit einem wilden Barrelhouse-Blues-Riff in die Jam eingestiegen?

All die R&B-Screamer mit ihren Pompadourfrisuren, pickeligen Rockabilly-Träumer, die Freaks und Geeks, aufwieglerischen Hüftwunder, Girly-Grabscher, Surfer, Rocker, „Das nennst du Musik?"-Teenybopper, die jüdischen Folksänger, christlichen Headbanger, rotzigen Punks, prahlerischen Säufer, Pillenschlucker, Bobby-Soxer, Stoner, Loner, die abgedrehten Hippies, Mods, Skins, Krautrocker, Glam-Rocker, Hair Metal, Black Metal, Nu Metal, Steelpedal, Rickenbacker, Gibson, Les Paul, Fender, Stratocaster in Flammen, Duckwalking, Windmilling, Shoegazing, Skateblazing, East Coast, West Coast, Rockabilly, Psychobilly, New Wave, No Wave, Neopunk, Indie, Goth; die Nackten, nur mit einer Socke bekleidet (aber nicht an den Füßen); Prog Rock, Jazzrock, Indie Rock, Afrorock, Latinrock, Dark Wave, Gothic, Postrock – intergalaktische Raumzeitreisende suchen in Fragmenten aus der Vergangenheit nach der Zukunft, und was als Nächstes kommt, wird der Lackmustest für das sein, was Rock war, was Rock ist und was Rock wird.

Die Welt des Rock steckt voller Gewinner, die zu Verlierern wurden, aber das geht auch umgekehrt. Denn was ist Rockmusik denn noch außer einer Schlacht der Bands, die zur Kneipenschlägerei wird – zwischen Hillbillies und Heshers, Punks und Poppern, Partylöwen und Wicca-Freaks, die alle außer Rand und Band, manchmal gegeneinander, ihre Schlachten kämpfen mit Rock als Munition? Wir versuchen hier ein Buch zu machen, das zu den meisten kampferprobten Rockern passt – egal, ob sie auf der Gitarre ihres Herzens Flammen oder das Peacezeichen zur Schau tragen.

Zwar kann man nur schwer abgrenzen, aber wir haben doch versucht, mit jedem gewählten Cover eine von vier Perspektiven zu erfüllen. Die erste: Wir wollten klassische Alben präsentieren, die unserer Meinung nach unerlässlich sind für ein Buch, das im Namen des Rock geschmiedet wurde. Aus unseren Sammlungen kamen Tausende von Vorschlägen und führten zu monatelangen Debatten, während wir die anderen Kriterien durcharbeiteten, um endlich bei der finalen Auswahl anzulangen.

Unsere zweite Messlatte war abseitiger: Wir wollten möglichst viele Raritäten und Absonderlichkeiten aufnehmen, die auch die pingeligsten Sammler würdigen würden. Einige davon sind privat gepresste, geheimnisumwobene Werke, einige stammen aus fernen Ländern und demonstrieren, dass Rock auch in

„Ein scheinbar universelles Gefühl, das die Leute mit diesen Covern verknüpfen, ist die bedeutungsvolle Aufladung selbst des profansten Bildes, wenn es mit einer phänomenalen Aufnahme gekoppelt ist."

anderen Sprachen stampfen, krachen und jaulen kann, und einige sind alternative Pressungen allbekannter Alben, die jeden Sammler zum Sabbern bringen und ihn auf der Jagd nach dem Einhorn schwer fasslicher vinyler Träume in die dunkelsten Ecken seiner Zunft treiben.

Drittens wollten wir Bilder würdigen, die nach unserer Einschätzung eigenständige Kunstwerke sind, visuell beeindruckend – egal, welche Musik sich dahinter verbirgt. Die Fähigkeit eines Plattencovers, den Hörer zum richtigen Punkt zu führen, ist wie ein gut geschürtes Feuer. Aber was geschieht, wenn die Klänge nicht mit der

Präsentation mithalten? Wie oft haben Sie schon eine Platte in Händen gehalten und die irrsinnig detaillierte, naiv-geniale oder einfach nur coole Kunst des Covers bewundert, aber das allein rechtfertigte nicht den Kauf der Platte? Hoffentlich können wir hier für Sie die Leere mit einigen auserlesenen Bildern füllen.

Und schließlich haben wir auch Cover genommen, die mit guten Hintergrundstorys zusammenhängen. Um diese Juwelen aus dem Rockschatz zu bergen, wandten wir uns direkt an die Fotografen, Illustratoren und Musiker. Oftmals entdeckten wir viel, viel mehr, als wir zu hoffen gewagt hatten. Wir trafen sowohl enge Freunde als auch versierte Profis an den Zeichenbrettern für die in diesem Buch favorisierten Cover. Wir fanden Musiker, die sich eigene Kreationen aus den Rippen schneiden mussten, und Bands, die sich derart weit von den Interna der Branche entfernt hatten, dass sie völlig ahnungslos waren, wie das jeweilige Cover entstanden war.

„Die Lunte ist entzündet, und diese drei Gitarrenakkorde stoßen die Tür auf in eine andere Dimension, in der die jungen Rebellen in uns ihre Feuerzeuge für eine letzte Zugabe in die Höhe halten."

Ein scheinbar universelles Gefühl, das die Leute mit diesen Covern verknüpfen, ist die bedeutungsvolle Aufladung selbst des profansten Bildes, wenn es mit einer phänomenalen Aufnahme gekoppelt ist. Alte Hasen beklagen, sie konnten keine Computer nutzen, und merken nicht, dass ihre kruden Resultate genau das sind, was die Jungspunde nachahmen wollen, wenn sie sich daranmachen, eigene Plattenhüllen zu ordern. Fotografen, deren Polaroid-Momentaufnahmen sich vom Gewöhnlichen zum Außergewöhnlichen verwandeln, und Illustratoren, deren Kritzeleien wegen der darin verborgenen genialen Momente für immer zu Meisterwerken wurden. Es ist wirklich schwer, an seine Lieblingsplatte zu denken, ohne das Cover vor dem geistigen Auge auftauchen zu sehen.

Der Auswahlprozess wurde dadurch weiter erschwert, dass wir mehr als eine Grundsatzdebatte darüber hatten, wie Rock zu definieren ist – und noch kontroverser: zu identifizieren, was kein Rock ist! Wo dreht ein Little-Richard-Fan auf seiner Flugbahn in Richtung Elvis ab statt zu James Brown? Sicherlich gibt es auch alle möglichen Zwischenstufen. Doch sämtliche Gründe, warum man Rockmusik lieben kann, werden in der Liste eindeutig von der Formbarkeit und Geschmeidigkeit des Mediums getoppt. Egal, ob Sie diese Musik als Spielart von Rhythm & Blues, Country oder Folk betrachten, die Rock-'n'-Roll-Musik folgte einem langen und gewundenen Pfad dorthin, wo sie heute steht, und wir haben diese Hartnäckigkeit zu würdigen. Die Fähigkeit von Rock, sich den Trends der Zeit sowie dem Publikumsgeschmack anzupassen und sich außerdem dem Können seiner Konstrukteure anzugleichen, hat diese Kunstform über all die Jahre lebendig und tonangebend gehalten.

Die Lunte ist entzündet, und diese drei Gitarrenakkorde stoßen die Tür auf in eine andere Dimension, in der die jungen Rebellen in uns ihre Feuerzeuge für eine letzte Zugabe in die Höhe halten. Wir spielen gerne Luftgitarre mit euch, und wenn es nur darum gehen soll, dass all die Spinner noch jahrhundertelang weiter darüber debattieren, was Rock eigentlich ist.

QU'EST-CE QUE LE ROCK?

Par Robbie Busch & Jonathan Kirby

Ce que vous tenez entre les mains est un livre sur les couvertures des disques de rock, sélectionnées dans les collections de quelques accros du vinyle obsessifs. Elles embrassent plus d'un demi-siècle, éclairant de tous feux les premiers pas de ce genre aujourd'hui omniprésent. Nous ne prétendons pas qu'il n'existe pas de collections meilleures ou différemment orientées, et nous pouvons vous affirmer que si vous demandez à 100 personnes «Quel est le meilleur disque de rock de tous les temps?», vous obtiendrez 100 réponses différentes. Presque chaque pochette mise en avant ici pourrait parfaitement être remplacée par une autre, avec un visuel complètement différent qui, collé sur du papier cartonné et fourré d'une galette de vinyle, pourrait détrôner n'importe quel disque présenté dans ce livre, parfois du même groupe. Il se pourrait que vous préfériez le premier album d'un certain artiste plutôt que son deuxième, ou que vous ayez une faiblesse pour le travail du bassiste d'un groupe temporairement séparé. Ce type de débat a proliféré dans les cercles du rock depuis la naissance du power chord, et c'est probablement cette même passion qui vous a conduit ici.

La dernière fois que nous avons vu Kurt Cobain, c'était au Castaic Lake Natural Amphitheater de Valencia, en Californie, le samedi 26 septembre 1992: il entra en scène en traînant des pieds avec sa guitare acoustique, pris en sandwich entre Sonic Youth et Mudhoney, pour jouer un morceau en solo. C'était sa version de «In the Pines» de Leadbelly, que les fans de Nirvana connaissent sous le titre «Where Did You Sleep Last Night?». Il ne fait aucun doute que le rock doit la vie au blues. L'amour et la douleur flirtaient dans l'ombre du diable aux «crossroads» de Robert Johnson pour se porter témoins et mettre à nu l'esprit frondeur et la mythologie du rock. Avec un glissement de bottleneck, l'entrée de E. Johnson au club des 27 n'a fait que cimenter la tradition d'une philosophie «vivre vite, mourir jeune» qui n'est peut-être pas la plus saine, mais est sans aucun doute, pour le meilleur et pour le pire, une pierre angulaire du rock. Et bien

> **«Parmi les personnes associées à ces couvertures, il semble régner un sentiment universel: l'importance que même l'image la plus triviale peut revêtir lorsqu'elle est mariée à un enregistrement exceptionnel.»**

que Cobain ait décidé qu'il «vaut mieux brûler franchement que s'éteindre à petit feu», nombreux sont les groupes dans l'histoire du rock qui sont la preuve de sa funeste erreur.

Le rock n'est pas prêt de disparaître. Peut-être a-t-il même toujours existé? On a peine à imaginer qu'une forme de musique aussi instinctivement primaire n'ait pas

existé depuis l'aube des temps. On peut se représenter facilement des hommes des cavernes abattant des os sur des peaux d'animaux dans une extase cacophonique, ou Beethoven se déchaînant sur son piano, perruque volant dans un nuage de poudre et de sueur. Aurait-il froncé les sourcils devant la folie amplifiée qui allait arriver, ou aurait-il attrapé un tabouret pour improviser un riff de blues échevelé ?

Hurleurs R&B aux cheveux coiffés en coque, rêveurs rockabilly criblés de boutons, freaks, geeks, joueurs de hanches, coureurs de filles, surfeurs, motards, préados jamais contents, chanteurs de folk juifs, métalleux chrétiens, punks morve au nez, ivrognes vociférant, gobeurs de pilules, minettes pâmées, camés, loups solitaires, hippies magouilleurs, mods, skins, krautrockers, créateurs transgenre armés d'électrodes et de robots, glam-rockers adeptes du gong, mères pacifiques débordantes d'invention, hair metal, black metal, nü metal, steel guitar, Rickenbacker, Gibson, Les Paul, Fender, Stratocaster en feu, duckwalk, windmill, archets de violon s'abattant sur des cordes de guitare, pédales d'effet, skateurs, côte ouest, côte est, chemises en flanelle et t-shirts arête de poisson, new wave, no wave, indé, goth, sous-vêtements optionnels, spationautes intergalactiques recherchant le futur à partir de fragments du passé… Tout cela, et tout ce qui est à venir, définit ce que fut, ce qu'est et ce que sera le rock.

Le monde du rock est rempli de gagnants qui sont devenus des perdants et vice versa. Car qu'est-ce que le rock sinon le cri de ralliement de bandes de paysans et métalleux, punks et BCBG, guerriers du dimanche et païens, se battant tous pour des causes décalées et parfois opposées dans une gigantesque bagarre de bar ? Que la guitare de votre choix porte des flammes ou un symbole de paix, nous avons essayé de faire un livre qui plaira à la plupart des rockers chevronnés.

Bien que les délimitations soient difficiles à tracer, chaque couverture que nous avons choisie s'inscrit dans l'une des quatre perspectives que nous avons définies. La première : présenter des albums classiques que nous considérions comme impératifs pour un livre qui revendique le nom du rock. Des milliers de candidats ont été tirés de nos collections, et les débats se sont étirés sur des mois tandis que nous examinions nos autres critères pour arriver aux sélections finales.

Notre deuxième critère était plus ésotérique : nous allions essayer d'inclure des raretés et des curiosités que même les collectionneurs les plus pointilleux pourraient apprécier. Certains de ces albums sont des œuvres pressées à titre privé, enveloppées de mystère, certains viennent de pays étrangers, démontrant que le rock est capable de se déhancher et de feuler dans toutes les langues, et d'autres sont des pressages alternatifs d'albums connus qui font saliver les collectionneurs, chasseurs de dragons de vinyle élusifs tapis dans les recoins les plus obscurs.

En troisième lieu, nous voulions mettre en valeur les images que nous considérions comme des œuvres d'art en elles-mêmes, indépendamment de la musique qu'elles représentent. Les pochettes d'album peuvent être des instruments sans pareil pour mettre l'auditeur dans la bonne atmosphère. Mais que se passe-t-il quand les morceaux ne sont pas à la hauteur de leur présentation ? Combien de fois avez-vous tenu un disque entre vos mains et vous êtes-vous émerveillé des détails déments, du génie naïf ou simplement de l'excellence de l'art, sans pouvoir justifier l'achat par la seule couverture ? Nous espérons pouvoir combler ce vide ici avec quelques images de choix.

Et enfin, nous voulions inclure des pochettes associées à des anecdotes intéressantes. Pour dénicher ces pépites de l'histoire du rock, nous sommes allés directement consulter les photographes, les illustrateurs et les musiciens, et souvent nous avons découvert bien plus que nous ne l'espérions. Derrière les planches à dessin des couvertures que ce livre défend, nous avons découvert à la fois des amis proches et des professionnels talentueux. Nous avons trouvé des musiciens forcés à concocter leurs propres créations, et des groupes bien trop éloignés des entrailles de l'industrie de la musique pour nous donner une piste sur l'origine de leur couverture.

Parmi les personnes associées à ces couvertures, il semble régner un sentiment universel : l'importance que même l'image la plus triviale peut revêtir lorsqu'elle est mariée à un enregistrement exceptionnel. Les anciens regrettent de ne pas avoir disposé d'ordinateur à l'époque, sans réaliser que leurs images souvent frustes sont exactement ce que la nouvelle garde a cherché à imiter – des photographes dont les moments Polaroid passèrent de l'ordinaire à l'extraordinaire, et des illustrateurs dont les griffonnages furent hissés au rang de chefs-d'œuvre grâce aux instants d'exception qu'ils renfermaient. On a vraiment du mal à penser à son disque préféré sans se représenter mentalement l'image de la couverture.

Le processus de sélection a encore été compliqué par plus d'un débat existentiel sur la définition du rock et, encore plus polémique, sur ce qui n'entre pas dans le rock. À quel endroit la trajectoire d'un fan de Little Richard vire-t-elle vers Elvis plutôt que James Brown ? Bien évidemment, rien n'est tout noir ni tout blanc. Mais de toutes les raisons pour aimer le rock, la plus importante est sans doute sa malléabilité. Que vous le considériez comme une déviation du rhythm and blues, de la country ou du folk, le rock a parcouru un chemin long et sinueux pour arriver là où il en est aujourd'hui, et nous ne pouvons que rendre hommage à sa ténacité. C'est la capacité du rock à s'adapter aux tendances de l'époque, aux goûts du public et aux talents de ses architectes qui a nourri la vitalité et la puissance de cette forme artistique au cours de toutes ces années.

La machine est lancée, et ces trois accords de guitare ouvrent la porte vers une autre dimension, où le jeune rebelle que nous portons tous en nous brandit son briquet allumé pour un ultime rappel. Nous sommes heureux d'écouter des disques avec vous en nous échinant sur des batteries imaginaires, ne serait-ce que pour faire en sorte que des fêlés continueront de débattre sans fin sur la nature du rock pour les siècles à venir.

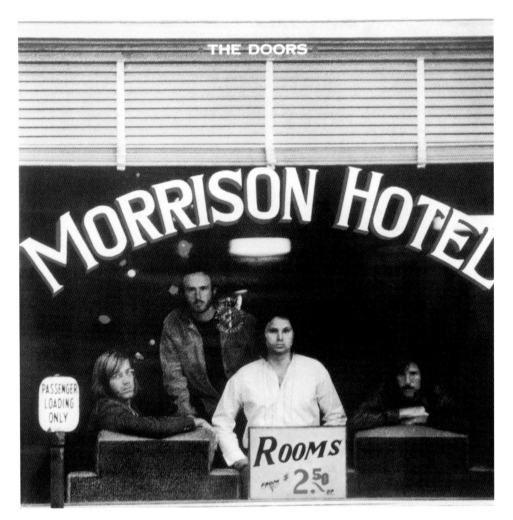

THE DOORS

artist THE DOORS
title MORRISON HOTEL
year 1970
label ELEKTRA
design GARY BURDEN
photo HENRY DILTZ

HENRY DILTZ

Photographer

Henry Diltz is an American photographer, closely associated with the folk and rock movements of the late '60s and early '70s. After recording two albums and touring extensively with the Modern Folk Quartet, Diltz began nurturing a love for photography using the creative class of Laurel Canyon as his early subjects. Diltz's talents were quickly in demand on both coasts, resulting in hundreds of legendary album covers. Alongside creative director Gary Burden, Diltz preferred to shoot in the wild, rarely within the sterile trappings of a photography studio. Having honed his skills at love-ins and on road trips, Diltz's images are defined by their casual intimacy, providing non-invasive impressions of his many beloved subjects. Diltz was the official photographer for Woodstock, and returned in 1994 and 1999 for both anniversary concerts. He is the co-founder of the Morrison Hotel galleries, and represents several of his peers from the Golden Era of rock photography.

Where did you grow up and how did you get your start in photography?

My father was a pilot for TWA and my mother was a stewardess. So before I was three or four I lived in a number of places, but we kind of settled in Long Island, New York. From 4th grade on, we lived overseas—five years in Tokyo, two years in Bangkok and two years in Munich.

During the '60s, folk music was so huge at all the colleges. The Modern Folk Quartet were together almost five years, traveling back and forth across the country, doing college concerts and folk clubs. So it was on the last tour in '66, we pulled our motor home up to a little second-hand store in East Lansing, Michigan. There was a table full of second-hand cameras and one of the guys in the group grabbed one, so we all grabbed one and said, "What the hell?!" We bought

> **"I wasn't really a trained photographer; I didn't go to art school. I didn't learn about lighting and backdrops. I didn't know any of that. All I knew was: look through the little window, and frame it up the way you want it, and push the button."**

some film, and we just sort of had a photo freak-out for a few weeks. And when we got back into L.A. and developed all this film, it turned out to be transparency film. I said, "Let's have a slide show with this stuff." And that's where, when that first slide hit the wall, that was the epiphany; that was the holy cow moment, like "Wow!"

I would try and do it fly-on-the-wall type of thing, because my favorite thing was to be able to put a picture up on the wall and have the person in the picture say, "Oh my god, I didn't even know you took that!" So from there it was an easy step to getting

into publicity photos, magazine photos, album covers and so on. Musicians have a need for photos and I quickly learned that and it quickly became a vocation.

Was this basically how work came about for you? Through friends of friends?

Yeah, people would say, "Why don't you do my album cover?" But then another thing happened. At a love-in one Sunday afternoon, I bumped into a fellow named Gary Burden, an architect who was redesigning Mama Cass's house. They got to be buddies and Mama Cass said, "Gary, why don't you design my first solo album cover?" And he said, "Well, I don't know how to do that—I'm an architect." And she said, "Well, it's the same thing—you make a blueprint, you make an album cover. I mean—it's art!" And right at that same time, he bumped into me and he said, "Hey, you want to help me take photos for this album cover?" We became a team, and between Gary and me, we really knew all these people really well—Joni Mitchell, the Mamas and the Papas, the Byrds.

One of our first big albums we did was Crosby, Stills and Nash. And Gary, being an architect, was very innovative. He told the printers, "I want you to print this, not on the glossy side where you always print album covers—I want you to turn the paper over and print it on the unfinished side." And the printers all said, "Oh well, we never do that," and he said, "I don't care." And the record company had a fuss over it, but then when it came out it was so cool, because it had a texture to it. From then on many people said, "We want that Crosby, Stills and Nash kind of feel to it." It was so organic you know, that it kind of went along with their acoustic, wooden music. It was the perfect fit for that.

And from then on, I think the Doors had seen that cover and loved it and asked Gary and me to do their cover for *Morrison Hotel* (p. 16) which we did in a funky hotel in Downtown L.A.—there's kind of a story to that album cover as well. They found this old hotel that said "Morrison Hotel," but the guy behind the desk wasn't going to let us shoot photos in there unless we had permission from the owner, who wasn't around. He was kind of a slumlord, and completely feared by the guy in the lobby. So we walked outside and I was just going to have them stand in front of the window,

"One of my favorite songs of all time was 'Sweet Baby James' by James Taylor, and I did that album cover. I took the photo that was on there, but hadn't heard that song. So it wasn't until after the album came out that I really fell in love with that song."

but then I saw a light go on through the window and I looked in and the guy had gotten in the elevator and nobody was in the lobby. So I said, "Quick! You gotta run in there!" And they ran and got behind the window and we took one roll of

film, and got out of there. Then Jim said, "Let's go get a drink," so we drove about six blocks to Skid Row in downtown L.A. We didn't know where to stop, because everything was a bar, and on one corner somebody said, "Look at that—'Hard Rock Cafe'!" You know, holy shit! So that picture of the Hard Rock Cafe appeared on the back of the *Morrison Hotel* album, and they got a call from England soon after it came out and a voice on the phone said, "Would you mind if we used that name? We're starting

a café here in London, and we'd like to call it the Hard Rock Cafe." So that was the start of that whole empire really—a momentous day.

Gary was such a cool art director. When we did covers, we would always plan a little adventure with the group, mostly to get them away from their managers and girlfriends and get them out somewhere where we could really have fun and get some interesting shit. We'd take the Eagles out to Joshua Tree, and spend the night and eat peyote buttons. Gary would say, "Just shoot everything that happens; film is the cheapest part"—that was his rallying cry. We never had a finished thing in mind; we'd just take hundreds of photos and then have a slide show.

You seem to remain friends with many of your subjects to this day. How integral was connecting with artists on a personal level—as friends—to your work?

That was just the way I was. I didn't know any other way. I wasn't really a trained photographer; I didn't go to art school. I didn't learn about lighting and backdrops. I didn't know any of that. All I knew was: look through the little window, and frame it up the way you want it, and push the button. But it worked! It was as simple as that. So I had the mentality of a musician—we were brothers. I wasn't the photographer and they were the musicians; we were all just guys hanging out.

Is there a cover that you loved that never really resonated with the public?

My favorite covers seem to be ones people like as well. One of my favorite songs of all time was "Sweet Baby James" by James Taylor, and I did that album cover. I took the photo that was on there, but hadn't heard that song. So it wasn't until after the album came out that I really fell in love with that song. I sang it to both my children when they were little, to sing them to sleep. I did about six albums for America, and traveled all around with them to the various places they were recording to do those covers, so they became really good friends of mine.

I noticed on one of those America albums you're credited as Henry "Snack" Diltz?

On the road, these funny words will come up and they become sort of buzz-words for the tour. It always happens—some funny incident occurs, there's a funny word, and people start saying it. So with America, at one point, somebody was drinking cognac, and somebody said, "Oh, you're having a cognac snack?" That was so funny that they kept saying "snack" for everything. And then they called me Henry Snack. They didn't really call me "Snack," but they just put it on the album as a way to keep that word alive. And so when that album came out, my dear mother on the East Coast saw it and called me up, and said, "Oh dear—I hope that doesn't mean drugs!"

HENRY DILTZ

Fotograf

Der amerikanische Fotograf Henry Diltz war sehr eng mit der Folk- und Rockbewegung Ende der 1960er- und Anfang der 1970er-Jahre verbunden. Nachdem Diltz zwei Alben mit dem Modern Folk Quartet aufgenommen hatte und ausgedehnt auf Tournee gegangen war, entdeckte er seine Liebe zur Fotografie und nahm in der kreativen Szene des Laurel Canyon seine ersten Motive auf. Durch sein Talent war Diltz sehr schnell an beiden Küsten Amerikas gefragt und sorgte für Hunderte legendäre Albumcover. In der Zusammenarbeit mit dem Creative Director Gary Burden bevorzugte Diltz Außenaufnahmen und begab sich selten in die sterile Enge eines Fotostudios. Er schulte seine Fähigkeiten bei Love-ins und auf Roadtrips. Seine Bilder sind von einer lässigen Intimität geprägt und lassen den Betrachter unangestrengt und ungestört an vielen Momenten mit seinen geliebten Musikern teilhaben. Diltz war offizieller Fotograf beim Woodstock-Festival und kehrte auch zu den beiden Jubiläumskonzerten 1994 und 1999 dorthin zurück. Er ist Mitbegründer der Morrison Hotel Gallery und vertritt verschiedene Kollegen aus der goldenen Ära der Rockfotografie.

Wo sind Sie aufgewachsen, und wie kamen Sie zur Fotografie?

Mein Vater war Pilot bei der TWA und meine Mutter Stewardess. Ich war gerade mal drei oder vier Jahre alt und hatte schon an verschiedenen Orten gewohnt, aber dann ließen wir uns doch in Long Island, New York, nieder. Ab der vierten Klasse lebten wir in Übersee: fünf Jahre in Tokio, zwei in Bangkok und zwei in München.

In den 60er-Jahren war Folkmusik an allen Colleges absolut in. Das Modern Folk Quartet gab es fast fünf Jahre lang, wir reisten im ganzen Land herum und traten in Colleges und Folkclubs auf. Dann, bei unserer letzten Tour 1966, parkten wir unser Wohnmobil in East Lansing, Michigan, vor einem kleinen Secondhandladen. Da stand ein Tisch voller gebrauchter Kameras. Einer nahm eine Kamera, dann griffen auch die anderen zu, einer sagte: „Könnte man doch mal ausprobieren, oder?" Wir kauften ein paar Filme und waren dann die nächsten Wochen voll im Fotorausch. Zurück in L.A., stellte sich beim Entwickeln heraus, dass es Diafilme waren. Ich sagte: „Los, wir machen mit dem ganzen Kram mal eine Diashow." Und als das erste Dia an der Wand erschien, war das wie eine Erscheinung, echt totaler Wahnsinn!

Ich blieb dann beim Fotografieren am Ball, machte das aber ganz dezent, weil ich es am tollsten finde, wenn ich ein Foto an die Wand hänge und der, den ich aufgenommen habe, sagt dann: „Meine Güte, ich hab nicht mal mitbekommen, wie du das gemacht hast!" Von da an war es nur ein kleiner Schritt, in die Werbefotografie einzusteigen, bei Magazinen, Plattencovern und so. Musiker brauchen Fotos, das hab ich gleich mitbekommen, und ziemlich schnell wurde das dann zu meinem Beruf.

War das im Prinzip auch Ihr Weg, an Aufträge zu kommen?
Also über Mundpropaganda?

Ja, genau, die Leute meinten zu mir: „Kannst du nicht auch mein Cover fotografieren?" Aber dann geschah etwas anderes. Bei einem Love-in an einem Sonntagnachmittag traf ich einen Typen namens Gary Burden, einen Architekten, der das Haus von Mama Cass neu gestalten sollte. Die waren gut befreundet, und Mama Cass meinte: „Gary, warum designst du nicht das Cover für mein erstes Soloalbum?" Er sagte: „Keine Ahnung, wie das geht, ich bin doch Architekt." Und sie: „Na, das ist doch das Gleiche – egal, ob du einen Entwurf oder ein Albumcover machst. Ich finde, so was ist doch Kunst!" Und genau zu der Zeit trafen wir uns zufällig, und er fragte mich: „Sag, kannst du mir nicht bei den Fotos für dieses Album helfen?" Wir wurden zum Team, Gary und ich, und wir kannten all diese Leute echt ziemlich gut – Joni Mitchell, die Mamas and Papas oder die Byrds.

> **„Mit Beleuchtung, Hintergründen oder Kulissen kannte ich mich nicht aus, hatte keine Ahnung davon. Mir war nur eines klar: Schau durch das kleine Fenster, such den Ausschnitt, der dir gefällt, dann drück auf den Knopf."**

Eines unserer ersten großen Alben war gleich für Crosby, Stills & Nash. Gary als Architekt war einfach sehr innovativ. Er sagte zu den Leuten in der Druckerei: „Ich will, dass ihr das Cover hier nicht so wie sonst immer auf der glänzenden Seite druckt, sondern ihr dreht das Papier um und druckt auf der unfertigen Seite." Und die meinten: „Tja, also, das machen wir nie so", und er dann: „Ist mir ganz egal." Deswegen machte die Plattenfirma ziemlichen Stress, aber als die Platte herauskam, war sie absolut cool, denn die Hülle hatte so eine Struktur. Ab da sagten viele Leute: „Bei uns soll das genauso sein wie bei Crosby, Stills & Nash." Das war so organisch, denn es entsprach unheimlich gut ihrer akustischen, handgemachten Musik. Das passte absolut perfekt.

Und dann hatten, glaube ich, die Doors dieses Cover gesehen und fanden es klasse und fragten Gary und mich, ob wir nicht das Cover für *Morrison Hotel* (S. 16) machen könnten. Dazu sind wir dann zu diesem ziemlich abgewrackten Hotel in Downtown L.A. gefahren, und zu dem Cover gibt es eine weitere kleine Story. Man hatte also dieses alte Hotel aufgetan, doch der Typ an der Rezeption ließ uns keine Fotos machen, denn wir sollten erst vom Eigentümer die Erlaubnis holen, aber der war nicht zu finden. Das war so eine Art „Slumlord", und der aus der Lobby hatte vor dem Typen mächtig Schiss. Also gingen wir raus. Alle hatten sich gerade für mich vors Fenster gestellt, aber dann sah ich, wie dahinter Licht anging, und ich konnte sehen, wie der aus der Lobby in den Fahrstuhl stieg und dass die Lobby jetzt leer war. Also rief ich: „Los! Alle sofort wieder zurück!" Alle rannten rein und stellten sich hinters Fenster, und wir verschossen einen Film und verschwanden schnell wieder. Jim meinte dann: „Kommt, wir trinken was", und wir fuhren sechs Blocks weiter nach Skid Row in Downtown L.A. Wir hatten keine Ahnung, wo wir hinsollten, weil es nur Bars gab, und an einer Kreuzung meinte dann jemand: „Schaut euch das mal an: ein ‚Hard Rock Cafe'!" Das war echt so abgefahren! Also erschien das Bild vom Hard Rock Cafe auf

der Rückseite von *Morrison Hotel*. Kurz nach dessen Erscheinen rief jemand aus England an und fragte: „Hätten Sie was dagegen, wenn wir diesen Namen verwenden? Wir wollen hier in London ein Café aufmachen und würden es gerne das Hard Rock Cafe nennen." Das war also der Beginn eines ganzen Imperiums – ein bedeutsamer Tag.

Gary war echt ein cooler Artdirector. Wenn wir Cover machen sollten, planten wir immer so ein kleines Abenteuer zusammen mit der Gruppe – vor allem, um sie von ihren Managern und Freundinnen loszueisen. Dann fuhren wir irgendwohin, wo wir gemeinsam Spaß haben konnten und interessantes Material zusammenbekamen. Mit den Eagles fuhren wir zum Beispiel raus in den Joshua-Tree-Nationalpark und verbrachten die Nacht damit, Peyote zu futtern. Gary sagte: „Nimm einfach alles auf, was passiert. Filme kosten uns am wenigsten." Das war so seine Parole. Wir hatten nie ein fertiges Konzept im Kopf, sondern nahmen einfach Hunderte Fotos auf und produzierten daraus dann Diashows.

> **„Einer meiner absoluten Lieblingssongs war ‚Sweet Baby James' von James Taylor, dafür habe ich das Cover gemacht. Ich schoss das Foto, ohne den Song zu kennen. Erst nach Erscheinen verknallte ich mich wirklich in den Song."**

Sie sind offenbar immer noch mit vielen befreundet, die Sie damals fotografiert haben. Wie wichtig war es, mit den Musikern auf einer persönlichen Ebene, so als Freund, verbunden zu sein, um mit ihnen zu arbeiten?

So war ich eben gestrickt. Ich kannte keine andere Möglichkeit. Ich war kein ausgebildeter Fotograf und hatte keine Kunsthochschule besucht. Mit Beleuchtung, Hintergründen oder Kulissen kannte ich mich nicht aus, hatte keine Ahnung davon. Mir war nur eines klar: Schau durch das kleine Fenster, such den Ausschnitt, der dir gefällt, dann drück auf den Knopf. Aber es funktionierte! So einfach war das. Ich hatte eher die Mentalität eines Musikers – wir waren wie Brüder. Ich kam da nicht als Fotograf hin, und die anderen waren dann die Musiker, sondern wir waren einfach nur Leute, die gern zusammen abhingen.

Gibt es ein Cover, das Sie lieben, das aber beim Publikum keinen Anklang fand?

Meine Lieblingscover sind wohl die, die auch den Leuten gut gefallen. Einer meiner absoluten Lieblingssongs war „Sweet Baby James" von James Taylor, dafür habe ich das Cover gemacht. Ich schoss das Foto, ohne den Song zu kennen. Erst nach Erscheinen verknallte ich mich wirklich in den Song. Meine beiden kleinen Kinder habe ich damit in den Schlaf gesungen. Ich gestaltete sechs Alben für America. Wir fuhren zusammen an die Orte, wo ihre Aufnahmen gemacht wurden. Ich fotografierte dann für die Cover, und so wurden wir wirklich gute Freunde.

Mir ist aufgefallen, dass Sie auf einem dieser Alben von America Henry „Snack" Diltz genannt werden.

Wenn wir unterwegs sind, spielen sich manchmal Begriffe ein, und die werden dann zu Running Gags. Es passiert was Lustiges, einer macht einen guten Witz, die Leute greifen das dann immer wieder auf. Bei America war das auch so: Da trank einer Cognac, ein anderer kommentierte das: „Na, gönnst du dir einen Cognac-Snack?"

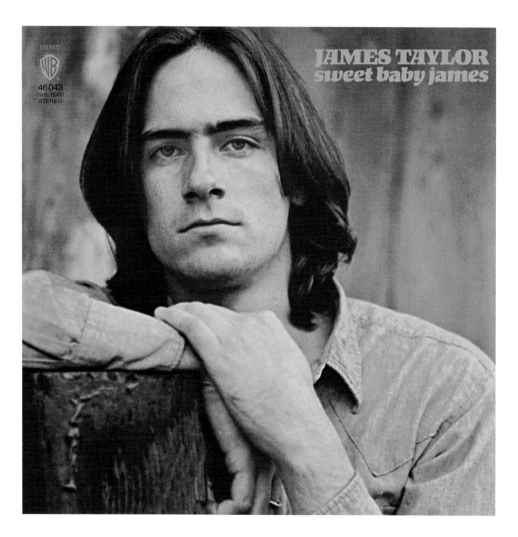

Das war so witzig, dass wir andauernd alles Mögliche „Snack" nannten. Und ich war dann „Henry Snack". Also, eigentlich hat mich keiner so genannt, man hat das einfach als Erinnerung mit aufs Album gepackt, um das Wort zu bewahren. Als das Album erschien und meine liebe Mutter an der Ostküste das las, rief sie mich an und meinte: „Oh, mein Lieber, ich hoffe, dass damit keine Drogen gemeint sind."

JAMES TAYLOR

artist JAMES TAYLOR
title SWEET BABY JAMES
year 1970
label WARNER BROS.
ad ED THRASHER
photo HENRY DILTZ

HENRY DILTZ

Photographe

Henry Diltz est un photographe américain étroitement associé aux mouvements folk et rock de la fin des années 1960 et du début des années 1970. Après avoir enregistré deux albums et être parti en tournée avec le Modern Folk Quartet, Diltz commença à nourrir une passion pour la photographie et prit pour premiers sujets les créatifs qui peuplaient Laurel Canyon. Ses talents furent bientôt très demandés sur la Côte Ouest comme sur la Côte Est. C'est ainsi que virent le jour des centaines de couvertures d'album légendaires. Aux côtés du directeur de la création Gary Burden, Diltz préférait photographier ses sujets dans leur environnement naturel. Diltz s'étant perfectionné sur la route et dans des love-in, ses images se caractérisent par une intimité décontractée, qui saisit ses sujets avec affection mais sans les envahir. Diltz fut le photographe officiel de Woodstock, et il y retourna en 1994 et en 1999 pour les deux concerts anniversaire. Il est le cofondateur des galeries Morrison Hotel, et il représente plusieurs de ses pairs de l'âge d'or de la photographie du rock.

Où avez-vous grandi, et comment avez-vous débuté dans la photographie ?

Mon père était pilote chez TWA, et ma mère était hôtesse de l'air. Avant d'avoir trois ou quatre ans j'avais donc déjà vécu dans plusieurs endroits, mais ensuite nous nous sommes installés à Long Island. À partir du CM1, nous avons vécu à l'étranger – quatre ans à Tokyo, deux ans à Bangkok et deux ans à Munich.

Dans les années 1960, la musique folk était omniprésente dans toutes les universités. The Modern Folk Quartet a duré près de cinq ans, nous n'arrêtions pas de voyager partout dans le pays, nous donnions des concerts dans les universités et les clubs de folk. Sur notre dernière tournée, en 1966, nous avons garé notre camping-car près d'un petit magasin d'articles d'occasion à East Lansing, dans le Michigan. Il y avait une table pleine d'appareils photo et l'un des membres du groupe en a pris un, alors nous en avons tous pris un et on s'est dit « Pourquoi pas ? » On a acheté des pellicules, et puis on a pris des photos comme des malades pendant quelques semaines. Lorsqu'on est revenus à Los Angeles et qu'on a développé tout ça, il s'est trouvé que c'était sur diapositives. J'ai proposé de monter une séance de projection. Et c'est là, lorsque cette première diapo apparut sur le mur, que ça a été la révélation, on a fait « Wow ! »

J'essayais d'être aussi discret que possible parce que, ce que je préférais, c'était quand j'accrochais une photo au mur et que la personne représentée me disait « Oh, mais je ne savais même pas que tu avais pris ça ! » À partir de là, il n'y avait qu'un pas à franchir pour arriver aux photos de publicité, de magazine, les couvertures d'album, etc. Les musiciens ont besoin de photos. J'ai vite appris ça, et c'est vite devenu une vocation.

Oui, les gens disaient «Tiens, et si tu faisais la photo de ma pochette ?» Mais ensuite il s'est passé autre chose. Un dimanche après-midi, à un love-in, je suis tombé sur un type appelé Gary Burden, un architecte qui était en train de travailler sur la maison de Mama Cass. Ils se lièrent d'amitié et Mama Cass lui dit «Gary, veux-tu faire la couverture de mon premier album en solo ?» Et il lui répondit «Je ne sais pas faire ça, je suis architecte». Alors elle dit «Mais c'est la même chose, dessiner un plan ou une couverture d'album. Je veux dire, c'est de l'art !» Et c'est juste à ce moment-là qu'il est tombé sur moi et qu'il m'a dit «Est-ce que tu veux m'aider à prendre des photos pour cette couverture ?» C'est ainsi que nous avons commencé à faire équipe, et à nous deux, on connaissait vraiment bien tous ces gens – Joni Mitchell, The Mamas and the Papas, les Byrds.

L'un des premiers grands albums sur lesquels nous avons travaillé était pour Crosby, Stills and Nash. Gary étant architecte, il aimait innover. Il dit aux imprimeurs «Je veux que vous imprimiez ceci, mais pas sur le côté brillant où vous imprimez toujours les couvertures d'album. Je veux que vous retourniez le papier et que vous imprimiez sur le côté brut.» Les imprimeurs répondirent «Ah, mais on ne fait jamais ça», et lui rétorqua «Je m'en fiche». La maison de disques fit des histoires, mais lorsque la pochette fut terminée, le résultat était génial, parce qu'elle avait de la texture. À partir de ce moment, beaucoup de gens ont commencé à dire «On veut quelque chose comme cet album de Crosby, Stills and Nash». C'était si naturel, vous voyez, ça allait parfaitement avec leur musique acoustique et chaleureuse.

Je crois que les Doors avaient vu la couverture et qu'elle leur avait plu. Ils nous demandèrent à Gary et moi de faire leur couverture pour *Morrison Hotel* (p. 16). Nous l'avons photographiée dans le centre de Los Angeles. Ils avaient trouvé ce vieil hôtel plein de personnalité dont la fenêtre disait «Morrison Hotel», mais le réceptionniste ne voulait pas nous laisser prendre de photos sans la permission du propriétaire, qui n'était pas là. C'était un requin et le type de la réception était complètement terrorisé. Alors nous sommes allés dehors et j'allais leur demander de se tenir devant la fenêtre, mais là j'ai vu une lumière s'allumer, j'ai regardé et j'ai vu que le type était

> **«Je n'étais pas photographe de formation, je ne suis jamais allé à l'école d'art. Je n'ai pas appris à utiliser l'éclairage et les faux décors. Tout ce que je savais, c'était regarder dans la petite fenêtre, cadrer et appuyer sur le bouton.»**

entré dans l'ascenseur et qu'il n'y avait personne dans le lobby. Alors j'ai dit «Vite ! Allez-y !» Ils ont couru se poster derrière la fenêtre et nous avons pris toute une pellicule de photos avant de repartir. Jim a dit «Allons prendre un verre», alors nous sommes allés à six pâtés de maisons de là, à Skid Row dans le centre de Los Angeles. Nous ne savions pas où nous arrêter, il y avait des bars partout, et à un coin de rue quelqu'un a dit «Regardez-ça : «Hard Rock Cafe»!» Incroyable ! Cette photo du Hard Rock Cafe apparut au verso de *Morrison Hotel*, et peu après sa sortie ils reçurent un appel d'Angleterre. La voix au bout du fil dit «Ça vous dérange si on utilise ce nom ?

On est en train de monter un café à Londres, et on aimerait l'appeler le Hard Rock Cafe ». C'est comme ça que cet empire est né. Ce fut une journée historique.

Gary était un directeur artistique très cool. Lorsque nous faisions des couvertures, il organisait toujours une petite aventure avec le groupe, surtout pour les éloigner de leurs managers et de leurs petites amies, et pour les emmener quelque part où on pourrait vraiment s'amuser et en tirer quelque chose d'intéressant. Nous avons emmené les Eagles au parc de Joshua Tree. On a passé la nuit là-bas et on a mangé des boutons de peyotl. Gary disait toujours « Photographie tout ce qui se passe, la pellicule c'est ce qu'il y a de moins cher ». Nous n'avions jamais un but précis, on prenait juste des centaines de photos et ensuite on en faisait une séance de projection.

Il semble que vous soyez resté ami avec nombre de vos sujets. Était-ce important pour votre travail d'établir une connexion personnelle – une amitié – avec les artistes ?

C'était ma façon d'être, c'est tout. Je ne savais pas comment faire autrement. Je n'étais pas photographe de formation, je ne suis jamais allé à l'école d'art. Je n'ai pas appris à utiliser l'éclairage et les faux décors. Tout ce que je savais, c'était regarder dans la petite fenêtre, cadrer et appuyer sur le bouton. Mais ça marchait ! C'était aussi simple que ça. J'avais la mentalité d'un musicien, nous étions frères. Il n'y avait pas un photographe d'un côté, et des musiciens de l'autre. Nous étions simplement des types qui passaient du bon temps ensemble.

Y a-t-il une couverture que vous aimez et qui n'a jamais vraiment trouvé un écho auprès du public ?

Mes couvertures préférées semblent être les mêmes que celles qui plaisent aux gens en général. L'une de mes chansons préférées est « Sweet Baby James » de James Taylor, et j'ai travaillé sur la couverture de cet album. J'ai pris la photo, mais je n'avais pas entendu cette chanson. Ce n'est qu'après la sortie de l'album que j'en suis tombé amoureux. Je l'ai chantée comme berceuse à mes deux enfants lorsqu'ils étaient petits. J'ai fait six albums pour America et je suis allé avec eux aux différents endroits où ils enregistraient pour faire ces couvertures, alors nous sommes devenus très bons amis.

J'ai remarqué que sur l'un de ces albums d'America vous apparaissez dans les crédits sous le nom Henry «Snack» Diltz ?

Sur la route, il y a des mots marrants qui fusent et qui s'intègrent à notre vocabulaire pour la durée de la tournée. Ça ne manque jamais : il se passe quelque chose de drôle, quelqu'un fait un bon mot et les autres commencent à le répéter. Avec America, à un moment, quelqu'un était en train de boire du cognac, et un autre a dit « Oh, tu te fais un snack au cognac ? » C'était si drôle qu'ils commencèrent à dire « snack » pour tout. Et puis ils m'appelèrent Henry Snack. Ils ne m'appelaient pas vraiment « Snack », mais ils ont mis ça sur l'album pour que ce mot continue à vivre. Quand l'album est sorti, ma chère mère sur la Côte Est a vu ça et m'a dit « Oh mon chéri, j'espère que ça ne veut pas dire drogue ! »

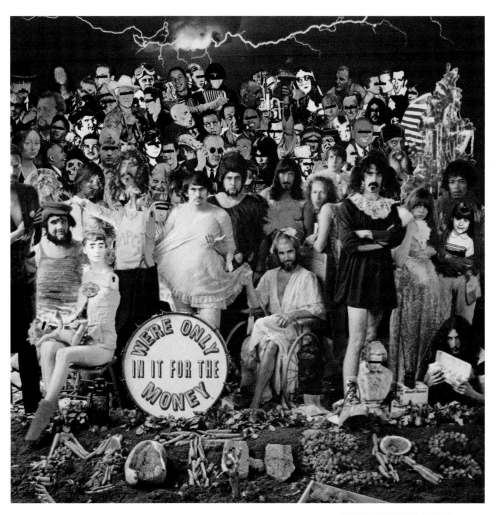

THE MOTHERS OF INVENTION

artist THE MOTHERS OF
INVENTION
title WE'RE ONLY IN IT
FOR THE MONEY
year 1968
label VERVE
ad CAL SCHENKEL
photo JERRY SCHATZBERG

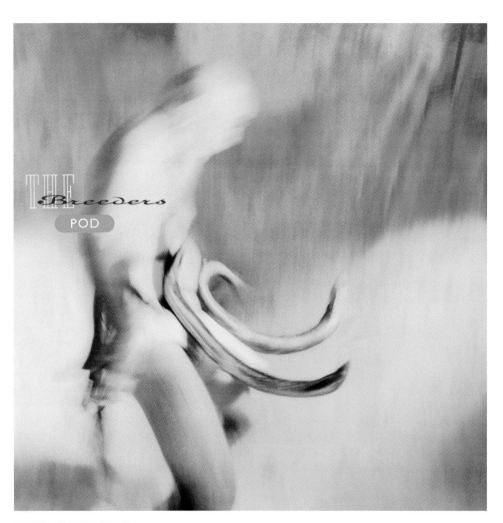

THE POD

THE BREEDERS

artist THE BREEDERS
title POD
year 1990
label 4AD
design VAUGHAN OLIVER/
V23
photo KEVIN
WESTENBERG

**"There was Roger Dean, who'd
done the Yes stuff, and the
guys at Hipgnosis, who were
doing the Pink Floyd stuff.
And I thought, 'Yeah, I wouldn't
mind a bit of that action.'"**

VAUGHAN OLIVER

Graphic designer

Vaughan Oliver is a British graphic designer, whose iconic covers set the visual tone for seminal London label, 4AD. Founded in 1979 by Ivo Watts-Russell and Peter Kent, the label became a sanctuary for some of the most innovative acts operating in the wake of the UK's punk invasion. In 1983 Oliver formed the design partnership 23 Envelope with photographer Nigel Grierson; they quickly established the visual tone and aesthetic for which the label became renowned. Two books are dedicated entirely to Oliver's work, Visceral Pleasures *and* This Rimy River. *Most recently,* Facing the Other Way *offers the first comprehensive account of 4AD's monumental place within modern music.*

What inspired you to become a designer?

I used to be captain of the football team; I was a bit of a jock, yeah? But the art room was my sanctuary. That's where we could talk about girls, music—I've still got my school bag with the Roxy Music logo that I patterned on there. There was Roger Dean, who'd done the Yes stuff, and the guys at Hipgnosis, who were doing the Pink Floyd stuff. And I thought, "Yeah, I wouldn't mind a bit of that action."

So how do you do that? You go to college, in my case to the local college, because I'm a shy provincial boy. I wanted to be an illustrator—I hated typography. Too many typefaces! How could you ever choose the fucking right one? I just wanted to draw pictures. From '76 through '79 I was at college, so I experienced the punk revolution. Everybody was standing up and doing their own thing, and independent record companies set up independent distribution systems. When I came to London, I got a job in a product design group called Michael Peters & Partners, who were top notch and quite progressive. A couple of guys who had done things for 4AD couldn't do the next sleeve and they suggested I go and meet Ivo Watts-Russell. Come '83, I was doing freelance stuff for him, and he was feeding me his music. That year they moved to a new space and there was room for one more person and I was that person. Imagine that! The first employee is the person that does the sleeves. He cared so much about the packaging of the music that he was putting out.

So did you ever talk about the design with Ivo?

Designwise, yes. But I was always keen to talk to the bands about their music. I would read the lyrics, and I would talk to them about what their songs were about. I think one of the unique things about working with 4AD was that I would hear the demos three or four months before the music came out. So when I would talk to contemporaries, they would say, "Fuck me—we get a call on a Friday and we need the sleeve by Monday." I had the luxury of kind of taking it home with me and thinking about it.

It seems like you began working with [photographer] Nigel Grierson early on?

I did. He was a schoolmate of mine. He followed me from grammar school through college. I was working at 4AD, he was at the Royal College of Art when we did all that Cocteau Twins and Modern English stuff together. And it was all about trying to reflect the atmosphere or the mood of the music. It's easy in a sense to do an interesting record—to lay an amazing image with some interesting typography. But if it doesn't really connect with the music, it's not worthwhile.

When you were working with Nigel how much collaboration was there?

We were big fans of blurring the boundaries, and that's why we chose the 23 Envelope [moniker]. So it wasn't "photo by" or "design by." I think typical of that period, there was a huge blurring of boundaries—you weren't just a graphic designer; you could make film, you could take photographs. So again, we didn't want to use our names, we felt egos were attached to them, despite the fact that obviously we had egos.

I think it was the early Cocteau Twins or the first This Mortal Coil LP where I realized "Oh, this guy's doing everything."

And how would that make you feel?

I was like, "Oh, well I've got to buy all of them!"

You fucking stuck with it, eh? You knew to get the series? I tend to reel against the idea of a style, because I think if you look at Colourbox and you look at the Bulgarian Voices and if you look at the Wolfgang Press and you look at Lush, there's a very different feel. I suppose our ambition, particularly after Nigel had moved on, was to give everybody their own identity, if you like, without trying to stamp it on them. And our ambition within that was to give a sense of recognition within the label that goes beyond the logo. If you trust this, try that.

Clearly Ivo had an overall aesthetic for the sound of the label. Similar to what you guys were doing, he had a vision. It's a rare situation where the designer and the label were connected for so long and created a body of artwork together.

If I go back in time, Blue Note, ECM. And while they were role models in one way, I thought they were both a little bit too rigid, graphically. And what we wanted was something that kind of just connected organically or loosely. There was a lot of stuff we did that was ambiguous. There was a sense of mystery. When we would have these exhibitions around the world, the Japanese in particular would come up with these elaborate "Ah, we see this, we see that." I said, "Well no, it's just a bit of colored spray-paint." But I guess that's kind of what was behind the whole thing—to leave things open to interpretation.

There's an idea—this is the first thing I ever wrote on a toilet wall: "To suggest is to create, to describe is to destroy." It's the idea of leaving space, just kind of inspiring and drawing people in—this idea of just raising a question, but not giving an answer. So you see this poster 60 inches by 40 inches on the streets of London, and say, "What the fuck is that about?" and it leaves a hook in you. And you go away with that hook. And you can't work it out. The best sleeves are the ones that kind of hit you right between the eyes, but then there's detail in there that you can come back to later.

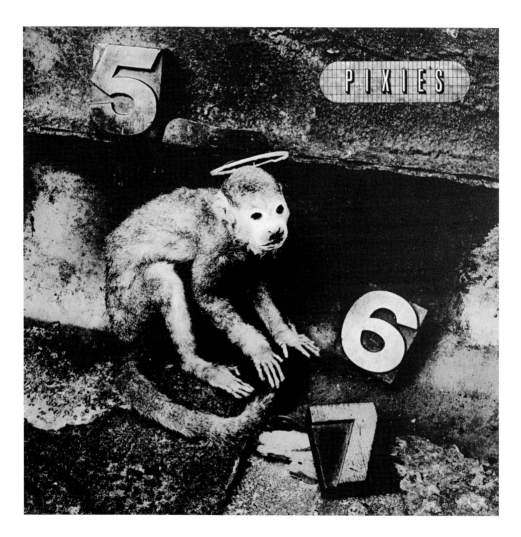

PIXIES
artist PIXIES
title DOOLITTLE
year 1989
label 4AD
design VAUGHAN OLIVER/
V23
photo SIMON
LARBALESTIER

<u>*Do you have an overall reasoning or sensibility when it*</u>
<u>*comes to typography?*</u>

As I said, I hated it in college. Type spoiled my illustrations. I learned about typography from working on these drinks labels at Michael Peters & Partners. Looking at a whisky label I saw these fat typefaces next to skinny typefaces next to a bit of script and it was all about mark-making all of a sudden. I'm talking about text as image. So my approach to typography is like that of an illustrator. There's a certain resonance in the idea of putting things together that maybe shouldn't be together. When I was using an old font [from the '30s or '40s], hopefully it wasn't pastiche because I'd put it with a bit of Futura or a contemporary type. Just to make you look at it in a different light.

VAUGHAN OLIVER 31

VAUGHAN OLIVER

Grafikdesigner

Vaughan Oliver ist ein britischer Grafikdesigner. Seine ikonischen Cover prägen den visuellen Ton des einflussreichen Londoner Labels 4AD. Gegründet im Jahre 1979 von Ivo Watts-Russell und Peter Kent, wurde das Label im Zuge der britischen Punkinvasion die Heimat einiger besonders innovativer Acts. 1983 gründete Oliver mit dem Fotografen Nigel Grierson die Designpartnerschaft 23 Envelope. Schnell etablierte man einen visuellen Charakter und eine Ästhetik, für die das Label berühmt wurde. Zwei Bücher widmen sich ausschließlich den Arbeiten von Vaughan Oliver: Visceral Pleasures *und* This Rimy River. *Aktuell bietet* Facing the Other Way *die erste umfassende Zusammenschau der monumentalen Stellung von 4AD innerhalb der modernen Musik.*

Was hat Sie inspiriert, Designer zu werden?

Ich war mal Kapitän des Footballteams, also schon ein ziemlicher Sportler, okay? Aber der Kunstraum war meine Zuflucht. Dort konnten wir offen über Mädchen und Musik reden. Ich besitze immer noch meine Schultasche, die ich mit dem Logo von Roxy Music geschmückt habe. Da gab es Roger Dean, der all die Sachen für Yes gemacht hat, und die Leute von Hipgnosis, die für Pink Floyd gearbeitet haben. Und ich dachte: „Da muss ich unbedingt einen Fuß in die Tür kriegen."

Wie packt man so was an? Man muss aufs College gehen, in meinem Fall war es das College vor Ort, weil ich ein schüchterner Junge aus der Provinz bin. Ich wollte Illustrator werden, denn ich hasste Typografie. Zu viele Schriftarten! Wie soll ich denn in dem ganzen verdammten Haufen bloß die richtige finden? Ich wollte einfach nur Bilder zeichnen.

Von 1976 bis 1979 war ich am College, also kriegte ich die Punkrevolution direkt mit. Alle kamen und machten eigene Sachen, und Indieplattenfirmen bauten unabhängige Vertriebssysteme auf. Als ich nach London kam, wurde ich in der Produktdesignagentur Michael Peters & Partners angestellt, die waren absolute Oberliga und ziemlich progressiv. Ein paar von den Leuten, die für 4AD arbeiteten, konnten sich nicht ums nächste Cover kümmern. Also schlugen sie vor, ich sollte mich mit Ivo Watts-Russell treffen. Für ihn habe ich ab 1983 als Freiberufler gearbeitet, und er ließ mir seine Musik zukommen. In dem Jahr zog die Firma um, und vor Ort hatte man noch Platz für genau einen Mitarbeiter, und das war ich. Was für ein Zufall! Der erste Angestellte ist der, der die Cover macht. Ivo lag besonders viel daran, wie die Musik, die er veröffentlichte, verpackt war.

Haben Sie jemals mit Ivo das Design besprochen?

In Bezug aufs Design, ja. Aber ich wollte immer mit den Bands über ihre Musik reden. Ich las die Texte und sprach mit den Musikern darüber, worum es in den Songs

geht. Ich glaube, das Besondere an der Arbeit mit 4AD war, dass ich, schon drei oder vier Monate bevor die Musik herauskam, die Demos hören konnte. Als ich also mit Kollegen von damals sprach, meinten die: „Das ist ja krass: Wir kriegen am Freitag einen Anruf und sollen das Cover dann schon am Montag liefern." Ich hatte den Luxus, alles mit nach Hause nehmen zu dürfen und darüber nachdenken zu können.

Sie haben offenbar schon ziemlich früh mit dem Fotografen Nigel Grierson zusammengearbeitet, oder?

Ja, genau. Er war einer meiner Klassenkameraden. Wir waren zusammen in der Grammar School und später auch gemeinsam an der Hochschule. Ich arbeitete bei 4AD, und er besuchte das Royal College of Art, als wir all die Sachen für die Cocteau Twins und Modern English gemacht haben. Dabei ging es vor allen Dingen darum, die besondere Atmosphäre oder auch die Stimmung der Musik widerzuspiegeln. Es ist in gewisser Hinsicht einfach, eine interessante Platte zu machen: Man schafft ein tolles Bild mit einer interessanten Typografie. Aber wenn das nicht zusammen mit der Musik klick macht, lohnt sich die ganze Arbeit nicht.

Wie intensiv war die Zusammenarbeit mit Nigel?

Wir liebten es, Grenzen zu überschreiten und verschwimmen zu lassen, und darum entschieden wir uns für den Namen *23 Envelope*. Fotos oder Designs sollten also nicht speziell namentlich zugeordnet werden. Das war für diese Periode wohl auch typisch. Die Grenzen verwischten sich, man war nicht nur Grafikdesigner, sondern konnte auch Filme oder Fotos machen. Also noch mal, wir wollten da nicht unbedingt unsere Namen sehen, denn unserer Meinung nach wäre das so ein Egoding gewesen, trotz der Tatsache, dass wir natürlich Egos hatten.

Ich glaube, es war bei der ersten LP von den Cocteau Twins oder der ersten von This Mortal Coil, als mir klar wurde: „Oh, der Typ macht da ja alles."

Und wie ging es Ihnen damit?

Na, ich wollte unbedingt alle kaufen!

Da hingen Sie am Haken, was? Sie wussten, wie man die ganze Serie kriegt? Ich halte nichts von der Idee eines Stils; wenn man sich Colourbox, die Bulgarian Voices oder The Wolfgang Press anschaut oder Lush, dann ist das immer ein ziemlich anderes Feeling. Ich nehme an, unser Ehrgeiz bestand darin, allen eine eigene Identität zu geben, ohne ihnen etwas aufzudrücken – vor allem nachdem Nigel ausgestiegen war. Und wir wollten unbedingt innerhalb des Labels einen Wiedererkennungswert aufbauen, der übers Logo hinausreicht. Wenn du dem Logo vertraust, probierst du gerne andere Sachen unter diesem Logo aus.

Für den Labelsound hatte Ivo eindeutig eine generelle Ästhetik. So ähnlich wie Sie mit Ihren Leuten hatte er eine Vision. Das kommt selten vor, dass Designer und Label über so lange Zeit gemeinsam eine ganze Gruppe von Kunstwerken schaffen.

Da gab es Blue Note, ECM. Die waren zwar in gewisser Hinsicht Vorbilder, aber ich fand, die waren grafisch auch ein bisschen zu streng. Wir wollten etwas, das gewissermaßen nur lose oder organisch eine Verbindung herstellt. Wir haben viele ehrgeizige Sachen gemacht und hatten auch so einen Sinn fürs Mysteriöse. Als unsere Sachen dann weltweit ausgestellt wurden, kamen vor allem die Japaner an und taten ziemlich wichtig mit Sprüchen wie: „Ah, verstehe, das steht hierfür, und das steht

dafür." Und ich dann: „Nö, das ist eigentlich bloß ein bisschen Sprühfarbe." Aber ich glaube, das war auch die Grundlage der ganzen Geschichte: die Sachen offen halten für Interpretationen.

Da gibt es eine Idee – das Erste, was ich jemals auf eine Klowand geschrieben habe: „Andeuten ist erschaffen, beschreiben ist zerstören." Diese Idee, den Raum zu öffnen, zu inspirieren, anzulocken... Fragen zu stellen, aber die Antwort schuldig zu bleiben. Da sieht man also so ein Plakat in London, vielleicht ein Meter mal anderthalb, und denkt: „Was ist das denn für ein Scheiß?", aber irgendwie hakt es sich bei dir fest. Und da hängst du dann und gehst weiter. Aber dir wird einfach nicht klar, was los ist. Die besten Cover sind die, die einen umhauen, aber auch Details enthalten, die dann weiter in dir arbeiten.

Haben Sie eine allgemeine Schlussfolgerung oder Sensibilität, wenn es um Typografie geht?

Wie gesagt, im College hasste ich das. Schrift verdarb meine Illustrationen. Ich lernte bei Michael Peters & Partners durch die Arbeit an Getränkemarken Typografie verstehen. Auf einem Whiskyetikett sah ich fette Schriften neben schlanken; plötzlich ging es darum, wie die Zeichen gesetzt werden. Ich spreche von Text als Bild. Mein Umgang mit Typografie ist der eines Illustrators, der Dinge kombiniert, die nicht zusammengehören. Als ich einen Zeichensatz aus den 30er- oder 40er-Jahren verwendete, war es hoffentlich okay, ihn mit Futura oder einer modernen Schrift zusammenzupacken, in ein anderes Licht zu stellen.

Ich habe den Eindruck, etwa um 1987 herum war einiges in Bewegung. Kennzeichnend für Ihre Arbeiten war ein düsterer Humor, aber zu jener Zeit schien er dunkler, vor allem hinsichtlich Ihrer Arbeit mit den Pixies, die so in Richtung Freakshow oder David Lynch ging.

Das kam Verschiedenes zusammen. Nigel verließ uns 1985/86. Er ist auf seine Weise ein Genie, aber am Ende gingen wir getrennte Wege. Die Compilation *Lonely is an Eyesore* markierte das Ende einer Periode und rundete die früheren Jahre ab. Dann machten wir weiter. 4AD nahm um 1987 drei amerikanische Bands unter Vertrag: Ultra Vivid Scene, Throwing Muses, die Pixies. Wir hatten mit solchen Bands wie den Cocteau Twins und The Wolfgang Press gearbeitet... aus denen bekam man kaum ein Wort heraus! Zeigte man ihnen Bildmaterial, sagten die: „Mögen wir nicht." – Okay, was mögt ihr? – „Keine Ahnung." Diese redegewandten Amerikaner waren also eine echte Offenbarung, Kurt Ralske, Kristin Hersh, Charles [Charles Thompson IV alias Black Francis] oder Kim Deal. Die konnten was zu ihren Sachen sagen... die konnten sogar *Interviews* geben! Kurt gab mir Bilder, die ich neu anpassen sollte. Kristin hasste meine Sachen, also bezog ich Chris Bigg mehr ein und fand einen japanischen Künstler namens Shinro Ohtake. Die Pixies waren die beste Band, mit denen ich gearbeitet habe, sie haben mich tief im Herzen berührt. Viele hat das *Doolittle*-Cover zu eigenem Grafikdesign angeregt. Ich weiß, es liegt an der Power der Musik, aber es ist wundervoll zu wissen, dass man Leute inspiriert.

VAUGHAN OLIVER

Graphiste

Vaughan Oliver est un graphiste britannique, dont les couvertures emblématiques définirent le style visuel du célèbre label londonien 4AD. Créé en 1979 par Ivo Watts-Russell et Peter Kent, ce label devint un véritable sanctuaire pour quelques-uns des artistes les plus novateurs qui étaient arrivés à la suite de la déferlante punk au Royaume-Uni. En 1983, Oliver s'associa avec le photographe Nigel Grierson sous le nom 23 Envelope. Ils ne tardèrent pas à créer le ton visuel et esthétique qui allait faire la renommée du label. Deux livres sont entièrement consacrés à l'œuvre d'Oliver, Visceral Pleasures *et* This Rimy River. *Paru plus récemment,* Facing the Other Way *propose la première analyse complète de la place monumentale que 4AD occupe dans la musique moderne.*

Qu'est-ce qui vous a donné envie de devenir graphiste ?

À l'école, j'étais capitaine de l'équipe de football. J'étais un fou de sport. Mais la salle d'arts plastiques était mon sanctuaire. C'est là que j'allais parler de filles, de musique… J'ai toujours mon sac de classe sur lequel j'avais copié le logo de Roxy Music. Il y avait Roger Dean, qui avait travaillé avec Yes, et les types de Hipgnosis, qui travaillaient avec Pink Floyd. Et je me suis dit « Ouais, ça me dirait bien de faire pareil. »

Alors comment faire ? Il faut aller à l'université, dans mon cas à la fac du coin, parce que je suis un provincial timide. Je voulais être illustrateur – je détestais la typographie. Trop de polices de caractères ! Comment voulez-vous choisir la bonne ? Je voulais juste dessiner des images.

De 1976 à 1979 j'étais à la fac, alors j'ai vécu la révolution du punk. Tout le monde se débrouillait pour faire ce qu'ils voulaient, et les maisons de disques indépendantes mirent en place des systèmes de distribution indépendants. Lorsque je suis arrivé à Londres, j'ai obtenu un job dans un groupe de conception de produits appelé Michael Peters & Partners, excellent et assez progressiste. Deux types qui avaient travaillé pour 4AD n'étaient pas disponibles pour faire une pochette et ils me conseillèrent d'aller rencontrer Ivo Watts-Russell. En 1983, je travaillais pour lui en freelance, et il me nourrissait de sa musique. Cette année-là ils déménagèrent dans un nouvel espace et il y avait de la place pour une personne de plus. Ce fut moi. Quel pied ! Le premier employé était celui qui faisait les pochettes. Pour Ivo, l'emballage de la musique était très important.

Parliez-vous des pochettes avec Ivo ?

Du graphisme, oui. Mais je tenais toujours à parler avec les groupes de leur musique. Je lisais les paroles, et je leur demandais ce que voulaient dire leurs chansons. Ce qui était bien chez 4AD, et qui ne se faisait pas ailleurs, c'est que j'avais accès aux démos trois à quatre mois avant la sortie du disque. Lorsque je disais ça à mes collègues

d'autres labels, ils s'exclamaient « Bordel, nous on reçoit un coup de fil le vendredi pour livrer la pochette le lundi. » Moi j'avais le luxe d'avoir le temps d'y penser.

Il semble que vous ayez commencé à travailler avec [le photographe] Nigel Grierson très tôt, n'est-ce pas ?

Oui, nous avons étudié ensemble, du collège à l'université. Je travaillais chez 4AD et il était au Royal College of Art lorsque nous avons bossé ensemble pour Cocteau Twins et Modern English. Il s'agissait d'essayer de refléter l'atmosphère ou l'humeur de la musique. En un sens, c'est facile de faire un disque intéressant, il suffit de prendre une belle image et de lui ajouter une typographie intéressante. Mais s'il n'y a pas une vraie connexion avec la musique, ça ne sert à rien.

Comment se passait la collaboration avec Nigel ?

Nous aimions beaucoup effacer les frontières entre domaines, c'est pour ça qu'on a choisi [le nom] 23 Envelope. Comme ça il n'y avait pas de « Photographie de X » ou « Graphisme de Y ». Je pense que c'était typique de l'époque, les limites étaient très floues. On n'était pas seulement graphiste, on pouvait aussi filmer, prendre des photos. Et nous ne voulions pas utiliser nos noms, à cause de l'égo qui est rattaché au nom, même si évidemment nous avions chacun notre égo.

Je crois que c'est sur l'un des premiers albums des Cocteau Twins ou sur le premier de This Mortal Coil que j'ai réalisé « Oh, mais ce type fait tout ».

Et qu'est-ce que ça vous a inspiré ?

Je me suis dit « Bon, ben il me les faut tous ! »

Et vous vous y êtes tenu, hein ? Vous avez eu l'idée de vous procurer toute la série ? Normalement je n'aime pas trop l'idée d'avoir un certain style, parce que je pense que si vous regardez Colourbox, Bulgarian Voices, Wolfgang Press ou Lush, il y a une différence palpable. Je suppose que notre ambition, particulièrement après le départ de Nigel, était de donner à chacun une identité propre, si vous voulez, sans essayer de la leur imposer. Et notre ambition à l'intérieur de ça était de donner une idée de reconnaissance au sein du label qui va plus loin que le logo. Si vous avez aimé ceci, essayez ça.

Ivo avait clairement une direction esthétique générale pour le son du label. Comme vous, il avait une vision. C'est très rare qu'un graphiste et un label restent associés si longtemps et créent ensemble une œuvre artistique.

Si je remonte dans le temps, Blue Note, ECM. Et bien qu'ils aient été des modèles d'une certaine façon, je pense qu'ils étaient un peu trop rigides, du point de vue graphique. Nous voulions plutôt quelque chose qui s'emboîte naturellement, sans forcer. Nous avons fait beaucoup de trucs ambigüs. Il y avait du mystère. Lorsque nous faisions des expositions aux quatre coins du monde, les Japonais en particulier imaginaient des explications compliquées « Ah, je vois ceci, je vois cela ». Je leur disais « En fait non, c'est juste un peu de peinture au spray ». Mais je suppose que derrière tout ça, il s'agissait bien de laisser la porte ouverte aux interprétations.

Voici une idée – c'est la première chose que j'ai écrite sur un mur de toilettes : « Suggérer c'est créer, décrire c'est détruire ». C'est l'idée de laisser de l'espace, d'inspirer et de faire participer les gens – soulever une question sans lui donner de réponse. Vous voyez cette affiche d'un mètre sur un mètre cinquante dans les rues de Londres

et vous pensez « Mais c'est quoi ce truc ? » et ça plante une graine en vous, que vous emportez. Et vous n'arrivez pas à comprendre. Les meilleures pochettes sont celles qui vous atteignent juste entre les deux yeux, et qui donnent matière à revenir dessus plus tard.

Avez-vous un certain raisonnement ou une sensibilité spéciale en ce qui concerne la typographie ?

Comme je l'ai déjà dit, à l'université je détestais ça. Les lettres gâchaient mes illustrations. J'ai appris à connaître la typographie quand j'ai travaillé sur des étiquettes de boissons chez Michael Peters & Partners. Je regardais une étiquette de whisky, avec de grosses lettres à côté de lettres fines et de quelques mots en cursives, et tout d'un coup j'ai compris qu'il s'agissait de dessin. Je vois le texte comme une image. Alors mon approche de la typographie est celle d'un illustrateur. Il y a une certaine résonance dans l'idée de réunir des éléments qui ne devraient peut-être pas être ensemble. Lorsque j'utilisais une vieille police de caractères [des années 1930 ou 1940], je pense que ce n'était pas du pastiche parce que je lui ajoutais un peu de Futura ou une police contemporaine. Juste pour la présenter sous un jour différent.

J'ai l'impression qu'il y a eu un basculement vers 1987. Votre travail a toujours eu une part d'humour noir, mais il semble avoir pris une teinte encore plus sombre à cette époque, particulièrement avec l'aspect musée des horreurs/ambiance David Lynch de votre travail pour les Pixies.

Ça a été une combinaison de plusieurs choses. Nigel est parti vers 1985/86. Je pense qu'il est une sorte de génie, à sa façon, mais le temps était venu de se séparer. *Lonely is an Eyesore*, une compilation qui résumait les années précédentes, marqua la fin d'une époque. Et puis nous sommes passés à autre chose. 4AD signa avec trois groupes américains vers 1987 : Ultra Vivid Scene, Throwing Muses et les Pixies. Jusque-là, nous avions travaillé avec des groupes tels que Cocteau Twins et Wolfgang Press... on arrivait à peine à leur tirer trois mots ! Quand on leur montrait les visuels ils disaient « On n'aime pas ça ». Alors qu'est-ce que vous aimez ? « Je ne sais pas ». Alors ça a été une révélation de travailler avec des Américains qui savent s'exprimer comme Kurt Ralske, Kristin Hersh, Charles [Charles Thompson IV, alias Black Francis] et Kim Deal. Ils savaient parler de tout ça... ils pouvaient faire des *interviews* ! Ça nous a insufflé une nouvelle énergie ! Kurt me donnait des images à transformer. Kristin détestait ce que je faisais alors je faisais participer Chris Bigg davantage, et puis j'ai trouvé un artiste japonais, Shinro Ohtake. Je pense que les Pixies sont le meilleur groupe avec qui j'ai travaillé, ils m'ont touché au cœur. Beaucoup de gens considèrent que la pochette de *Doolittle* a été le tremplin de leur exploration du graphisme. Je sais que c'est le pouvoir de la musique, mais c'est magnifique de savoir qu'on a inspiré des gens dans leur œuvre.

page 39

AC/DC

artist AC/DC
title FOR THOSE ABOUT
TO ROCK (WE
SALUTE YOU)
year 1981
label ATLANTIC

RECORD COVERS
A to Z

FOR THOSE ABOUT TO ROCK

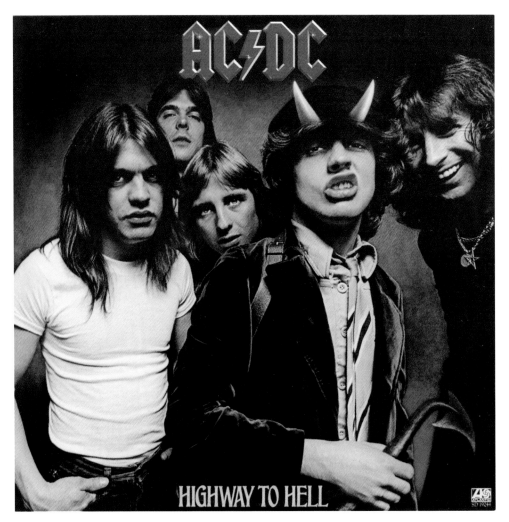

AC/DC

artist AC/DC
title HIGHWAY TO HELL
year 1979
label ATLANTIC
ad BOB DEFRIN
photo JIM HOUGHTON

Highway to Hell took this Australian group from local heroes to world-dominating rock gods, though unfortunately it would be singer Bon Scott's last as he drank himself to death shortly after the album was released. Former Richard Avedon assistant Jim Houghton shot the cover in NYC a couple of years earlier for the group's *Powerage* LP, but it was unused for that release. The horns and devil's tail were airbrushed in to complete the dark satanic vibe.

THE 101ERS

artist THE 101ERS
title ELGIN AVENUE
BREAKDOWN
year 1981
label ANDALUCIA
photo MIKKI RAIN

In 1976 this seasoned pub
rock band, named after the
house number of their London
squat, found themselves
gigging with a support act
called the Sex Pistols. The
experience proved to be a
pivotal moment for 101ers
frontman John "Woody"
Mellor. A few months later
Mellor, aka Joe Strummer,
departed to join the Clash,
whose first gig, in a twist
of fate, was supporting the
Sex Pistols in Sheffield.
Elgin Avenue Breakdown was
eventually released as a com-
pilation of recordings from
different sources.

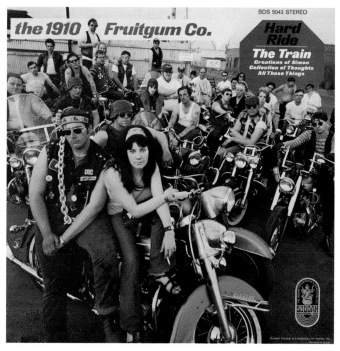

THE 1910
FRUITGUM CO.

artist THE 1910
FRUITGUM CO.
title HARD RIDE
year 1969
label BUDDAH

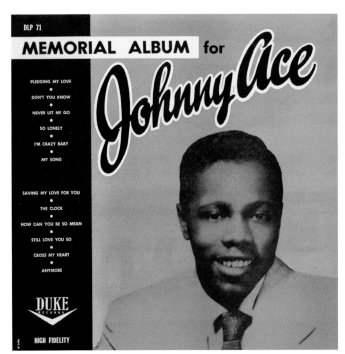

JOHNNY ACE

artist JOHNNY ACE
title MEMORIAL ALBUM
FOR JOHNNY ACE
year 1956
label DUKE

AESOP'S FABLES

artist AESOP'S FABLES
title IN DUE TIME...
year 1969
label CADET CONCEPT
art JOE FRATICELLI
design FRANK KREPELA

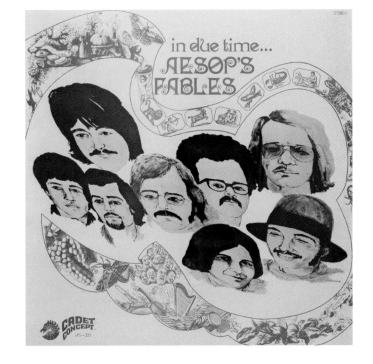

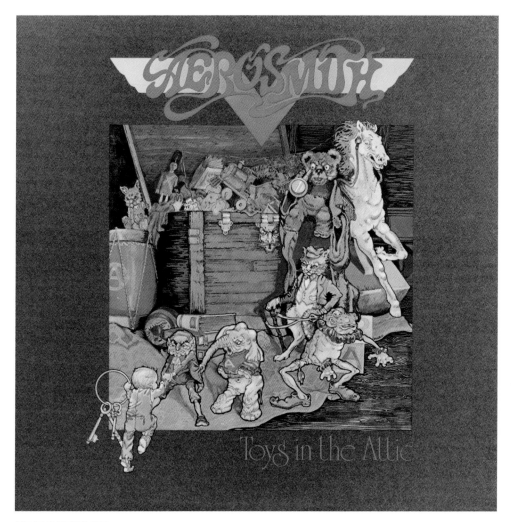

AEROSMITH

artist AEROSMITH
title TOYS IN THE ATTIC
year 1975
label COLUMBIA
art INGRID HAENKE
design PACIFIC EYE & EAR
photo BOB BELOTT

Pacific Eye & Ear staffer Ingrid Haenke collaborated on the *Toys in the Attic* cover with Aerosmith frontman Steven Tyler, whose original vision involved a gathering of toys encircling a teddy bear that'd slit its wrist. A team player, Haenke posed for her boss Drew Struzan for the back-cover illustration for Black Sabbath's 1973 album *Sabbath Bloody Sabbath*.

"After a 3-day meeting with Joe Perry and Steven Tyler on this cover, there was only one illustrator in my mind that could give the band what they wanted: fashion and children's book illustrator, Ingrid Haenke. She is a beautiful person and a great artist and in the end this piece is one of Aerosmith's biggest and most recognized albums of all time." – Ernie Cefalu

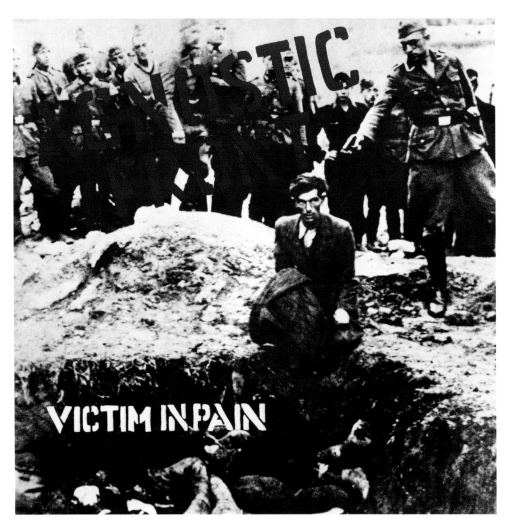

AGNOSTIC FRONT

artist AGNOSTIC FRONT
title VICTIM IN PAIN
year 1984
label RAT CAGE
design MIR
photo ANONYMOUS/
JESSICA BARD

The deliberate use of shocking images within the hardcore punk subculture has long been a commonplace, sometimes intended to reflect political ideologies or to highlight social injustices, and sometimes simply to provoke. Whilst bands like Agnostic Front, with its multi-ethnic line-up, have always maintained an anti-racist and anti-fascist stance, their skinhead roots have by default attracted a minority contingent of right-wing followers. Together with *United Blood*, the band's 1983 debut EP, *Victim in Pain* remains a defining moment in the early New York hard-core scene.

THE AMERICAN REVOLUTION

artist THE AMERICAN
REVOLUTION
title THE AMERICAN
REVOLUTION
year 1968
label FLICK-DISC
design ARW PRODUCTIONS

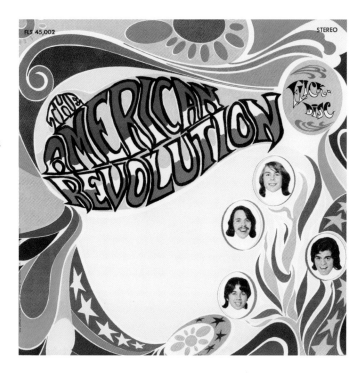

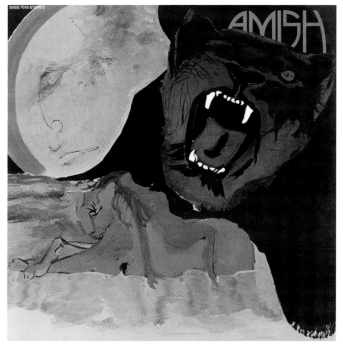

AMISH

artist AMISH
title AMISH
year 1972
label SUSSEX
ad GLEN CHRISTENSEN
art JUDY TALBERT

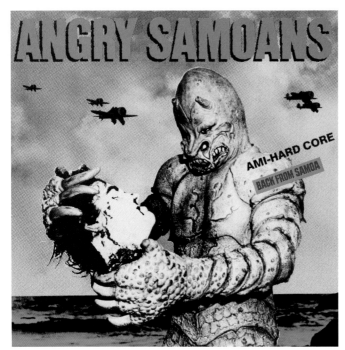

ANGRY SAMOANS

artist ANGRY SAMOANS
title BACK FROM SAMOA
year 1982
label BAD TRIP
design LISA ADAMS
photo ED COLVER

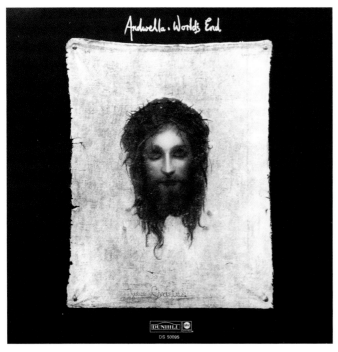

ANDWELLA

artist ANDWELLA
title WORLD'S END
year 1970
label DUNHILL
design BARRY D'ARCY,
MICK TAYLOR
photo TERENCE IBBOTT

THE ANIMALS

artist THE ANIMALS
title THE ANIMALS
year 1964
label MGM

This self-titled American inaugural release from the British Invasion group contains a selection of gritty R&B covers from the oeuvres of Chuck Berry, Fats Domino and John Lee Hooker. In amongst the pack you'll find the definitive rock version of the folk ballad and number 1 hit single, "House of the Rising Sun," delivered by vocalist Eric Burdon in his trademark coarse blues style.

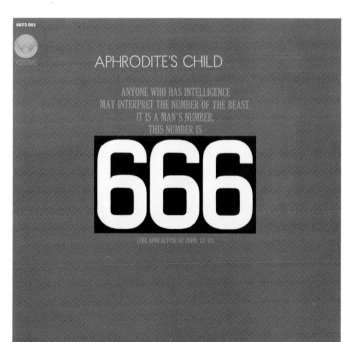

APHRODITE'S CHILD

artist APHRODITE'S CHILD
title 666
year 1972
label VERTIGO
ad KIYOSHI TOKIWA

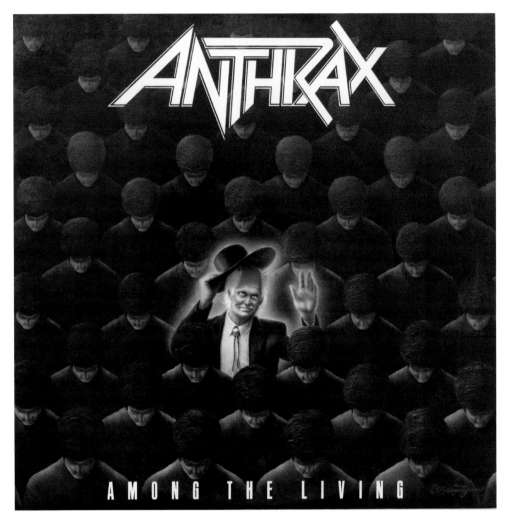

ANTHRAX

title AMONG THE LIVING
year 1986
label ISLAND/MEGAFORCE
ad BOB DEFRIN,
SCOTT IAN
art DON BRAUTIGAM
design CHARLIE BENANTE

The third studio offering by the US thrash metal giants expanded the group's appeal to a broader fan-base—in no small way by MTV's regular playing of "Indians" which cemented it as one of their best-known hits. The latter would eventually feature in the *Guitar Hero: Warriors of Rock* game. Artist Don Brautigam illustrated numerous book and album covers, including titles by Stephen King and Dean Koontz as well as Metallica's classic 1986 album, *Master of Puppets*. This cover features a portrayal of Reverend Henry Kane, the evil ghost from the *Poltergeist* movie trilogy.

THE AQUARIANS

artist THE AQUARIANS
title JUNGLE GRASS
year 1969
label UNI
art WELLER

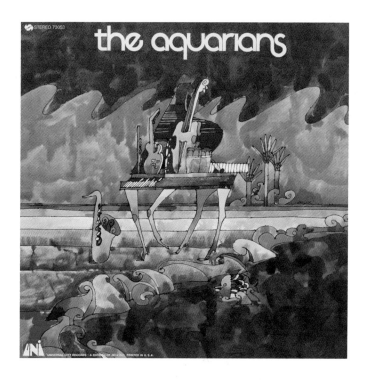

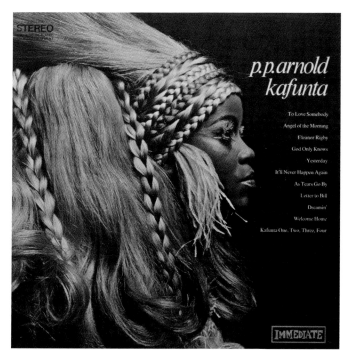

P.P. ARNOLD

artist P.P. ARNOLD
title KAFUNTA
year c. 1968
label IMMEDIATE
design LOOG AT THE
HOUSE OF
IMMEDIATE
(ANDREW LOOG
OLDHAM)
photo GERED MANKOWITZ

*"Apart from the funda-
mentals of light, composi-
tion, focus and exposure
it's all about managing to
get the subject to give a
tiny piece of their soul
to the lens which makes
one portrait stand out
from another."*

Gered Mankowitz

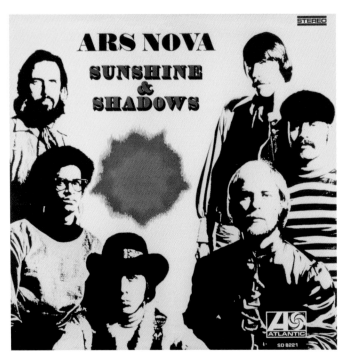

ARS NOVA
artist ARS NOVA
title SUNSHINE &
SHADOWS
year 1969
label ATLANTIC
design GRAFFITERIA
photo JOEL BRODSKY

FRANKIE AVALON
artist FRANKIE AVALON
title FRANKIE AVALON
year 1958
label CHANCELLOR
photo BOB GHIRALDINI

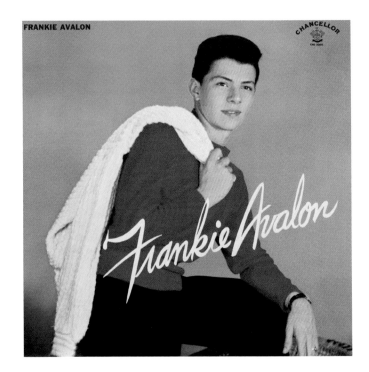

THE ARTHUR SOUND

artist THE ARTHUR SOUND
title THE WILD ONES
year 1965
label UNITED ARTISTS
photo RICHARD AVEDON

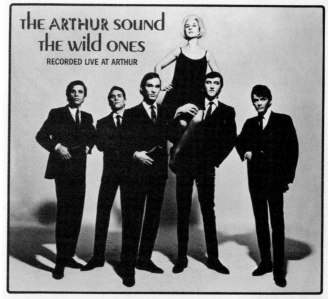

THE ASTRONAUTS

artist THE ASTRONAUTS
title SURFIN' WITH THE ASTRONAUTS
year 1963
label RCA VICTOR

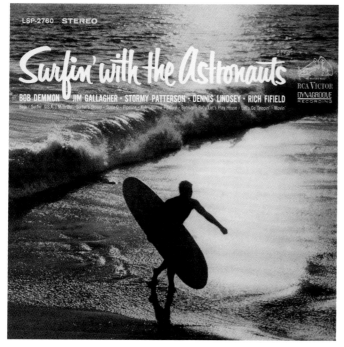

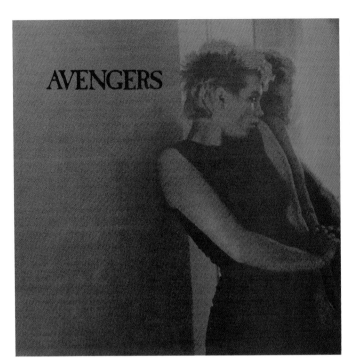

AVENGERS

artist AVENGERS
title AVENGERS
year 1983
label WHITE NOISE
ad BOB DEFRIN
photo MARCUS
LEATHERDALE

Known primarily as "the pink album," this rarity took years to release after the band called it quits in 1979 (just a year and a half after they opened for the Sex Pistols' farewell show at Winterland Ballroom). The band's personal photographer, Marcus Leatherdale, turned a classically beautiful black & white shot into a radioactive slice of day-glo tension that perfectly fit Penelope Houston and the group's ferocious Northern Cali punk ethos.

AZUCAR, CACAO & LECHE

artist AZUCAR,
CACAO & LECHE
title AZUCAR,
CACAO & LECHE
year 1971
label TOP HITS

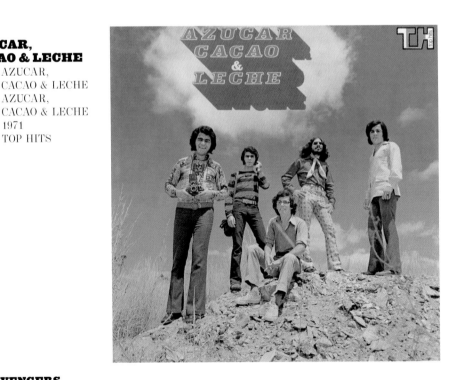

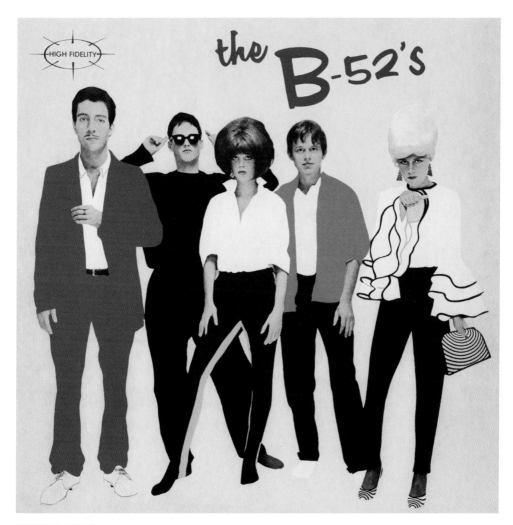

THE B-52'S

artist THE B-52'S
title THE B-52'S
year 1979
label WARNER BROS.
ad TONY WRIGHT
(SUE AB SURD)
photo GEORGE DUBOSE

New Jersey natives Fred Schneider and Kate Pierson conspired with locals Cindy Wilson, brother/guitarist Ricky and drummer Keith Strickland to form the quirky and charming B-52's. Many of the band's songs and concepts were developed at Pierson's rural cabin—which lacked plumbing and running water—immortalized years later with the group's most enduring hit, "Love Shack."

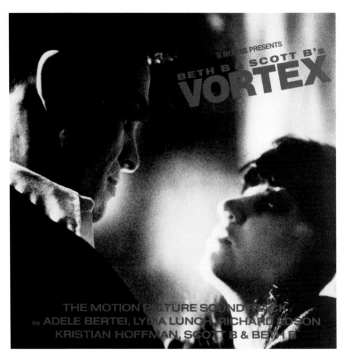

BETH B & SCOTT B

artist BETH B & SCOTT B
title VORTEX
year 1982
label NEUTRAL
design BETH B & SCOTT B,
 PARTIE ASSOCIATES
photo BETH B & SCOTT B

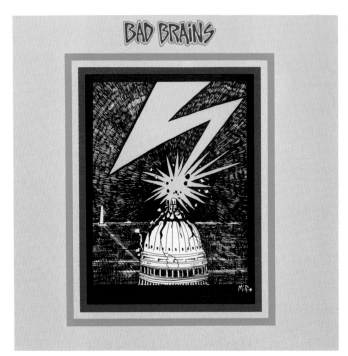

BAD BRAINS

artist BAD BRAINS
title BAD BRAINS
year 1982
label ROIR
art MIR, JAY JONES,
 DONNELL GIBSON
photo LAURA LEVINE

A cassette-only release on storied NYC punk and no-wave label ROIR in its first run, this hardcore-punk prototype's jarring cover image is the discordant vision of Mir, aka Dave Ratcage, the brain behind the *Mouth of the Rat* fanzine and NYC record shop/label, Ratcage. Its lightning bolt to the US Capitol building would become a symbol of the aggro-underground for years to come.

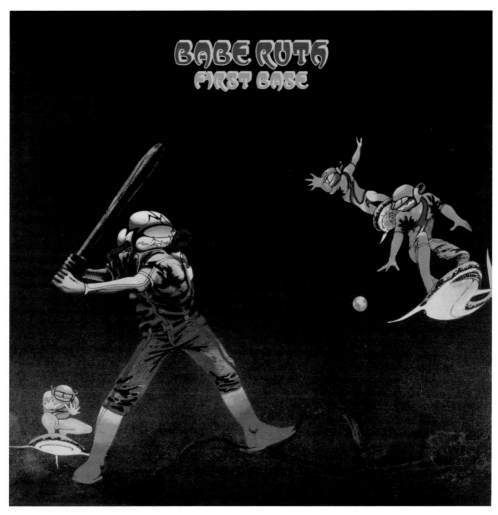

BABE RUTH
artist BABE RUTH
title FIRST BASE
year 1972
label HARVEST EMI
design ROGER DEAN
photo ROGER DEAN

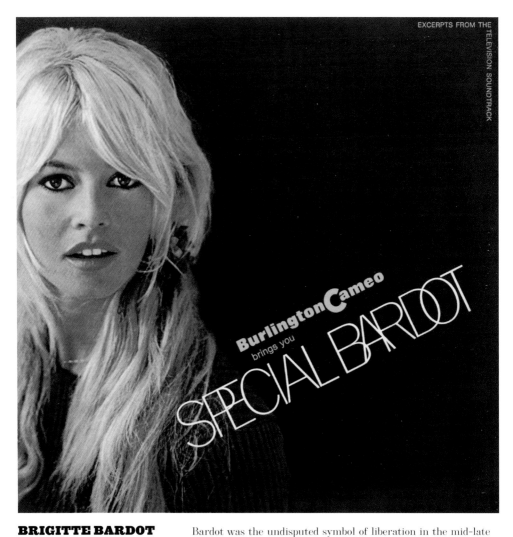

Burlington Cameo
brings you
SPECIAL BARDOT

BRIGITTE BARDOT

artist BRIGITTE BARDOT
title BURLINGTON
CAMEO BRINGS YOU
SPECIAL BARDOT
year 1968
label BURLINGTON
CAMEO/RCA

Bardot was the undisputed symbol of liberation in the mid-late 20th century, and during her stellar career the actress and model also released numerous albums and singles. This recording features performances from a December 3, 1968 NBC-TV special and includes duets with French chanteurs Serge Gainsbourg and Sacha Distel. While it is a testament to her prominence in the swinging '60s, her debut US release remains largely over-shadowed by the network's broadcast earlier the same evening, the now legendary *Elvis '68 Comeback Special*.

PETER BARDENS

artist PETER BARDENS
title THE ANSWER
year 1970
label VERVE FORECAST
photo KEITH MORRIS

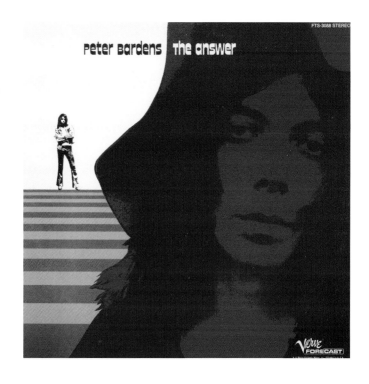

KALI BAHLU

artist KALI BAHLU
title COSMIC
REMEMBRANCE
year 1967
label WORLD PACIFIC
ad WOODY WOODWARD
art KALI BAHLU
design GABOR HALMOS

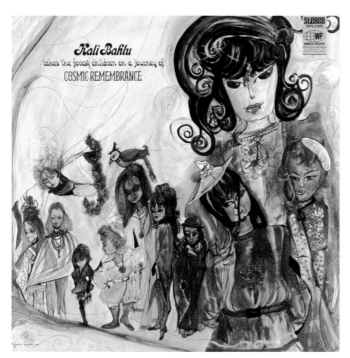

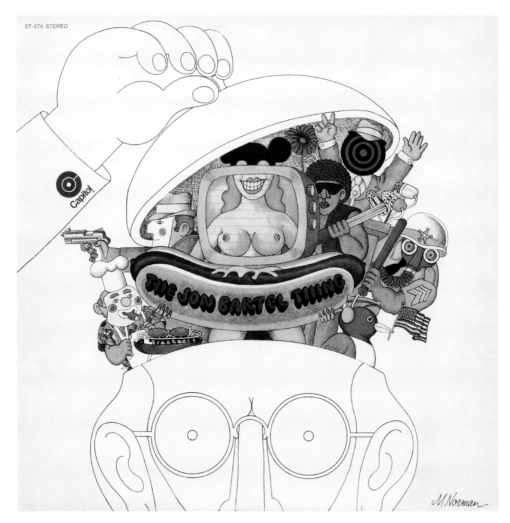

THE JON BARTEL THING

artist THE JON BARTEL
 THING
title THE JON BARTEL
 THING
year 1969
label CAPITOL
art MARTY NORMAN
design MARTY NORMAN

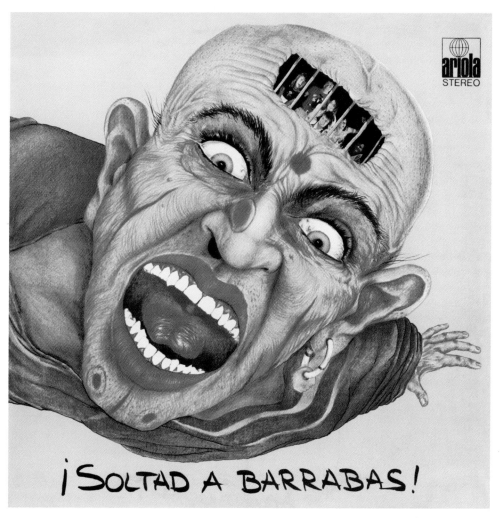

BARRABÁS
artist BARRABÁS
title ¡SOLTAD A
 BARRABÁS!
year 1974
label ARIOLA
art MIQUEL A.
 LÓPEZ PARRAS

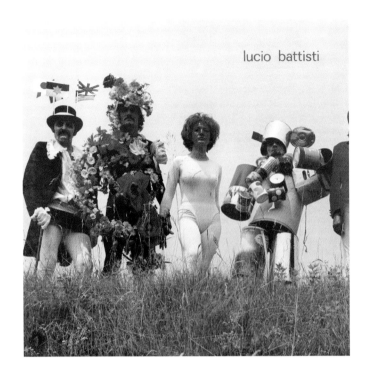

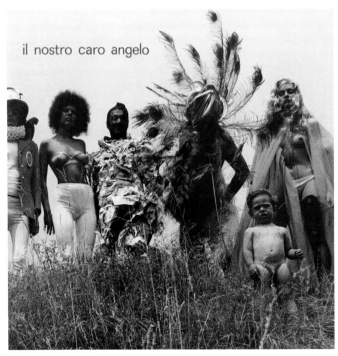

LUCIO BATTISTI
artist LUCIO BATTISTI
title IL NOSTRO CARO
ANGELO
year 1973
label NUMERO UNO
design STUDIO G7, MOGOL
(AKA GIULIO
RAPETTI)

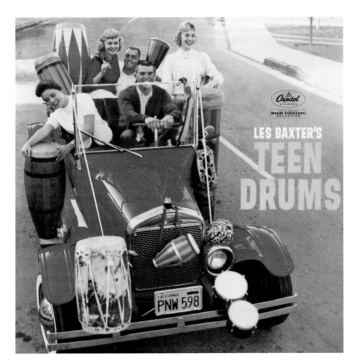

LES BAXTER

artist LES BAXTER
title TEEN DRUMS
year 1960
label CAPITOL

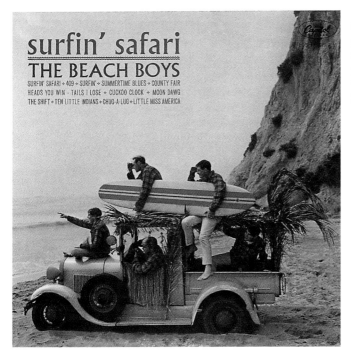

THE BEACH BOYS

artist THE BEACH BOYS
title SURFIN' SAFARI
year 1962
label CAPITOL
photo KEN VEEDER

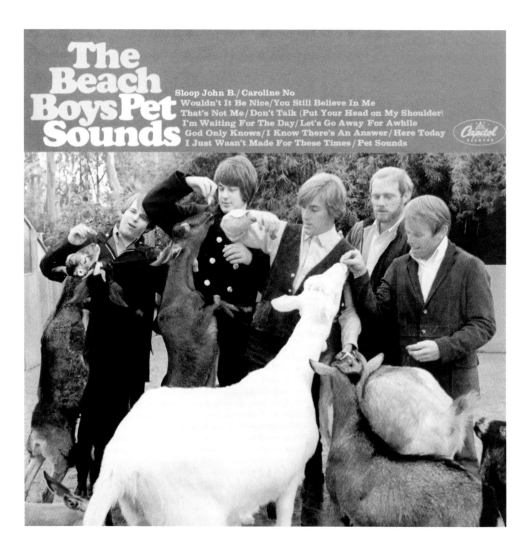

The Beach Boys Pet Sounds

Sloop John B./Caroline No
Wouldn't It Be Nice/You Still Believe In Me
That's Not Me/Don't Talk (Put Your Head on My Shoulder)
I'm Waiting For The Day/Let's Go Away For Awhile
God Only Knows/I Know There's An Answer/Here Today
I Just Wasn't Made For These Times/Pet Sounds

THE BEACH BOYS

artist THE BEACH BOYS
title PET SOUNDS
year 1966
label CAPITOL
photo GEORGE JERMAN

The true story behind the title of Brian Wilson's great opus may never be known. Whether it indicates Phil Spector's initials, with regard to the way the album was recorded in reaction to his Wall of Sound method, or simply refers to people's preferred or "pet" sounds, what is certain is that the title had already been decided on when the band showed up at the San Diego Zoo for the cover shoot, which is attributed to Capitol staff photographer George Jerman and is a play on the album's title.

BEASTIE BOYS

artist BEASTIE BOYS
title POLLY WOG STEW
year 1982
label RATCAGE
photo ROBIN MOORE

Dave Parsons's Ratcage
Records was located in the
basement of 171A Studios
in New York's East Village,
where future rap luminaries
the Beastie Boys recorded
their debut release as a punk
quartet. Photographer Robin
Moore was acquainted with
the group through her own
Decline of Art fanzine, which
published the first Beastie
Boys interview in 1981.

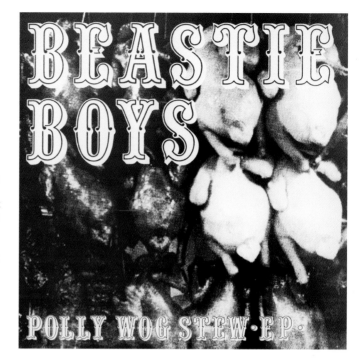

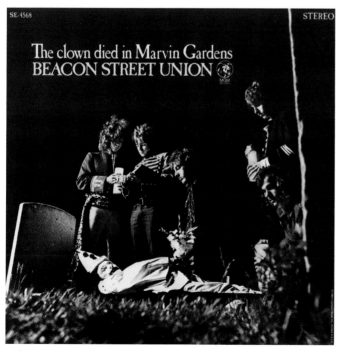

THE BEACON STREET UNION

artist THE BEACON
STREET UNION
title THE CLOWN
DIED IN MARVIN
GARDENS
year 1968
label MGM
ad ACY R. LEHMAN
photo JOEL BRODSKY

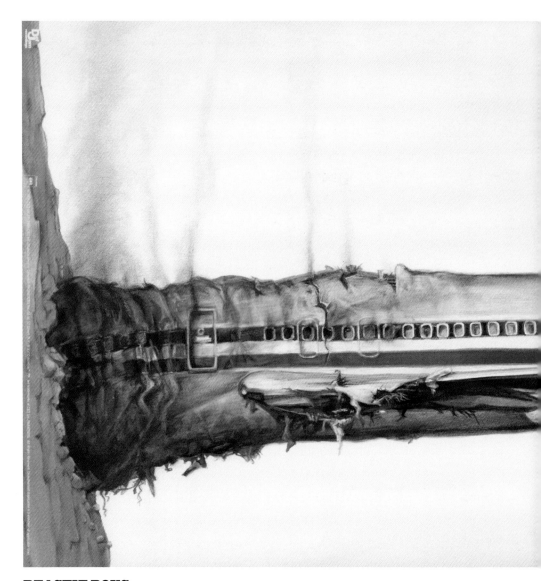

BEASTIE BOYS

artist BEASTIE BOYS
title LICENSED TO ILL
year 1986
label DEF JAM/CBS
ad STEPHEN BYRAM
art WORLD B. OMES
 (DAVID GAMBALE)

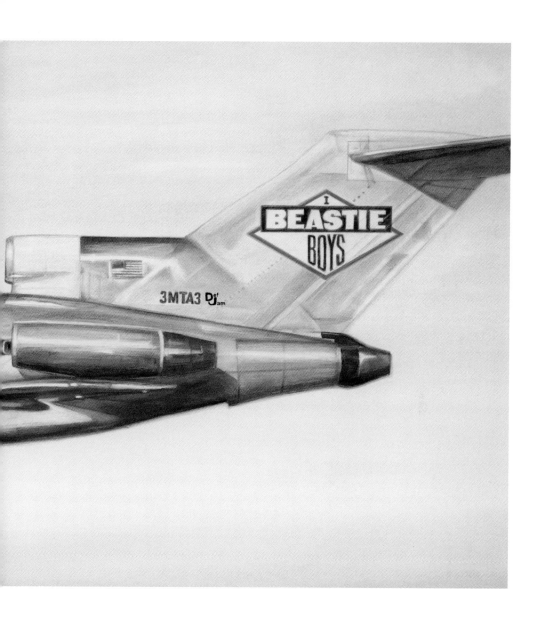

"*The Beastie Boys were just a bunch of little guys and I wanted us to have a Beastie Boys jet. I wanted to embrace and somehow distinguish, in a sarcastic way, the larger-than-life rock 'n' roll lifestyle, the excesses and the destruction.*"

Rick Rubin

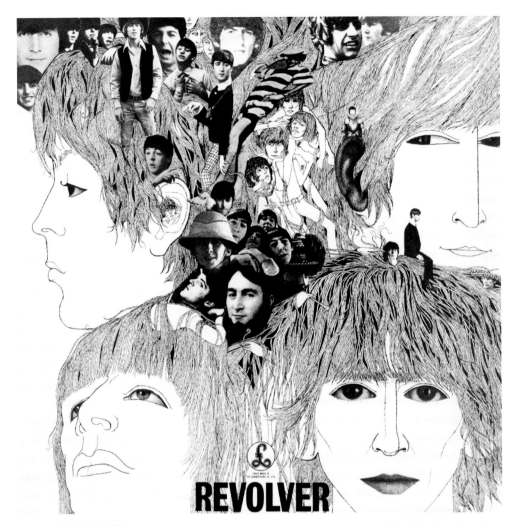

REVOLVER

THE BEATLES

artist THE BEATLES
title REVOLVER
year 1966
label PARLOPHONE
art KLAUS VOORMANN
design KLAUS VOORMANN
photo ROBERT WHITAKER

The collage created by Klaus Voormann belied his close friendship with the Beatles. He combined ink drawings of their faces and offset them with images meant to show a softer side of the band, including one of Ringo on the toilet. Voormann also included his own name and image near the right margin of the cover in George's hair.

THE BEATLES

artist THE BEATLES
title WITH THE BEATLES
year 1963
label PARLOPHONE
photo ROBERT FREEMAN

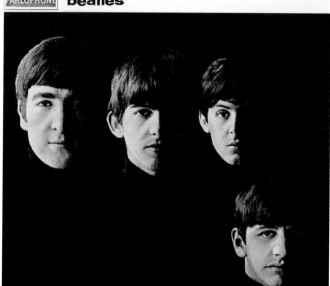

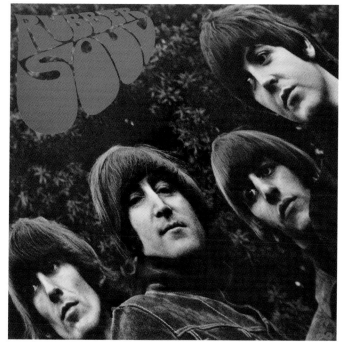

THE BEATLES

artist THE BEATLES
title RUBBER SOUL
year 1965
label PARLOPHONE
art CHARLES FRONT
 (LETTERING)
design KLAUS VOORMANN
photo ROBERT FREEMAN

When photographer Robert
Freeman showed the band
images from a session he did
with them at John Lennon's
house in Weybridge, he
projected them on an album-
sized piece of cardboard.
When Freeman accidentally
moved the card, stretching
out and distorting the faces,
the band immediately clam-
ored for that effect.

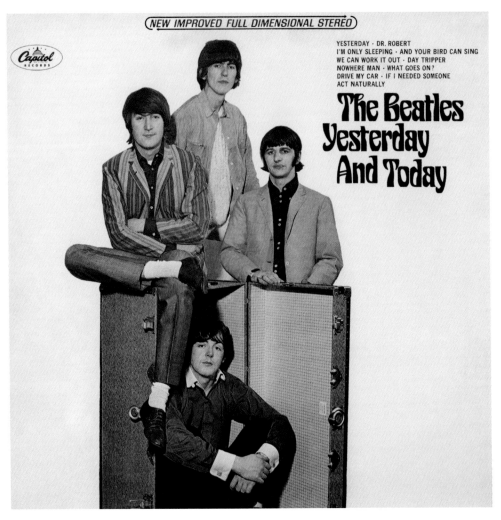

YESTERDAY · DR. ROBERT
I'M ONLY SLEEPING · AND YOUR BIRD CAN SING
WE CAN WORK IT OUT · DAY TRIPPER
NOWHERE MAN · WHAT GOES ON?
DRIVE MY CAR · IF I NEEDED SOMEONE
ACT NATURALLY

**The Beatles
Yesterday
And Today**

THE BEATLES

artist THE BEATLES
title YESTERDAY
AND TODAY
year 1966
label CAPITOL
photo ROBERT WHITAKER

The original image used for this LP was the legendarily rare "butcher" cover (p. 496) shot by Robert Whitaker earlier in the year for a projected triptych in which the band would be seen as religious icons, with tipped-in haloes, to be called "Somnambulant Adventure." Shortly before his death John Lennon commented on the gruesome image: "It was inspired by our boredom and resentment at having to do *another* photo session and *another* Beatles thing. We were sick to death of it." Very few copies have survived as this issue was only on sale to the public for one day. After Capitol recalled the LP a portion of the 750,000 copies was destroyed, but rather than junk the whole run that had been printed up the label decided to re-use the covers with a neutral image pasted on top of the shocking original, this being the photo with Paul sitting in an up-ended trunk and the other three around it.

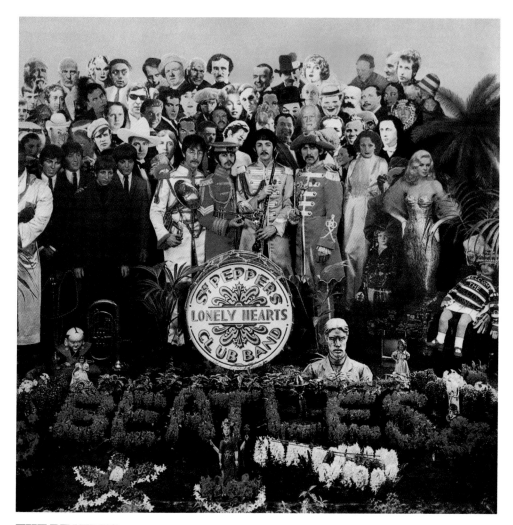

THE BEATLES

artist THE BEATLES
title SGT. PEPPER'S
LONELY HEARTS
CLUB BAND
year 1967
label PARLOPHONE
ad ROBERT FRASER
design MC PRODUCTIONS
AND APPLE STAGED
BY PETER BLAKE,
JANN HAWORTH
photo MICHAEL COOPER

California-born pop artist Jann Haworth and British-born pop artist Peter Blake joined forces to piece together one of rock's most memorable album covers. It was good enough to receive a Grammy for cover art and still remains a feast for the eyes. More than 50 figures, including actors, writers, poets, gurus, and musicians, appear behind the band, creating a veritable *Where's Waldo* starring Shirley Temple, who made it on the cover three times. But why all the wax figurines? Lennon said it best when, sick of touring, he suggested that perhaps they simply "send out four waxworks" for the crowds. The four band members spiraled off into their own interests shortly thereafter, rejoining with their "fictitious" band, Sgt. Pepper's, largely influenced by the Beach Boys' album *Pet Sounds*.

BECK

artist BECK
title ONE FOOT IN
THE GRAVE
year 1994
label K
photo JEFF SMITH

Although it was released a
few months after *Mellow
Gold*, the debut LP that shot
Beck to fame at the age of
only 23, *One Foot in the
Grave* was actually recorded
first. The bluesy folk sound
reflected in the melancholy
cover photo was undoubtedly
a bit confusing for Beck's
new-found fans, who had
grown quickly accustomed to
the *Mellow Gold* sound we still
hear today.

THE BEE GEES

artist THE BEE GEES
title THE BEE GEES' 1ST
year 1967
label ATCO
design KLAUS VOORMANN
photo KLAUS VOORMANN

Built around bandleader
Barry Gibb and younger twin
brothers Robin and Maurice,
the Bee Gees' debut was a
psychedelic outing deserving
of an imaginative cover by
Klaus Voormann, known
for his work on the Beatles'
Revolver the summer before.
Voormann befriended the Fab
Four in the early '60s during
their residency in Hamburg,
and remained allied with the
band, designing the Anthology
series in the '90s.

THE BELMONTS

artist THE BELMONTS
title CARNIVAL OF HITS
year 1962
label SABINA

"*I was heavily into rock 'n' roll and had to create something that hit the spot without question.*"
Chuck Berry

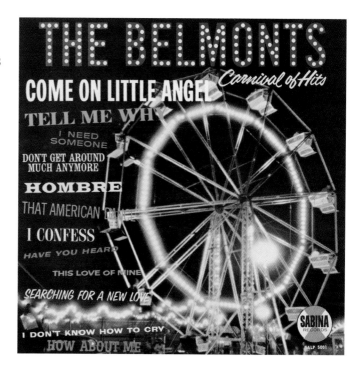

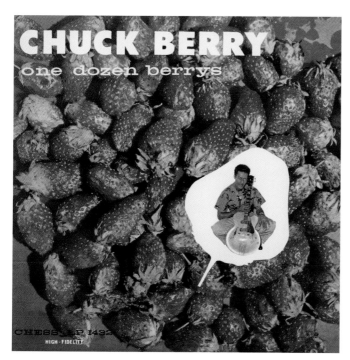

CHUCK BERRY

artist CHUCK BERRY
title ONE DOZEN BERRYS
year 1958
label CHESS

Chuck Berry is inarguably one of the pioneers of rock 'n' roll music. With this release, featuring a range of ballads and boogies over its twelve tracks, it's "Rock at the Philharmonic", "Reelin' and Rockin'" and "Rock & Roll Music" that truly establish Berry at the advent of the genre.

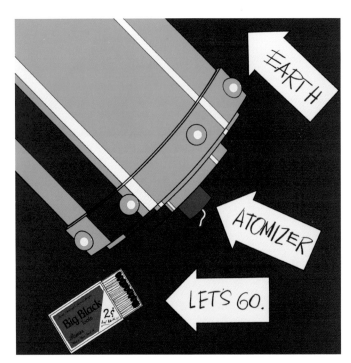

BIG BLACK

artist BIG BLACK
title ATOMIZER
year 1986
label HOMESTEAD
design STEVE ALBINI

Chicago recording engineer Steve Albini's first band gathered members of beloved local punk act Naked Raygun and set the pace for many of the industrial-rock acts that followed. After releasing a string of EPs, this full-length studio debut presented the trio's most recognized song, "Kerosene," a meandering epic steered by metallic guitars and aggressive drum-machine programming, credited simply to "Roland" in the liner notes.

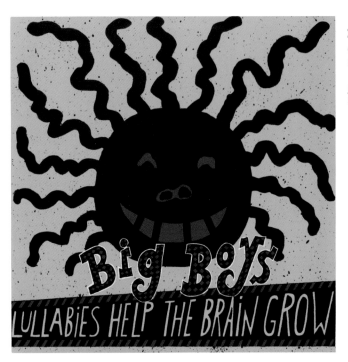

BIG BOYS

artist BIG BOYS
title LULLABIES HELP
 THE BRAIN GROW
year 1983
label MOMENT
 PRODUCTIONS

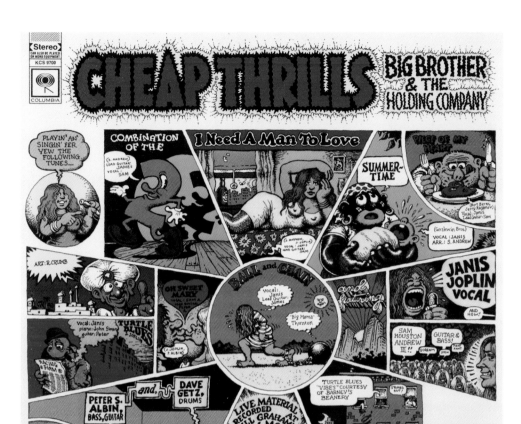

"This is probably one of the things I'm best known for having done, this probably got more women interested in me than anything else I've ever done. Basically I did it because Janis Joplin asked me to do it and I liked her. She used to hang around, she liked comics... you know. I didn't like her music, but I did it because she asked me to and I needed the money. I got six hundred bucks! Originally this was supposed to be the back cover. I did a whole different thing for the front cover which none of the band members liked so they never used it."

Robert Crumb

BIG BROTHER & THE HOLDING COMPANY

artist BIG BROTHER & THE HOLDING COMPANY
title CHEAP THRILLS
year 1968
label COLUMBIA
art ROBERT CRUMB

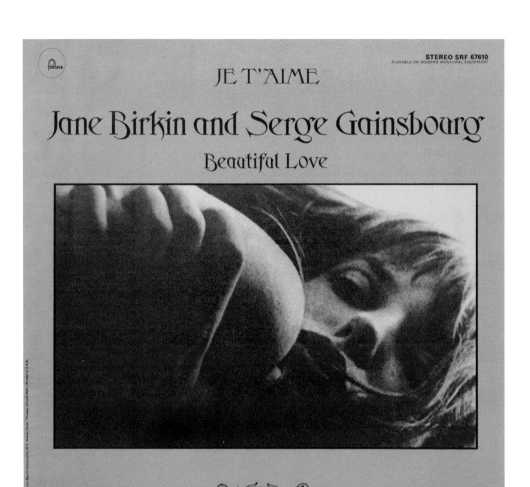

JE T'AIME

Jane Birkin and Serge Gainsbourg

Beautiful Love

JANE BIRKIN AND SERGE GAINSBOURG

artist JANE BIRKIN AND
SERGE GAINSBOURG
title JE T'AIME/
BEAUTIFUL LOVE
year 1969
label FONTANA
design RICHARD GERMINARO
photo RICHARD STIRLING

Add a dash of deep, Gitane-infused vocals to a slow caressing organ and high-pitched moaning—and bring to a bubbling climax. What you get is one of the most overtly erotic love songs in the history of popular music. Originally written for and recorded as a duet with Gainsbourg's then lover Brigitte Bardot, the song "Je T'Aime... Moi Non Plus" was pulled from release at Bardot's request as it angered her husband at the time, millionaire playboy Gunter Sachs. This album of duets and solo songs features the definitive re-recorded version with Gainsbourg's subsequent partner, British actress Jane Birkin. Despite causing widespread controversy and bans in various countries, the song managed to top the charts in the UK.

BIG STAR

artist BIG STAR
title BIG STAR'S 3RD:
SISTER LOVERS
year 1987
label PVC
design MURRAY BRENMAN
photo MICHAEL O'BRIEN

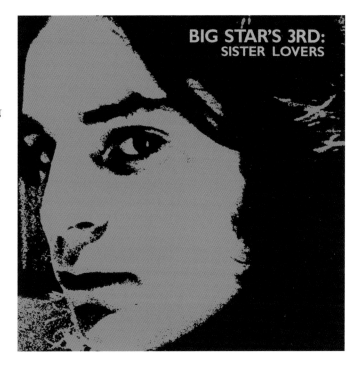

BIKINI KILL

artist BIKINI KILL
title PUSSY WHIPPED
year 1992
label WHIJA
photo TAMMY RAE
CARLAND

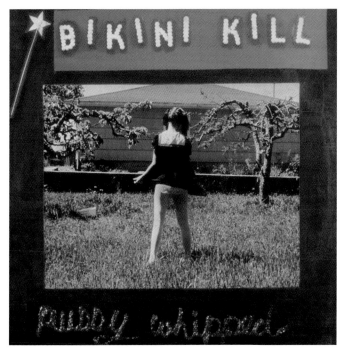

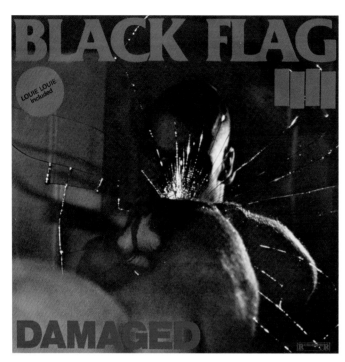

BLACK FLAG

artist BLACK FLAG
title DAMAGED
year 1981
label SST
photo ED COLVER

The eye of Los Angeles punk, Edward Colver took this photograph of 20-year-old Henry Rollins that seems born of a B-horror film. After applying tape to the back of the mirror Colver shattered the front with a hammer and then tidied its reflective surface for the frontman's *faux*-bloody fist, made possible by applying a formula of red India ink, liquid dishwashing soap, and powdered instant coffee.

BLACK FLAG

artist BLACK FLAG
title IN MY HEAD
year 1985
label SST
art RAYMOND PETTIBON

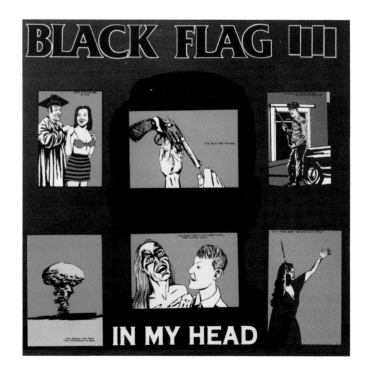

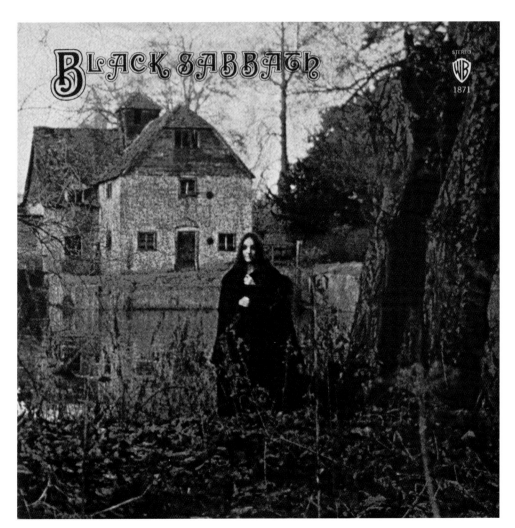

BLACK SABBATH

artist BLACK SABBATH
title BLACK SABBATH
year 1970
label VERTIGO
design MARCUS KEEF

An archetype of the heavy metal genre, Black Sabbath's self-titled debut was recorded in just one day and, apropos of its dark-lore themes, was released in the UK on Friday the 13th in February of 1970. In Europe, the inner sleeve of the gatefold featured an upside-down cross, which was omitted for its US release after rumors that the band participated in Satanist practices.

BLAKE BABIES
artist BLAKE BABIES
title NICELY, NICELY
year 1987
label CHEW BUD

BLIND FAITH
artist BLIND FAITH
title BLIND FAITH
year 1969
label POLYDOR
art STANLEY MILLER,
MICK MILLIGAN
photo BOB SEIDEMANN

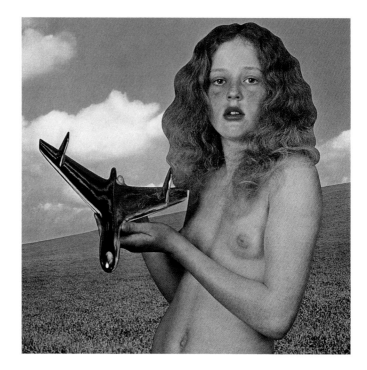

BLUE CHEER

artist BLUE CHEER
title VINCEBUS ERUPTUM
year 1968
label PHILIPS
ad GUT
photo JOHN VAN
HAMERSVELD

If ever there were a quintessential '60s psychedelic look, this album has it. It may surprise you though, at first glance, since this is one of the first heavy metal albums to hit the scene, but with the look of the times it made sense that the celebrated John Van Hamersveld did the cover art. He's known first and foremost for this style, which he has effortlessly transformed into tripped-out album covers, movie posters and '60s- and '70s-inspired works of art.

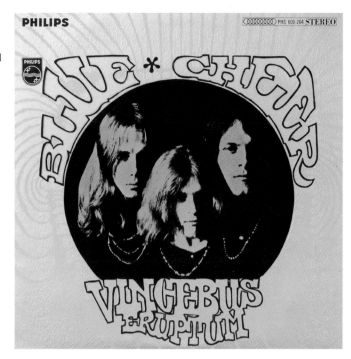

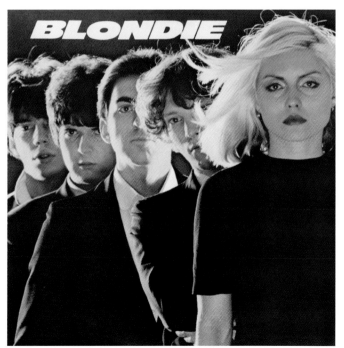

BLONDIE

artist BLONDIE
title BLONDIE
year 1976
label PRIVATE STOCK
design DAVID PERL
photo SHIG IKEIDA

In late 1975, Angel and the Snake adopted the name Blondie to suit the catcalls and jeers elicited by the group's vocalist Deborah Harry, a recognizable beauty on the seedy streets of downtown Manhattan. The group's danceable debut sowed seeds of punk, disco and new wave in the national consciousness, establishing the group as icons across pop and underground platforms.

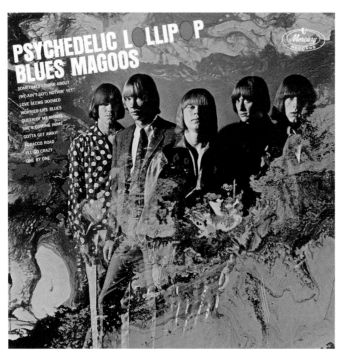

BLUES MAGOOS

artist BLUES MAGOOS
title PSYCHEDELIC
LOLLIPOP
year 1966
label MERCURY
design THREE LIONS
STUDIOS
photo THREE LIONS
STUDIOS

While the '60s may now scream psychedelic to us, Blues Magoos were among the first to plaster the term across an album cover, nearly leading the pack in this genre. Add in "lollipop" and it's no wonder this gem was a pop chart success in 1967. Its most notable song, "(We Ain't Got) Nothin' Yet," sounds more like a garage track than the acid-drenched cuts other groups were producing around the same time—but we can all agree that the real star here is the band's Beatles-influenced mops.

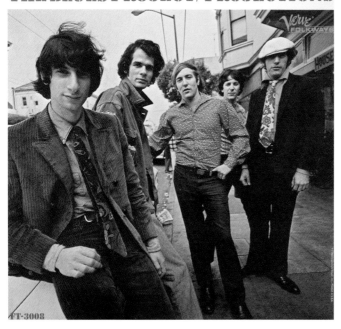

THE BLUES PROJECT

artist THE BLUES
PROJECT
title PROJECTIONS
year 1966
label VERVE FOLKWAYS
design KEN KENDALL
photo JIM MARSHALL

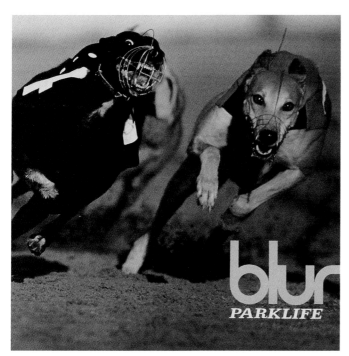

BLUR

artist BLUR
title PARKLIFE
year 1994
label FOOD
design STYLOROUGE
photo CHRIS BRUNSKILL

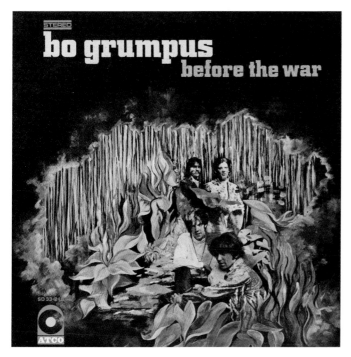

BO GRUMPUS

artist BO GRUMPUS
title BEFORE THE WAR
year 1968
label ATCO
design GAIL COLLINS
photo GAIL COLLINS

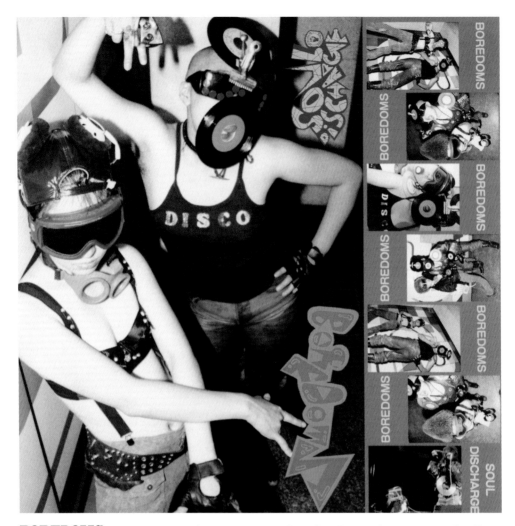

BOREDOMS

artist BOREDOMS
title SOUL DISCHARGE
year 1989
label SHIMMY DISC
art YAMATSUKA EYE

An onslaught of nail-gargling demons drowning in a 10-gallon hat of kool-aid leads to a surfin' safari with Godzilla spilling out of a clown car full of piranhas. The Boredoms' primary goal was to fit as many styles and bits of songs into one track as possible, and they succeeded with gleeful abandon. Chief of the mayhem brigade, Yamatsuka Eye, had been honing his ADD vision with Hanatarash and John Zorn's Naked City when Shimmy Disc decided to unleash the Boredoms on an unsuspecting populace. A few years later they became perhaps the oddest major label signing of the great "next big thing" bidding wars of the early 1990s through the support of Sonic Youth and Nirvana.

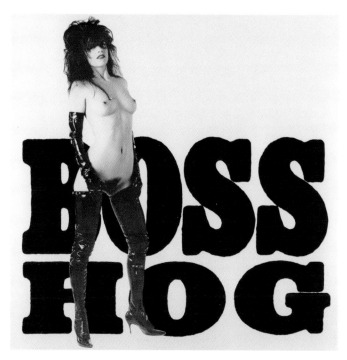

BOSS HOG

artist BOSS HOG
title DRINKIN',
LECHIN' & LYIN'
year 1989
label AMPHETAMINE
REPTILE
photo MICHAEL LAVINE

THE BOSTON
TEA PARTY

artist THE BOSTON TEA
PARTY
title THE BOSTON TEA
PARTY
year 1968
label FLICK-DISC
design CONNIE WEBB
photo TOM DENOVE

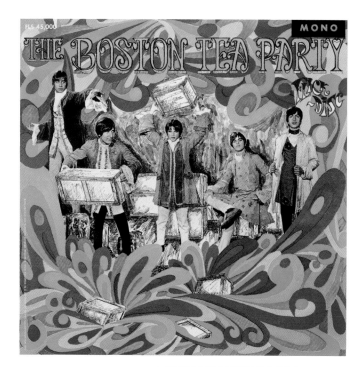

THE BOSTON TEA PARTY 83

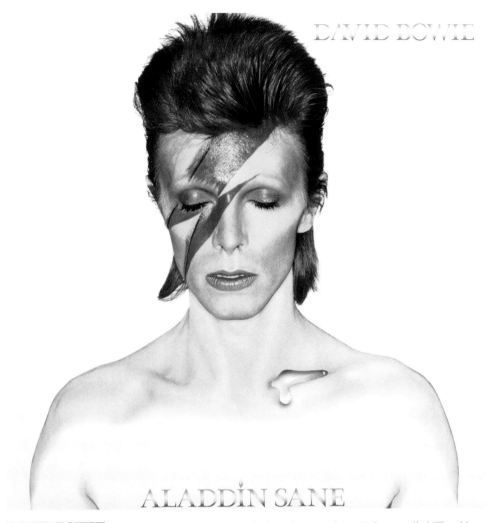

ALADDIN SANE

DAVID BOWIE

artist DAVID BOWIE
title ALADDIN SANE
year 1973
label RCA
art PIERRE LA ROCHE
(MAKE-UP),
PHILIP CASTLE
(AIRBRUSH)
design BRIAN DUFFY,
CELIA PHILO
photo BRIAN DUFFY

In company with the other members of the so-called "Terrible Three," Terence Donovan and David Bailey, Brian Duffy's photographs exported the explosive energy and fashion of London in the swinging '60s. The image of Ziggy Stardust with a lightning bolt over one eye and a mysterious teardrop remains probably the most memorable frame from Duffy's studio sessions and was a pivotal moment in Bowie's rise as an international star. Duffy would later produce covers for Bowie's *Lodger* (1979) and *Scary Monsters* (1980), but at the end of the '70s he gave up photography and destroyed most of his negatives.

DAVID BOWIE

artist DAVID BOWIE
title DIAMOND DOGS
year 1974
label RCA
art GUY PEELLAERT
design AGI
photo LEEE BLACK
CHILDERS

The canine chimera on the cover of Bowie's eighth album got a rise out of RCA execs when it became clear Guy Peellaert's fantastical painting was real enough to depict the genitalia too. Quickly airbrushed out of future re-issues, the original cover depicting the stones of the diamond dog is now a collector's item.

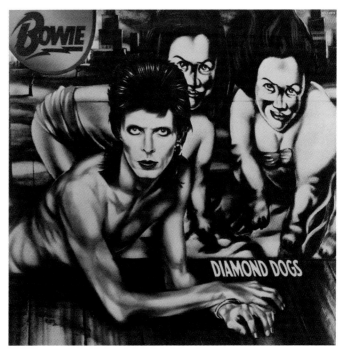

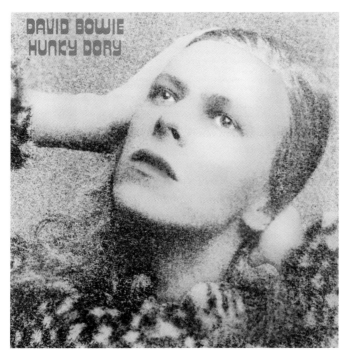

DAVID BOWIE

artist DAVID BOWIE
title HUNKY DORY
year 1971
label RCA
ad GEORGE
UNDERWOOD
art TERRY PASTOR
photo BRIAN WARD

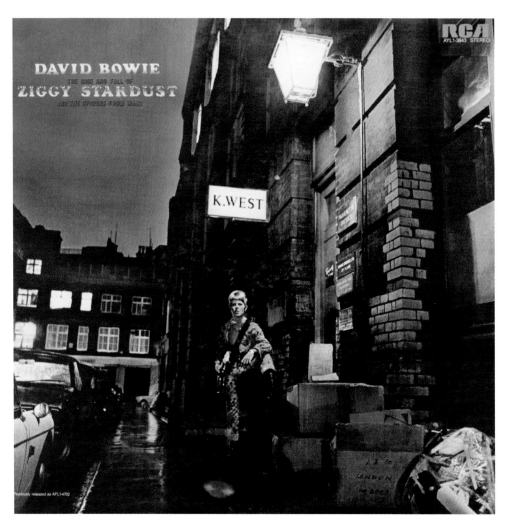

DAVID BOWIE

artist DAVID BOWIE
title THE RISE AND FALL
OF ZIGGY STARDUST
AND THE SPIDERS
FROM MARS
year 1972
label RCA
design TERRY PASTOR
photo BRIAN WARD

"The lettering was set using Letraset, then traced down onto hardline art board and painted using the airbrush. All the lettering for track titles and credits for the back of Ziggy were rub down Letraset type. A very hands on way of doing things. But this was at least twenty years before computers took over the world!"

Terry Pastor

THE BREEDERS

artist THE BREEDERS
title LAST SPLASH
year 1993
label 4AD/ELEKTRA
design VAUGHAN OLIVER
photo JASON LOVE

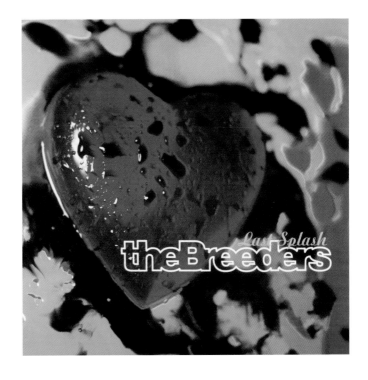

BREAKOUT

artist BREAKOUT
title NA DRUGIM BRZEGU
TECZY
year 1969
label PRONIT
design MARIA
SPYCHALSKA
photo JERZY
STRZESZEWSKI,
MIECZYSŁAW
KAREWICZ

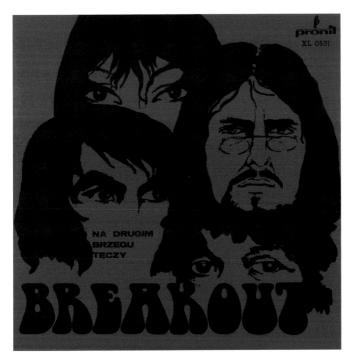

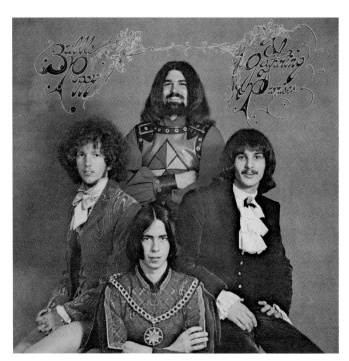

BUBBLE PUPPY

artist BUBBLE PUPPY
title A GATHERING
OF PROMISES
year 1969
label INTERNATIONAL
ARTISTS
design ROYALE STUDIOS

DUNCAN BROWNE

artist DUNCAN BROWNE
title GIVE ME TAKE YOU
year 1968
label IMMEDIATE
art PAUL WELDON

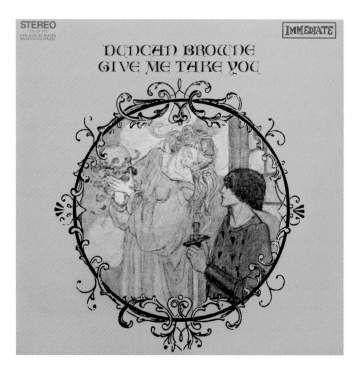

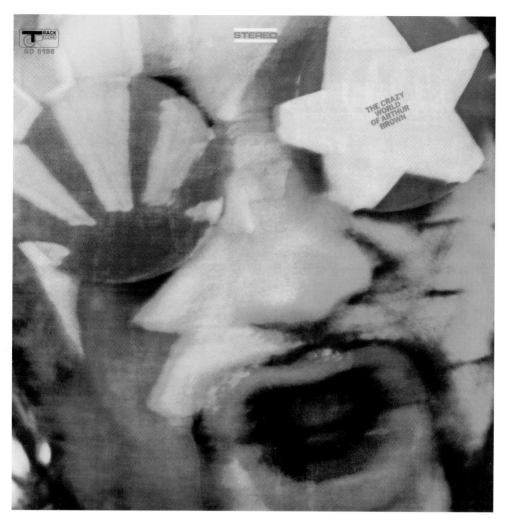

ARTHUR BROWN

artist ARTHUR BROWN
title THE CRAZY WORLD
OF ARTHUR BROWN
year 1968
label TRACK/ATLANTIC
design DAVID KING
photo DAVID
MONTGOMERY

Crazy doesn't even begin to describe the infamous Arthur Brown—from a voice that rivals Julie Andrews's four octaves, to live performance antics (lest we forget his burning helmets), he led the way for the Gene Simmonses of the rock world. Highlighting Brown's use of stage make-up, a team of Davids completed the cover art for this debut release—David King on design and David Montgomery behind the lens.

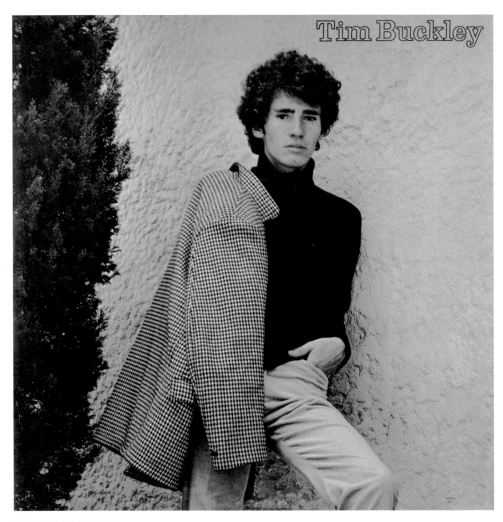

TIM BUCKLEY
artist TIM BUCKLEY
title TIM BUCKLEY
year 1966
label ELEKTRA
design WILLIAM S. HARVEY
photo WILLIAM S. HARVEY

"Poetry is poetry and songs are songs...
I know poets who write things I could never write."
Tim Buckley

BUFFALO SPRINGFIELD

artist BUFFALO
SPRINGFIELD
title LAST TIME AROUND
year 1968
label ATCO
design JIMINI
PRODUCTIONS

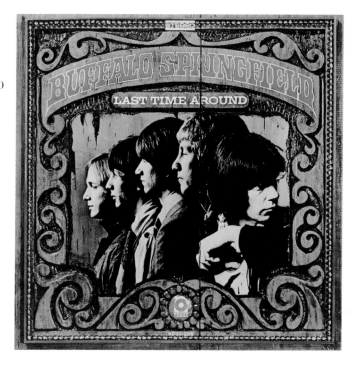

RANDY BURNS

artist RANDY BURNS
title EVENING OF THE
MAGICIAN
year 1968
label ESP DISK
art HOWARD
BERNSTEIN

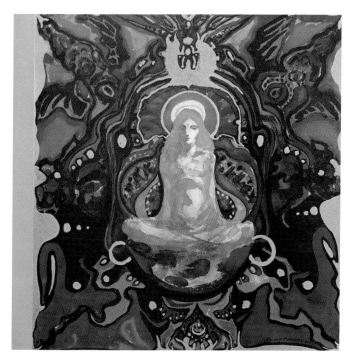

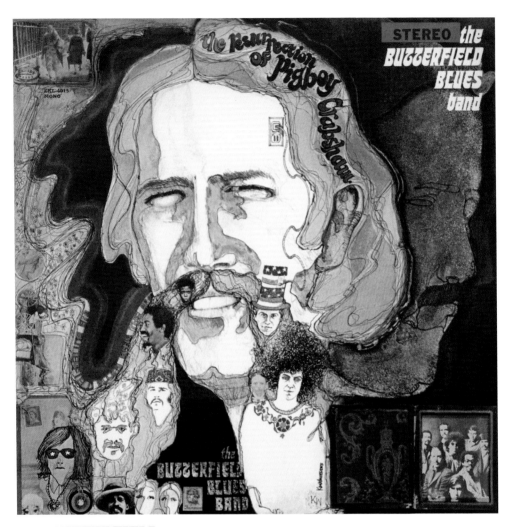

THE BUTTERFIELD BLUES BAND

artist THE BUTTERFIELD
BLUES BAND
title THE RESURRECTION
OF PIGBOY
CRABSHAW
year 1968
label ELEKTRA
art KIM WHITESIDES

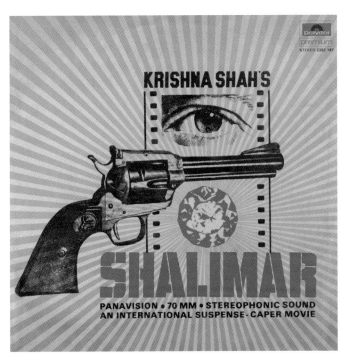

R.D. BURMAN

artist R.D. BURMAN
title SHALIMAR
year 1978
label POLYDOR

Rahul Dev Burman, known as R.D. Burman, revolutionized the Bollywood film soundtrack style in the 1960s and 1970s. His wild mix of disco, jazz and electronic rock sounds combined with traditional Bengali music was like a perfectly satisfying Indian meal, spicy and funky in all the right ways. *Shalimar* is a Bollywood car chaseploitation/heist flick that has gained cult status over the years in part because of Burman's frenetic soundtrack that mixes great horn arrangements and far-out Moog sounds with wah-wah guitar and amped-up raga percussion.

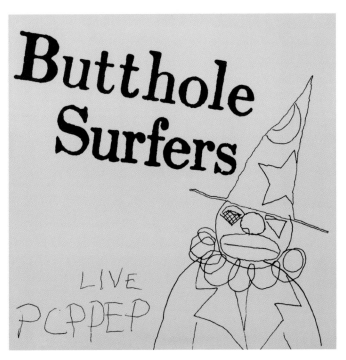

BUTTHOLE SURFERS

artist BUTTHOLE SURFERS
title LIVE PCPPEP
year 1984
label ALTERNATIVE TENTACLES

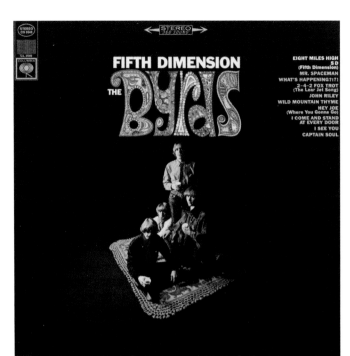

THE BYRDS

artist THE BYRDS
title FIFTH DIMENSION
year 1966
label COLUMBIA
photo HORN/GRINER

CAN

artist CAN
title EGE BAMYASI
year 1972
label UNITED ARTISTS
art INGO TRAUER
design RICHARD J. RUDOW

Facilitated by an unlikely placement of their lucid composition "Spoon" in the German TV series *Das Messer*, Can had a larger budget and increased visibility for the roll-out of their fourth studio album. The Warholian can of Aegean okra was the creation of Ingo Trauer, who designed precious few album covers for United Artists during the early '70s.

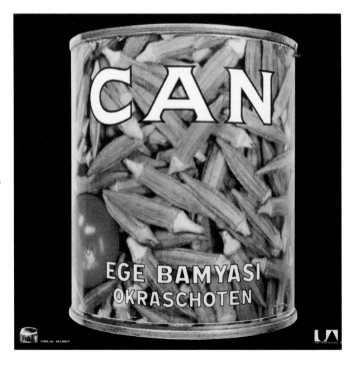

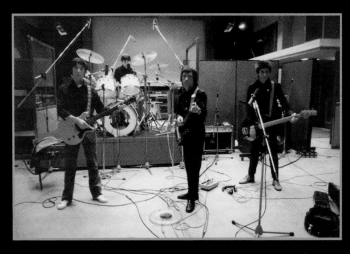

singles
going steady

BUZZCOCKS

artist BUZZCOCKS
title SINGLES GOING
 STEADY
year 1979
label I.R.S./CAPITOL
photo JILL FURMANOVSKY

This 1979 collection of power-pop and punk singles and b-sides charges along at a fast clip and is a timeless and deeply influential release by the Manchester quartet, pioneers in the 45 movement in British punk. The cover photography, particularly the four head-shots on the back, is a parody of the Beatles' *Let It Be*. A 2001 CD re-release included a 12-page booklet designed by EMI's in-house studio, The Red Room, with liner notes by Mark Paytress of *Mojo*.

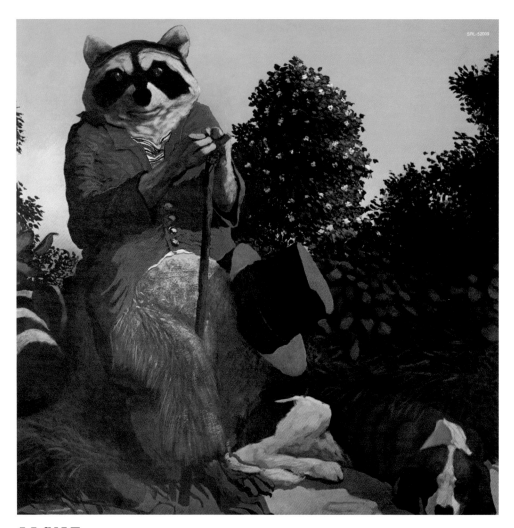

J.J. CALE

artist J.J. CALE
title NATURALLY
year 1972
label SHELTER
art WILLIAM RABON

"I thought the image of the raccoon on top of the dog was very indicative of his music, because his music was very smooth and was very elegant. The painting's been around for years, but I recently saw it at Dewey Bartlett's house. He's the mayor of Tulsa. He owns it now. I don't even know how he got it."

William Rabon

AL CASEY

artist AL CASEY
title SURFIN'
HOOTENANNY
year 1963
label STACY
ad BRODIE HERNDON
art STACY ART
DEPARTMENT
design STACY ART
DEPARTMENT

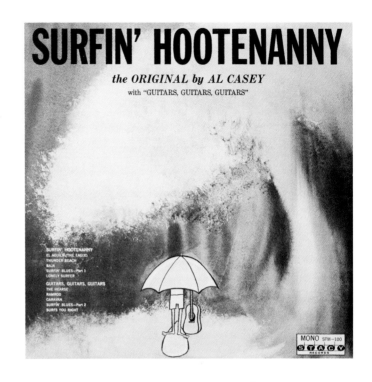

CAPTAIN BEEFHEART & HIS MAGIC BAND

artist CAPTAIN BEEFHEART
& HIS MAGIC BAND
title TROUT MASK REPLICA
year 1969
label STRAIGHT/REPRISE
design CAL SCHENKEL
photo CAL SCHENKEL

The titular disguise of this Cal Schenkel cover did little to obscure the identity of Don Van Vliet, more commonly known as Captain Beefheart. As for fishy lyrics, the songs on this Frank Zappa-produced double LP concern themselves with fishing, worms, fish in a pond, goldfish, a squid, a fish head that breaks a window, and the enigmatic dreaming octafish.

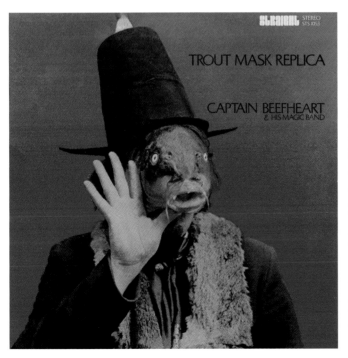

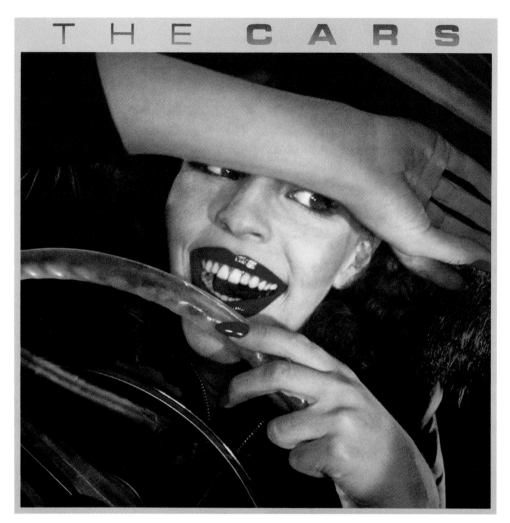

THE CARS

artist THE CARS
title THE CARS
year 1978
label ELEKTRA
ad RON CORO
design JOHNNY LEE
photo ELLIOT GILBERT

"The idea was to get a girl on the cover taking a bite out of a clear steering wheel and 'crashing' into the group. I wanted a model with huge lips and big teeth. I found that in Natalya Medvedeva, a new model to Los Angeles from Russia. She had a natural ability to turn on and off her smile. She really 'made the photo' come alive."

Elliot Gilbert

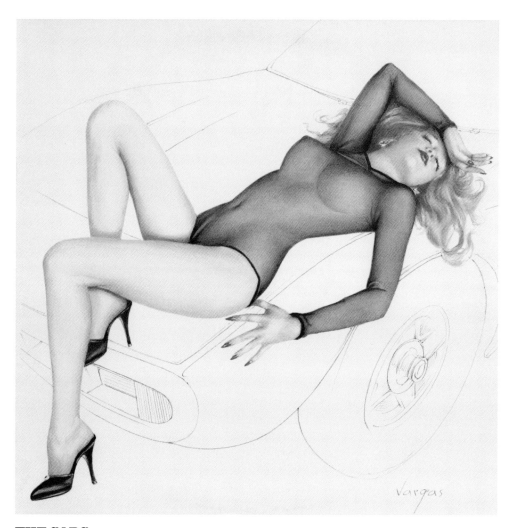

THE CARS

artist THE CARS
title CANDY-O
year 1979
label ELEKTRA
art ALBERTO VARGAS

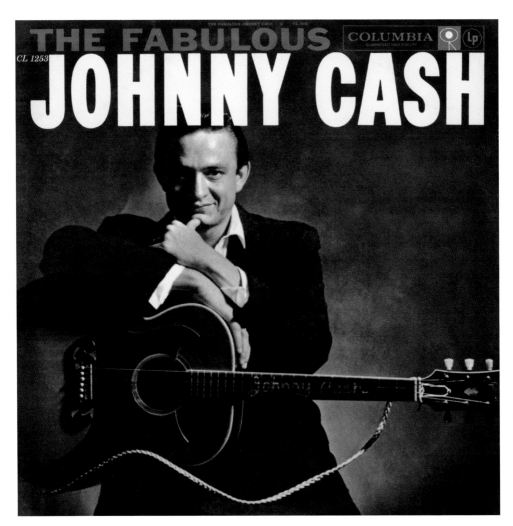

JOHNNY CASH

artist JOHNNY CASH
title THE FABULOUS
JOHNNY CASH
year 1958
label COLUMBIA
ad HOWARD FRITZSON
design GEOFF GILLETTE
photo HAL ADAMS

After two releases on Sun Records, Cash's marriage to Columbia was marked with this album—*The Fabulous Johnny Cash*. This would be the only time album art would be credited to Geoff Gillette whose talents were better known for his engineering skills, from work with Sergio Mendes and various Brazilian musicians and which continues to be heard on countless recordings from B.B. King to Yo-Yo Ma.

JOHNNY CASH

artist JOHNNY CASH
title JOHNNY CASH AT
 FOLSOM PRISON
year 1968
label COLUMBIA
ad HOWARD FRITZSON
design RANDALL MARTIN
photo JIM MARSHALL

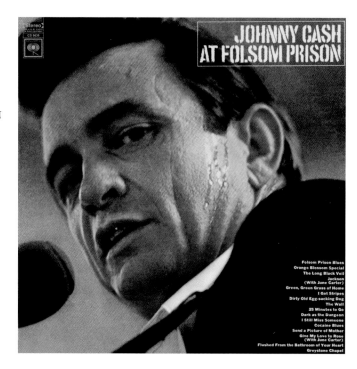

NICK CAVE & THE BAD SEEDS

artist NICK CAVE &
 THE BAD SEEDS
title KICKING AGAINST
 THE PRICKS
year 1986
label MUTE
design ASSORTED IMAGES,
 NICK CAVE &
 THE BAD SEEDS
photo PETER MILNE

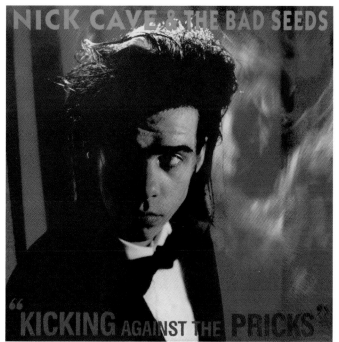

"There's enough almost casual brilliance on **Kicking Against the Pricks** *to justify Cave's bloated sense of his own importance."*
Melody Maker

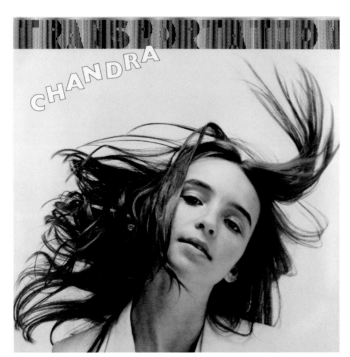

CHANDRA
artist CHANDRA
title TRANSPORTATION
year 1980
label GO GO
photo EARL RIPLING

"I was a kid of a well-known conceptual artist so I was used to being around crazy people in crazy situations all the time."

Chandra

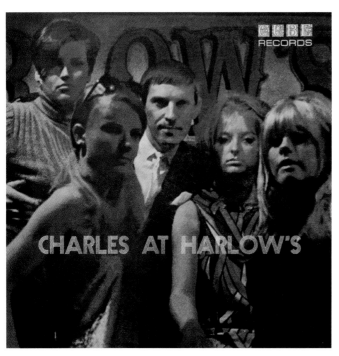

CHARLES AT HARLOW'S
artist CHARLES AT
 HARLOW'S
title CHARLES AT
 HARLOW'S
year 1969
label CUBE
design NICK SCHILLIZZI
photo JON DAVID

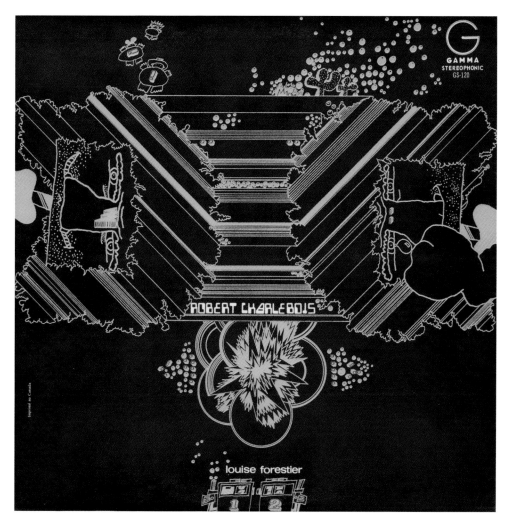

ROBERT CHARLEBOIS/ LOUISE FORESTIER

artist ROBERT CHARLEBOIS/
LOUISE FORESTIER
title ROBERT CHARLEBOIS
AVEC LOUISE
FORESTIER
year 1968
label GAMMA
design ROBERT BARBEAU

Identifiable by his broad nose and unruly locks, the opposing caricatures of Robert Charlebois are situated on either side of this esoteric illustration for his 1968 collaboration with vocalist Louise Forestier. Something of a satirist, Charlebois was a founding member of Canada's *faux* political Rhinoceros Party, which vowed to create the world's biggest parking lot by paving over Manitoba, and to impose a quota on miserable winters in the Great White North.

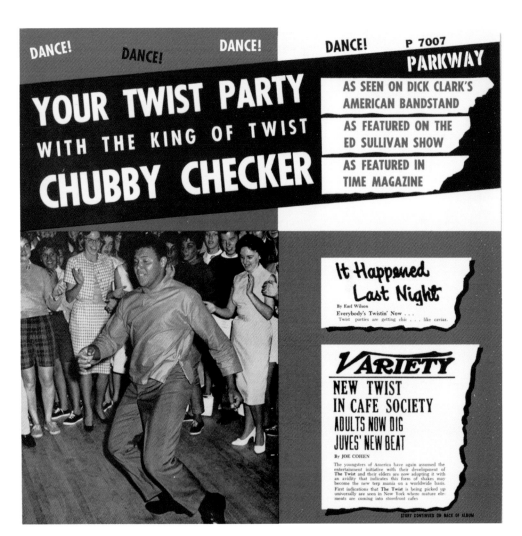

CHUBBY CHECKER

artist CHUBBY CHECKER
title YOUR TWIST PARTY
WITH THE KING OF
TWIST
year 1961
label PARKWAY
design WALTER RICH

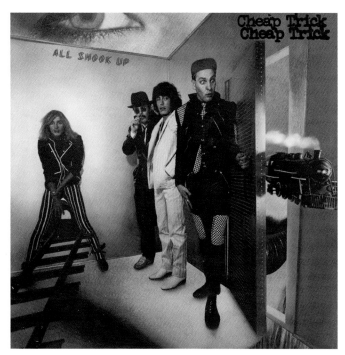

CHEAP TRICK

artist CHEAP TRICK
title ALL SHOOK UP
year 1980
label EPIC
design RIA LEWERKE-
 SHAPIRO,
 RICK NIELSEN
photo MOSHE BRAKHA

Cheap Trick, under the wand of Sir George Martin, goes for the arena rock gusto with disappointing results. A lot of the pop confection they had been known for was burnished down by Martin's heavy-handed production combined with a lack of infectious tunes. Photographer Moshe Brakha always captured his subjects with a sophisticated yet disorientating approach, and his disinfected surrealism served Cheap Trick's humorous side well for this classic cover.

CHICKEN SHACK

artist CHICKEN SHACK
title 100 TON CHICKEN
year 1969
label BLUE HORIZON
design TERENCE IBBOTT
photo TERENCE IBBOTT

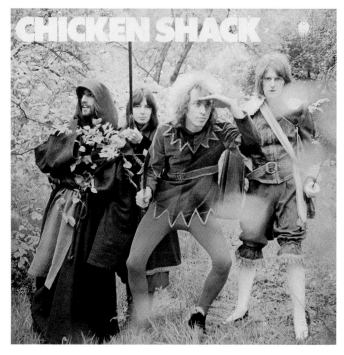

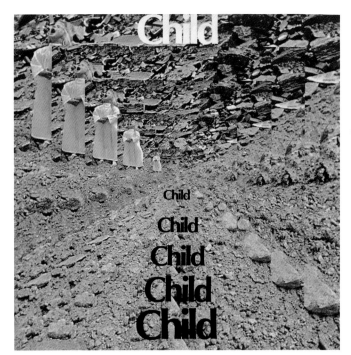

CHILD

artist CHILD
title CHILD
year 1968
label JUBILEE
ad JANIE GANS
design GRAFFITERIA
photo GRAFFITERIA

CHUMBAWAMBA

artist CHUMBAWAMBA
title PICTURES OF
STARVING
CHILDREN SELL
RECORDS:
STARVATION,
CHARITY AND
ROCK & ROLL –
LIES & TRADITIONS
year 1986
label AGIT PROP

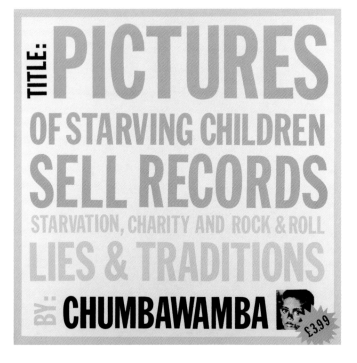

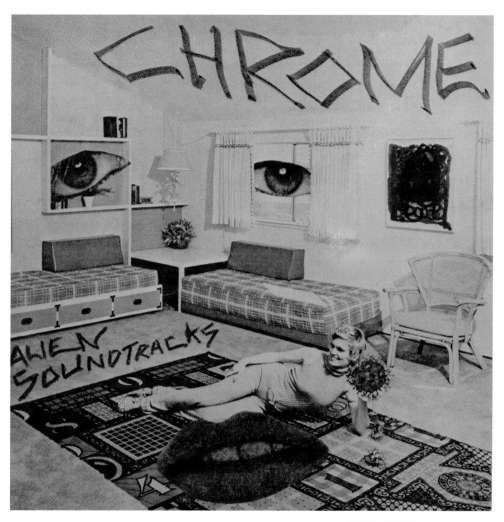

CHROME

artist CHROME
title ALIEN
SOUNDTRACKS
year 1977
label SIREN
photo AMY JAMES

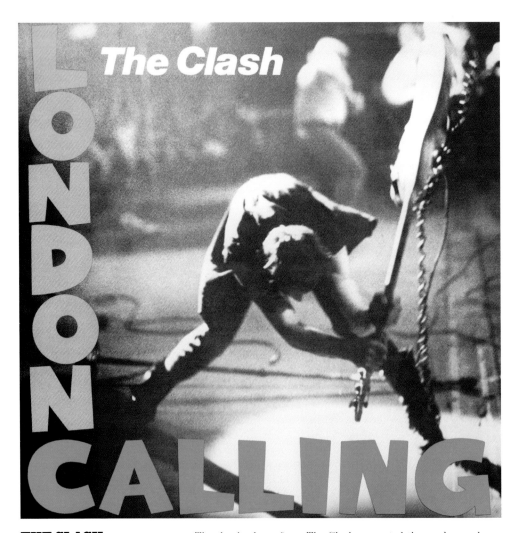

The Clash

LONDON CALLING

THE CLASH

artist THE CLASH
title LONDON CALLING
year 1979
label CBS
design RAY LOWRY
photo PENNIE SMITH

The third release from The Clash cemented the punk sound with a socially conscious message that still resonates today. Its powerful cover was designed very much with Elvis Presley's debut LP in mind and used a photograph by Pennie Smith of bassist Paul Simonon in the process of smashing his instrument to pieces on stage in New York. A little out of focus, but this only made it more appealing to both lead singer Joe Strummer and Ray Lowry. The image has since been voted the #1 rock 'n' roll photograph of all time by *Q* magazine, which said that "it captures the ultimate rock 'n' roll moment—total loss of control." In the UK it featured in a set of ten special "Classic Album Cover" postage stamps issued by the Royal Mail in January 2010.

THE CLASH
artist THE CLASH
title THE CLASH
year 1977
label CBS
design ROSŁAW SZAYBO
photo KATE SIMON

"Merry and tough, passionate and large-spirited, London Calling *celebrates the romance of rock & roll rebellion in grand, epic terms."*
Tom Carson

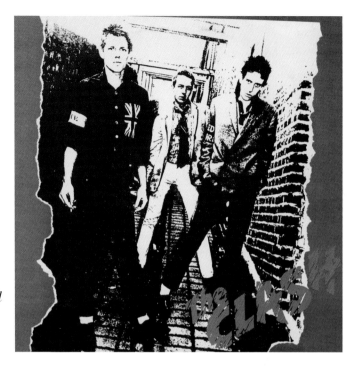

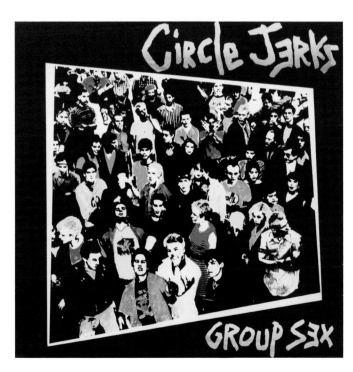

CIRCLE JERKS
artist CIRCLE JERKS
title GROUP SEX
year 1980
label FRONTIER
art SHAWN KERRI
design D. ZINCAVAGE,
DOUG DRUG (LOGO)
photo ED COLVER

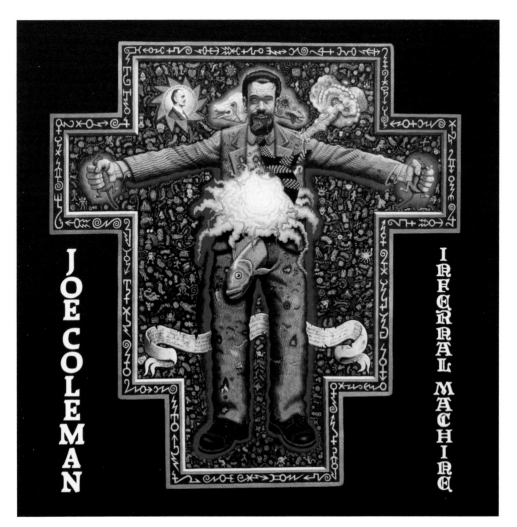

JOE COLEMAN

artist JOE COLEMAN
title INFERNAL MACHINE
year 1990
label BLAST FIRST
art JOE COLEMAN

An outsider artist and freak show aficionado, Joe Coleman's work has been preoccupied with apocalyptic visions, tragic celebrities and macabre characters plucked from the underbelly of American culture. A self-obsessed prankster, Coleman has performed pyrotechnical stunts under the alias of Professor Mombooz-o—even appearing to blow himself up on stage. His paintings have garnered a cult following, with examples finding their way into the art collections of Iggy Pop, Johnny Depp, Jim Jarmusch and Leonardo DiCaprio. Side A's "Homage To Mass Murderers" sets audio interviews with infamous killers against a backdrop of country tunes, whilst the flipside of this LP features live recordings by Steel Tips, Coleman's occasional band from the '70s whose venues included strip bars and an insane asylum.

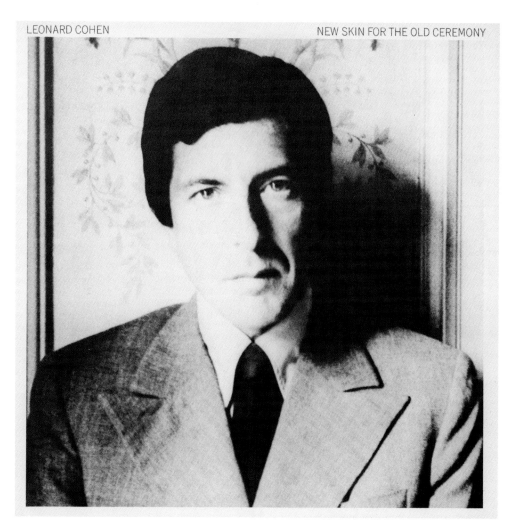

LEONARD COHEN

artist LEONARD COHEN
title NEW SKIN FOR THE
 OLD CEREMONY
year 1974
label COLUMBIA
design TERESA ALFIERI
photo ERICA LENNARD

*"I don't consider myself a great singer.
I just play guitar and interpret my lyrics."*

Leonard Cohen

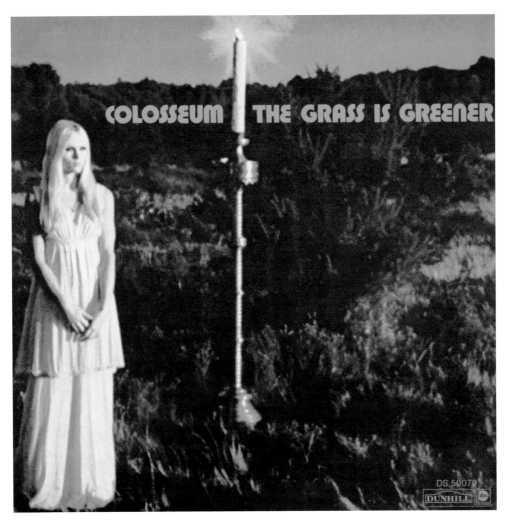

COLOSSEUM

artist COLOSSEUM
title THE GRASS IS
GREENER
year 1970
label ABC/DUNHILL
design MARCUS KEEF
photo MARCUS KEEF,
PETER SMITH

CONJUNTO PRIMAVERA

artist CONJUNTO PRIMAVERA
title BAILEMOS TWIST CON TEXACO
year c. 1960
label FRAGOSO
design THE HIGHLEY ADVERTISING CO.

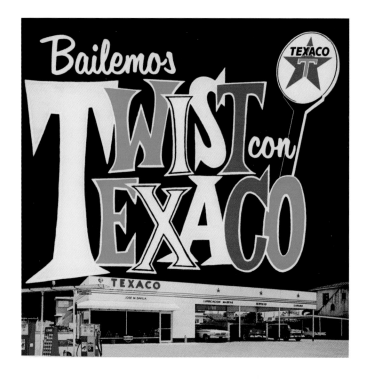

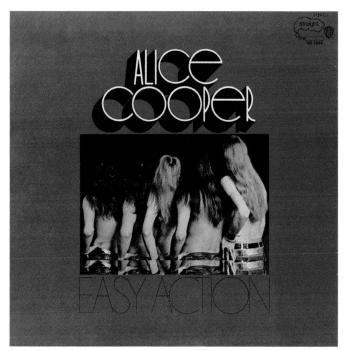

ALICE COOPER

artist ALICE COOPER
title EASY ACTION
year 1970
label STRAIGHT
ad JOHN WILLIAMS
photo LORRIE SULLIVAN

The backside photo gracing the cover of Alice Cooper's second studio LP is perhaps more memorable than its sonic content. Though not formally attributed to the firm, staff photographer Lorrie Sullivan of the design studio Pacific Eye and Ear, responsible for a number of iconic album covers including Cooper's *Billion Dollar Babies*, is credited as the shutterbug for the cheeky shot.

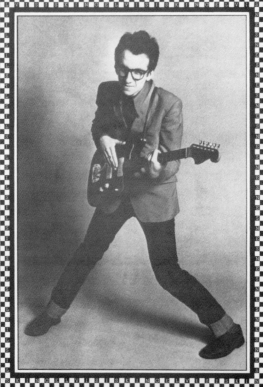

ELVIS COSTELLO

MY AIM IS TRUE

ELVIS COSTELLO

artist ELVIS COSTELLO
title MY AIM IS TRUE
year 1977
label STIFF
ad BARNEY BUBBLES,
JAKE RIVIERA
photo KEITH MORRIS

The cover of the pub rock patriarch's debut was the product of a collaboration between two British notables. Barney Bubbles, who was not credited, designed the cover with its checkerboard border and declaration that "Elvis is King" while the photo by Keith Morris, responsible for iconic shots of Marc Bolan, Nick Drake and Led Zeppelin, shows the bespectacled Costello in the awkward posture that would become his signature.

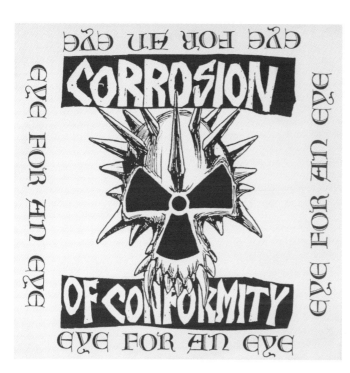

CORROSION OF CONFORMITY

artist CORROSION OF CONFORMITY
title EYE FOR AN EYE
year 1984
label NO CORE/TOXIC SHOCK
art ERROL ENGLEBRECHT

"It was the '80s and that was a big part of the whole hardcore punk rock scene—anti-establishment, Cold War, all the Reagan-era stuff. Maybe it was subliminal in a way, but I really just liked drawing skulls and creepy weird stuff like that."

Errol Englebrecht

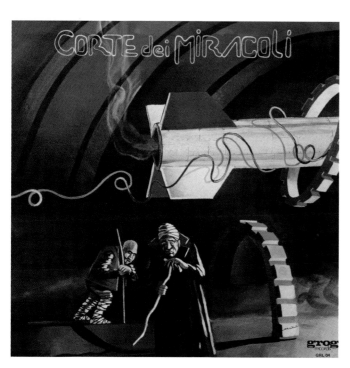

CORTE DEI MIRACOLI

artist CORTE DEI MIRACOLI
title CORTE DEI MIRACOLI
year 1976
label GROG
art ENRICO AONZO

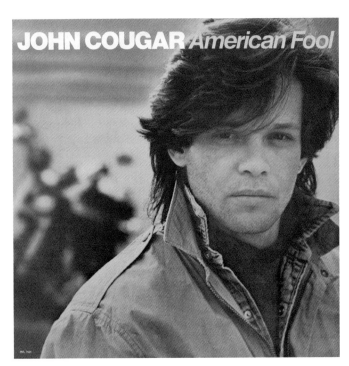

JOHN COUGAR

artist JOHN COUGAR
title AMERICAN FOOL
year 1982
label RIVA
ad BILL LEVY
design JOHN VAN
 HAMERSVELD
photo JÜRGEN VOLLMER

The last LP to bear this Indiana-born songwriter's stage name is also reckoned to be his commercial breakthrough, and features 1980s earworms "Jack and Diane" and "Hurts So Good." The cover photo by former Beatles photographer Jürgen Vollmer cemented Mellencamp's image as an everyman of the heartland and was cropped to remove the frayed lower part of his tattered denim shirt, which dangles from underneath the bottom of his jacket in its unedited version.

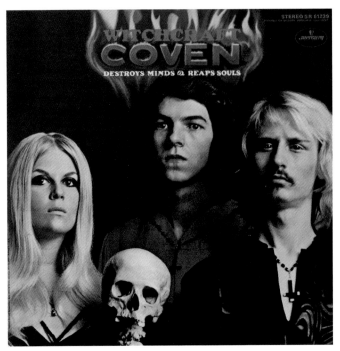

COVEN

artist COVEN
title WITCHCRAFT
 DESTROYS MINDS
 & REAPS SOULS
year 1969
label MERCURY
design JERRY GRIFFITH
photo SIG BINDER

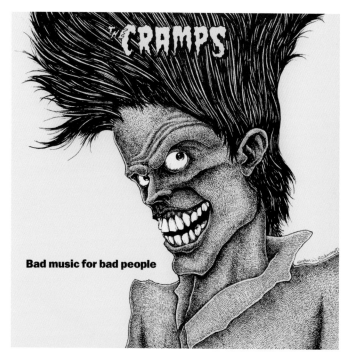

Bad music for bad people

THE CRAMPS

artist THE CRAMPS
title BAD MUSIC FOR
BAD PEOPLE
year 1984
label I.R.S.
art STEPHEN
BLICKENSTAFF
design RON SCARSELLI

The fleshless ghoul-punk
smirking across the canary
cover of this scant, 31-min-
ute collection of B-sides and
rarities deftly suits the horror
aesthetic of the demonic surf-
rock act fronted by the psycho-
sexual husband and wife duo
of Lux Interior and Poison Ivy.
Though the LP's sonic offerings
are perhaps somewhat negli-
gible, fans continue to scoop up
this compilation for artist Ste-
phen Blickenstaff's remarkable
cover drawing, inspired by the
band's raunchy frontman and
penned on Halloween in 1983.

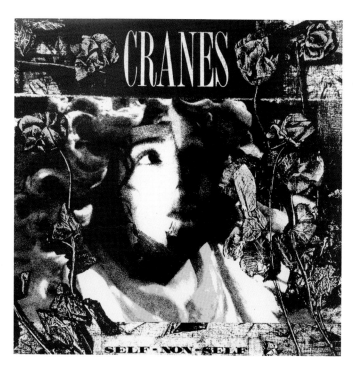

CRANES

artist CRANES
title SELF-NON-SELF
year 1989
label BITE BACK!
design ROBERT COLEMAN

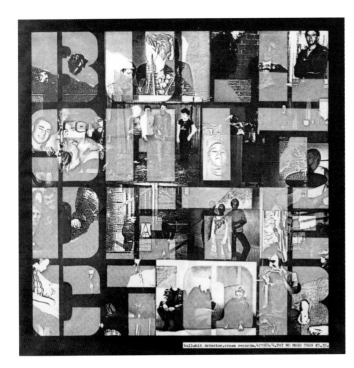

CRASS

artist CRASS
title STATIONS
OF THE CRASS
year 1979
label CRASS
design GEE VAUCHER

Gee Vaucher's goal was always
to bring about social change
with her artwork, and so when
anarcho-punk legends Crass
needed album art, the mar-
riage seemed a match made
in art punk heaven. Vaucher's
continuing work with Crass
made such a ripple that her
1999 book bears the title
*Crass Art and Other Pre Post-
Modernist Monsters.*

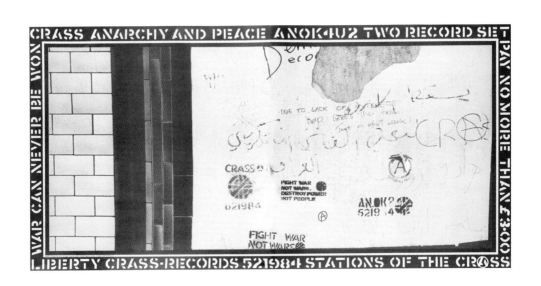

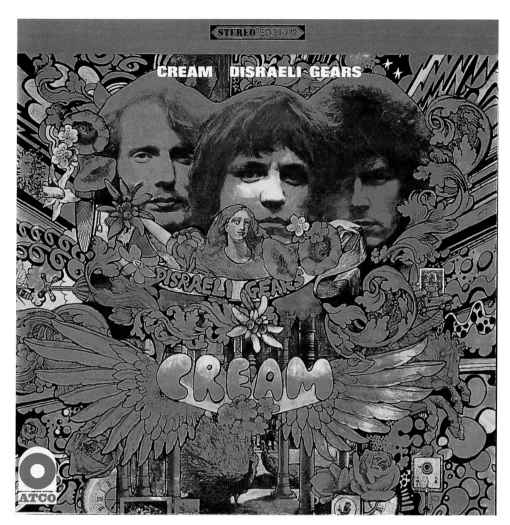

CREAM

artist CREAM
title DISRAELI GEARS
year 1967
label REACTION
art MARTIN SHARP
photo ROBERT WHITAKER,
 JIM MARSHALL
 (ADDITIONAL
 PHOTOGRAPHY)

Disraeli Gears is the sophomore release by British rock band Cream, often referred to as the first 'supergroup'. The album signaled a move from their blues origins into the realms of psychedelic rock and spawned such classics as "Strange Brew" and "Sunshine of Your Love." Cream's power trio of soloists Eric Clapton on guitar and vocals, Jack Bruce on vocals and bass, and Ginger Baker on drums held court for a mere two years before disbanding. The cover art here was created by Australian artist Martin Sharp who for a time lived at the same Chelsea address as Clapton.

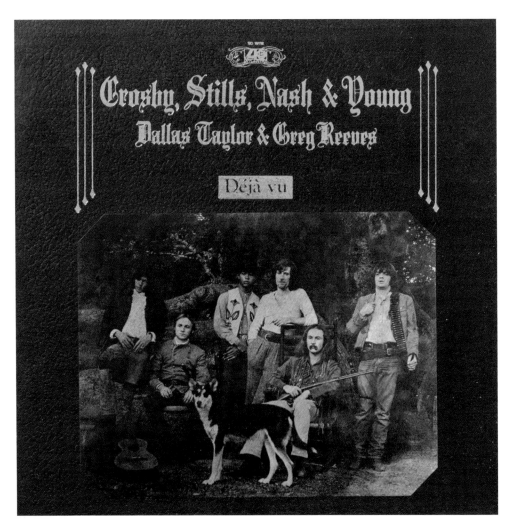

CROSBY, STILLS, NASH & YOUNG

artist CROSBY, STILLS, NASH & YOUNG
title DÉJÀ VU
year 1970
label ATLANTIC
design GARY BURDEN
photo TOM GUNDELFINGER O'NEAL

After a trip to the costume shop, Stephen Stills, Graham Nash and Neil Young—plus supplemental players Dallas Taylor and Greg Reeves—gathered behind David Crosby's Marin County rental property to orchestrate an image that recalled a bygone era. Photographer Tom O'Neal used archaic equipment and printed to fiberboard in accordance with Civil War-era photo techniques.

"Stephen Stills requested that I use the same photo techniques from the Civil War era. The exposure was two and a half minutes long. During the long exposure the dog walked into the center of the group and spontaneously became part of the photograph."

Tom Gundelfinger O'Neal

CREEDENCE CLEARWATER REVIVAL

artist CREEDENCE
 CLEARWATER
 REVIVAL
title GREEN RIVER
year 1969
label FANTASY
photo BASUL PARIK

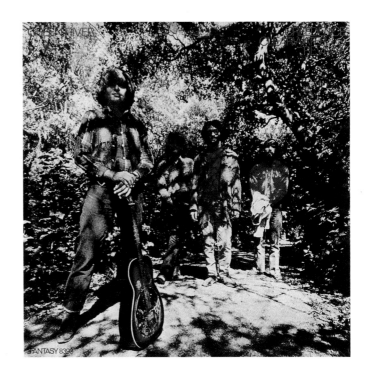

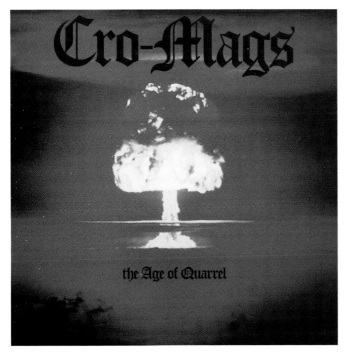

CRO-MAGS

artist CRO-MAGS
title THE AGE OF
 QUARREL
year 1986
label PROFILE

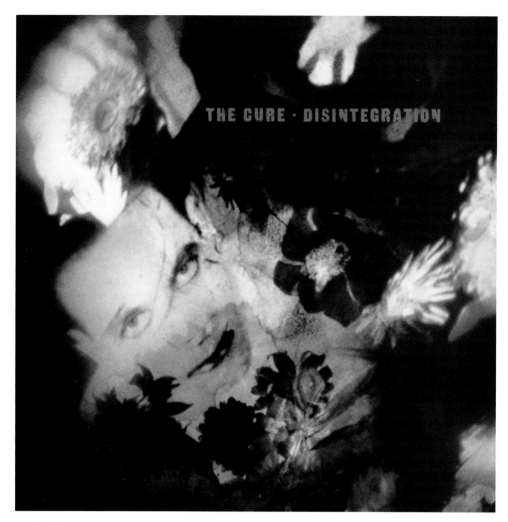

THE CURE · DISINTEGRATION

THE CURE
artist THE CURE
title DISINTEGRATION
year 1989
label FICTION/ELEKTRA
design PARCHED ART
photo PARCHED ART

Parched Art was the official name for Cure guitarist Porl Thompson and designer Andy Vella's collaborations. While *Disintegration* was decidedly a group effort, only vocalist Robert Smith appears on the front amidst the smattering of abstract shapes and designs that would more commonly populate a Cure cover. This album, the band's eighth, marked a return to their anti-pop introspection, doused in rich layers of synthetic tones and melodies, the welcome contributions of newly enlisted keyboardist Roger O'Donnell.

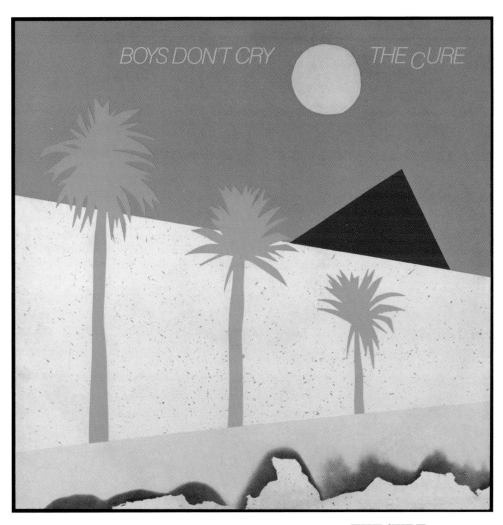

THE CURE

artist THE CURE
title BOYS DON'T CRY
year 1980
label FICTION
art BILL SMITH
design BILL SMITH

"Disintegration, *pre-many moons before computers. Merely using polaroid transparencies and overlaying in various depths, re-shooting elements many times to build up the picture so it became more than just a photograph, more like a painting; we wanted depth, texture and translucency. Then, to finish it all, the album cover—when printed—had a special UV crackle varnish to finish it off, which was added within the lithographic process."*

Andy Vella

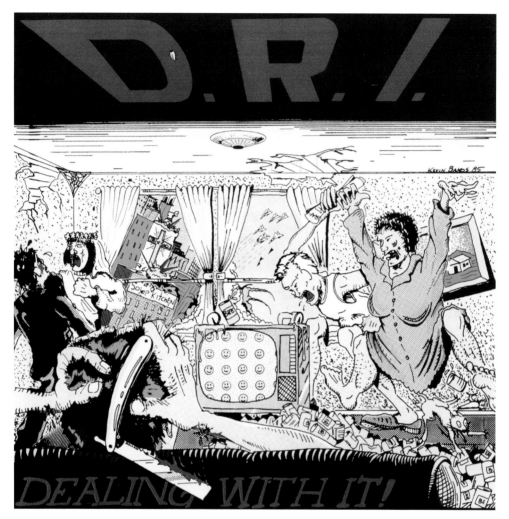

D.R.I.
artist D.R.I. (DIRTY ROTTEN
 IMBECILES)
title DEALING WITH IT
year 1985
label METAL BLADE
art KEVIN BAKOS

D.O.A.

artist D.O.A.
title HARDCORE '81
year 1981
label FRIENDS
design BOB MERCER

At the dawn of hardcore punk rock these Vancouver boys laid down the gauntlet with their debut *Something Better Change*, and by the time they released their sophomore LP they were a force to be reckoned with. From the photo-booth siren call of the cover design to the beastly drumming of Chuck Biscuits coupled with the acerbic wit of Joey Shithead, *Hardcore '81* was a muscular bouillabaisse of social commentary and party anthems neatly wrapped up and ready to be tossed in the nearest mosh pit.

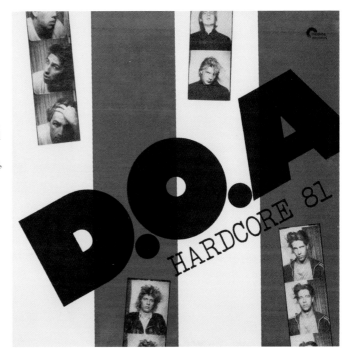

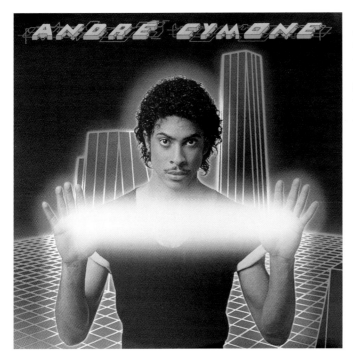

ANDRÉ CYMONE

artist ANDRÉ CYMONE
title LIVIN' IN THE NEW WAVE
year 1982
label COLUMBIA

"Back then my emphasis was always on the future. So if I did 10 songs on my album, I wanted at least 9 of those songs to be of a very futuristic persuasion. There were just so many cool artists that I really respected—Devo, Kraftwerk, Gary Numan, the Cars—that were able to straddle that line of rock and future, yet add a new twist. That's kind of what I was trying to come up with." – André Cymone

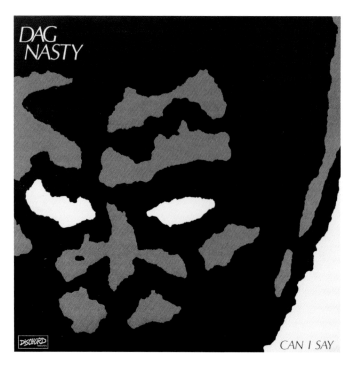

DAG NASTY

artist DAG NASTY
title CAN I SAY
year 1986
label DISCHORD
design JEFF NELSON

Dischord Records—Washington DC's proletariat punk label of note—was a tight-knit family of musical progressives. Founded by Minor Threat alumni Ian MacKaye and Jeff Nelson, it was their former band-mate Brian Baker whose quartet Dag Nasty would go on to take the first steps toward ushering in an era of emotionally resonant hardcore, but this was not the frat-boy-friendly emo that would come in its wake. This was a tight melodic gut-punch that would kick that frat-boy's ass.

DAMNATION

artist DAMNATION
title THE SECOND DAMNATION
year 1970
label UNITED ARTISTS
ad WOODY WOODWARD

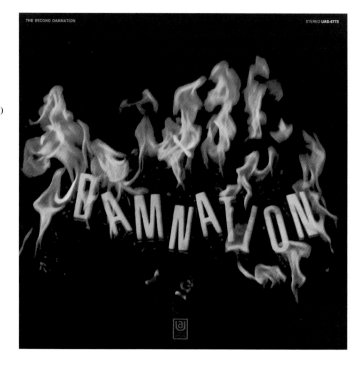

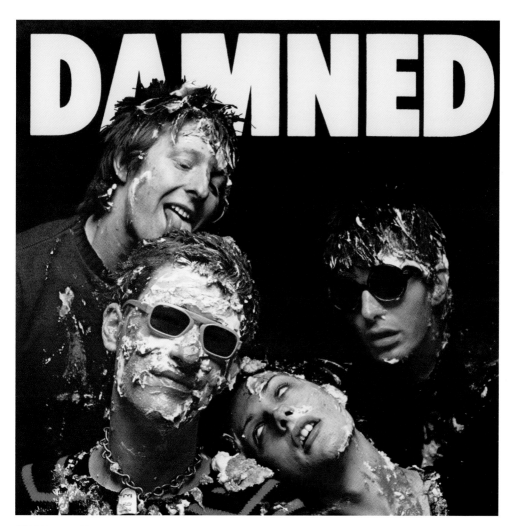

THE DAMNED

artist THE DAMNED
title DAMNED DAMNED
DAMNED
year 1977
label STIFF
design BIG JOBS INC.
photo PETER KODICK,
(ASSISTANTS:
JUDY NYLON,
PAT PALLADIN)

"*Fashion photographer Peter Gravelle was asked to do a photo session with the as yet unsigned band by their guitarist Brian James's girlfriend, Judy Nylon. Peter said, 'She asked me to take pictures of the band for free as they had no money. I agreed to take pictures as long as I got to do what I want-ed, and we did the pies in the face photos.' When it came time to credit his work on the cover he adopted the 'punk name' Peter Kodick.*"

Teddie Dahlin

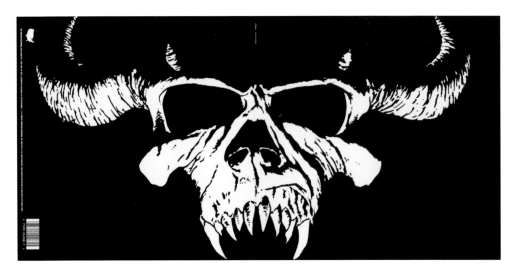

DANZIG

artist DANZIG
title DANZIG
year 1988
label DEF AMERICAN RECORDINGS
art MICHAEL GOLDEN

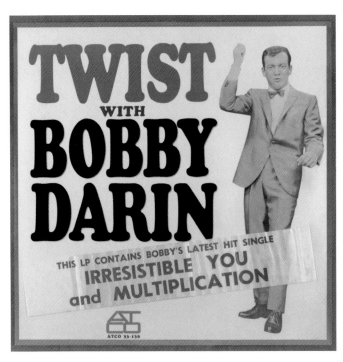

BOBBY DARIN

artist BOBBY DARIN
title TWIST WITH
 BOBBY DARIN
year 1962
label ATCO
design LORING EUTEMEY
photo CURT GUNTHER,
 TOPIX

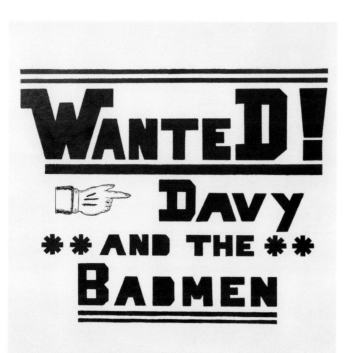

DAVY AND
THE BADMEN

artist DAVY AND
 THE BADMEN
title WANTED!
year 1963
label GOTHIC

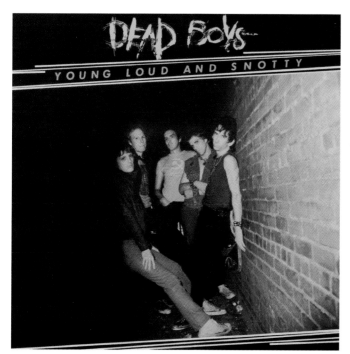

DEAD BOYS

artist DEAD BOYS
title YOUNG LOUD
 AND SNOTTY
year 1977
label SIRE
art KEN SITZ (LOGO)
design JOHN GILLESPIE
photo GLENN BROWN

DEAD KENNEDYS

artist DEAD KENNEDYS
title FRANKENCHRIST
year 1985
label ALTERNATIVE
TENTACLES
design JELLO BIAFRA
(CONCEPT)
photo LESTER SLOAN

Frankenchrist resulted in two legal run-ins for the Dead Kennedys. A poster insert of H.R. Giger's graphic illustration "Penis Landscape" hastened criminal charges against the band and Alternative Tentacles for distribution of harmful material to minors. In 1989, the Shriners—a fraternal organization known for driving miniature automobiles in community parades—alleged commercial misappropriation of likeness and false light against the group.

THE DEAD MILKMEN

artist THE DEAD
 MILKMEN
title BIG LIZARD IN MY
 BACKYARD
year 1985
label RESTLESS
art DEAN CLEAN
photo TOMMY LEONARDI

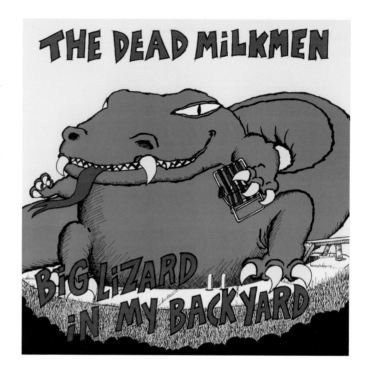

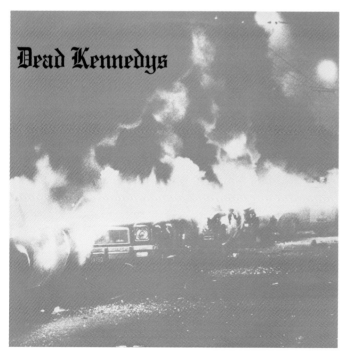

DEAD KENNEDYS

artist DEAD KENNEDYS
title FRESH FRUIT
 FOR ROTTING
 VEGETABLES
year 1981
label I.R.S.
art ANNIE HORWOOD
photo JUDITH CARLSON

THE DEEP

artist THE DEEP
title PSYCHEDELIC
MOODS: A MIND
EXPANDING
PHENOMENA
year 1966
label CAMEO PARKWAY
ad DOUGLAS FISKE
art RUSTY EVANS

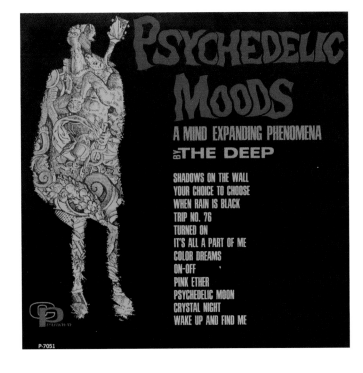

DEEP PURPLE

artist DEEP PURPLE
title SHADES OF
DEEP PURPLE
year 1968
label TETRAGRAMMATON
design LES WEISBRICH

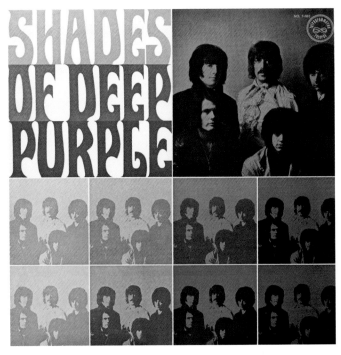

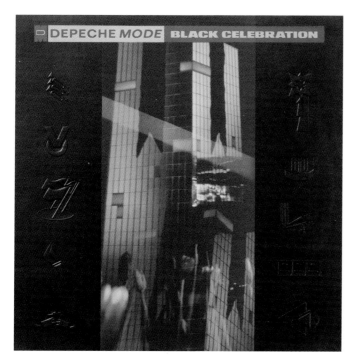

DEPECHE MODE

artist DEPECHE MODE
title BLACK CELEBRATION
year 1986
label SIRE/MUTE
design D.A. JONES,
 M. HIGENBOTTAM,
 M. ATKINS
photo BRIAN GRIFFIN,
 STUART GRAHAM
 (ASSISTANT)

Primary songwriter Martin Gore sings on an unprecedented four tracks on this conspicuous sonic departure for the British quartet. The lauded album raised the band's profile from the bubble-gum pop à la "Just Can't Get Enough" to an arena-rock act steered by sepulchral synthesizers and an earnest blend of heavy-handed lyricism delivered via naked, front-and-center vocals.

DEREK & THE DOMINOS

artist DEREK & THE
 DOMINOS
title LAYLA AND
 OTHER ASSORTED
 LOVE SONGS
year 1970
label ATCO
art FRANDSEN
 DE SCHONBERG

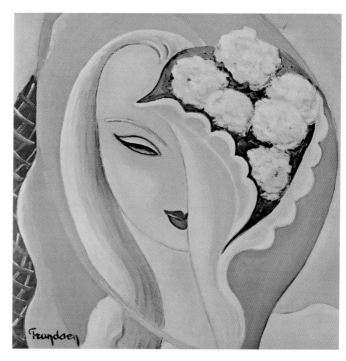

THE DEVIANTS

artist THE DEVIANTS
title PTOOFF!
year 1968
label UNDERGROUND
　　　 IMPRESARIOS
art KIPPS

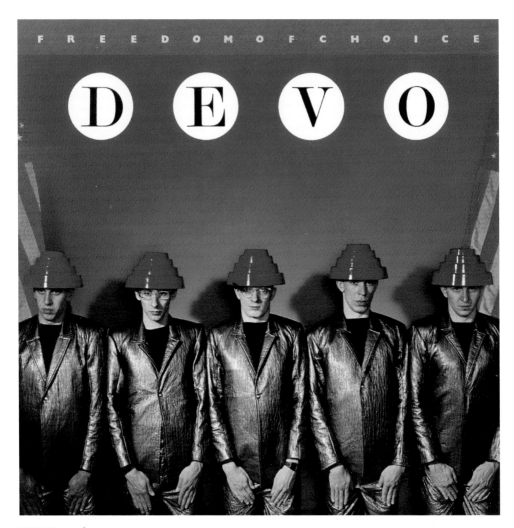

DEVO
artist DEVO
title FREEDOM OF
CHOICE
year 1980
label WARNER BROS.
design ARTROUBLE

DESCENDENTS

artist DESCENDENTS
title MILO GOES
TO COLLEGE
year 1982
label NEW ALLIANCE
art JEFF ATKINSON

Designed as a well-meaning
jab at their departing vocal-
ist, the debut album by the
Descendents was dedicated to
Milo Aukerman, who'd left
the group to pursue a biol-
ogy degree at the University
of California at San Diego.
Aukerman returned in 1985,
and his line-drawn likeness
would remain an integral ele-
ment of the band's identity.

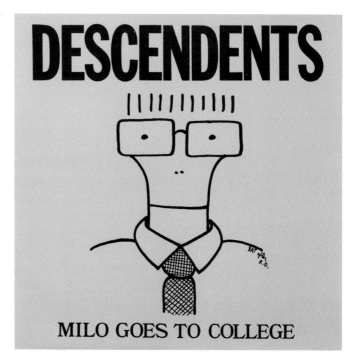

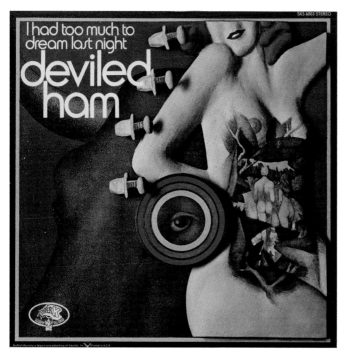

DEVILED HAM

artist DEVILED HAM
title I HAD TOO MUCH
TO DREAM LAST
NIGHT
year 1968
label SUPER K
ad ACY R. LEHMAN
art DAVID WILCOX

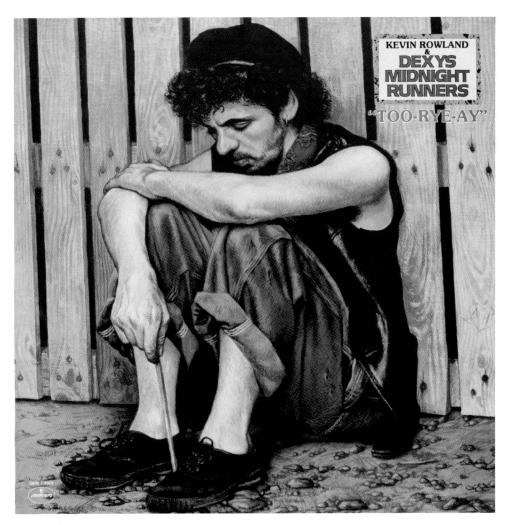

DEXYS MIDNIGHT RUNNERS

artist DEXYS MIDNIGHT
RUNNERS
title TOO-RYE-AY
year 1982
label MERCURY
art ANDREW RATCLIFFE
design PETER BARRETT
photo KIM KNOTT

Before Das EFX brought the bum stiggedy bum stiggedy bum, hon and Kid Rock bawitdaba'd us, Dexys Midnight Runners shot into our brains with a too-ra-loo-ra-too-ra-loo-rye-ay earworm. If it's not the first time we've heard this Irish lullaby, it's definitely the catchiest, and also makes the title of this album. The music video for the hit single features Bananarama singer Siobhan Fahey's sister Máire, as does the actual cover for the single, though she doesn't appear on the LP sleeve. Peter Barrett designed the sleeve seen here and with Mercury Records he went on to craft several other album covers for the band.

NEIL DIAMOND

artist NEIL DIAMOND
title THE FEEL OF NEIL
DIAMOND
year 1966
label BANG
design LORING EUTEMEY
photo LEONARD LINTON

Working from the Brill Build-
ing—a Manhattan office com-
plex that provided sanctuary
for some of the century's
most enigmatic songwriters—
Brooklyn native Neil Diamond
achieved his first industry
triumphs in the mid-'60s
crafting pop hits for the Mon-
kees and Elvis Presley. With
his debut album came a slew
of chart successes—"Solitary
Man," "Kentucky Woman,"
"Cherry, Cherry"—establish-
ing Diamond as a rock star in
his own right.

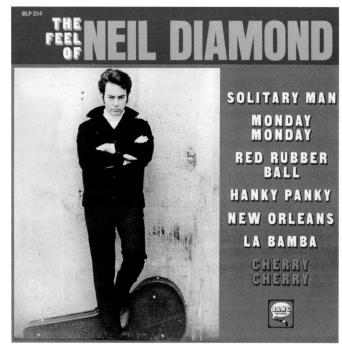

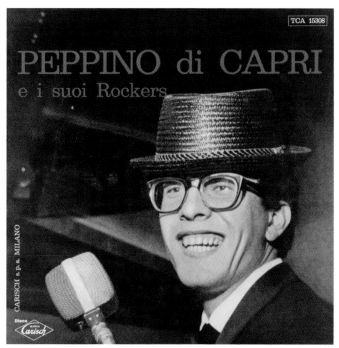

PEPPINO DI CAPRI

artist PEPPINO DI CAPRI
title PEPPINO DI CAPRI
E I SUOI ROCKERS
year 1962
label CARISCH
photo FARABOLA

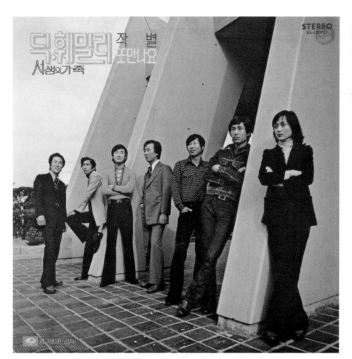

DICK FAMILY

artist DICK FAMILY
title DICK FAMILY
QUEST'S FAMILY
year 1976
label JIGU

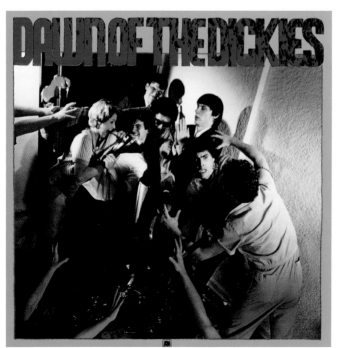

THE DICKIES

artist THE DICKIES
title DAWN OF
THE DICKIES
year 1979
label A&M
design ARTROUBLE:
DAVID ALLEN
photo JULES BATES

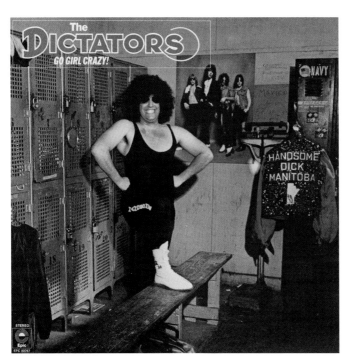

THE DICTATORS

artist THE DICTATORS
title GO GIRL CRAZY!
year 1975
label EPIC
design JOHNNY MONTANA,
GRINGO HUERTA
photo DAVID GAHR

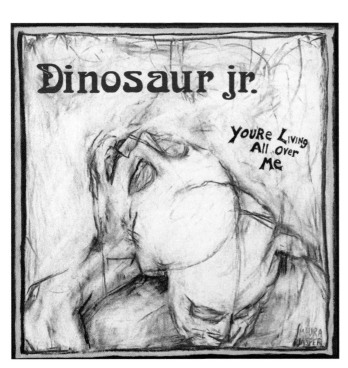

DINOSAUR JR.

artist DINOSAUR JR.
title YOU'RE LIVING ALL
OVER ME
year 1987
label SST
art MAURA JASPER

aLCHEMY ⇄ dIRE sTRAITS Live

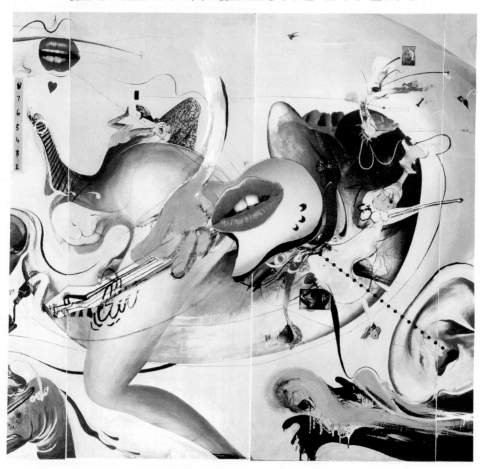

DIRE STRAITS

artist DIRE STRAITS
title ALCHEMY –
DIRE STRAITS LIVE
year 1984
label VERTIGO
art BRETT WHITELEY
design C-MORE-TONE
STUDIOS

Recorded live at London's Hammersmith Odeon on July 22 and 23, 1984, this double album contains some of Dire Straits's most popular hits, including "Romeo and Juliet," "Sultans of Swing" and "Going Home"—lead guitarist Mark Knopfler's theme to the 1983 film *Local Hero*. The cover image is a detail from *Alchemy* (1972–74), an epic 18-panel mixed media mural by Australian abstract painter Brett Whiteley. The work is said to have originated in the death of Japanese writer Yukio Mishima, and the enlightened and transformative vision he experienced as he committed *seppuku* in 1970, although the mouth, hand and guitar were an addition for this cover.

NED DOHENY

artist NED DOHENY
title HARD CANDY
year 1976
label COLUMBIA
photo MOSHE BRAKHA

"Ned's music was amazing for that time. It was like two minutes before punk rock came into Los Angeles. We shot the album in Mexico—I'd just finished school, and the guy takes me to Mexico to shoot? I asked one of the waiters there to splash water on him. This was during a period where you didn't even get to take an assistant."

Moshe Brakha

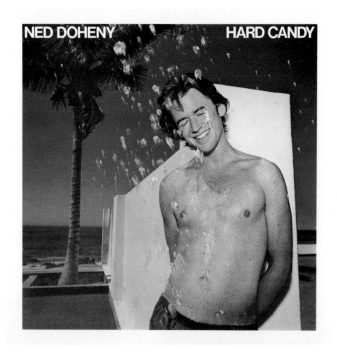

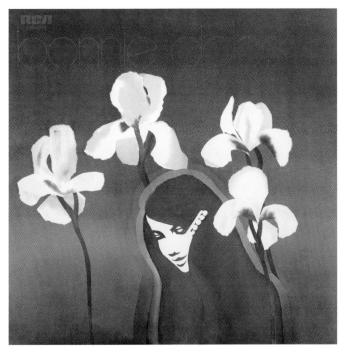

BONNIE DOBSON

artist BONNIE DOBSON
title BONNIE DOBSON
year 1969
label RCA
ad PETER CLAYTON
design NICK SPEKE

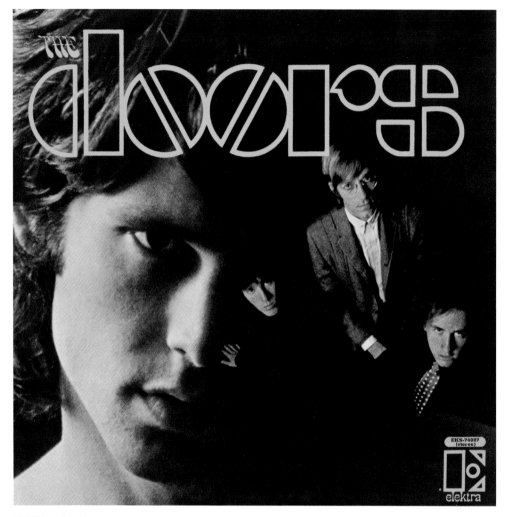

EKS-74007
(stereo)

elektra

THE DOORS

artist THE DOORS
title THE DOORS
year 1967
label ELEKTRA
design WILLIAM S. HARVEY
photo GUY WEBSTER

Armed with a monumental tracklist of material developed from well-rehearsed live sets in West Hollywood's Whisky a Go Go club, the Doors were ready to lay down their now seminal studio debut. The album duly features such hallmark classics as the explosive "Light My Fire" and "The End," the latter with its epic spoken-word crescendo performed by Jim Morrison. During the early '60s Guy Webster avoided a tour of Vietnam by teaching photography as an Army reservist, even though he had no experience of using a camera. Indeed, he later recounted, "I had never taken a photograph in my life."

DONOVAN

artist DONOVAN
title A GIFT FROM A
 FLOWER TO A
 GARDEN
year 1967
label EPIC
ad SID MAURER
art MICK TAYLOR,
 SHEENA McCALL
design KARL FERRIS
photo KARL FERRIS

An infra-red photo of British
folk singer Donovan by Karl
Ferris, considered the father
of the psychedelic aesthetic in
photography, graces the cover
of what was also one of the
first box-set releases in rock.
The back-cover shot shows
the pair being introduced to
the Maharishi Mahesh Yogi
in Los Angeles, and gaining
their first insights into tran-
scendental meditation.

THE DOORS

artist THE DOORS
title L.A. WOMAN
year 1971
label ELEKTRA
design CARL COSSICK
photo WENDELL HAMICK

SILLON DS-500

GEORGES DOR

GEORGES DOR

artist GEORGES DOR
title AU RALENTI
year 1972
label SILLON
design MICHEL FORTIER

Georges Dor began his career as a radio announcer for the Canadian Broadcasting System, but established himself as a notable *chansonnier* with 1966's working-class lament, "La Manic." A mix of love songs and nationalist anthems, *Au Ralenti*—literally "In Slow Motion"—provides a suitable soundtrack for Quebec's strides toward sovereignty, a cause in which Dor was a vocal supporter.

DR. JOHN, THE NIGHT TRIPPER

artist DR. JOHN THE
NIGHT TRIPPER
title GRIS-GRIS
year 1968
label ATCO
ad RAPHAEL
design MARVIN ISRAEL

Equal parts voodoo and the
psychedelic id of New Orleans,
the Night Tripper persona
of Malcolm John "Mac"
Rebennack, Jr. crawled out
of the proverbial bayou with
this release. The ritualistic,
hazy image on the cover was
the work of Marvin Israel, a
well-known photographer who
spent time as an art director
for Atlantic Records as well
as *Mademoiselle* magazine.

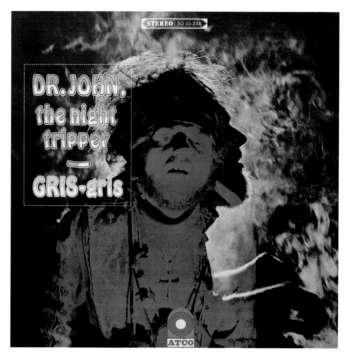

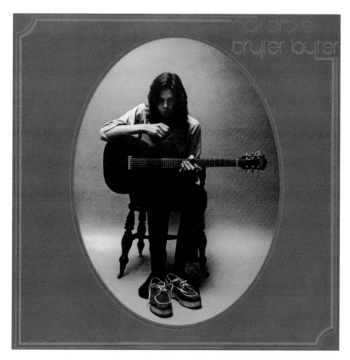

NICK DRAKE

artist NICK DRAKE
title BRYTER LAYTER
year 1970
label ISLAND
design NIGEL WAYMOUTH
photo NIGEL WAYMOUTH

Using a chair purportedly
once the property of Charles
Dickens, photographer Nigel
Waymouth captured this
iconic image of melancholy
folk hero Nick Drake in
his London photography
studio. Waymouth used a
pair of his own shoes for
the composition, by his own
reasoning, to reflect the
album's optimistic title.

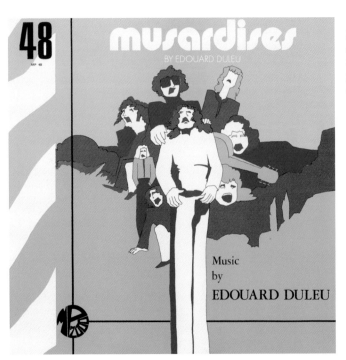

EDOUARD DULEU

artist EDOUARD DULEU
title MUSARDISES
year 1976
label EDITIONS
MONTPARNASSE
2000

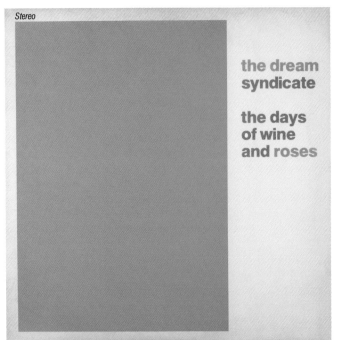

**THE DREAM
SYNDICATE**

artist THE DREAM
SYNDICATE
title THE DAYS OF WINE
AND ROSES
year 1982
label RUBY

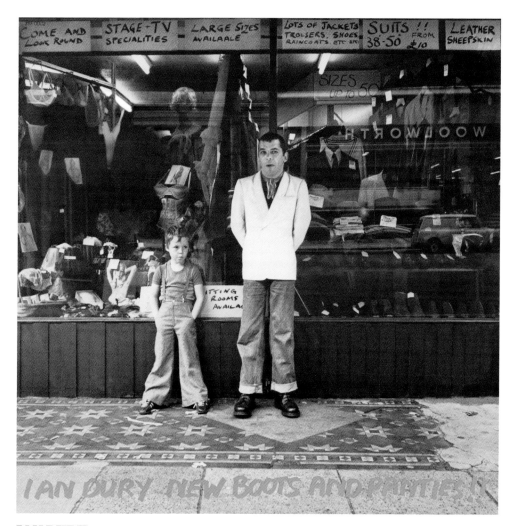

IAN DURY

artist IAN DURY
title NEW BOOTS AND
 PANTIES!!
year 1977
label STIFF
art BARNEY BUBBLES
 (BRUSH LETTERING)
photo CHRIS GABRIN

The title screams with excitement, and you'd be excited too
if the only clothes you ever bought new were footwear and
undergarments. That's the story of Ian Dury, the rest of whose
wardrobe came from second-hand sources, captured here in
time by Chris Gabrin with son Baxter who is now himself a
musician.

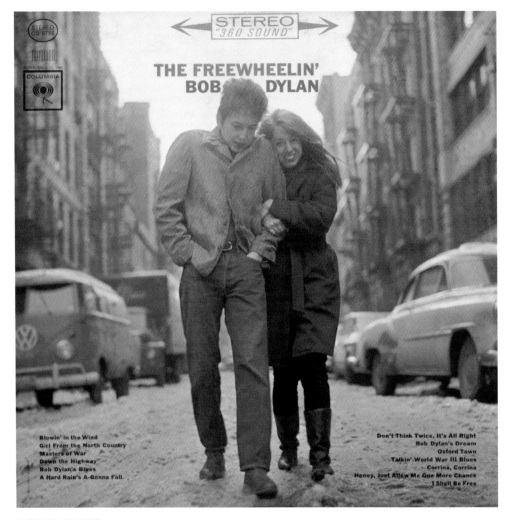

Blowin' in the Wind
Girl From the North Country
Masters of War
Down the Highway
Bob Dylan's Blues
A Hard Rain's A-Gonna Fall

Don't Think Twice, It's All Right
Bob Dylan's Dream
Oxford Town
Talkin' World War III Blues
Corrina, Corrina
Honey, Just Allow Me One More Chance
I Shall Be Free

BOB DYLAN

artist BOB DYLAN
title THE FREEWHEELIN'
year 1963
label COLUMBIA
photo DON HUNSTEIN

Though barely 21 at the time of recording, Dylan's political commentary in his sophomore album speaks of a man twice his age. Dylan has credited his girlfriend at the time, the politically active Suze Rotolo, as the muse for his astute narration. Don Hunstein's instantly recognizable cover image, shot in New York's West Village, was described by Rotolo in her memoir, *A Freewheelin' Time*, as "one of those cultural markers that influenced the look of album covers precisely because of its casual down-home spontaneity and sensibility. Most album covers were carefully staged and controlled... Whoever was responsible for choosing that particular photograph for *The Freewheelin' Bob Dylan* really had an eye for a new look."

BOB DYLAN

artist BOB DYLAN
title BLONDE ON BLONDE
year 1966
label COLUMBIA
photo JERRY SCHATZBERG

By 1965 Dylan had made the transition to electric, much to the resentment of folk purists who had hailed him as a new-wave hero. *Blonde on Blonde* places Dylan's folk-beat compositions in new musical territory with an accomplished sound provided by a host of Nashville's leading country session musicians. It was Dylan who picked the now iconic blurred cover portrait taken by photographer Jerry Schatzberg on a freezing cold day in New York's meat packing district. The singer-songwriter would wear the same suede jacket on his following two album covers, *John Wesley Harding* (1967) and *Nashville Skyline* (1969).

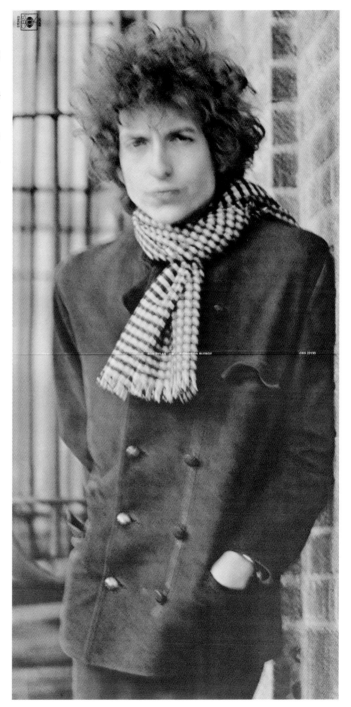

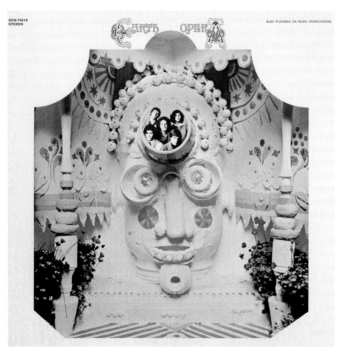

EARTH OPERA

artist EARTH OPERA
title EARTH OPERA
year 1968
label ELEKTRA
ad WILLIAM S. HARVEY
art EVE BABITZ
design ABE GURVIN
photo JOEL BRODSKY

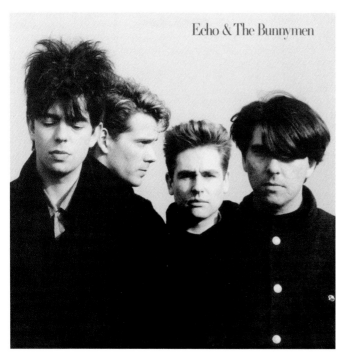

ECHO & THE BUNNYMEN

artist ECHO & THE BUNNYMEN
title ECHO & THE BUNNYMEN
year 1987
label SIRE
photo ANTON CORBIJN

"Depth is important. I can see quite quickly which features of a face are worth photographing. After that I search for the people."

Anton Corbijn

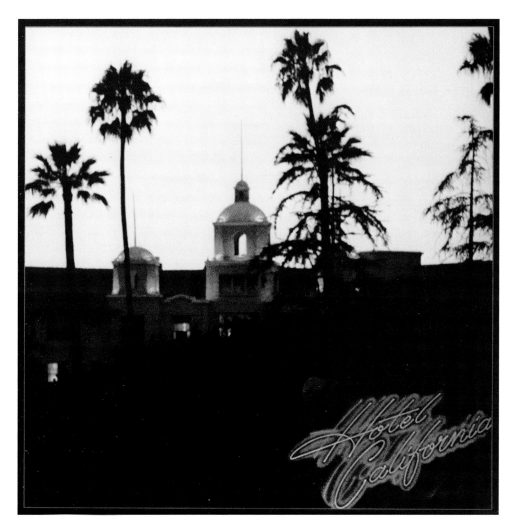

EAGLES

artist EAGLES
title HOTEL CALIFORNIA
year 1976
label ASYLUM
ad DON HENLEY,
 JOHN KOSH
design JOHN KOSH
photo DAVID ALEXANDER

This mega best-selling album by the Eagles produced three chart hits: "New Kid in Town," "Life in the Fast Lane" and the title track "Hotel California," for which the album is far and away best known. Released amid the backdrop to the US Bicentennial, the album can be interpreted as an allegorical State of the Union address reflecting on the material excesses of Californian high-life and the decline of morality. Founding member Don Henley drafted in ex-Beatles art director John Kosh to co-ordinate the iconic cover, with David Alexander's images, featuring the cropped towers of the Beverly Hills Hotel on the front and Hollywood's Lido Apartments on the back, adding an eerie tonality to the album's *mise-en-scène*.

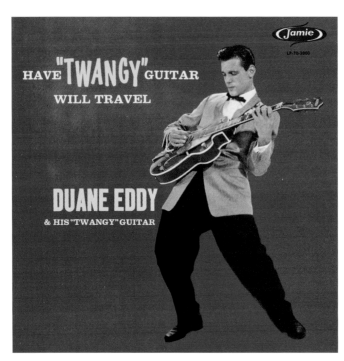

DUANE EDDY

artist DUANE EDDY
title HAVE TWANGY
 GUITAR, WILL
 TRAVEL
year 1958
label JAMIE

*"So I wanted to be
distinct, and I knew
that the bass strings
were more powerful
in the studio and
recordings than the
treble strings, so I
just went down there
in that neighborhood
and worked out some
melodies and things..."*
Duane Eddy

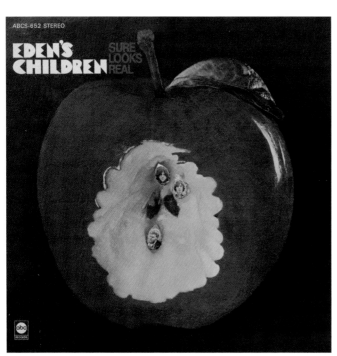

EDEN'S CHILDREN

artist EDEN'S CHILDREN
title SURE LOOKS REAL
year 1968
label ABC
design WILLIAM DUEVELL,
 HENRY EPSTEIN
photo NORMAN TRIGG
 (PHOTO OF APPLE),
 ELLIOT LANDY
 (PHOTOS OF GROUP)

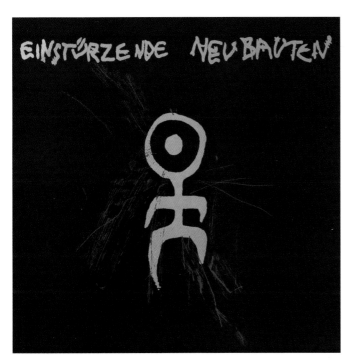

EINSTÜRZENDE NEUBAUTEN

artist EINSTÜRZENDE
 NEUBAUTEN
title STRATEGIES
 AGAINST ARCHI-
 TECTURE 80-83
 (STRATEGIEN
 GEGEN ARCHITEK-
 TUREN 80-83)
year 1984
label MUTE/HOMESTEAD
design MARTYN ATKINS/
 TOWN & COUNTRY
 PLANNING

*"I had an idea that music
could be anything you
wanted it to be. We were
very indignant about this
because it meant we had
no rules to follow."*

Blixa Bargeld

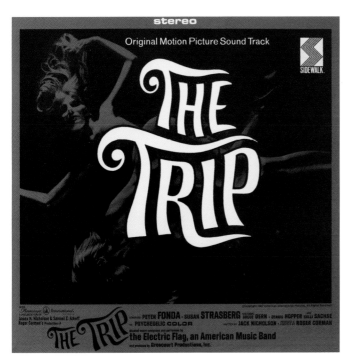

THE ELECTRIC FLAG

artist THE ELECTRIC
 FLAG
title THE TRIP
year 1967
label SIDEWALK

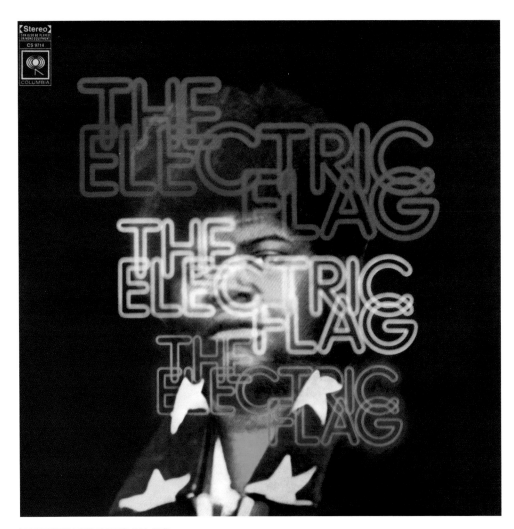

THE ELECTRIC FLAG

artist THE ELECTRIC FLAG
title AN AMERICAN
MUSIC BAND
year 1968
label COLUMBIA
design RON CORO
photo FRED LOMBARDI,
SANDY SPEISER

"To make music together is to perform an act of intimate communication, an act which transcends differences of personality and environment. Making music creatively, in fact, relies upon those very differences as much as it relies upon individual similarities. It is that powerful combination of varied elements—of differences in geographical background, social environment and cultural identity, of similarities in musical and personal points of view—which makes the Electric Flag a truly American music band."

Harvey Brooks

THE ELECTRIC PRUNES

artist THE ELECTRIC
PRUNES
title UNDERGROUND
year 1967
label REPRISE
ad ED THRASHER
photo TOM TUCKER

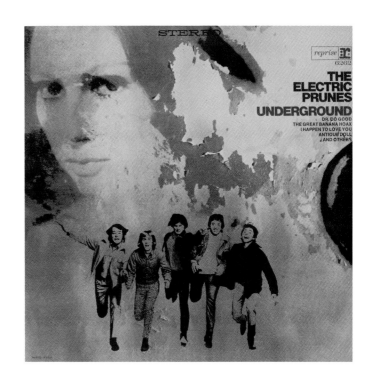

THE EMBERS

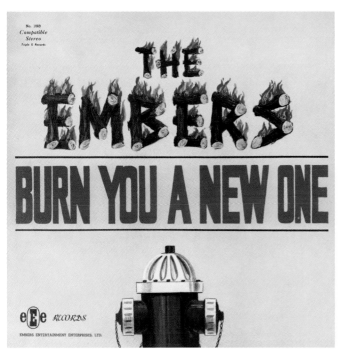

artist THE EMBERS
title BURN YOU A
NEW ONE
year 1967
label EEE
design JOE BALINT

"The best I can remember,
that title inferred that the
group was so hot that you
needed a fire hydrant to
put us out. You notice on
all of our first albums,
we wrote our name with
rocks and fire—that was
our logo. All of us were in
our twenties—we weren't
the most creative people in
the world."

Bobby Tomlinson

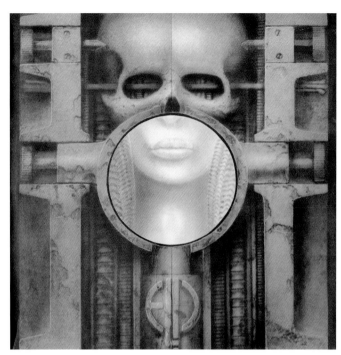

EMERSON, LAKE AND PALMER

artist EMERSON, LAKE
 AND PALMER
title BRAIN SALAD
 SURGERY
year 1973
label MANTICORE
art H.R. GIGER
photo ROSEMARY ADAMS

"Giger was an extraordinary character. His paintings always looked like photos. He used airbrushing to come up with art that looked like it was part of a movie image."

Keith Emerson

BRIAN ENO

artist BRIAN ENO
title HERE COME THE
 WARM JETS
year 1973
label ISLAND
design CAROL MCNICOLL
photo LORENZ ZATECKY

The still-life on the cover, arranged by Brian Eno's then-girlfriend Carol McNicoll, features numerous references and gags. Eno claimed the title was inspired by the name he'd given a particular guitar sound, but has also slyly suggested there may be something to the small playing-card picture of a woman on the cover hiking up her dress.

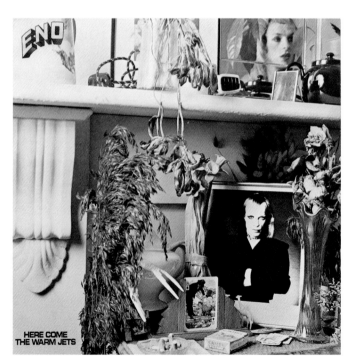

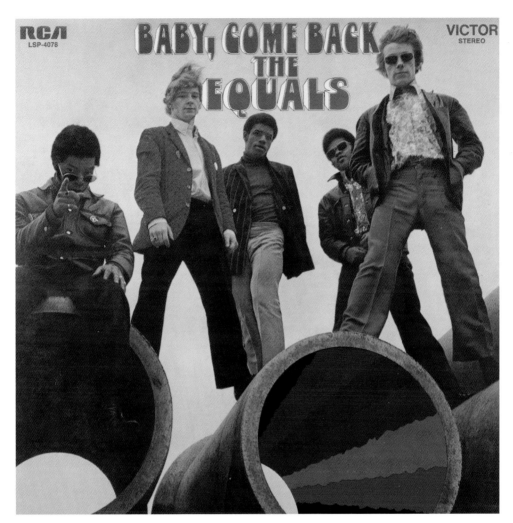

THE EQUALS

artist THE EQUALS
title BABY, COME BACK
year 1968
label RCA VICTOR
ad BOB JONES

Although the Equals had their fair share of hits in the UK, they are perhaps best known for launching the career of song-writer/guitarist Eddy Grant. His 1982 hit "Electric Avenue" is named after a thoroughfare popular with vendors in the South London neighborhood of Brixton, where riots erupted the previous year.

"*The Black component of the Equals came from the West Indies, and the White component came from England. John Hall [drummer] suggested that we call the band the Equals, because we would all be equal partners in whatever happened. Nothing's more democratic than that.*"

Eddy Grant

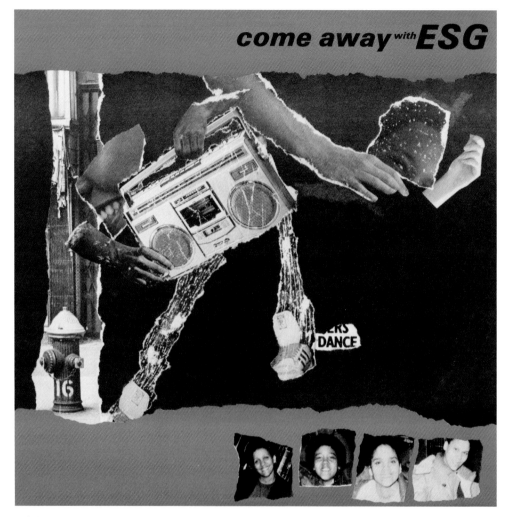

come away *with* **ESG**

ESG

artist ESG
title COME AWAY WITH ESG
year 1983
label 99 RECORDS
art STEPHEN KRONINGER
design STEPHEN KRONINGER,
CHRIS MATHAN

At the same time that Jean-Michel Basquiat was re-inventing the art world with his distinctive style of Primitivist paintings, the Scroggins sisters Marie, Valerie, Renee and Lorraine "Sweet L," along with their conga player Tito Libran, were doing something similar with music. Their double-jointed polyrhythmic slices of post-punk cool helped to launch a thousand ships that all returned with treasures more wondrous than Emerald, Sapphire and Gold. Stephen Kroninger's anthropomorphic boombox collage set the tone for the brazenly funky downtown grooves the sisters were laying down.

EURYTHMICS

artist EURYTHMICS
title IN THE GARDEN
year 1981
label RCA
ad LAURENCE
STEVENS
design ROCKING RUSSIAN,
LAURENCE
STEVENS
photo PETE ASHWORTH

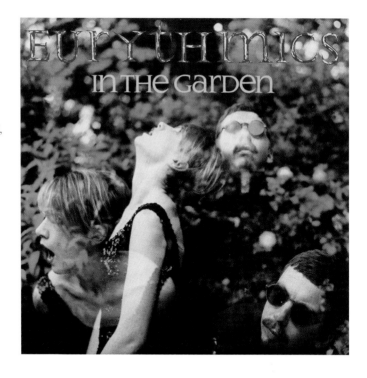

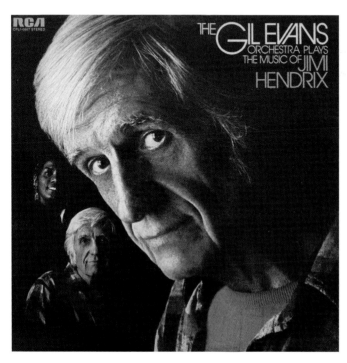

THE GIL EVANS
ORCHESTRA

artist THE GIL EVANS
ORCHESTRA
title THE GIL EVANS
ORCHESTRA PLAYS
THE MUSIC OF
JIMI HENDRIX
year 1974
label RCA
art ACY R. LEHMAN
photo NICK SANGIAMO

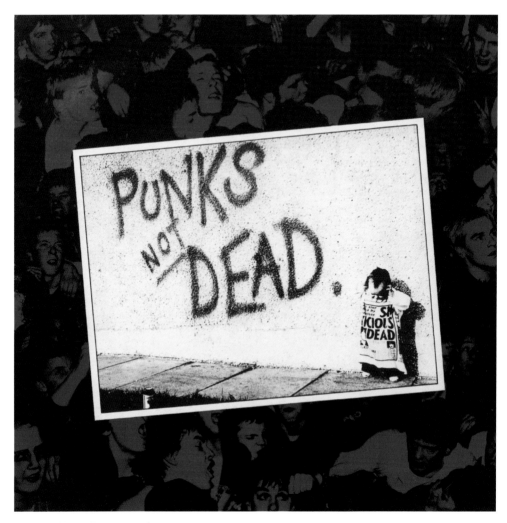

THE EXPLOITED

artist THE EXPLOITED
title PUNKS NOT DEAD
year 1981
label SECRET
design THE EXPLOITED
photo SCOTT BILLETT

By the early '80s critics and skeptics alike were pondering whether or not the relatively new genre of punk had indeed perished with the passing of Sex Pistols bassist Sid Vicious, the rising tide of new wave, and the emergence of post-punk. Scottish band the Exploited sought to preserve the snotty integrity of punk's UK roots with this collection of throwback battle-cries.

EYELESS IN GAZA

artist EYELESS IN GAZA
title CAUGHT IN FLUX
year 1981
label CHERRY RED
design JAMES WOLF

"... we feel it's important for the visual representation to convey a warmth, a human feeling... The main reason we did it was this 'anti' thing, all these groups are all about their heads exploding off and people dying..."

Martyn Bates

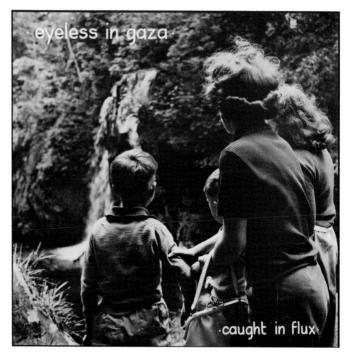

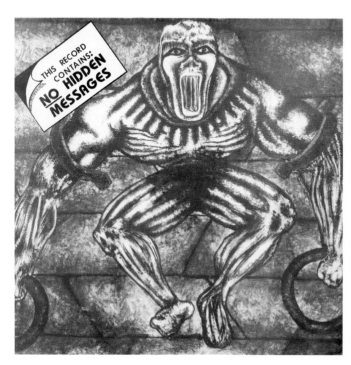

THE FACTION

artist THE FACTION
title NO HIDDEN MESSAGES
year 1983
label IM
art MOFO

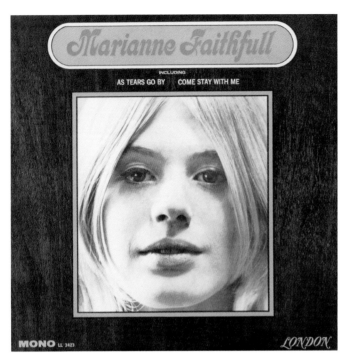

MARIANNE FAITHFULL

artist MARIANNE
 FAITHFULL
title MARIANNE
 FAITHFULL
year 1965
label LONDON

FANTASY

artist FANTASY
title FANTASY
year 1970
label LIBERTY
design ANTASY, BENNETT
 & BENNETT
photo AL KAPLAN

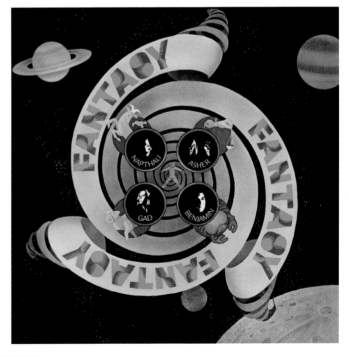

FATS DOMINO

artist FATS DOMINO
title FATS ON FIRE
year 1964
label ABC-PARAMOUNT
design JOE LEBOW
photo FORSHEE
 PHOTOGRAPHY INC.

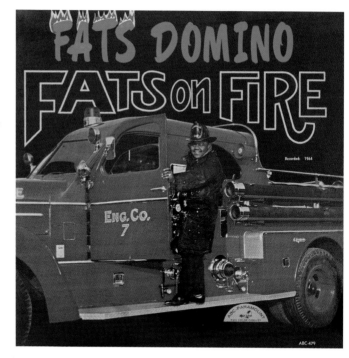

*"Teens always heard
my music with their
hearts... The beat was
just happy. It didn't
have color or hidden
meaning."*

Fats Domino

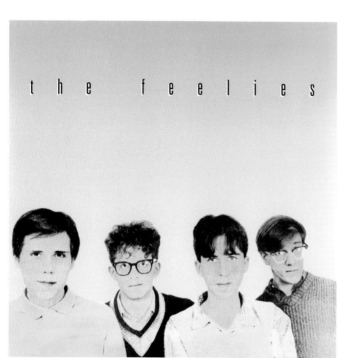

THE FEELIES

artist THE FEELIES
title CRAZY RHYTHMS
year 1980
label STIFF
design BILL MILLION,
 GLENN MERCER

*"Like so many great bands,
the Feelies came before
the world was ready for
them, but unlike the Velvet
Underground and Hüsker
Dü, they've never really
gotten their due. Crazy
Rhythms created a sound
that drove some of the best
American music of the
decade. Still moving."*

Brian Shelly

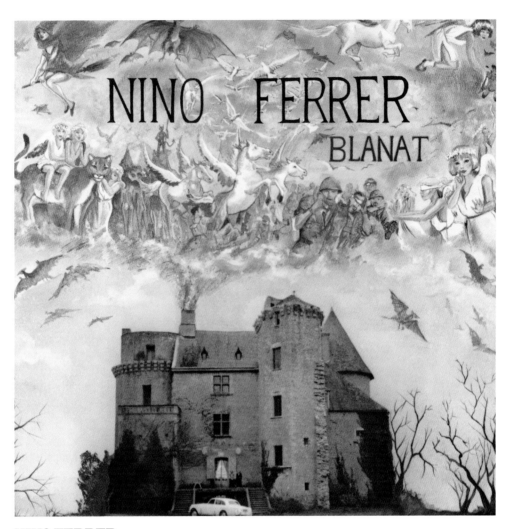

NINO FERRER

artist NINO FERRER
title BLANAT
year 1979
label DISQUES LA
 TAILLADE
photo KINOU

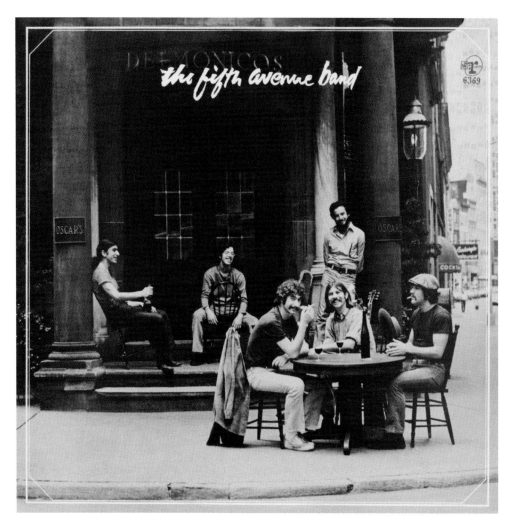

THE FIFTH AVENUE BAND

artist THE FIFTH
AVENUE BAND
title THE FIFTH
AVENUE BAND
year 1969
label REPRISE
ad ED THRASHER
photo BOBBY MILLER

Produced by Lovin' Spoonful alumni Zal Yanovsky and Jerry Yester, the Fifth Avenue Band's self-titled debut enjoys a generous portion of stylistic overlap with their corduroyed peers from the Greenwich Village scene. This photo was taken at 2 South Williams Street in front of Delmonico's, a legendary dining establishment whose strict dress code would have prohibited the Fifth Avenue Band from gaining entry wearing the garments pictured.

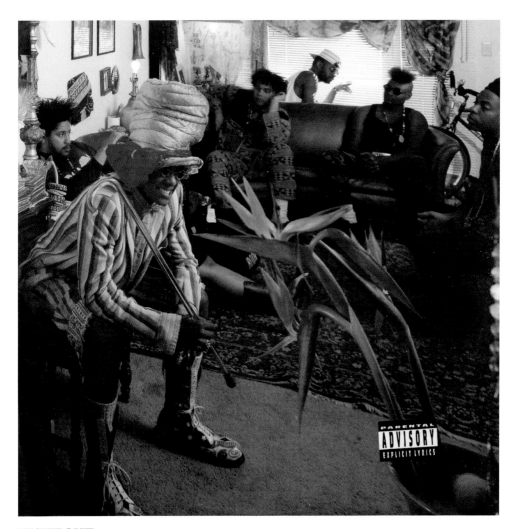

FISHBONE

artist FISHBONE
title THE REALITY OF
MY SURROUNDINGS
year 1991
label COLUMBIA
design STACY DRUMMOND
photo MAX AGUILERA-HELLWEG

"*Those guys were very chill, opposed to being assholes, which a lot of rock music people are. I would arrange people in situations like that—trying to make it look as real-life as possible. I generally don't have people looking in the camera, and I never have people smiling. I just as soon have people staring off in different places, as if I wasn't there.*"

Max Aguilera-Hellweg

FIVE MAN
ELECTRICAL BAND

artist FIVE MAN
ELECTRICAL BAND
title GOOD-BYES AND
BUTTERFLIES
year 1970
label LIONEL
design DON RECORD

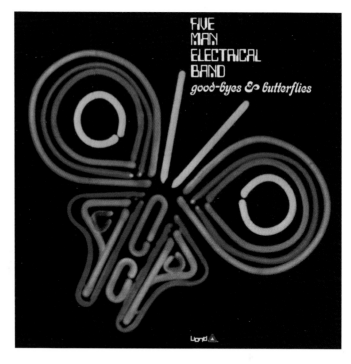

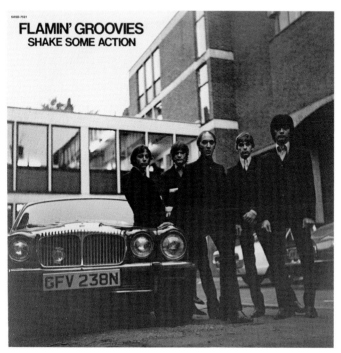

FLAMIN' GROOVIES

artist FLAMIN' GROOVIES
title SHAKE SOME
ACTION
year 1976
label SIRE
ad TOM WILKES
photo ARMAND HAYE

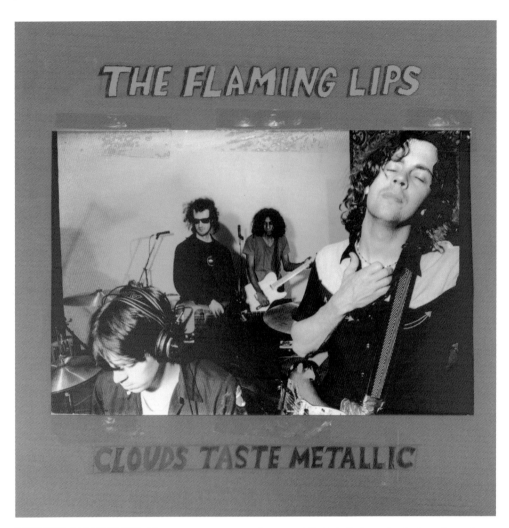

THE FLAMING LIPS

artist THE FLAMING LIPS
title CLOUDS TASTE
METALLIC
year 1995
label WARNER BROS.
design FATE, DISCORPORATED
photo GWEN DOBBS,
J. MICHELLE MARTIN

Before Wayne Coyne and Erykah Badu embarked on the nudity feud heard round the world, there was this stage of the Flaming Lips. And before Michelle Martin had (what would appear) Glamour Shots photograph her for her own album in 1996, she photographed the Flaming Lips for their seventh studio album, *Clouds Taste Metallic*. Lips fans far and wide would mark this album as the last of its kind for the Oklahoma band since their follow-up 1997 release would usher them into the trippy *Soft Bulletin* and *Yoshimi...* golden era that made them famous.

FLEETWOOD MAC

artist FLEETWOOD MAC
title RUMOURS
year 1977
label WARNER BROS.
art LARRY VIGON
design DESMOND STROBEL
photo HERBERT
WORTHINGTON

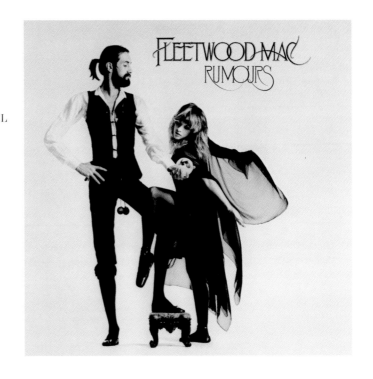

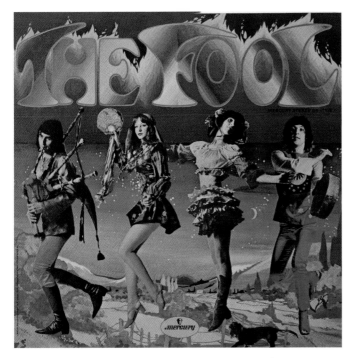

THE FOOL

artist THE FOOL
title THE FOOL
year 1968
label MERCURY
design THE FOOL:
SIMON POSTHUMA,
MARIJKE KOGER

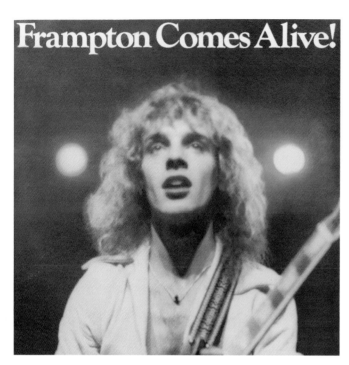

PETER FRAMPTON

artist PETER FRAMPTON
title FRAMPTON COMES
ALIVE!
year 1976
label A&M
ad ROLAND YOUNG
design STAN EVENSON
photo RICHARD E. AARON

One of the best-selling live albums of all time, *Frampton Comes Alive!* did as much to popularize the British guitarist as it did his voice-modulating effect of choice, the talk box. "They used to sterilize my talk box tube by dipping the end in Rémy Martin. This would get me going for the evening," confessed Frampton. "After the show, it was 'Okay, where's the Rémy?'"

FORMULA V

artist FORMULA V
title BUSCA UN AMOR
year 1969
label BORINQUEN

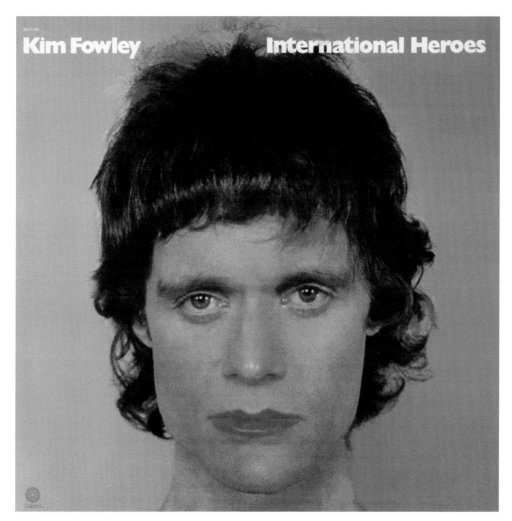

KIM FOWLEY

artist KIM FOWLEY
title INTERNATIONAL
 HEROES
year 1973
label CAPITOL

"That was when glam rock/glitter rock was the rage, so 'OK, we've got to do one of those covers in color, because that's a colorful visual category of music in the marketing sense so go and do a Bowie-esque, Iggy-esque album cover, please!' We took about an afternoon of renting or buying or borrowing or stealing the clothes—forgot which—and photographing it. Then I put my T-shirt and jeans back on, took the make-up off, and went to Denny's. That was just called show business."

Kim Fowley

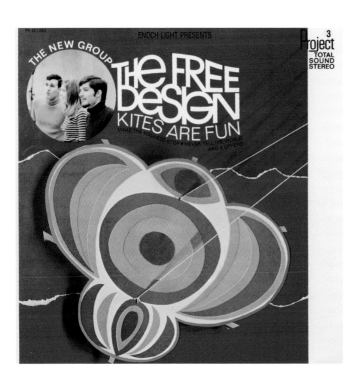

THE FREE DESIGN

artist THE FREE DESIGN
title KITES ARE FUN
year 1967
label PROJECT 3 TOTAL
SOUND
design CHARLES E. MURPHY

Comprising three singing
siblings from Delevan, New
York, the Free Design were
only able to share their sun-
soaked masterpieces and inno-
vative folk rearrangements with
a wider audience when Bruce,
Chris and Sandy Dedrick
relocated to New York City in
the '60s. A string of imagina-
tive albums went relatively
unnoticed until the '90s, when
nostalgic artists like Stereolab
and Cornelius began champion-
ing the band's progressive brand
of baroque pop.

JOHN FRED AND HIS PLAYBOY BAND

artist JOHN FRED AND
HIS PLAYBOY BAND
title PERMANENTLY
STATED
year 1968
label PAULA
art GENE NUMEZ
design JERRY GRIFFITH
photo ALAN GROSSMAN

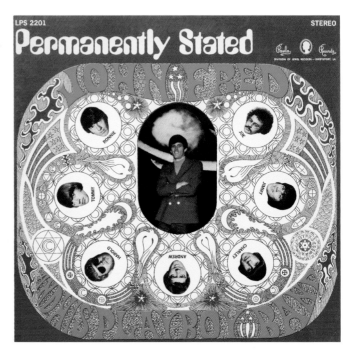

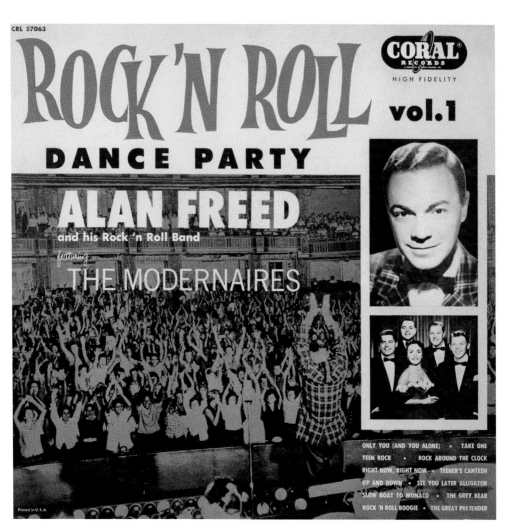

ONLY YOU (AND YOU ALONE) • TAKE ONE
TEEN ROCK • ROCK AROUND THE CLOCK
RIGHT NOW, RIGHT NOW • TEENER'S CANTEEN
UP AND DOWN • SEE YOU LATER ALLIGATOR
SLOW BOAT TO MONACO • THE GREY BEAR
ROCK 'N ROLL BOOGIE • THE GREAT PRETENDER

ALAN FREED AND HIS ROCK 'N ROLL BAND

artist ALAN FREED AND
HIS ROCK 'N ROLL
BAND
title ROCK 'N ROLL
DANCE PARTY VOL. 1
year 1956
label CORAL

"*What Paul Whiteman was to jazz in the Twenties, and Benny Goodman and Glenn Miller were to the swing era, Freed is to rock and roll. On the basis of past musical history, it seems quite safe to predict that in years to come, many a scholarly thesis will be written about the 'fascinating, uninhibited music of the Fifties' and the 'disk-jockey messiah, who started the whole country rocking and rolling to a new beat.'*"

June Bundy

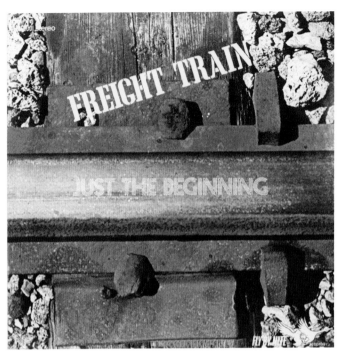

FREIGHT TRAIN

artist FREIGHT TRAIN
title JUST THE
BEGINNING
year 1971
label FLY BY NITE
design DOUGLAS FISKE
photo DOUGLAS FISKE

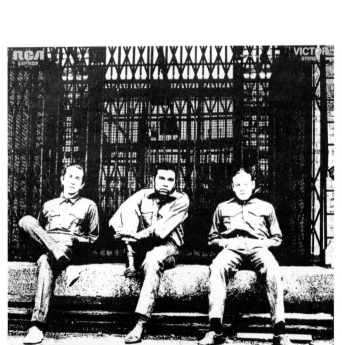

FRESH

artist FRESH
title FRESH OUT OF
BORSTAL
year 1970
label RCA
design ROB ALLEN

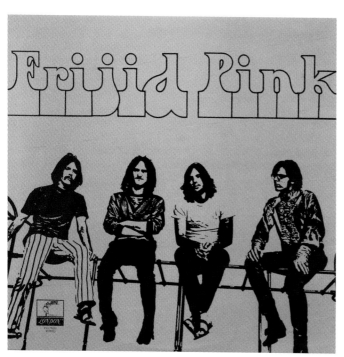

FRIJID PINK

artist FRIJID PINK
title FRIJID PINK
year 1970
label PARROT
design VICTOR KAHN
photo JEFF BAILEY

Although fellow Detroit rockers MC5 and the Stooges always overshadowed them, Frijid Pink delivered a serious dose of soulful boogie rock with this, their debut release. And whilst the Animals' version gained more popularity on American soil, Frijid Pink's version of "House of the Rising Sun" still managed to make a huge impression worldwide. The hit was in fact such a success that when they played Detroit's Grande Ballroom no less than a young Led Zeppelin opened for them.

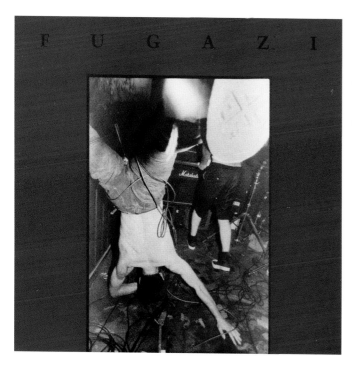

FUGAZI

artist FUGAZI
title FUGAZI
year 1988
label DISCHORD
design KURT SAYENGA
photo ADAM COHEN

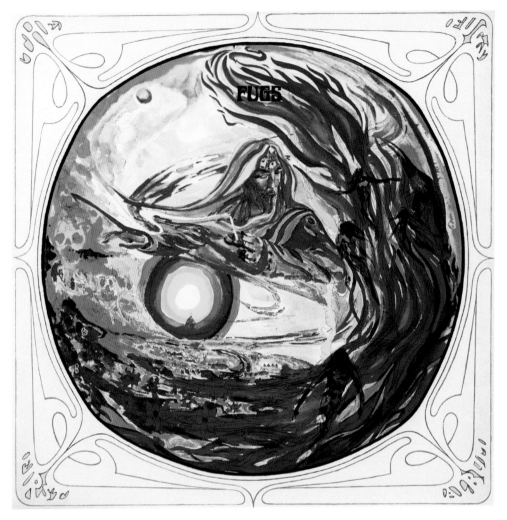

THE FUGS

artist THE FUGS
title THE FUGS FIRST
 ALBUM
year 1966
label ESP/BASE
art HOWARD
 BERNSTEIN
design BABY JERRY
photo DAVID GAHR

JUN FUKAMACHI

artist JUN FUKAMACHI
title SGT. PEPPER'S
LONELY HEARTS
CLUB BAND
year 1977
label TOSHIBA
ad HIDEAKI TAKA-
HASHI, SEIJI KUDO
art FUMIO TAMABUCHI

Jun Fukamachi's tribute to the Beatles' masterpiece is a triumph unto itself. Recorded direct-to-disc, Fukamachi played an array of instruments, simultaneously, pounding a bass drum while navigating the grand piano, and leading on the glockenspiel while complementing things on the Fender Rhodes. A forward-facing Fukamachi embellishes Jann Haworth's and Peter Blake's iconic original cover design, spun around by illustrator Fumio Tamabuchi.

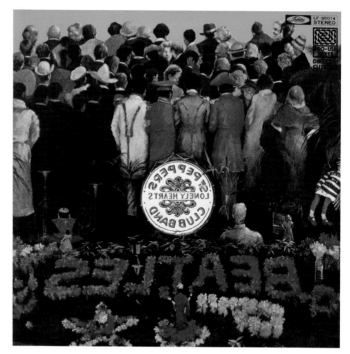

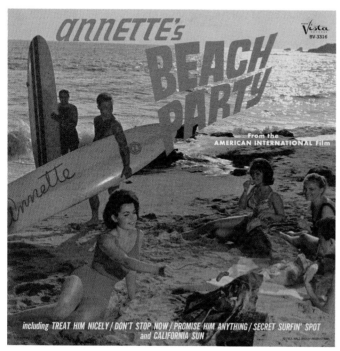

ANNETTE FUNICELLO

artist ANNETTE
FUNICELLO
title ANNETTE'S BEACH
PARTY
year 1963
label BUENA VISTA

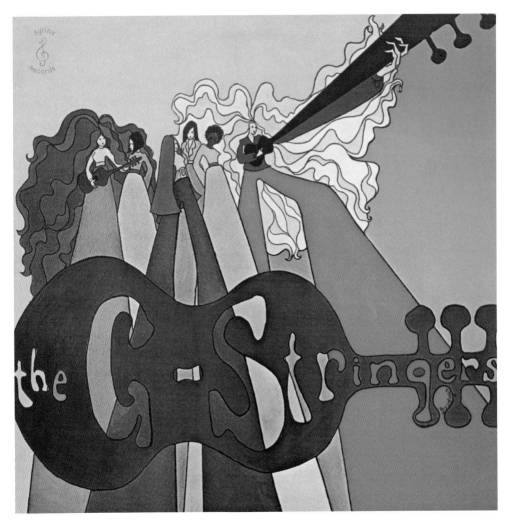

THE G-STRINGERS

artist THE G-STRINGERS
title THE G-STRINGERS
year 1969
label SYRINX
art JUDITH BRIDGES
design JUDITH BRIDGES

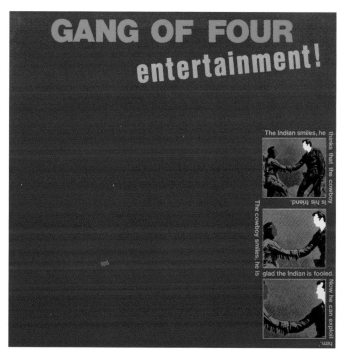

GANG OF FOUR

artist GANG OF FOUR
title ENTERTAINMENT!
year 1979
label WARNER BROS.
design JON KING, ANDY GILL

As a testament to the immense creativity that went into Gang of Four's debut its influence still resonates with young bands today. From post-punk dance music to rap-metal, the disaffected talk-singing, syncopated rhythms and scratchy guitar squall capture the essence of their sound here. While funk and reggae influences are clearly present, everything from the sound to the jacket design are punk to the core. Band members Jon King and Andy Gill not only perform and share in production, but are credited for the artwork as well.

SERGE GAINSBOURG

artist SERGE GAINSBOURG
title LOVE ON THE BEAT
year 1984
label PHILIPS
photo WILLIAM KLEIN

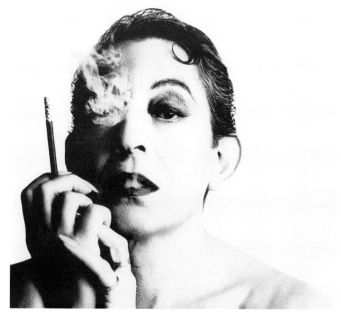

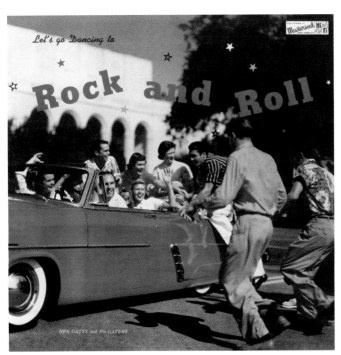

HEN GATES AND HIS GATERS

artist HEN GATES AND
 HIS GATERS
title LET'S GO DANCING
 TO ROCK AND ROLL
year 1957
label MASTERSEAL

GENERAL

artist GENERAL
title HEART OF ROCK
year 1979
label POLSKIE NAGRANIA
 MUZA
design GENERAL

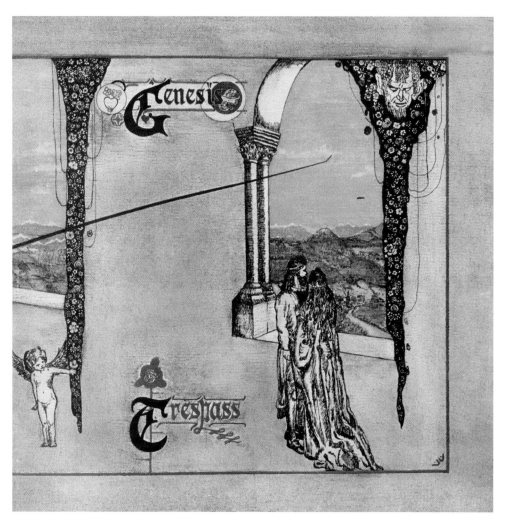

GENESIS

artist GENESIS
title TRESPASS
year 1970
label CHARISMA
art PAUL WHITEHEAD
FOR CLEEN
MASHINE STUDIO

"I finished the painting, brought it in and said, 'Now we're going to slash it' and they said, 'You're not going to slash it?' and I said, 'Yeah' and I just did one ssht with the razor blade... actually I rented a knife from a prop house and got a Renaissance like dagger and stuck it in and that was it..."

Paul Whitehead

THE GERALDINE FIBBERS

artist THE GERALDINE FIBBERS

title GET THEE GONE

year 1994

label SYMPATHY FOR THE RECORD INDUSTRY

art MARK BROOKS

design MISS CRYSTAL MESS

GIORGIO

artist GIORGIO

title SON OF MY FATHER

year 1972

label ABC/DUNHILL

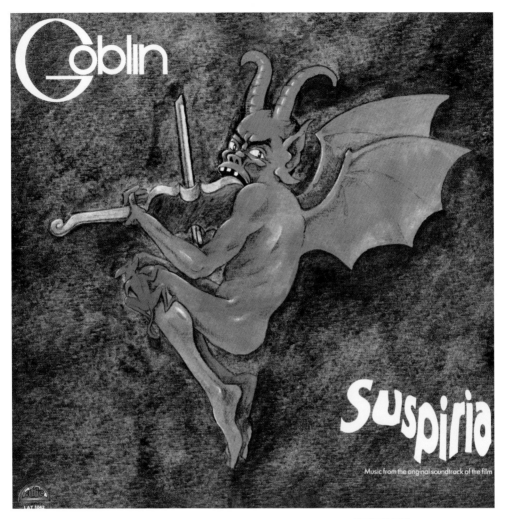

GOBLIN
artist GOBLIN
title SUSPIRIA –
MUSIC FROM
THE ORIGINAL
SOUNDTRACK
OF THE FILM
year 1977
label ATTIC

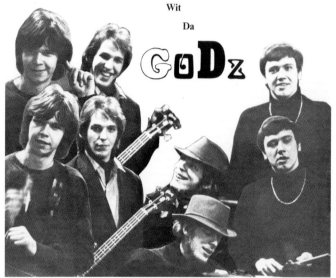

GODZ

artist GODZ
title CONTACT HIGH
year 1966
label ESP DISK
design JIM MCCARTHY
photo SANDRA STOLLMAN

GRAND FUNK RAILROAD

artist GRAND FUNK
RAILROAD
title E PLURIBUS FUNK
year 1971
label CAPITOL
design ERNIE CEFALU
(ORIGINAL SILVER
COIN DESIGN),
TERRY KNIGHT
(CONCEPT),
CRAIG BRAUN

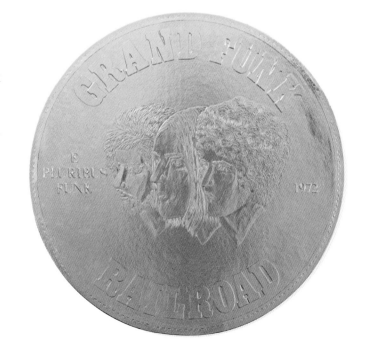

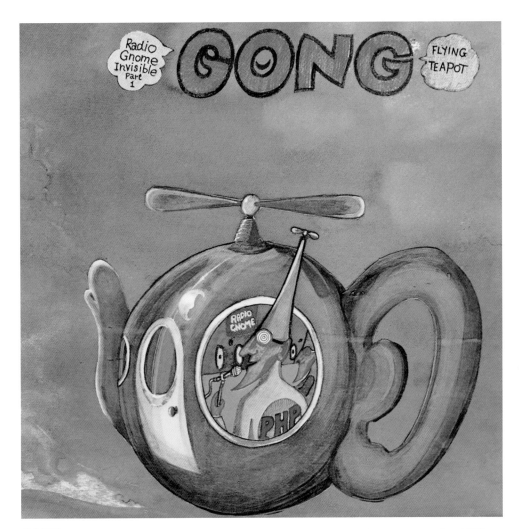

GONG

artist GONG
title FLYING TEAPOT
(RADIO GNOME
INVISIBLE PART 1)
year 1973
label BYG/VIRGIN
art TOM FU (TOMAS LIPPS)
design DINGO, MAGGIE,
TOM FU

The first in Gong's trilogy of *Radio Gnome* albums, this 1973 release leads by a mile for trippiest cover art in the series. Reading the album's personnel credits is enough to make you feel like you're either on drugs yourself, or texting your 14-year-old niece. "Shakesperian meat bass," "drumbox, kicks and knocks," "left bank uptightright pno," "road crew & trux," and so on and on. With cover design completed by a few mysteriously named artists, you've got yourself the '70s wrapped up in a neat little package.

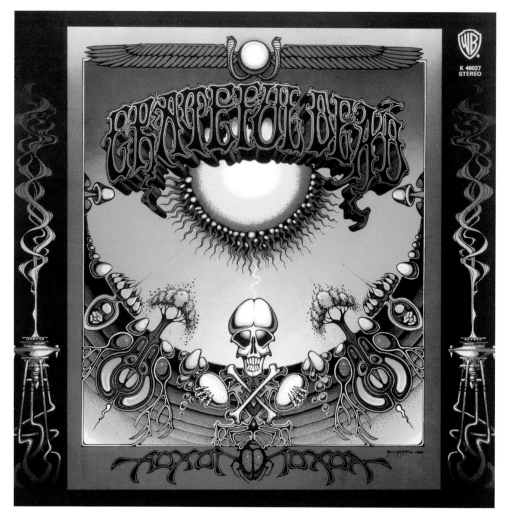

THE GRATEFUL DEAD

artist THE
GRATEFUL DEAD
title AOXOMOXOA
year 1969
label WARNER BROS./
SEVEN ARTS
design RICK GRIFFIN

For the Grateful Dead's third studio outing, the palindromic title dreamt up by acid-popping lyricist Robert Hunter and cover illustrator Rick Griffin is neatly balanced by the lettering of the band's name, which at a squint can also be read as "We ate the acid." On the back cover Courtney Love can be seen in the group photo, at the age of five, her father Hank Harrison being the band's manager at the time. Griffin was a key figure in psychedelic illustration in the '60s, designing concert posters and contributing to a range of underground comics.

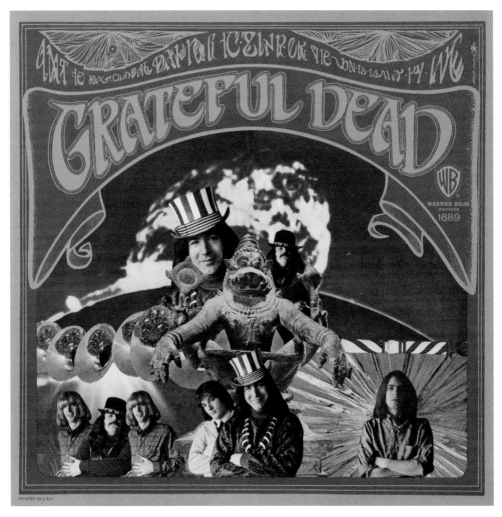

THE GRATEFUL DEAD

artist THE GRATEFUL DEAD
title THE GRATEFUL DEAD
year 1967
label WARNER BROS.
art ALTON KELLEY (COLLAGE)
design MOUSE STUDIOS

When Warner Bros. signed the Grateful Dead in 1966, the California group had recorded only rarely—a single with jazz vocalist Jon Hendricks (as the Warlocks), a 45 for Gene Estribou's Scorpio imprint, and a hallucinogenic LP with acid advocate/author Ken Kesey. Their major-label debut boasted an array of folk and blues adaptations, pared down from mighty jams to suit industry standards regarding song length.

"The first real rock 'n' roll group I signed was the Grateful Dead. When Tom Donahue, who was a disc jockey up there, told me the guys were ready to see me, I was over at Ernie's Restaurant in my dark blue Bank of America suit, and my wife was in her black dress with pearls. I said, 'We're dressed kind of funny.' And he said, 'Nobody will notice.'" – Joe Smith

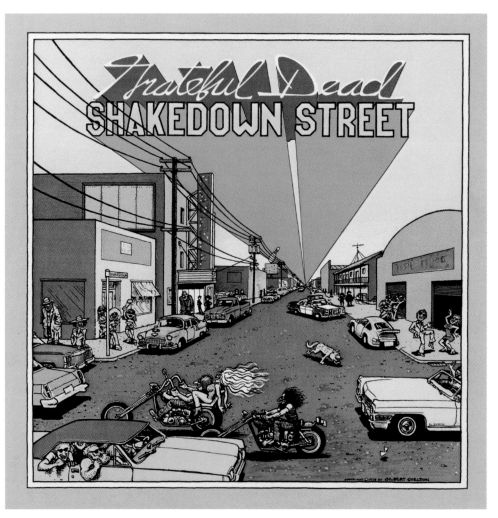

THE GRATEFUL DEAD

artist THE GRATEFUL
DEAD
title SHAKEDOWN
STREET
year 1978
label ARISTA
art GILBERT SHELTON

Texan Gilbert Shelton led a double life throughout the '60s, bouncing between blue-collar illustration jobs for greeting-card and automotive companies, and drawing adult comics and concert posters. Having received a military deferment for admitting to psychedelic drug use, he relocated to San Francisco in 1968, achieving cult notoriety through *The Fabulous Furry Freak Brothers* and later this cover for local rock icons, the Grateful Dead.

THE GROUPIES

artist THE GROUPIES
title THE GROUPIES
(PRODUCED BY
ALAN LORBER)
year 1969
label EARTH
design STEPHEN LORBER
photo STEPHEN LORBER

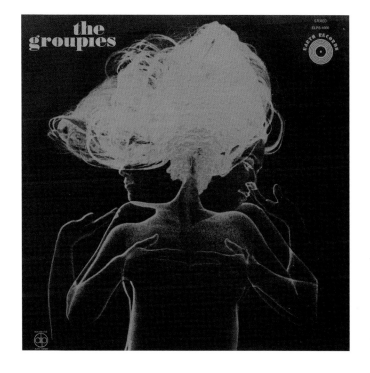

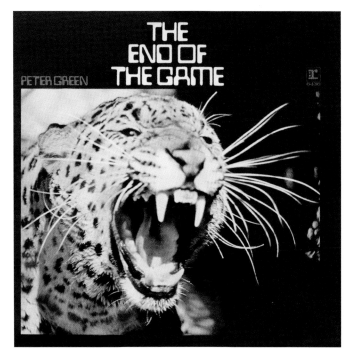

PETER GREEN

artist PETER GREEN
title THE END OF
THE GAME
year 1970
label REPRISE
design AFRACADABRA
photo KEYSTONE

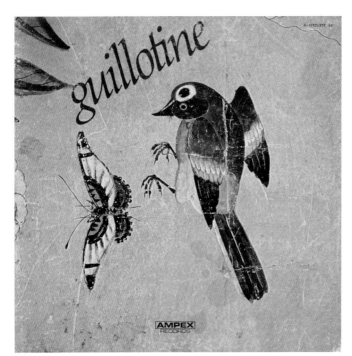

GUILLOTINE
artist GUILLOTINE
title GUILLOTINE
year 1971
label AMPEX
design BOB CATO
photo BOB CATO

GUN
artist GUN
title GUN
year 1968
label EPIC
art ROGER DEAN

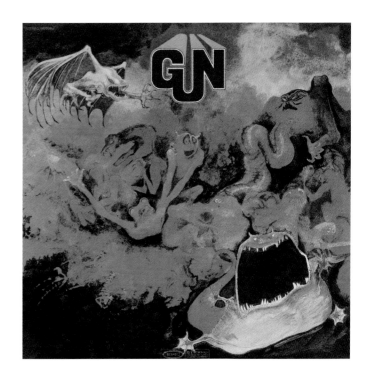

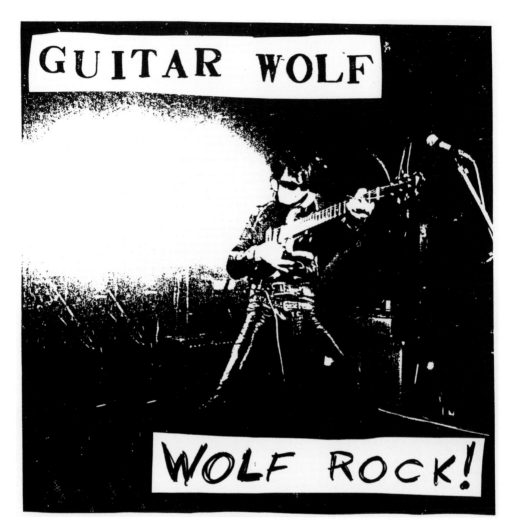

GUITAR WOLF

artist GUITAR WOLF
title WOLF ROCK!
year 1993
label GONER
design ERIC FRIEDL
photo RYOICHI YAMAMICHI

It's messy, and Guitar Wolf doesn't care. An unkempt portrait and photocopied cover completely matches the rough, live recordings featured on *Wolf Rock!* Recorded in Memphis, the record's back cover explains it all: "YEAH so there's a lot of NOISE in these tracks, ON these tracks, IN YOUR HEAD. If you don't like it, go fling it out the window and buy some more ROCKABILLY REVIVAL CDs. Or real records from some REAL LABEL. I don't know where/how these songs were recorded, I don't know how they ended up sounding so FUCKED on this Lp, hey I'm not a scientist, I'm a MORON... You want a CLEAN recording of this? YOU AIN'T GONNA GET IT! So learn to love it NOW!"

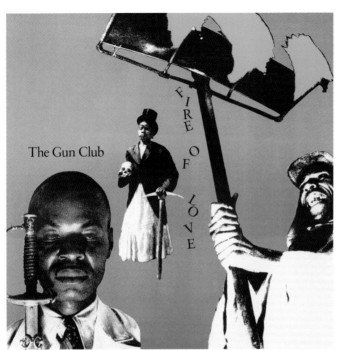

THE GUN CLUB

artist THE GUN CLUB
title FIRE OF LOVE
year 1981
label RUBY
design CHRIS D.
photo REX HARDY JR.,
W.B. SEABROOK,
HERMANN DEUTSCH

AVNEI HAKOTEL

artist AVNEI HAKOTEL
title REFLECTIONS
year 1971
label I.D. MUSIC

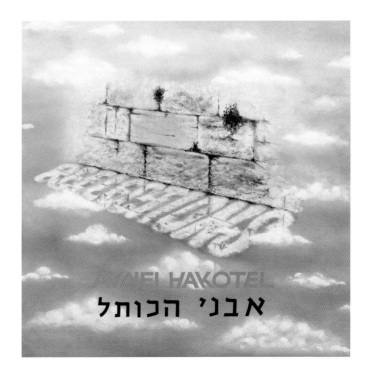

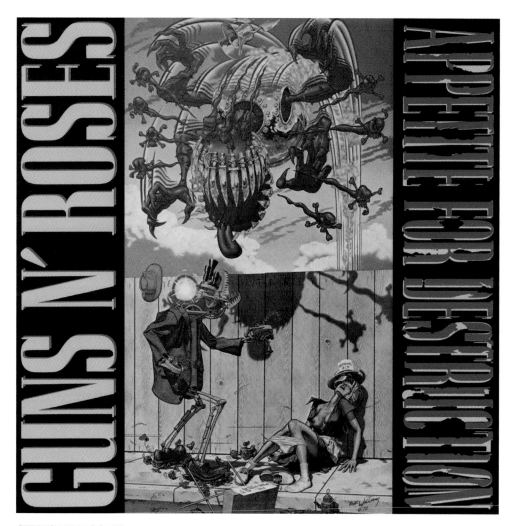

GUNS N' ROSES

artist GUNS N' ROSES
title APPETITE FOR
DESTRUCTION
year 1987
label GEFFEN/UZI
SUICIDE
art ROBERT WILLIAMS
design MICHAEL HODGSON

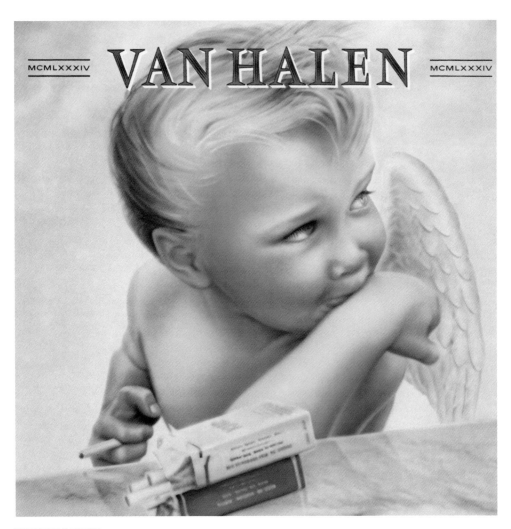

VAN HALEN

artist VAN HALEN
title 1984
year 1983
label WARNER BROS.
ad PETE ANGELUS,
RICHARD SEIREENI,
DAVID JELLISON
art MARGO ZAFER
NAHAS
photo RAUL VEGA

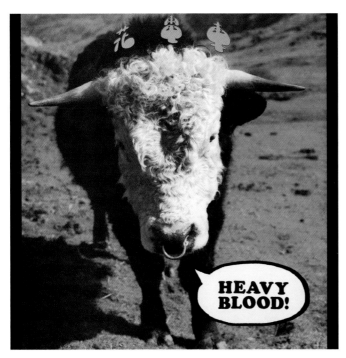

HANADENSHA

artist HANADENSHA
title THE GOLDEN AGE
OF HEAVY BLOOD
year 1989
label ALCHEMY
design MASAHIKO OHNO,
HIRA
photo YUKIKO
MATSUMOTO

BILL HALEY AND HIS COMETS

artist BILL HALEY AND
HIS COMETS
title ROCK AROUND
THE CLOCK
year 1955
label DECCA

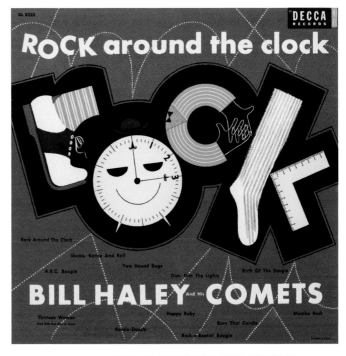

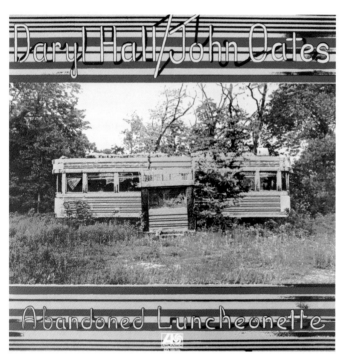

DARYL HALL & JOHN OATES

artist DARYL HALL &
JOHN OATES
title ABANDONED
LUNCHEONETTE
year 1973
label ATLANTIC
design B.P. WILSON
photo B.P. WILSON

The remains of the former
Rosedale Diner of Pottstown,
Pennsylvania, was abandoned
in this patch of woodland
beside the highway after being
decommissioned in 1965,
where it sat unused near the
home of Daryl Hall's grand-
mother. In 1973, Hall and
Oates approached owner Bill
Faulk about using it for a photo
shoot. Faulk's one condition,
that no one was to go inside,
was disobeyed for the back
cover shot, which prompted a
call to Pottstown police.

FRANÇOISE HARDY

artist FRANÇOISE HARDY
title ALONE
year 1970
label REPRISE
ad ED THRASHER

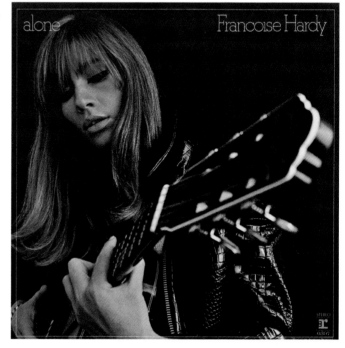

Gina Harlow
and the Cutthroats

RECORDED LIVE
AT
Max's
Kansas City

 Live On Stage

GINA HARLOW AND THE CUTTHROATS

artist GINA HARLOW AND
THE CUTTHROATS
title LIVE ON STAGE
year 1979
label CUTTHROATS
design THE CUTTHROATS
photo NAT

"The album cover photo was taken in a mirrored room in an abandoned massage parlor in Times Square. The Colony Music record store at Broadway and 49th covered their windows from floor to ceiling with empty covers, facing the street. I'm sure it helped record sales. To promote club dates, we blew the photo up to poster size and pasted them all over New York City."

Gina Harlow

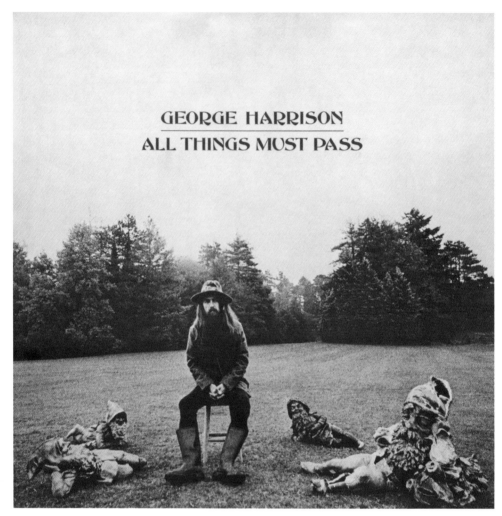

GEORGE HARRISON
ALL THINGS MUST PASS

GEORGE HARRISON

artist GEORGE HARRISON
title ALL THINGS
MUST PASS
year 1970
label APPLE
design CAMOUFLAGE
PRODUCTIONS:
TOM WILKES,
BARRY FEINSTEIN
photo BARRY FEINSTEIN

Upon the Beatles' disintegration, guitarist George Harrison emerged from the rubble to reveal a triple LP's worth of fresh and thoughtful material, much of which had been vetoed by his former bandmates. Photographer Barry Feinstein was responsible for numerous other album covers as well, among them Bob Dylan's *The Times They Are A-Changin'* and Janis Joplin's *Pearl*.

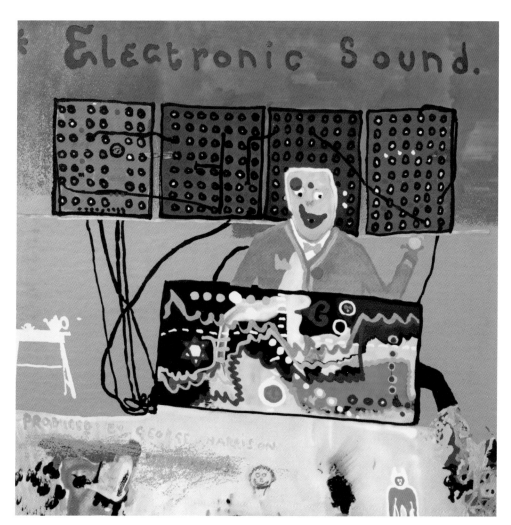

GEORGE HARRISON

artist GEORGE HARRISON
title ELECTRONIC SOUND
year 1969
label ZAPPLE
art GEORGE HARRISON

George Harrison painted this cover himself in a wonky cartoon style that complements the Moog-drenched experiments within. The single track on side 2, "No Time or Space," is the subject of some controversy, however, since Bernie Krause claimed it was taken from a session where he was showing Harrison the capabilities of the new Moog III and then taped and used on the album without his consent. The Beatles' experimental label, Zapple, was quickly discontinued after this release failed to either chart or make any money.

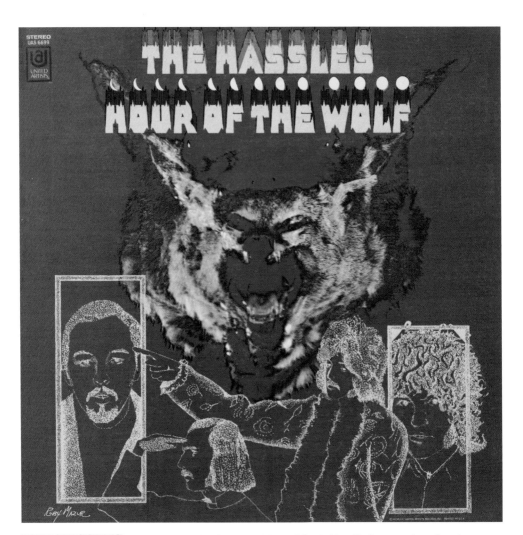

THE HASSLES

artist THE HASSLES
title HOUR OF THE WOLF
year 1968
label UNITED ARTISTS
art RUBY MAZUR

The Hassles of Long Island, New York are perhaps best known for launching the recording career of pianist and Bronx native Billy Joel. After their self-titled debut sank under the weight of underwhelming cover material, the suitably psychedelic *Hour of the Wolf* became a somewhat compelling showcase of Joel's songwriting abilities.

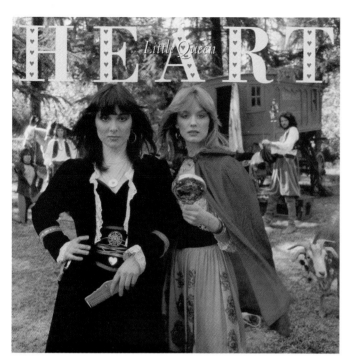

HEART

artist HEART
title LITTLE QUEEN
year 1977
label PORTRAIT
ad MIKE DOUD
design JOHN KEHE
photo BOB SEIDEMANN

Staring confidently into the camera lens, power vocalist sisters Ann and Nancy Wilson have scarcely any need for the feminine props of comb and mirror they are holding. With other members of the band in the background, camped beside a horse-drawn caravan and with everyone wearing outfits from an imagined middle ages, Bob Seidemann captured the essence of Heart, from power ballads to acoustic folk-tinged songs like this album's "Treat Me Well."

RICHARD HELL & THE VOIDOIDS

artist RICHARD HELL & THE VOIDOIDS
title BLANK GENERATION
year 1977
label SIRE
design JOHN GILLESPIE, RICHARD HELL
photo ROBERTA BAYLEY

Fill in the blank: "You Make Me ___." While Richard Hell's chest is left blank intentionally, hence the album title, you're encouraged to scribble in whatever you want. Whether that's "grateful" or "dance," both would be appropriate for the first album by this legendary punk band. His cover photo was even taken by CBGB's Roberta Bayley. It doesn't get more punk than this.

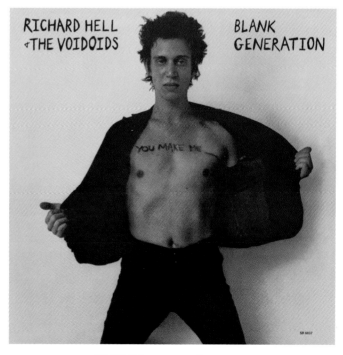

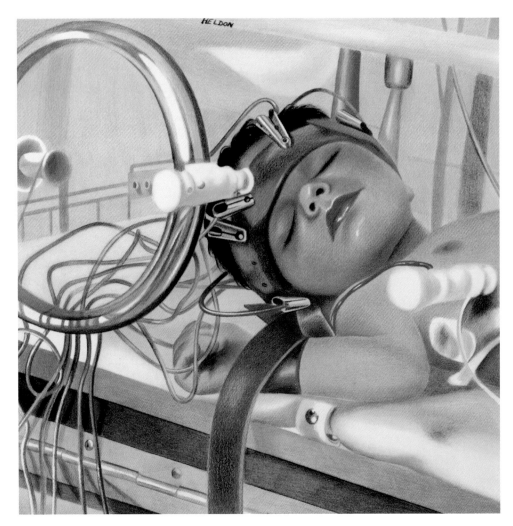

HELDON

artist HELDON
title HELDON IV/
 AGNETA NILSSON
year 1976
label URUS
art DAPHNE MOUCHOUX

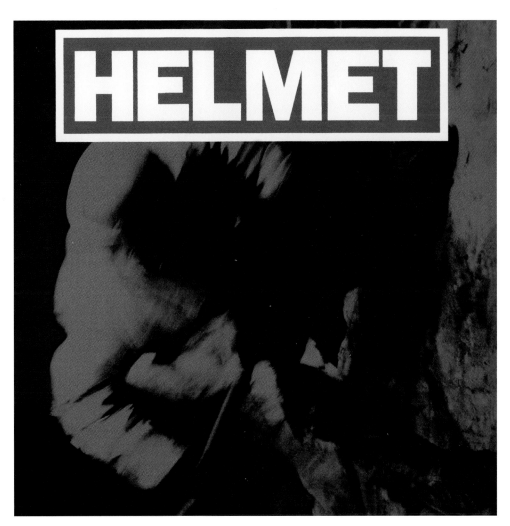

HELMET

artist HELMET
title MEANTIME
year 1992
label INTERSCOPE/
AMPHETAMINE
REPTILE
design REINER DESIGN
CONSULTANTS:
ROGER GORMAN
photo DAVID PLOWDEN

Helmet were poised to be the "next big thing" when they found themselves in a major label bidding war that ended with a million-dollar payday. Classically trained guitarist Page Hamilton led the charge with a controlled intensity on the band's sophomore LP with its stop-start onslaught that made the rock world shudder. Roger Gorman's Reiner Design Consultants had worked on some of the biggest pop and rock packages of the era, including Madonna, Aerosmith, David Bowie and Metallica. His clean design and use of David Plowden's photo, "Walker, Puddler in Blast Furnace Cast House, Steel Mill, East Chicago, Indiana" (1979), gave the album a powerful and enigmatic presence that beautifully matched the music.

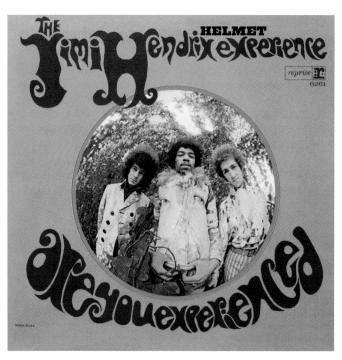

THE JIMI HENDRIX
EXPERIENCE
artist THE JIMI HENDRIX
EXPERIENCE
title ARE YOU
EXPERIENCED
year 1967
label REPRISE
ad ED THRASHER
photo KARL FERRIS

THE JIMI HENDRIX
EXPERIENCE
artist THE JIMI HENDRIX EXPERIENCE
title ELECTRIC LADYLAND
year 1968
label TRACK
design DAVID KING
photo DAVID MONTGOMERY

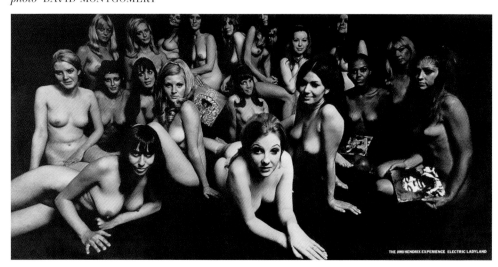

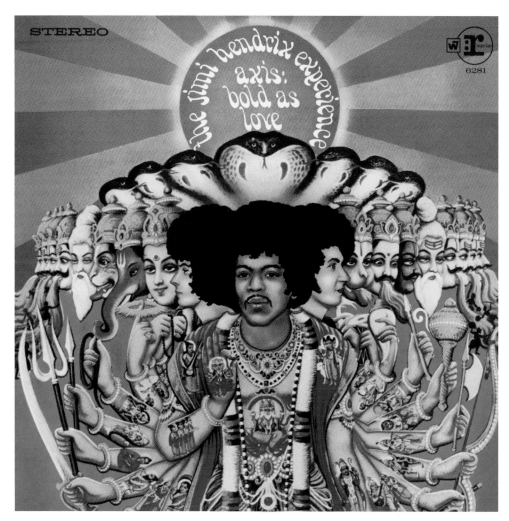

THE JIMI HENDRIX
EXPERIENCE

artist THE JIMI HENDRIX
EXPERIENCE
title AXIS: BOLD AS
LOVE
year 1967
label REPRISE
ad ED THRASHER
design DAVID KING,
ROGER LAW

This release from the Jimi Hendrix Experience was a full-tilt psychedelic experience which made notable use of recording techniques and effects, making it very much a studio album. The Indian-inspired cover was an assemblage of a small painting by Roger Law, based on a photo of the band taken by Karl Ferris and laid over a Hindu devotional poster of Viraat Purushan-Vishnuroopam.

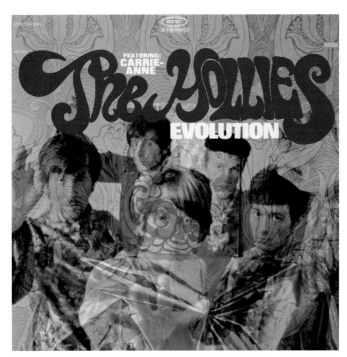

THE HOLLIES

artist THE HOLLIES
title EVOLUTION
year 1967
label EPIC
design RICH RUSSELL,
DICK SMITH
photo KARL FERRIS

No stone was left unturned in order to next-level the hell out of this album design. Before Rich Russell designed eight albums for the Meters, he lent his talents to the Hollies (as well as Sonny & Cher). *Evolution*'s photography was done by Karl Ferris (Donovan, Clapton, Hendrix) and the artwork is credited to Dutch legends The Fool Design Collective. With so many cooks in the kitchen it's a wonder the visuals fit so perfectly with the tripped-out pop sound within—but they do. In fact, many believe this to be the band's most digestible album.

ROBYN HITCHCOCK AND THE EGYPTIANS

artist ROBYN HITCHCOCK
AND THE
EGYPTIANS
title ELEMENT OF LIGHT
year 1986
label GLASS FISH
photo ROSALIND KUNATH

Sometimes your greatest creative allies can come from the most unexpected places, in this case, the sister of Robyn Hitchcock's former housemate and bandmate, Simon Kunath. Rosalind Kunath would go on to photograph Hitchcock for decades. Her elegant yet playful black & white shot for this second studio release with the Egyptians sets the tone perfectly for the album.

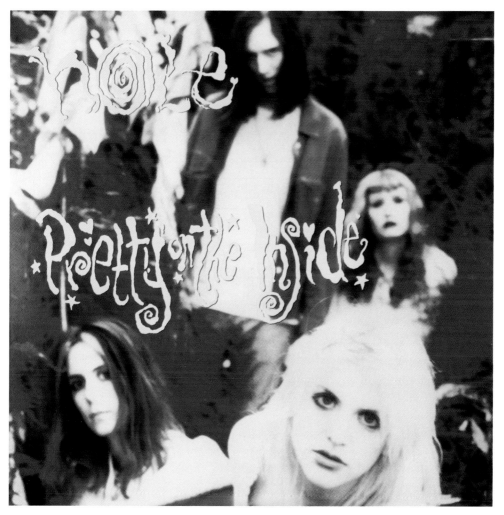

HOLE
artist HOLE
title PRETTY ON
 THE INSIDE
year 1991
label CITY SLANG
art PIZZ
photo VICKIE BERNDT

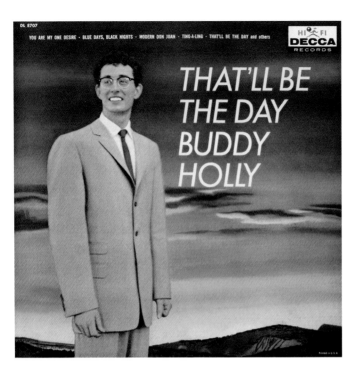

BUDDY HOLLY

artist BUDDY HOLLY
title THAT'LL BE THE
DAY
year 1958
label DECCA

The last album released before
the rock 'n' roll patriarch's
untimely death collects
the fruits of Holly's 1956
Nashville sessions, which
placed a country emphasis on
a number of the performer's
singles and included support
by famous session-men like
Grady Martin and Floyd
Cramer, as well as Crickets
bandmates Jerry Allison—who
co-authored the title track
with Holly—and Sonny Curtis,
who took over frontman duties
after Holly passed away.

THE HOLY MODAL
ROUNDERS

artist THE HOLY MODAL
ROUNDERS
title THE MORAY EELS
EAT THE HOLY
MODAL ROUNDERS
year 1969
label ELEKTRA
ad WILLIAM S.
HARVEY
art GENE SZAFRAN

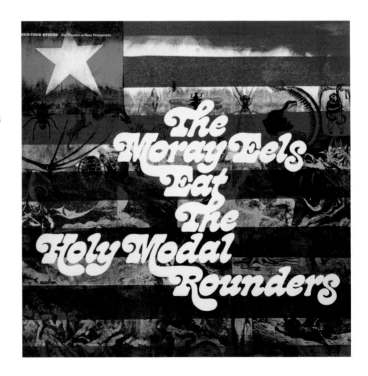

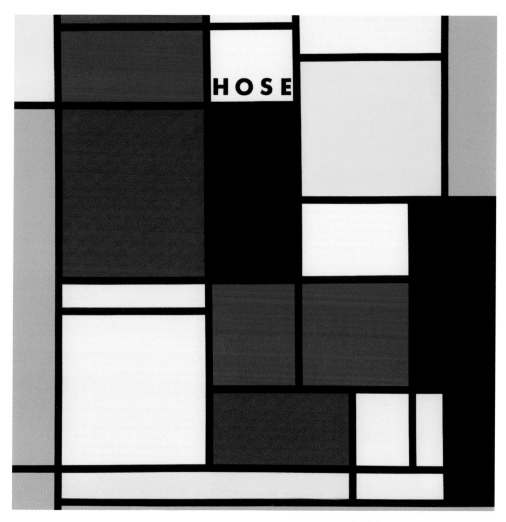

HOSE
artist HOSE
title HOSE
year 1983
label DEF JAM
RECORDINGS
art RICK RUBIN
(COVER BASED ON
PIET MONDRIAN,
TABLEAU II)
design RICK RUBIN

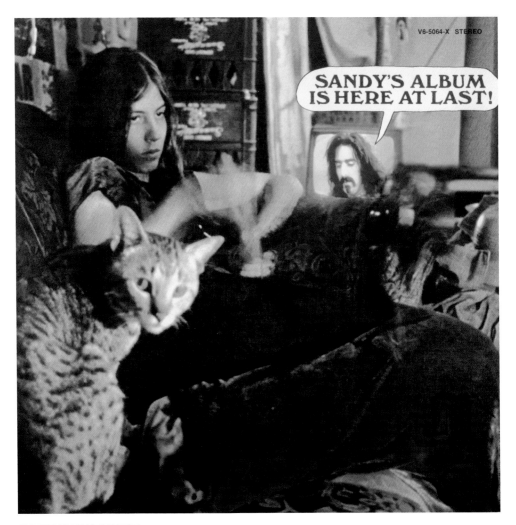

SANDY HURVITZ
artist SANDY HURVITZ
title SANDY'S ALBUM
IS HERE AT LAST!
year 1968
label VERVE
design CAL SCHENKEL
photo CAL SCHENKEL

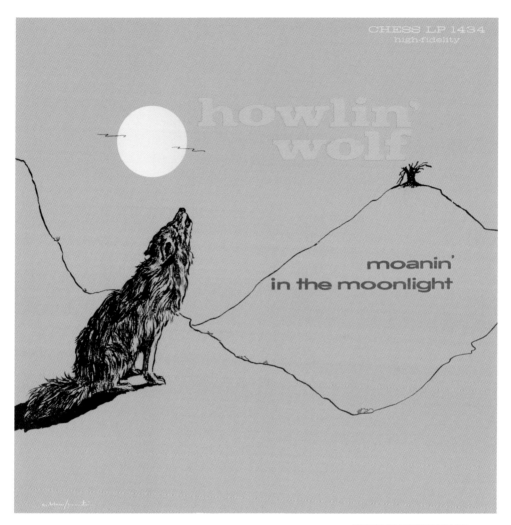

HOWLIN' WOLF

artist HOWLIN' WOLF
title MOANIN' IN THE
MOONLIGHT
year 1958
label CHESS
design DON S. BRONSTEIN

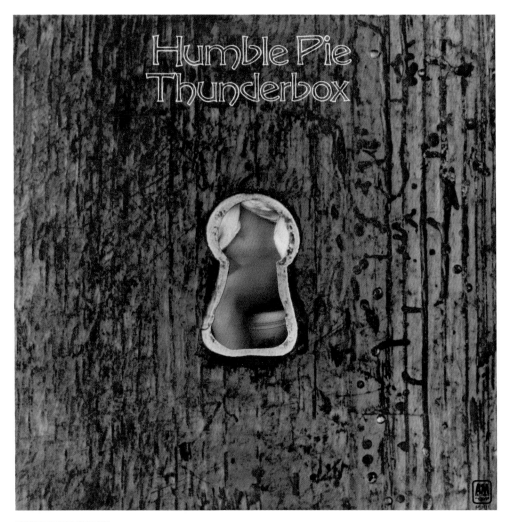

HUMBLE PIE

artist HUMBLE PIE
title THUNDERBOX
year 1974
label A&M
art COLIN ELGIE
design HIPGNOSIS
photo HIPGNOSIS

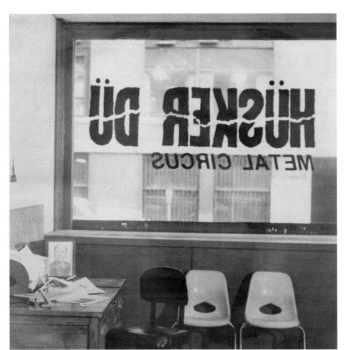

HÜSKER DÜ

artist HÜSKER DÜ
title METAL CIRCUS
year 1983
label SST
design FAKE NAME
GRAPHX

"It was St. Patrick's Day, 1983. The reason I remember that is because we shot two rolls of two-and-a-quarter, but in all but a few shots, somebody with one of those green plastic trumpets that was popular back then would march by—on their way to Robbins Street in St. Paul—all geared up and drunk for the St. Patrick's Day parade."

Grant Hart

CLARK-HUTCHINSON

artist CLARK-
HUTCHINSON
title $\Lambda=MH^2$
year 1969
label SIRE
photo DAVID WEDGBURY

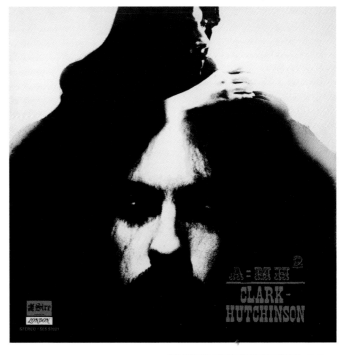

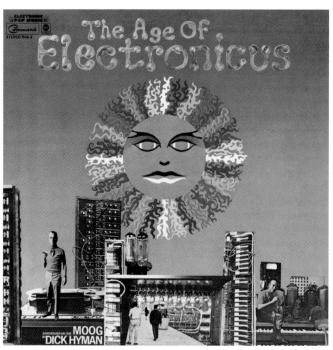

DICK HYMAN

artist DICK HYMAN
title THE AGE OF
ELECTRONICUS
year 1969
label COMMAND
design BYRON GOTO,
HENRY EPSTEIN
photo ROGER POLA,
ERIC GOTO

Born in Hawaii in 1919, Byron Goto studied under French artist Fernand Léger in pursuit of a MFA from the Art Institute of Chicago. Upon graduating, he identified most with Abstract Expressionism practitioners de Kooning and Pollock. Goto spent 17 years as an art director at ABC, whose Command subsidiary released this switched-on collection of rock and R&B hits in 1969.

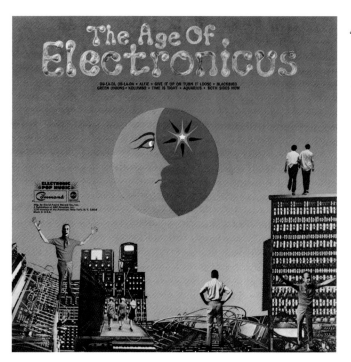

"*That was an interesting cover. My dad was the designer. I was sent to photograph the Moog synthesizer (Robert Moog set up the synthesizer for me to shoot). I painted the sun and moon and my dad did the collage and the lettering—one of our closest collaborations. We worked together at ABC for about six years, from the late '60s to the early '70s. We worked on a lot of album covers together: James Gang, Soft Machine, but also a lot of jazz and classical.*"

Eric Goto

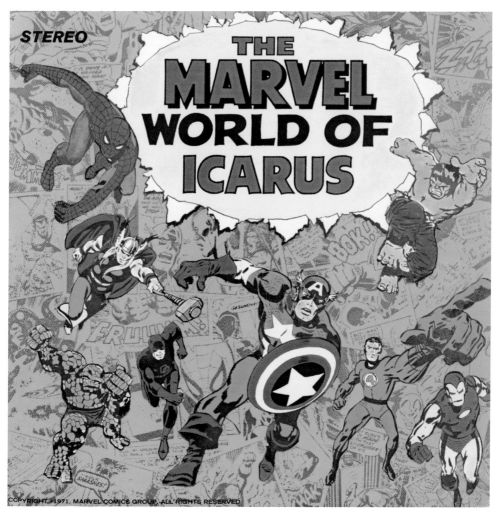

ICARUS
artist ICARUS
title THE MARVEL
WORLD OF ICARUS
year 1972
label PYE
INTERNATIONAL

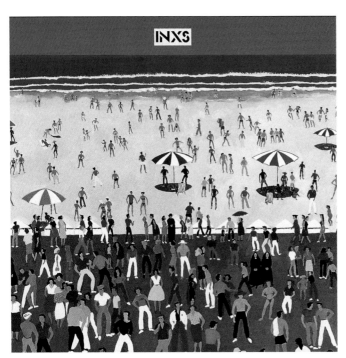

INXS

artist INXS
title INXS
year 1980
label DELUXE
art GECKO GRAPHICS
(AFTER NOEL
COWARD)

This self-titled debut with
elements of ska and new wave
put the band on the Australian
chart map. However, the road
to international fame would
prove to be a long and steady
one for this working band
who started off on the pub
circuit in Western Australia.
Featuring three siblings, the
Farriss brothers—Andrew,
Jon and Tim—the addition
of Michael Hutchence as
photogenic frontman spurred
on their ascendancy. In 1997
Hutchence was found dead
in an apparent suicide in a
Sydney hotel room.

IMPLOG

artist IMPLOG
title HOLLAND TUNNEL
DIVE
year 1980
label INFIDELITY
design STATIC KLING

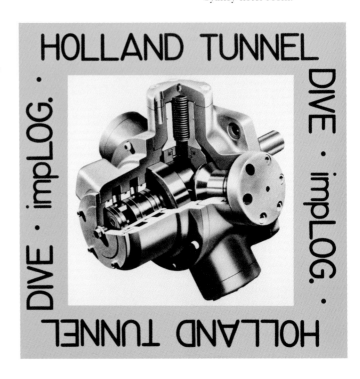

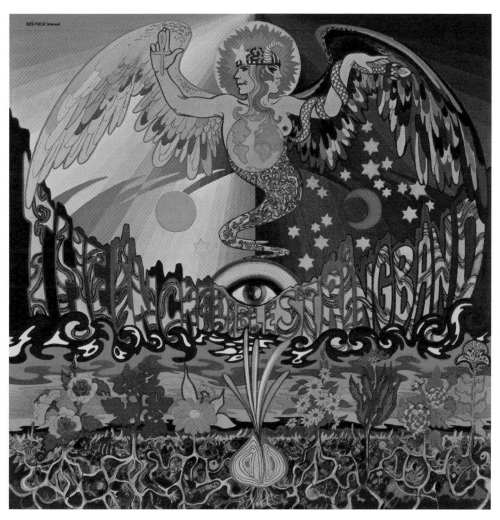

THE INCREDIBLE
STRING BAND

artist THE INCREDIBLE
STRING BAND
title THE 5000 SPIRITS
OR THE LAYERS OF
THE ONION
year 1967
label ELEKTRA
art THE FOOL:
SIMON POSTHUMA,
MARIJKE KOGER

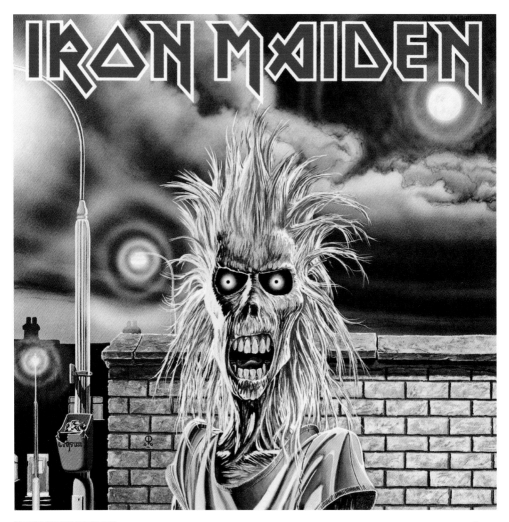

IRON MAIDEN

artist IRON MAIDEN
title IRON MAIDEN
year 1980
label EMI
art DEREK RIGGS
design CREAM

With a serious nod of the head to Judas Priest, Iron Maiden's debut was a cornerstone of the new wave of British heavy metal. By fusing punk rock's energy with prog's intricate changes the band unleashed a high-octane fracas of metal bangers. Derek Riggs originally painted "Electric Matthew Says Hello" with a punk cover in mind until Iron Maiden's management asked him to add some hair and in this way the band's mascot, Eddie, was born. The demented creature was a perfect visual representation of the band's sound—tough, spooky and highly detailed.

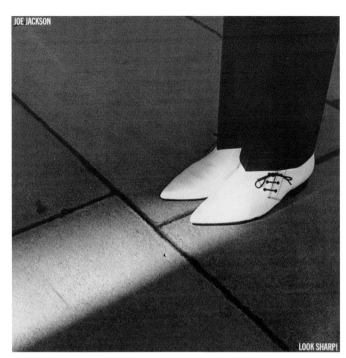

JOE JACKSON

artist JOE JACKSON
title LOOK SHARP!
year 1979
label A&M
ad MICHAEL ROSS
photo BRIAN GRIFFIN

Those aren't just shoes—they're white, Denson winklepickers. A 31-year-old, flat-broke photographer named Brian Griffin caught this iconic image which *Rolling Stone* named one of the top 100 album covers of ALL TIME. This album with its beloved "Is She Really Going Out With Him?" would go on to be very successful, as too would Griffin, his talent being most recently used by the National Portrait Gallery during the 2012 London Olympics.

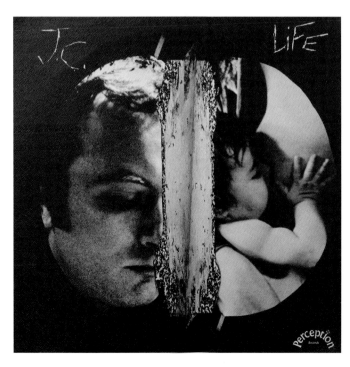

J.C.

artist J.C.
title LIFE
year 1969
label PERCEPTION
design J.C.
photo ULRICH BOEGE
(WOMAN AND
CHILD), RAY JACOBS
(FACE)

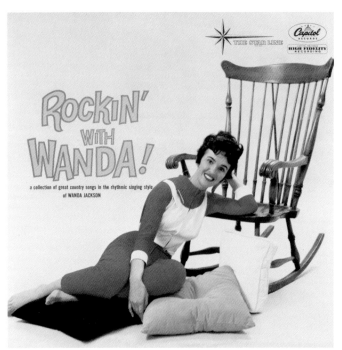

WANDA JACKSON

artist WANDA JACKSON
title ROCKIN' WITH
 WANDA
year 1962
label STARLINE/CAPITOL

Encouraged by Elvis to sing
rockabilly, Wanda Jackson
gained popularity in the '50s
and '60s for her blend of
country and up-tempo rock
'n' roll. The singer is often
credited with being the first
woman ever to release a
rock 'n' roll record. Armed
with a hard-headed attitude,
confident vocal delivery and
raunchy lyrics, Jackson
thwarted the stereotype of
female singers of the era by
becoming widely known as
the Queen of Rockabilly.

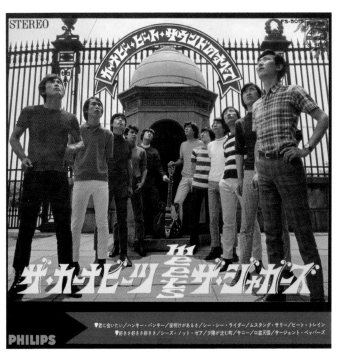

THE JAGUARS VS.
THE CARNABEATS

artist THE JAGUARS VS.
 THE CARNABEATS
title CARNABEATS
 MEETS JAGUARS
year 1967
label PHILIPS

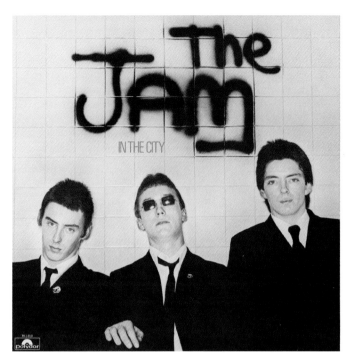

THE JAM

artist THE JAM
title IN THE CITY
year 1977
label POLYDOR
art WADEWOOD
 ASSOCIATES
design BILL SMITH
photo MARTYN GODDARD

Martyn Goddard's stark black and white photo on the cover sums up the group on their debut quite nicely. Frontman Paul Weller was a child of the Northern Soul scene and '60s Mod bands like the Who and the Kinks. Add in a dash of the new punk attitude sweeping through London and you get much more than a breakfast condiment—you get one of the key albums of the punk era.

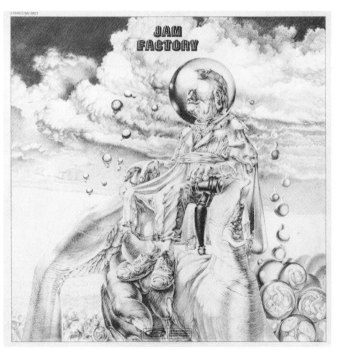

JAM FACTORY

artist JAM FACTORY
title SITTIN' IN THE
 TRAP
year 1970
label EPIC
art JULIO SAN JOSE

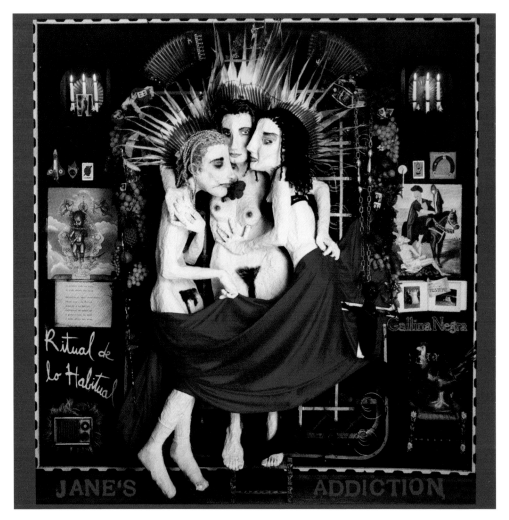

JANE'S ADDICTION

artist JANE'S ADDICTION
title RITUAL DE LO
HABITUAL
year 1990
label WARNER BROS.
ad KIM CHAMPAGNE,
TOM RECCHION
design PERRY FARRELL, CASEY
NICCOLI (SCULPTURE)

Sculpted by frontman Perry Farrell and girlfriend Casey Niccoli, this evocative cover is in homage to Xiola Blue, a former girlfriend of Farrell's who overdosed in 1987. To the band's chagrin, *Ritual de lo Habitual* was released with a variant cover bearing only the band's name, album title, and the First Amendment in an attempt by Warner Bros. to quell the concerns of uneasy retailers.

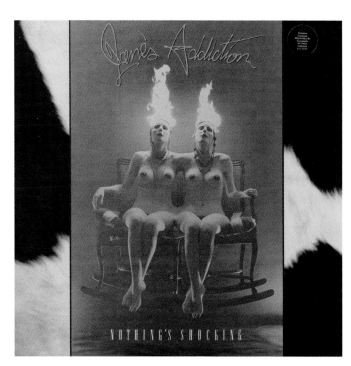

JANE'S ADDICTION

artist JANE'S ADDICTION
title NOTHING'S
SHOCKING
year 1988
label WARNER BROS.
design PERRY FARRELL,
CASEY NICCOLI
photo PERRY FARRELL,
CASEY NICCOLI

JETHRO TULL

artist JETHRO TULL
title AQUALUNG
year 1971
label REPRISE
art BURTON
SILVERMAN

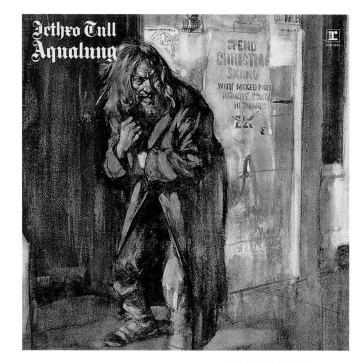

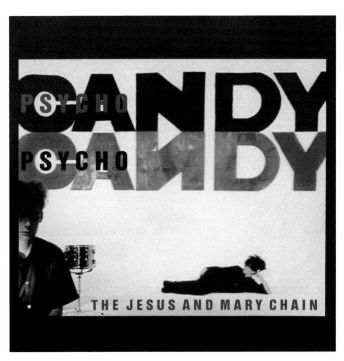

THE JESUS AND MARY CHAIN

artist THE JESUS AND MARY CHAIN
title PSYCHOCANDY
year 1985
label BLANCO Y NEGRO
ad GREG ALLEN
photo ALASTAIR INDGE,BLEDDYN BUTCHER, CHRIS CLUNN, MIKE LAYE, RONA MCINTOSH, STUART CASSIDY

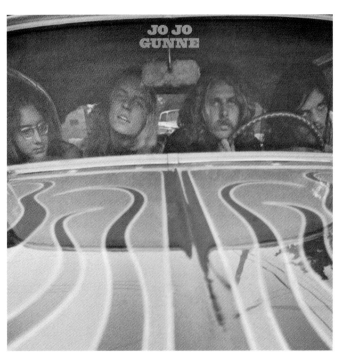

JO JO GUNNE

artist JO JO GUNNE
title JO JO GUNNE
year 1972
label ASYLUM
design CAMOUFLAGE PRODUCTIONS: BARRY FEINSTEIN, TOM WILKES
photo BARRY FEINSTEIN, TOM WILKES

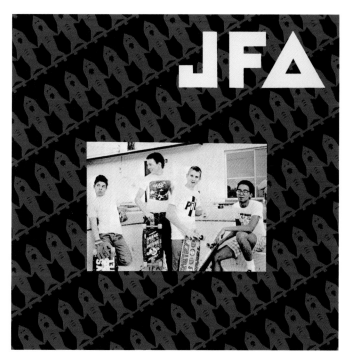

JFA

artist JFA
title VALLEY OF
THE YAKES
year 1983
label PLACEBO
art DAWN KELLY
photo RENÉ PRONK

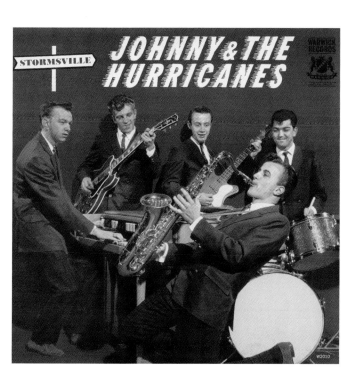

**JOHNNY & THE
HURRICANES**

artist JOHNNY & THE
HURRICANES
title STORMSVILLE
year 1960
label WARWICK

JOY DIVISION

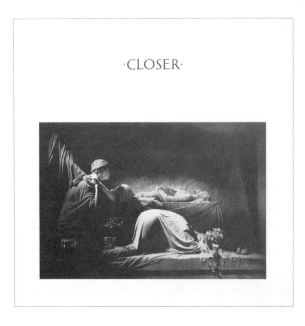

artist JOY DIVISION
title CLOSER
year 1980
label FACTORY
design PETER SAVILLE,
MARTYN ATKINS
photo BERNARD-PIERRE
WOLFF

Manufactured as the news
of lead singer Ian Curtis's
suicide came out, the cover
for *Closer* took on an eerie
significance with the graphic
foreshadowing proving
unsettling to many fans.
Bernard-Pierre Wolff's stark
photo from the crypt of the
Staglieno Cemetery in Genoa
served as a dark signifier of
the tragic loss.

JUDAS JUMP

artist JUDAS JUMP
title SCORCH
year 1970
label MGM/PRIDE
design STEVEN THOMAS

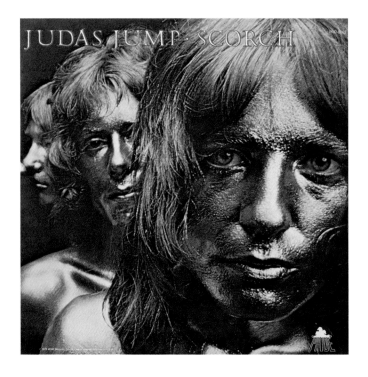

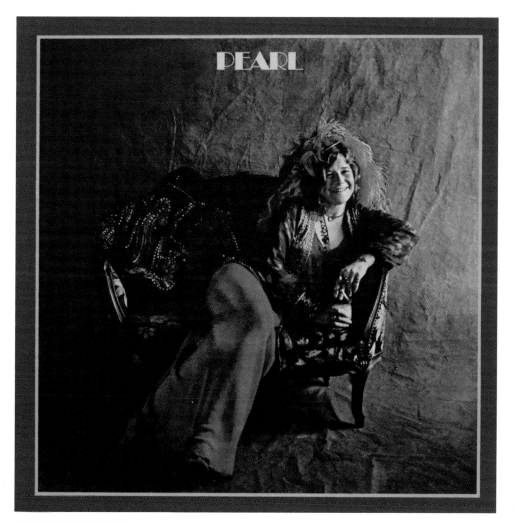

PEARL

JANIS JOPLIN & THE FULL TILT BOOGIE BAND

Artist JANIS JOPLIN &
 THE FULL TILT
 BOOGIE BAND
title PEARL
year 1971
label COLUMBIA
design CAMOUFLAGE
 PRODUCTIONS:
 BARRY FEINSTEIN,
 TOM WILKES
photo BARRY FEINSTEIN,
 TOM WILKES

Rock master-photographer Barry Feinstein caught a relaxed and seemingly happy Joplin lounging in a love seat, resplendent in multicolored feather boa with drink and cigarette in hand. The next day the 27-year-old singer was found dead of a heroin overdose in her Hollywood hotel room. Joplin's hypnotic and soulful voice established her as a defining sound of the psychedelic rock era, most notably through her legendary live appearances at the Monterey Pop Festival and Woodstock. Following her rise to prominence as lead vocalist of Big Brother and the Holding Company, Joplin went on to develop her craft as a solo artist backed by the Kozmic Blues Band and finally the Full Tilt Boogie Band.

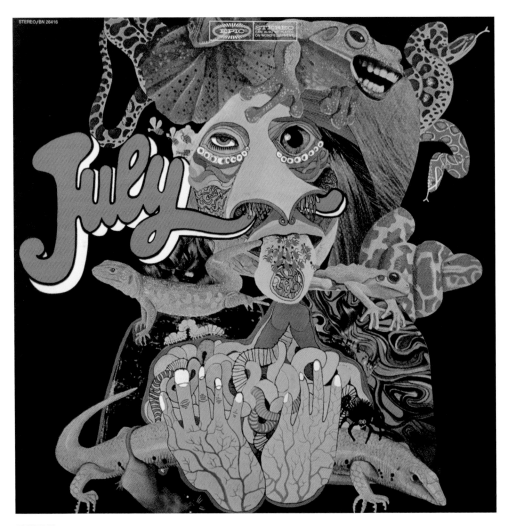

JULY
artist JULY
title JULY
year 1968
label EPIC
design STEPHEN HILL

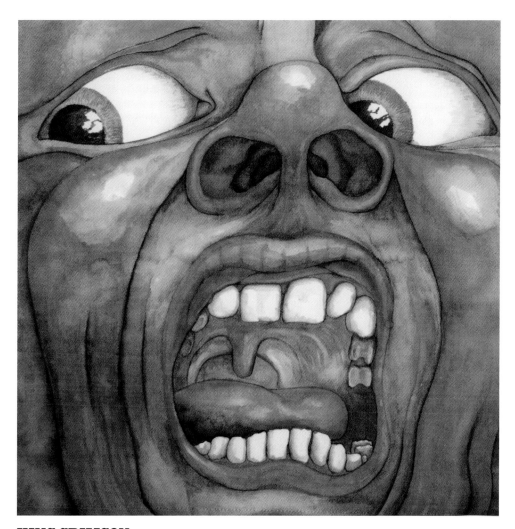

KING CRIMSON

artist KING CRIMSON
title IN THE COURT OF
THE CRIMSON KING
year 1969
label ISLAND
art BARRY GODBER

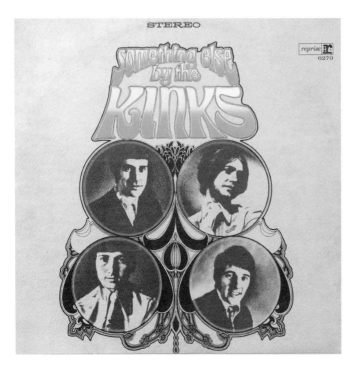

THE KINKS

artist THE KINKS
title SOMETHING ELSE
BY THE KINKS
year 1967/1976
label PYE/REPRISE
design PYE
photo MARIO HALLHUBER

This album marked the fifth, but not the last time Mario Hallhuber would be credited for capturing the Kinks at their best. In the March 9, 1968 edition of *Rolling Stone*, writer James Pomeroy noted that *Something Else by the Kinks* "is the best album the Kinks have yet made, but, paradoxically, may be the last they will release in this country." Luckily for us, Pomeroy ate his words just eight months later when the band released *The Village Green Preservation Society*, which also credited Hallhuber, for the final time, as photographer.

KISS

artist KISS
title KISS
year 1974
label CASABLANCA
design ROCK STEADY
(CONCEPT),
LOCKART
photo JOEL BRODSKY

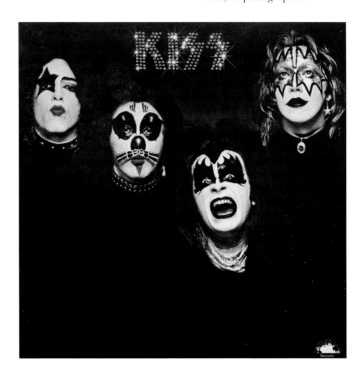

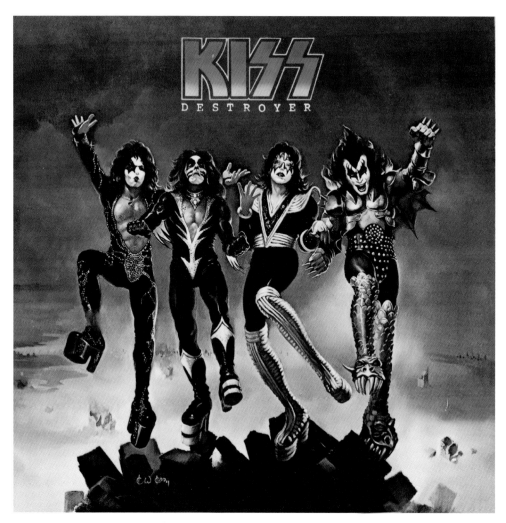

KISS
artist KISS
title DESTROYER
year 1976
label CASABLANCA
art KEN KELLY

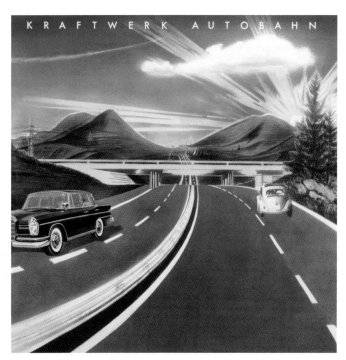

KRAFTWERK

artist KRAFTWERK
title AUTOBAHN
year 1974
label PHILIPS/VERTIGO
art EMIL SCHULT

"*Bowie used to tell everyone that we were his favorite group, and in the mid-'70s the rock press used to hang on every word from his mouth. We met him when he played in Düsseldorf on one of his first European tours. He was traveling by Mercedes, listening to nothing but* Autobahn *all the time.*" – Ralf Hütter

KRAFTWERK

artist KRAFTWERK
title RALF & FLORIAN
year 1973
label PHILIPS/VERTIGO
ad RALF HÜTTER,
FLORIAN
SCHNEIDER
photo ROBERT FRANCK

KRAUT

artist KRAUT
title AN ADJUSTMENT
 TO SOCIETY
year 1982
label CABBAGE
ad DON COWAN
photo J. RABID, TOM
 MARCELLINO

L7

artist L7
title L7
year 1988
label EPITAPH
design N. TODD SKILES,
 SUZY BEAL
photo AL FLIPSIDE

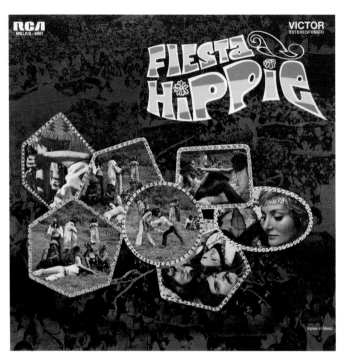

LA FRESA ACIDA/
EL KLAN

artist LA FRESA ACIDA/
 EL KLAN
title FIESTA HIPPIE
year 1969
label RCA VICTOR

LAIBACH

artist LAIBACH
title LET IT BE
year 1988
label MUTE
art IRWIN
design NEW COLLECTIVISM
 STUDIO, SLIM
 SMITH

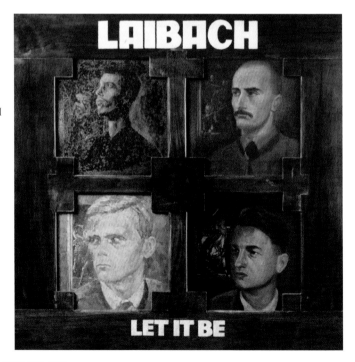

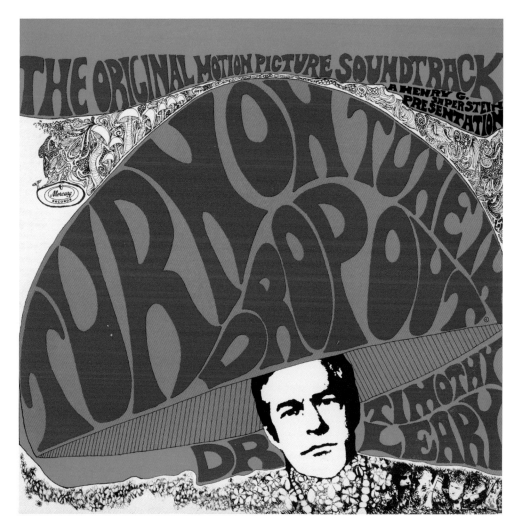

DR. TIMOTHY LEARY

artist DR. TIMOTHY LEARY
title TURN ON, TUNE IN, DROP OUT (OST)
year 1967
label MERCURY
design UPA PICTURES INC.

"Few controversies have waxed so furiously in this country as that caused by Dr. Timothy Leary and his espousal of the drug L.S.D. Millions of people have heard about Dr. Leary, but only a few have had the opportunity to hear and see him on his lecture tours throughout the US. The Psychedelic Celebration, 'Turn On, Tune In, Drop Out', provides a wider audience with the chance to witness this strange new L.S.D. Cult."

S. Richard Krown

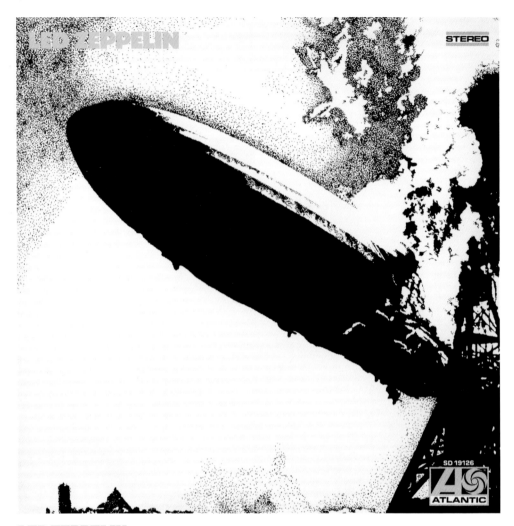

LED ZEPPELIN

artist LED ZEPPELIN
title LED ZEPPELIN
year 1969
label ATLANTIC
design GEORGE HARDIE

"... the image was famous not for my creativity but because I dot-stippled an iconic photograph to avoid copyright and because my client later became world famous. It was not even the best phallic image I made in my second year at the RCA."

George Hardie

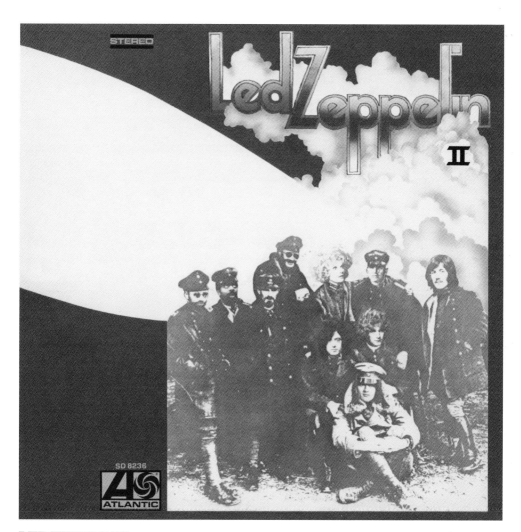

LED ZEPPELIN

artist LED ZEPPELIN
title LED ZEPPELIN II
year 1969
label ATLANTIC
art DAVID JUNIPER
design DAVID JUNIPER

The cover image of *Led Zeppelin II* may not be as bombastic as the one the group used for their debut but artist David Juniper balanced the sense of hugeness in the band's sound (as well as popularity) with a delicate mist of nostalgia and wry psychedelic newness for the follow-up. He did this by abstracting the Zeppelin shape the band had become associated with into a ghostly specter that is so large it has to wrap around to the back cover, and juxtaposing it with a sepia-tinted photo of the Red Baron's team, the Flying Circus, whose faces have been replaced with those of the band and a few notables including Miles Davis (or Blind Willie Johnson?), Mary Woronov (muse to Andy Warhol) and Neil Armstrong. Juniper's graphic ingenuity was rewarded when the cover was nominated for the '69 Grammy Awards and is remembered as one of the most iconic rock covers in history.

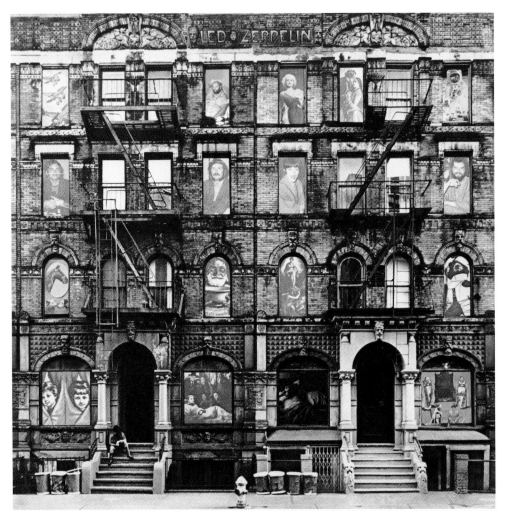

LED ZEPPELIN

artist LED ZEPPELIN
title PHYSICAL GRAFFITI
year 1975
label SWAN SONG
art DAVE HEFFERNAN
design AGI/MIKE DOUD,
PETER CORRISTON,
MAURICE TATE
photo ELLIOT ERWITT,
B.P. FALLON, ROY
HARPER

Corriston and Doud's Grammy-nominated album art was a crowning achievement as epic as the band's double album here. The outer sleeve, depicting a pair of tenement buildings at 96 and 98 St. Mark's Place in New York with die-cut holes over the windows, would be filled in by various images when lined up with the inner sleeves, including Robert Plant in a dress.

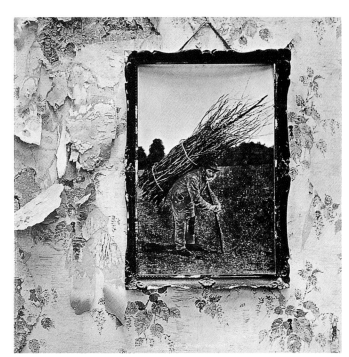

LED ZEPPELIN

artist LED ZEPPELIN
title HOUSES OF
 THE HOLY
year 1973
label ATLANTIC
design HIPGNOSIS
photo AUBREY POWELL

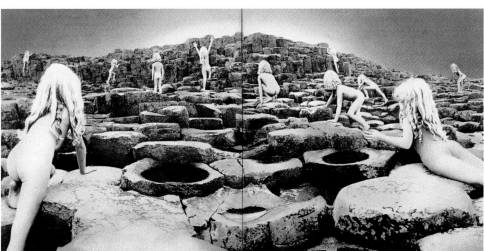

With *Houses of the Holy* representing a key period in Led Zep's artistic development, involving original songs only and a greater emphasis on production, this cover with its nod to the finale of Arthur C. Clarke's 1953 novel, *Childhood's End*, presents a suitably otherworldly image. It was built up from a series of photographs taken at the Giant's Causeway, a natural rock formation in Northern Ireland, by Aubrey Powell of design outfit Hipgnosis. Though controversial upon its release, the cover remains a superb example of artistry using pre-digital multi-printing techniques.

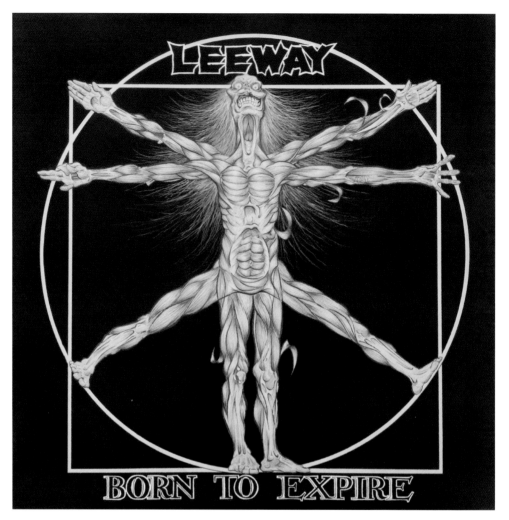

LEEWAY

artist LEEWAY
title BORN TO EXPIRE
year 1989
label PROFILE
art BEVIN STONE
design BEVIN STONE

LEHAKAT TSLILEY HAUD

artist LEHAKAT
TSLILEY HAUD
title LEHAKAT
TSLILEY HAUD
year 1973
label KOLIPHONE

JOHN LENNON AND YOKO ONO

artist JOHN LENNON
AND YOKO ONO
title UNFINISHED MUSIC
NO. 2: LIFE WITH
THE LIONS
year 1969
label ZAPPLE
design JOHN LENNON,
YOKO ONO
photo SUSAN WOOD

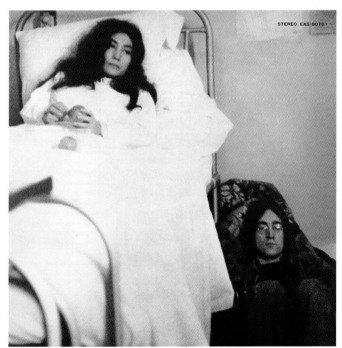

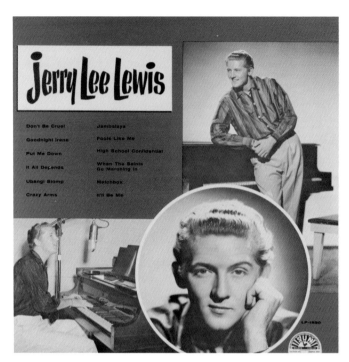

JERRY LEE LEWIS

artist JERRY LEE LEWIS
title JERRY LEE LEWIS
year 1958
label SUN

LEVITICUS

artist LEVITICUS
title THE STRONGEST
POWER
year 1985
label TWILIGHT
design TONY BERGLUND
(POSITIVE DESIGN)

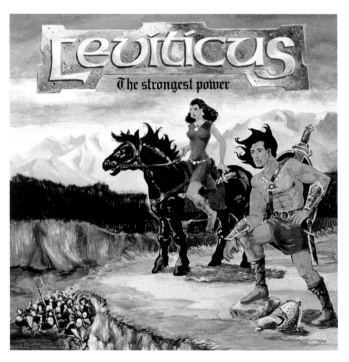

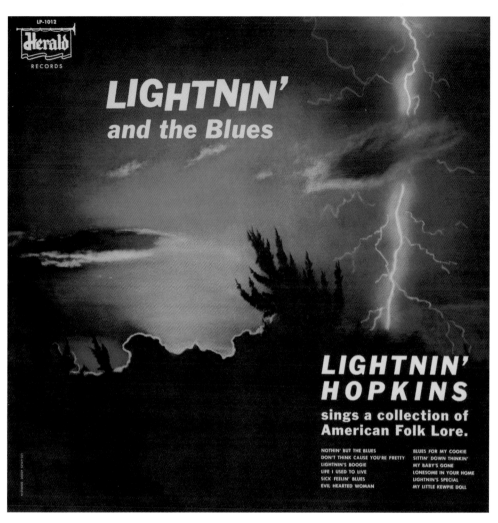

**LIGHTNIN'
HOPKINS**

artist LIGHTNIN' HOPKINS
title LIGHTNIN' AND
THE BLUES
year 1955
label HERALD
design LEE-MYLES
ASSOCIATES

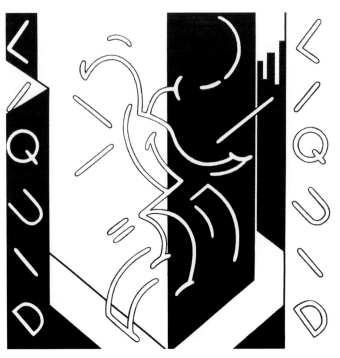

LIQUID LIQUID

artist LIQUID LIQUID
title LIQUID LIQUID
year 1981
label 99 RECORDS
art RICHARD MCGUIRE
design RICHARD MCGUIRE

THE LITTLE BOY BLUES

artist THE LITTLE BOY BLUES
title IN THE WOODLAND OF WEIR
year 1968
label FONTANA
photo RAY KOMORSKI

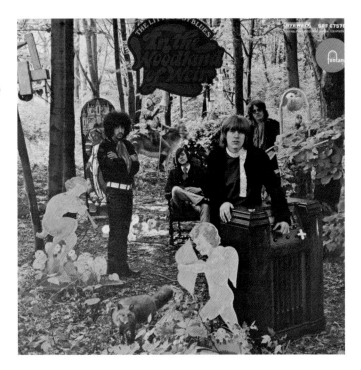

LOS SOLITARIOS
artist LOS SOLITARIOS
title LOS SOLITARIOS
year 1966
label RCA

LOS ARAGÓN

artist LOS ARAGÓN
title LA NUEVA ONDA
DE LOS ARAGÓN
VOL. 17
year 1969
label MUSART

Named after Cuba's legendary Orquesta Aragón, Los Aragón
formed in Mexico City in the early '60s. A departure from the
big bands prevalent in Mexican music at that time, Los Aragón's
economic roster cross-pollinated surf, garage, psych and funk
imports with indigenous flavors of cumbia and boogaloo. Source
material on Volume 17 ranges wildly from the Chordettes' "Mr.
Sandman" to the Meters' "Cissy Strut."

THE LOADING ZONE

artist THE LOADING ZONE
title THE LOADING
ZONE...
year 1968
label RCA VICTOR
design DANA JOHNSON
photo MIKE

LOVE

artist LOVE
title FOREVER CHANGES
year 1967
label ELEKTRA
art BOB PEPPER
design WILLIAM S.
HARVEY

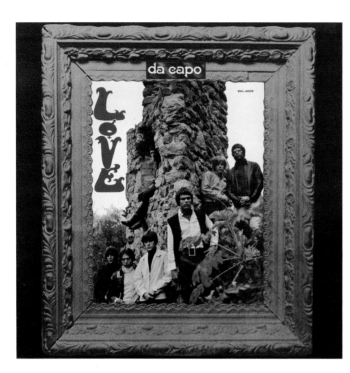

LOVE

artist LOVE
title DA CAPO
year 1967
label ELEKTRA
design WILLIAM S. HARVEY
photo WILLIAM S. HARVEY

The image of Love's spiritual leader Arthur Lee—perched above his bandmates in Laurel Canyon, supposedly exhaling smoke from a joint—set the tone for the L.A. band's second album. Elektra's art director William S. Harvey utilized the same burnt-out brick structure for the sophomore release that appeared on their self-titled debut the year before.

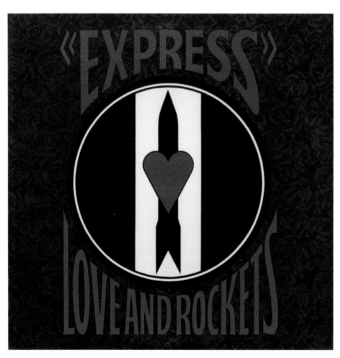

LOVE AND ROCKETS

artist LOVE AND ROCKETS
title EXPRESS
year 1986
label BEGGARS
 BANQUET/BIG TIME
design LOVE AND ROCKETS
photo MITCH JENKINS

A prescient nod to the American alternative music scene to come, and a distinct break from the sound of Bauhaus where the trio had previously worked together, the LP jacket's flip side shows the photographic talents of frequent Love and Rockets artistic collaborator Mitch Jenkins, while the band's iconic logo treatment which first appeared on the "Ball of Confusion" single appears on the front.

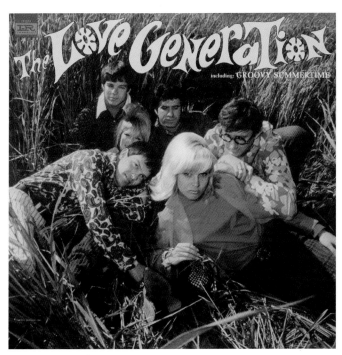

THE LOVE GENERATION

artist THE LOVE GENERATION
title THE LOVE GENERATION
year 1967
label IMPERIAL
ad WOODY WOODWARD
design ANDREW C. RODRIGUEZ
photo IVAN NAGY

This short-lived studio vocal group forged minor commercial success with three albums of cheery pop harmonies with a psychedelic twist, with this self-titled debut release featuring the minor hit "Groovy Summertime." After disbanding, siblings and founder members John and Tom Bahler went on to provide backing vocals for the long-running '70s US sitcom *The Partridge Family*.

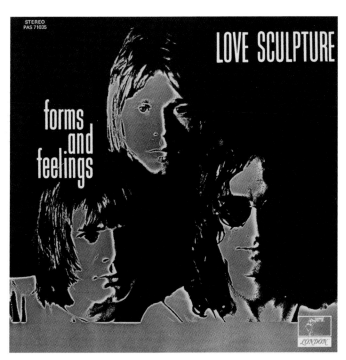

LOVE SCULPTURE

artist LOVE SCULPTURE
title FORMS AND FEELINGS
year 1970
label PARROT
design JOHN THORNE
photo JOHN THORNE

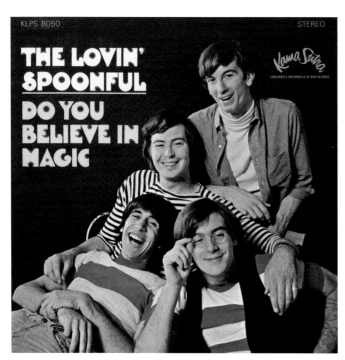

THE LOVIN' SPOONFUL

artist THE LOVIN' SPOONFUL
title DO YOU BELIEVE IN MAGIC
year 1965
label KAMA SUTRA
design JOEL TANNER
photo CHARLES STEWART

The Lovin' Spoonful's leader, John Sebastian, had come up playing guitar and harmonica in New York's Greenwich Village as part of the burgeoning folk rock scene. His signature laid-back style was epitomized on the title track of the group's debut, *Do You Believe in Magic*, while the band's fun-loving, easy-going attitude was captured on the cover which was shot by famed jazz & R&B photographer Chuck Stewart.

LUCIFER

artist LUCIFER
title BLACK MASS
year 1971
label MCA
design VIRGINIA CLARK

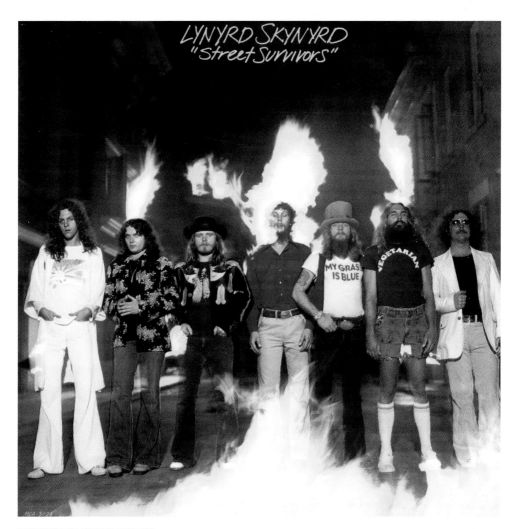

LYNYRD SKYNYRD

artist LYNYRD SKYNYRD
title STREET SURVIVORS
year 1977
label MCA
ad GEORGE OSAKI
photo DAVID ALEXANDER

Only three days after this album was released in October 1977, a plane crash effectively halted Lynyrd Skynyrd's journey to megastardom. The band was traveling between venues in the course of a tour where they were the headline act, and among the dead were band members Ronnie Van Zant along with the group's new talent, singer-guitarist Steve Gaines, as well as other members of their entourage. The original cover photo, showing the band engulfed in flames, was immediately replaced by a group portrait against a plain black background.

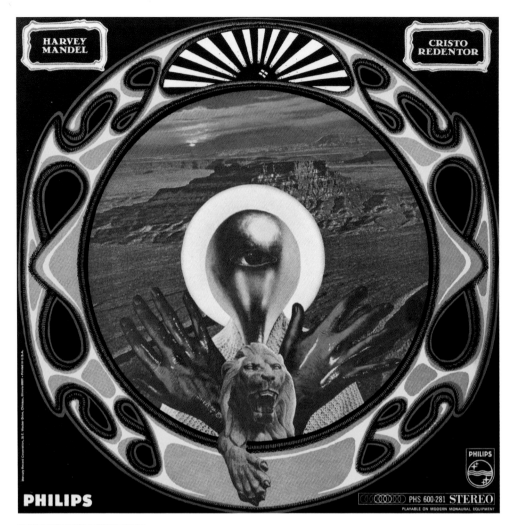

HARVEY MANDEL

artist HARVEY MANDEL
title CRISTO REDENTOR
year 1968
label PHILIPS
design ALTON KELLEY

Harvey Mandel was a guitarist with a pioneering style whose debut LP was full of feedback-edged solos, swelling orchestrations and mean drumming by Kenny Buttery and "Fast" Eddie Hoh as well as Armando Peraza on congas. Famed psychedelic record-sleeve and poster designer Alton Kelley supplied this appropriately warm and mysterious cover design. Kelley and his life-long collaborator Stanley Mouse were the go-to team in the late '60s and early '70s; their posters for San Francisco promoter Bill Graham were some of the most enduring images to come out of the hippie era and they created many memorable images for the Grateful Dead, Journey, Steve Miller, Jimi Hendrix, the Beatles and others.

MADNESS

artist MADNESS
title ONE STEP BEYOND...
year 1979
label STIFF
design EDDIE, JULES, STIFF
photo CAMERON MCVEY

For a man best known for producing albums by Neneh Cherry, Massive Attack, All Saints, and other groups, Cameron McVey takes a pretty mean photograph. The image used for the single edition of the title track, "One Step Beyond," was taken by McVey and then repurposed in black and white for the album cover. Though Chas Smash isn't in the group photo (he hadn't fully joined the band at the time the album was put out), he is shown dancing on the back cover, photographed by Chris Gabrin, who was working for Stiff Records at the time.

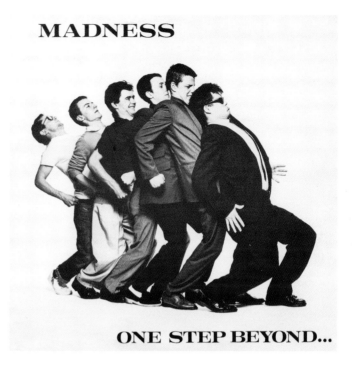

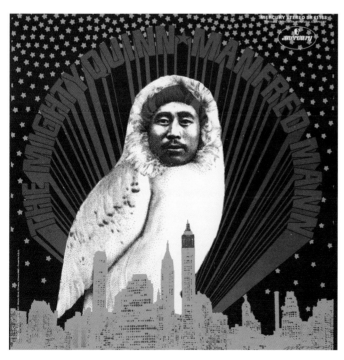

MANFRED MANN

artist MANFRED MANN
title THE MIGHTY QUINN
year 1967
label MERCURY
art VICTOR MOSCOSO
design VICTOR MOSCOSO

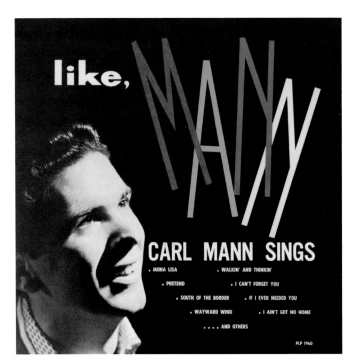

CARL MANN

artist CARL MANN
title LIKE, MANN
year 1960
label PHILLIPS
INTERNATIONAL

MARILYN MANSON

artist MARILYN MANSON
title MECHANICAL
ANIMALS
year 1998
label NOTHING
design PAUL R. BROWN
FOR BAU-DA DESIGN
LAB
photo JOSEPH CULTICE

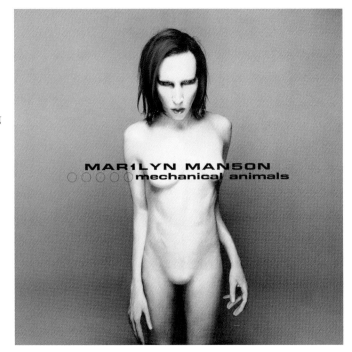

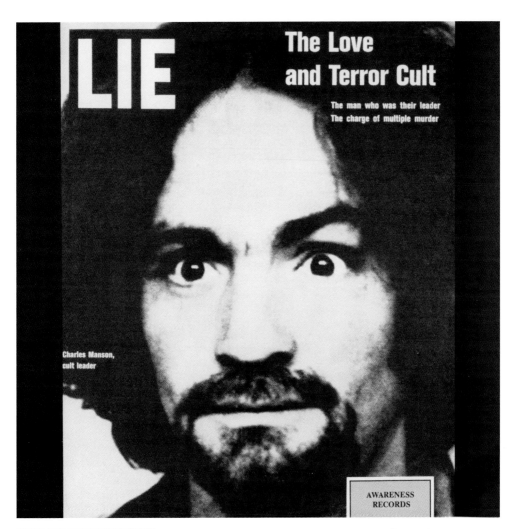

Charles Manson,
cult leader

LIE

The Love
and Terror Cult

The man who was their leader
The charge of multiple murder

AWARENESS
RECORDS

CHARLES MANSON

artist CHARLES MANSON
title LIE: THE LOVE AND
TERROR CULT
year 1970
label AWARENESS

In 1969 Charles Manson gained infamy after orchestrating a series of brutal killings carried out by a group of his cult followers known as the Family. The victims included film director Roman Polanski's wife and actress Sharon Tate. Prior to the killing spree the serial convict had aspirations of becoming a folk singer-songwriter, and a chance encounter with Dennis Wilson of the Beach Boys provided Manson with some minor connections in the LA music scene. Although a commercial flop, this album has retained cult status owing to the artist's notoriety in pop culture, and songs from it have been covered by such rock descendants as Guns N' Roses and Marilyn Manson. The sleeve design is a tongue-in-cheek mock-up of a cover feature from *LIFE* magazine.

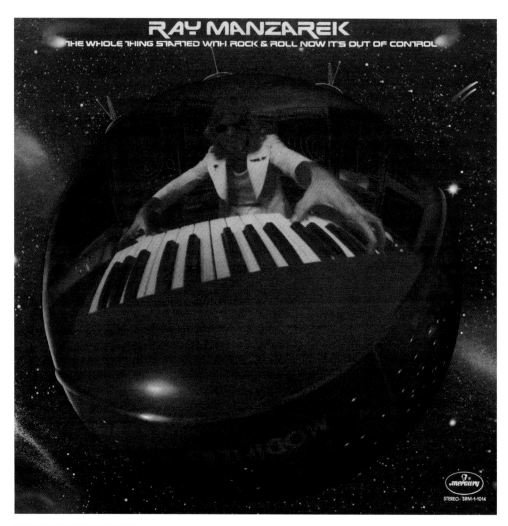

STEREO SRM-1-1014

RAY MANZAREK

artist RAY MANZAREK
title THE WHOLE THING
 STARTED WITH ROCK
 & ROLL, NOW IT'S
 OUT OF CONTROL
year 1974
label MERCURY
ad DESMOND STROBEL,
 JOHN DAVID MOORE
photo JAMES FORTUNE,
 KEITH RODABAUGH
 FOR PUBLIC EYE
 FEATURES

With his left hand on a Minimoog, his right on an Arp, and his 35-year-old frame ensconced in towering amplifiers, it's likely that the Guitar Center made this album's thanks list for allowing keyboardist and Doors co-founder Ray Manzarek to shoot his album cover on site. Of the two synthesizers at Manzarek's fingertips, the Arp is the only one featured on this recording.

MAXX MANN

artist MAXX MANN
title MAXX MANN
year 1982
label RED DOG
PRODUCTIONS
design DOUGLAS RILEY

**JOHN MAYALL'S
BLUES BREAKERS**

artist JOHN MAYALL'S
BLUES BREAKERS
title CRUSADE
year 1967
label LONDON
design JOHN MAYALL
photo PETER SMITH

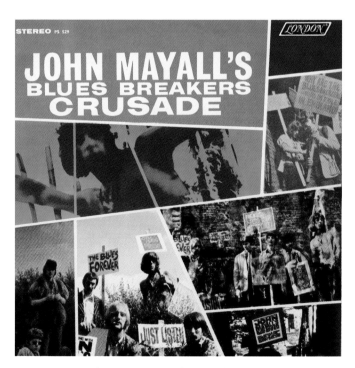

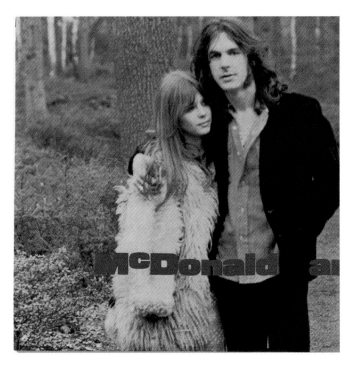

MCDONALD AND GILES

artist McDONALD AND
GILES
title McDONALD AND
GILES
year 1971
label COTILLION
art CHARLOTTE BATES
photo RICHARD DILELLO

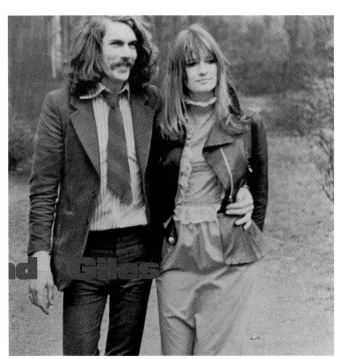

Apple Records' self-
proclaimed "house hippie"
Richard DiLello was also a
capable photographer, shoot-
ing jacket-bound portraits
of Janis Joplin, Badfinger,
and this woodland image of
King Crimson alumni Ian
McDonald and Michael Giles.
DiLello's rock history book
*The Longest Cocktail Party:
An insider's diary of The
Beatles, their million-dollar
Apple empire and its wild rise
and fall* was published by
Playboy Press in 1973.

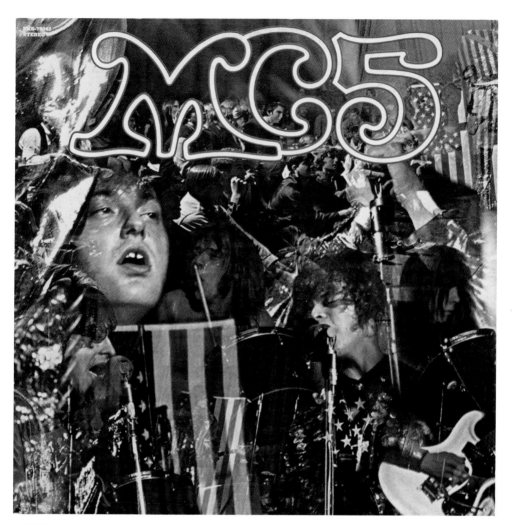

MC5

artist MC5
title KICK OUT THE
JAMS
year 1969
label ELEKTRA
ad WILLIAM S.
HARVEY
design BOB HEIMALL
photo JOEL BRODSKY

Recorded live at Detroit's Grande Ballroom over two nights, Devil's Night and Halloween 1968, *Kick Out the Jams* is widely hailed as a protopunk classic. The original pressing was taken off the record store racks for including the expletive in "Kick out the jams, motherfucker!" in the text on the inside of the gatefold sleeve. MC5 were early hard-rock natives of Lincoln Park, Michigan who established themselves as left-wing countercultural stalwarts amidst a backdrop of growing social tension in the '60s.

"We got in the habit, being the sort of punks we are, of screaming at them to get off the stage, to kick out the jams, meaning stop jamming. We were saying it all the time and it became a sort of esoteric phrase. Now, I think people can get what they like out of it; that's one of the good things about rock and roll." – Wayne Kramer

MC5 261

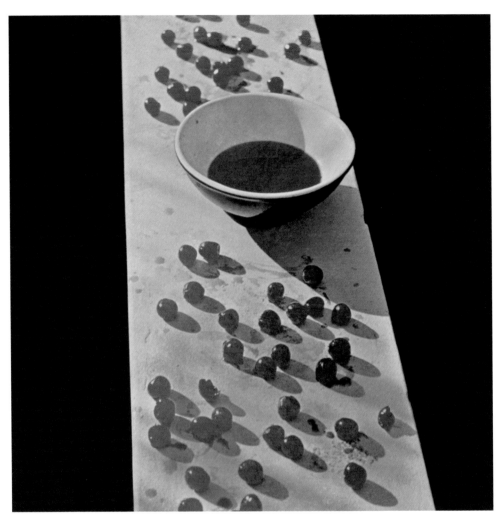

PAUL McCARTNEY

artist PAUL McCARTNEY
title McCARTNEY
year 1970
label APPLE
design PAUL McCARTNEY,
GORDON HOUSE,
ROGER HUGGETT
photo LINDA MCCARTNEY

Recorded singlehandedly at home, or under assumed names at various studios, Paul McCartney's dexterous debut—officially self-titled—is often referred to as "The Cherries Album" because of wife Linda McCartney's now ubiquitous cover shot. The gatefold features an assortment of candid snaps by the celebrated photographer, most famously of daughter Mary, peering out from inside her father's jacket.

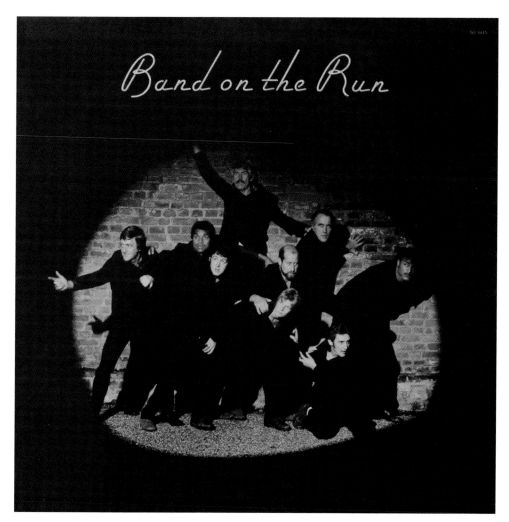

Paul McCartney & Wings

artist PAUL McCARTNEY &
WINGS
title BAND ON THE RUN
year 1973
label APPLE
photo CLIVE ARROWSMITH

If you look up "photographer" in the dictionary, that's London's Clive Arrowsmith's mug next to the definition. Or, rather, it should be, since he's photographed legends from Mick Jagger to the Dalai Lama. For *Band on the Run* Paul & Linda McCartney and Denny Laine are pictured among: three actors, a boxer, a chat-show host and the celebrated raconteur and polymath Clement Freud, grandson of Sigmund.

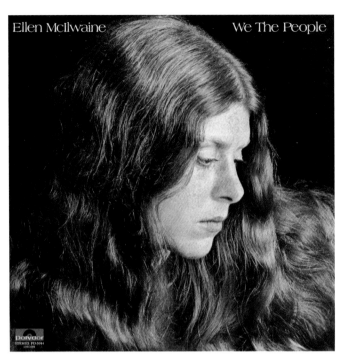

ELLEN MCILWAINE

artist ELLEN MCILWAINE
title WE THE PEOPLE
year 1973
label POLYDOR
design PAULA BISACCA
photo CHRISTIAN
STEINER

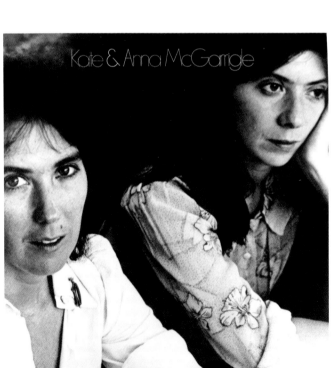

KATE & ANNA McGARRIGLE

artist KATE & ANNA
MCGARRIGLE
title KATE & ANNA
McGARRIGLE
year 1975
label WARNER BROS.
design IRA FRIEDLANDER
photo GAIL KENNEY

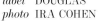

JOHN McLAUGHLIN

artist JOHN MCLAUGHLIN
title DEVOTION
year 1970
label DOUGLAS
photo IRA COHEN

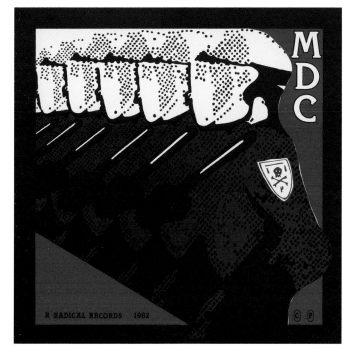

MDC

artist MDC
title MILLIONS OF
DEAD COPS
year 1982
label R RADICAL
art CARLOS LOWRY
(BASED ON A
MURAL BY RAUL
VALDEZ)

MEAT PUPPETS

artist MEAT PUPPETS
title UP ON THE SUN
year 1985
label SST
art CURT KIRKWOOD

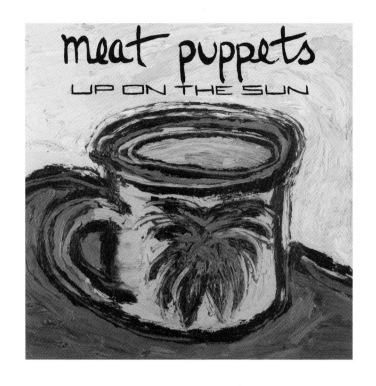

THE MEATMEN

artist THE MEATMEN
title WE'RE THE
 MEATMEN...
 ...AND YOU SUCK!
year 1983
label TOUCH AND GO
art BRIAN POLLACK

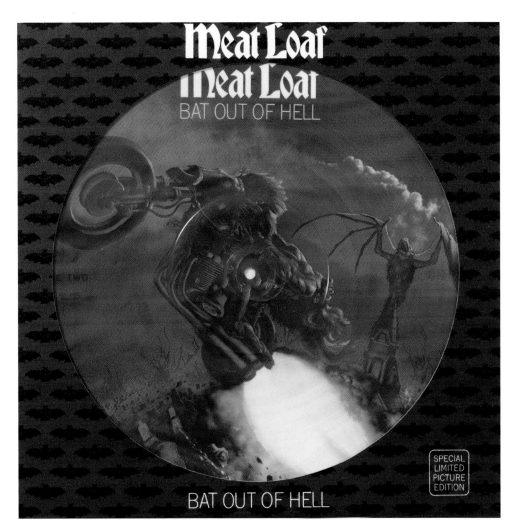

BAT OUT OF HELL

MEAT LOAF

artist MEAT LOAF
title BAT OUT OF HELL
year 1977
label CLEVELAND
INTERNATIONAL/EPIC
art RICHARD CORBEN
design JIM STEINMAN

Richard Corben's fantasy art cover illustration adds motion and power to one of rock's most recognizable symphonic anthems. Jim Steinman, composer of the title crash song, is also credited with conceiving the epic cover design. The multi award-winning album has sometimes drawn comparisons with Bruce Springsteen's *Born to Run* (1975)—indeed, Steinman cited Springsteen as an influence and, serendipitously, Roy Bittan and Max Weinberg from the E Street Band sessioned on the recording.

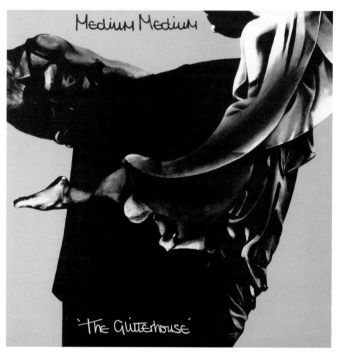

MEDIUM MEDIUM

artist MEDIUM MEDIUM
title THE GLITTERHOUSE
year 1981
label CACHALOT/
CHERRY RED
design ROGER PHILLIPS

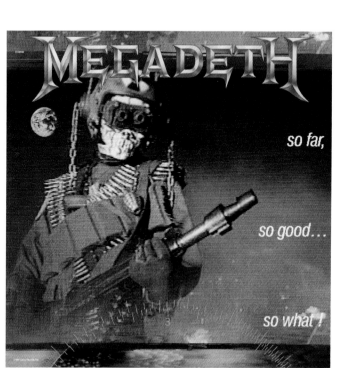

MEGADETH

artist MEGADETH
title SO FAR, SO GOOD...
SO WHAT!
year 1988
label CAPITOL
design DAVE MUSTAINE

Band mascot Vic Rattlehead's third straight Megadeth LP cover appearance put the skeletal icon in full Cold War military fatigues, gave him a nasty-looking weapon, and put him on what seems to be the Moon. The horizontal hold on this VHS-era still image is a bit distorted, but there's no mistaking tranquil Earth in the deep distance.

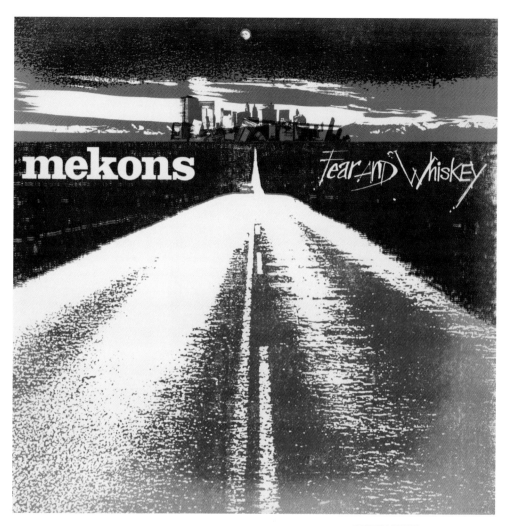

MEKONS

artist MEKONS
title FEAR AND
WHISKEY
year 1985
label SIN RECORDINGS
art SOPHIE BOURBON
design SOPHIE BOURBON

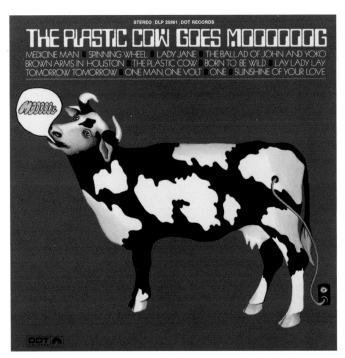

MIKE MELVOIN

artist MIKE MELVOIN
title THE PLASTIC COW
GOES MOOOOOOG
year 1970
label DOT
ad HONEYA THOMPSON
art HONEYA THOMPSON

MEN AT WORK

artist MEN AT WORK
title BUSINESS AS
USUAL
year 1982
label COLUMBIA
art JON "JD" DICKSON

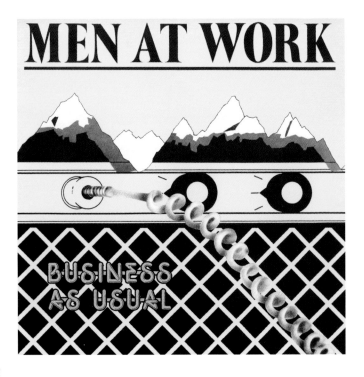

MESSIAH

artist MESSIAH
title FINAL WARNING
year 1984
label VINICULUM
art MIKE DEMSKE
design MIKE DEMSKE

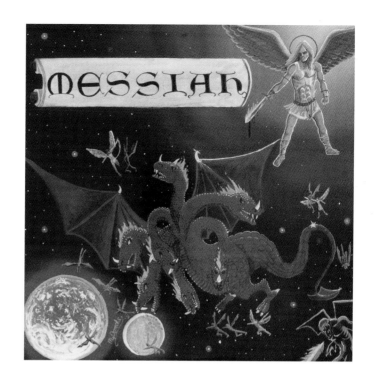

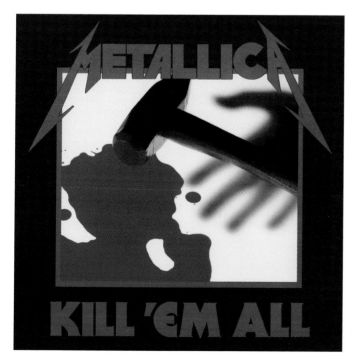

METALLICA

artist METALLICA
title KILL 'EM ALL
year 1983
label ELEKTRA/ASYLUM
design HAROLD RISCH,
 SHARI RISCH,
 GARY L. HEARD
photo GARY L. HEARD

Metallica's intention was to call their debut *Metal Up Your Ass*, the cover of which was to feature a hand sticking out of a toilet, holding a dagger. Distributors refused to carry the proposed album, forcing Metallica to reconsider. A new title was born of bassist Cliff Burton's suggested means of dealing with industry opponents: "Why don't we just kill 'em all?"

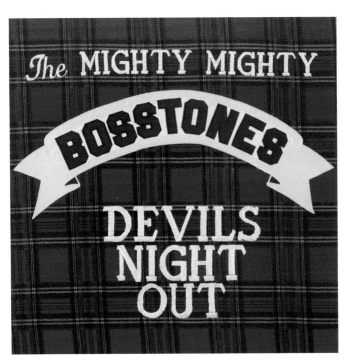

THE MIGHTY MIGHTY BOSSTONES

artist THE MIGHTY MIGHTY BOSSTONES
title DEVILS NIGHT OUT
year 1990
label TAANG!
design THE MIGHTY MIGHTY BOSSTONES, JANE GULICK

MINISTRY

artist MINISTRY
title THE MIND IS A TERRIBLE THING TO TASTE
year 1989
label SIRE/WARNER BROS.
design DOG (AL JOURGENSEN), ILL (BRIAN SHANLEY), MAURA
photo TOM YOUNG

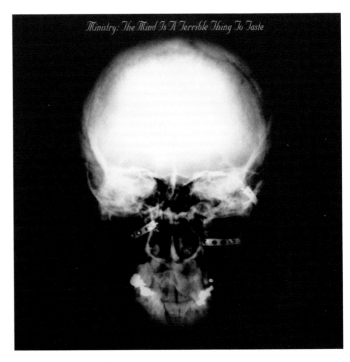

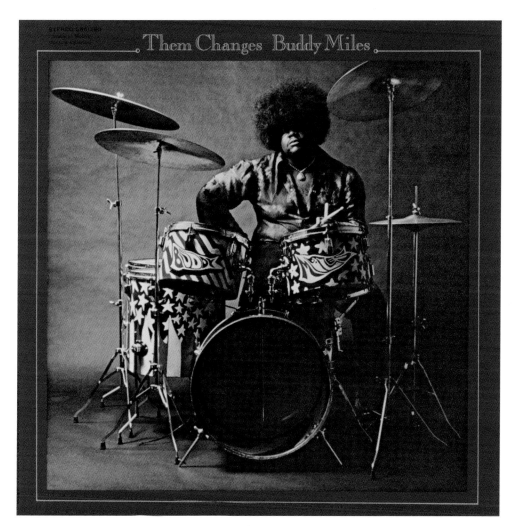

Them Changes Buddy Miles

BUDDY MILES

artist BUDDY MILES
title THEM CHANGES
year 1970
label MERCURY
ad DESMOND STROBEL
design RICHARD GERMINARO
photo BURNELL CALDEWELL

Celebrated for his time-keeping tenure in Jimi Hendrix's late-career Band of Gypsys, Buddy Miles wrote, sang and played drums on several solo outings for Mercury and Columbia. In 1986, after years out of the spotlight, his rendition of "I Heard It Through the Grapevine" became central to a wildly successful ad campaign for the California Raisin Advisory Board, featuring a cast of anthropomorphized raisins.

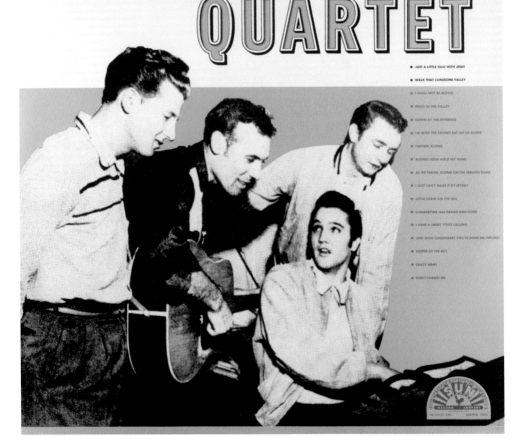

SUN 1006

THE MILLION DOLLAR QUARTET

- JUST A LITTLE TALK WITH JESUS
- WALK THAT LONESOME VALLEY
- I SHALL NOT BE MOVED
- PEACE IN THE VALLEY
- DOWN BY THE RIVERSIDE
- I'M WITH THE CROWD BUT OH SO ALONE
- FARTHER ALONG
- BLESSED JESUS HOLD MY HAND
- AS WE TRAVEL ALONG ON THE JERICHO ROAD
- I JUST CAN'T MAKE IT BY MYSELF
- LITTLE CABIN ON THE HILL
- SUMMERTIME HAS PASSED AND GONE
- I HEAR A SWEET VOICE CALLING
- AND NOW SWEETHEART YOU'VE DONE ME WRONG
- KEEPER OF THE KEY
- CRAZY ARMS
- DON'T FORBID ME

THE MILLION DOLLAR QUARTET

artist THE MILLION
 DOLLAR QUARTET
title THE MILLION
 DOLLAR QUARTET
year 1981
label SUN

On Tuesday December 4, 1956 Sun Record Studios in Memphis hosted an off-the-cuff session with four legendary pioneers of the era—Carl Perkins, Jerry Lee Lewis, Johnny Cash and Elvis Presley. Sensing a promotional opportunity from this rare alignment, Sun owner Sam Phillips contacted the local newspaper and an article appeared in the next day's *Memphis Press Scimitar* titled "Million Dollar Quartet," alongside the same photo as was later used on the LP cover release.

MINOR THREAT

artist MINOR THREAT
title OUT OF STEP
year 1983
label DISCHORD
art CYNTHIA CONNOLLY
design JEFF NELSON

"*The white sheep were
done in watercolor
to express a sort of
a dreary, boring
sophistication. The
black sheep, in crayon,
showed youthful
exuberance and
represented all of us
in the punk scene, as
far as I saw it.*"

Cynthia Connolly

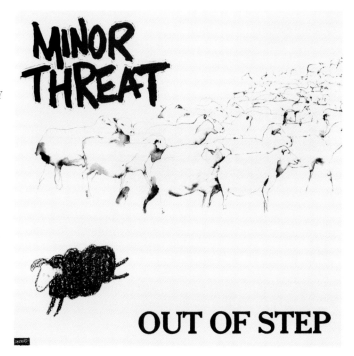

MINOR THREAT

artist MINOR THREAT
title MINOR THREAT
year 1981
label DISCHORD
design JEFF NELSON
photo SUSIE JOSEPHSON

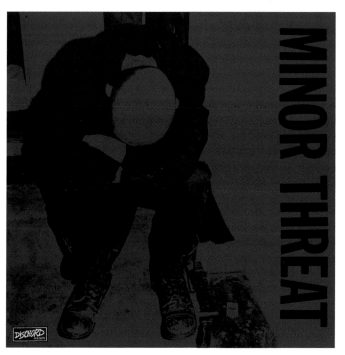

MINUTEMEN

MINUTEMEN

artist MINUTEMEN
title WHAT MAKES A
 MAN START FIRES?
year 1983
label SST
art RAYMOND
 PETTIBON

What Makes a Man Start Fires? marked the fifth release and sophomore long-player for the Minutemen. It was also the third time Raymond Pettibon lent his artistic talent to the band, and the relationship forged between the two creative entities appears to have been a fair trade, with Pettibon crafting a brand for the band, and the Minutemen initiating a long album-design career for the artist. Both would go on to be highly regarded for their craft, and Pettibon's artwork can be seen not only on later Minutemen albums, but also on a slew of classic LPs from Black Flag and Sonic Youth to the Foo Fighters.

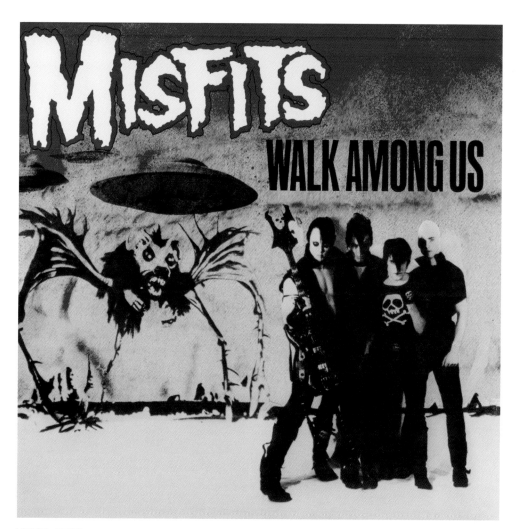

MISFITS

artist MISFITS
title WALK AMONG US
year 1982
label RUBY
design DANZIG, SCHLOCK
photo EERIE VON
STELLMAN,
DANZIG, MARY
ANN, MORTICA,
RYNSKY, SCHLOCK

With titles like "Mommy, Can I Go Out and Kill Tonight?," "Astro Zombies" and "Braineaters," the Misfits' full-length debut tossed the punk norm of politics and societal vitriol out the window. Instead we are treated to a speed-freak version of '50s horror flicks and teenage rebellion. Two films provided the band's singer and founding member Glenn Danzig with inspiration and imagery for the cover, the creepy "Rat-Bat-Spider" from *The Angry Red Planet* and the flying saucers from *Earth vs. the Flying Saucers* combining with a darkened image of the band superimposed like a cheap B-movie poster.

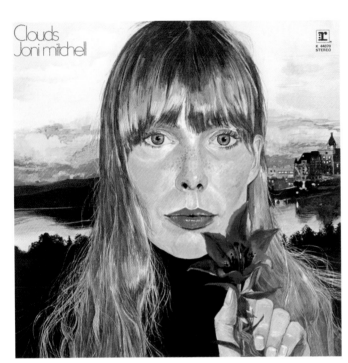

JONI MITCHELL

artist JONI MITCHELL
title CLOUDS
year 1969
label REPRISE
ad ED THRASHER
art JONI MITCHELL

THE MONKEES

artist THE MONKEES
title INSTANT REPLAY
year 1969
label COLGEMS
design ALAN WOLSKY

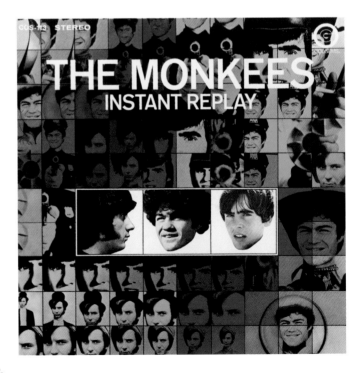

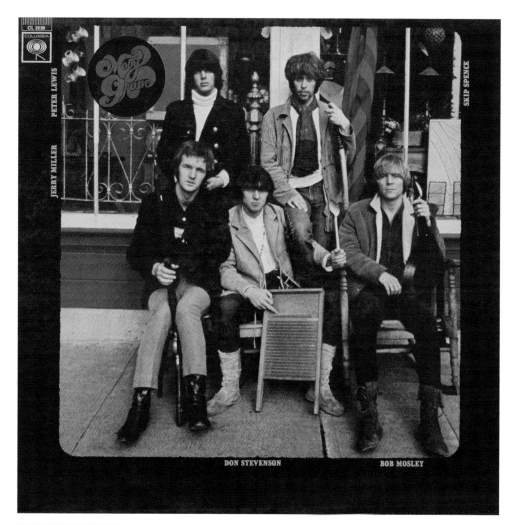

MOBY GRAPE

artist MOBY GRAPE
title MOBY GRAPE
year 1967
label COLUMBIA
photo JIM MARSHALL

If you have this album in your collection, look closely at Don Stevenson, front and center. Is he flipping you off? If not, you are the proud owner of a second-run issue, since the subtly controversial image had to be changed when listeners noticed the indiscretion. The original cover image is only fitting though, considering half the band was busted for drug possession the week the album was released. Photographer Jim Marshall would continue to snap the biggest and best of the '60s and '70s, even landing a spot as the main photographer for Woodstock '69.

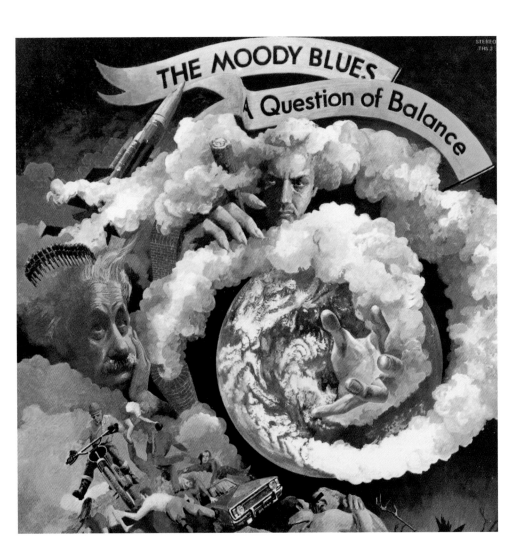

THE MOODY BLUES

artist THE MOODY BLUES
title A QUESTION OF
BALANCE
year 1970
label THRESHOLD
art PHIL TRAVERS

"He'd [Phil Travers] somehow tie up all the
elements that we'd been singing and talking about.
We had to take an even lower royalty to have
those sleeves because it was important to us that
we should have gatefold stuff."

Justin Hayward

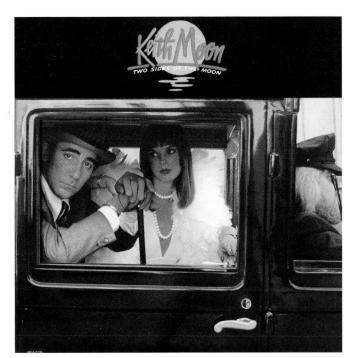

KEITH MOON

artist KEITH MOON
title TWO SIDES OF THE MOON
year 1975
label MCA
ad GEORGE OSAKI
design GARY STROMBERG, BRUCE REILEY, SKIP, JOHN, KEITH MOON (CONCEPT)
photo RAINBOW PHOTOGRAPHY: JIM MCCRARY, ROBERT FAILLA

VAN MORRISON

artist VAN MORRISON
title MOONDANCE
year 1970
label WARNER BROS.
design BOB CATO
photo ELLIOT LANDY

"Van had a huge pimple on his forehead... I mean like a really big pimple... That's the reason I cut the picture because it was impossible to photograph any higher."

Elliot Landy

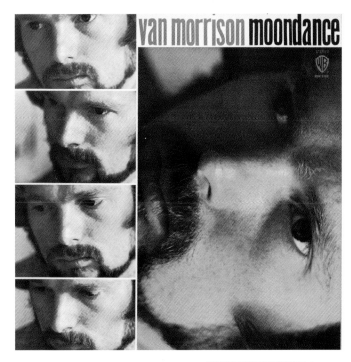

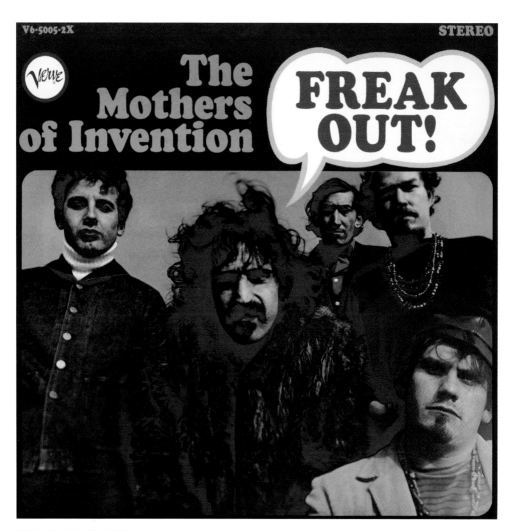

**THE MOTHERS
OF INVENTION**

artist THE MOTHERS
 OF INVENTION
title FREAK OUT!
year 1966
label VERVE
design JACK ANESH
photo RAY LEONG

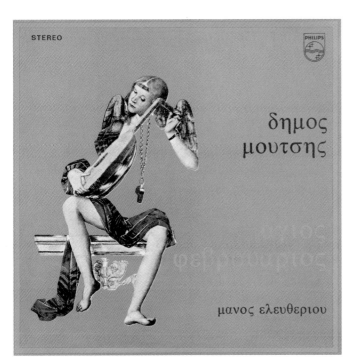

STEREO

PHILIPS

δημος
μουτσης

μανος ελευθεριου

DIMOS MOUTSIS

artist DIMOS MOUTSIS
title AGIOS
FEVROUARIOS/
SAINT FEBRUARY
year 1971
label PHILIPS

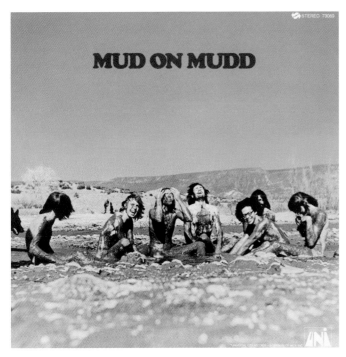

STEREO 73089

MUD ON MUDD

MUD

artist MUD
title MUD ON MUDD
year 1970
label UNI

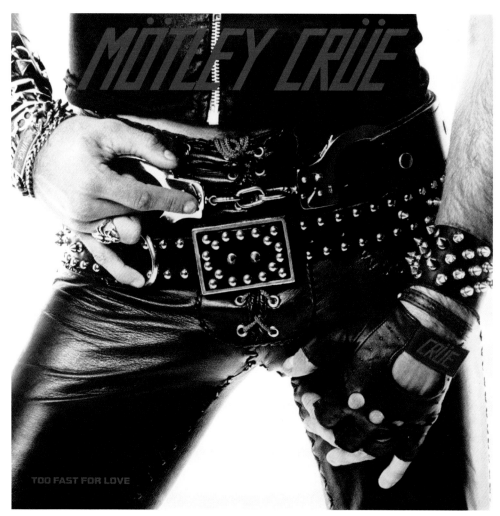

TOO FAST FOR LOVE

MÖTLEY CRÜE

artist MÖTLEY CRÜE
title TOO FAST FOR LOVE
year 1982
label ELEKTRA
design COFFMAN AND
COFFMAN
PRODUCTIONS
photo MICHAEL PINTER

Originally released in 1981 on the band's own Leathür Records, *Too Fast for Love* would ultimately see reissue by Elektra upon the band's signing in 1982. Although variations exist between pressings regarding font color, track listing and back cover/insert composition, Michael Pinter's photographic homage to the Rolling Stones' *Sticky Fingers* remains a constant.

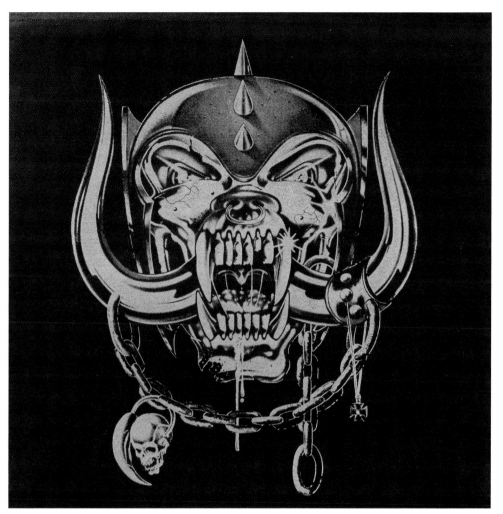

MOTÖRHEAD

artist MOTÖRHEAD
title NO REMORSE
year 1984
label BRONZE
art PHIL SMEE
design JOE PETAGNO,
CHRIS WEBSTER

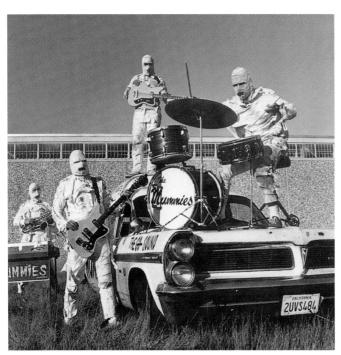

THE MUMMIES

artist THE MUMMIES
title NEVER BEEN
 CAUGHT
year 1992
label TELSTAR
photo SVEN-ERIK GEDDES,
 UNCLE MIKE LUCAS

MURPHY'S LAW

artist MURPHY'S LAW
title MURPHY'S LAW
year 1986
label PROFILE
art ALEX MORRIS
photo GLEN E. FRIEDMAN

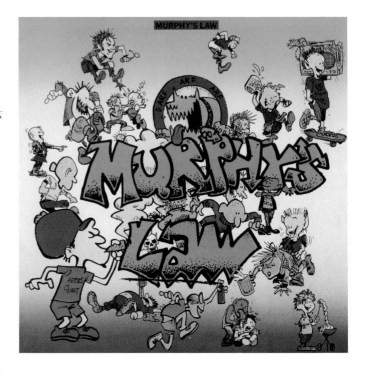

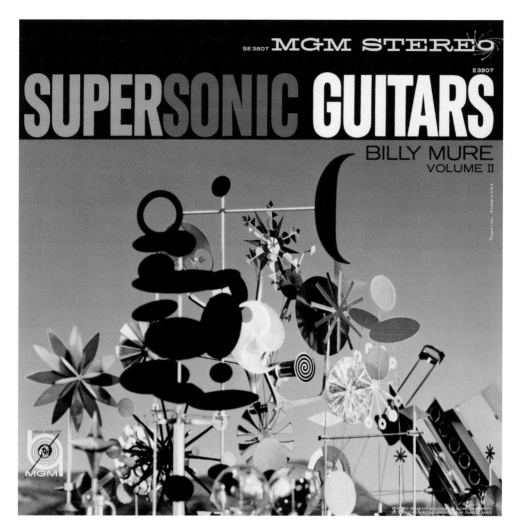

BILLY MURE

artist BILLY MURE
title SUPERSONIC GUITARS
VOLUME II
year 1959
label MGM
art CHARLES EAMES

Space-age toys and supersonic guitars neatly encapsulate the enthusiasm of the post-war US nuclear era, and the cover photo here shows a detail of the *Do-Nothing Machine*—a solar-powered toy designed in 1957 by Charles and Ray Eames for Alcoa. Billy Mure's versatility as a session guitarist enabled him to traverse the popular styles of the day, from Hawaiian surf and exotica to pop. He enjoyed a few minor hits, including the cha-cha instrumental "Toy Balloons," and in 1959 released the single "A String of Trumpets," credited to Billy Mure and the Trumpeteers.

MY BLOODY VALENTINE

artist MY BLOODY VALENTINE
title LOVELESS
year 1991
label CREATION
ad DESIGNLAND
design MY BLOODY VALENTINE
photo ANGUS CAMERON

1991 was a banner year for rock with Nirvana, Guns N' Roses, Red Hot Chili Peppers, U2, R.E.M. and Metallica all releasing huge records. But squeaking in towards the end of that year was *Loveless*. It's a record that kept daring you to turn up the volume, and with every increasing decibel the waves of beautiful noise washed through you. Kevin Shields's magnum opus was a siren's call and in a sea of guitar-based behemoths his is the one that still rings true.

THE MUSIC MACHINE

artist THE MUSIC
MACHINE
title (TURN ON) THE
MUSIC MACHINE
year 1966
label ORIGINAL SOUND
design SYLVESTER BROWN
photo GENE SIMMONS

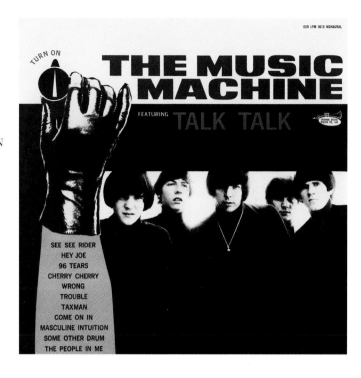

NAZZ

artist NAZZ
title NAZZ NAZZ
year 1969
label SGC
design HAIG ADISHIAN
photo BRUCE LAURANCE

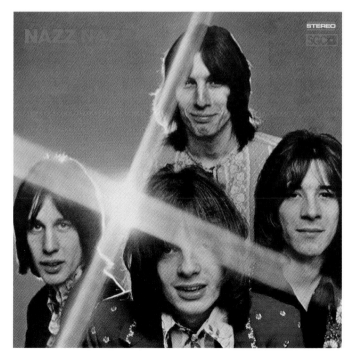

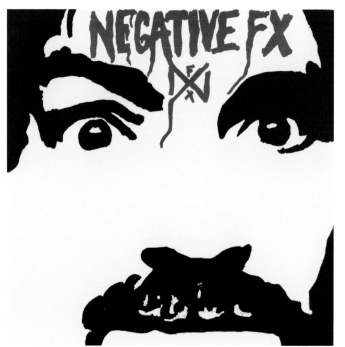

NEGATIVE FX

artist NEGATIVE FX
title NEGATIVE FX
year 1985
label TAANG!
art CHOKE
design CHOKE

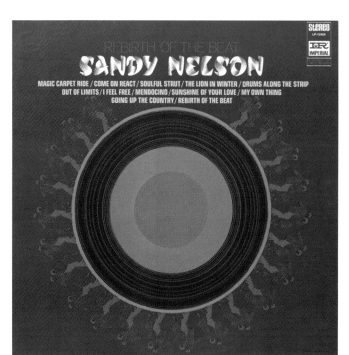

SANDY NELSON

artist SANDY NELSON
title REBIRTH OF
THE BEAT
year 1969
label IMPERIAL
ad WOODY WOODWARD
deisgn MARSHA
SALISBURY

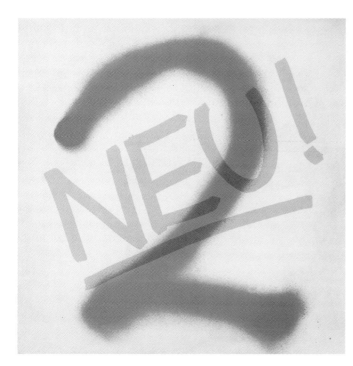

NEU!

artist NEU!
title NEU! 2
year 1973
label BRAIN/
 UNITED ARTISTS
design KLAUS DINGER,
 MICHAEL ROTHER

The b-side of the Krautrock pioneers' second LP was initially interpreted by fans as a rip-off, but lauded later by critics and historians as a prototype for remix culture to come. Money ran out halfway through making the record so the band simply included a manipulated version of their "Neuschnee/Super" single on side two, a decision that would eventually become a mark of its deconstructive ethos.

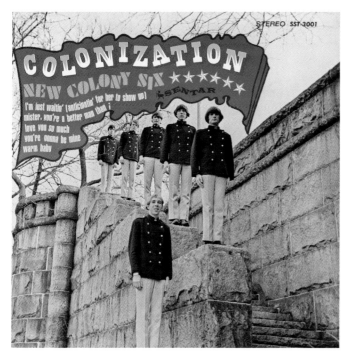

NEW COLONY SIX

artist NEW COLONY SIX
title COLONIZATION
year 1967
label SENTAR
ad DOUGLAS FISKE

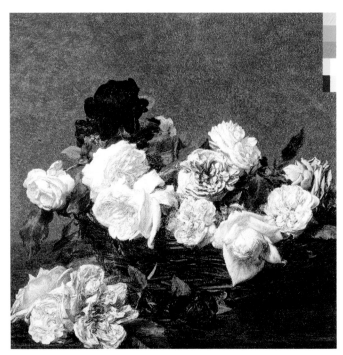

NEW ORDER

artist NEW ORDER
title POWER, CORRUPTION & LIES
year 1983
label FACTORY
art HENRI FANTIN-LATOUR
design PETER SAVILLE

Lead vocalist Bernard Sumner took the title from an act of art vandalism by German painter Gerhard Richter, whilst the cover was another chance art discovery by design guru Peter Saville. Picking up a postcard of a painting entitled *A Basket of Roses* (1890) whilst visiting the National Gallery in London, he was taken with his girlfriend's joking idea to use it for the sleeve and liked how the innocent yet seductive nature of flowers worked as a visual metaphor for the album's title.

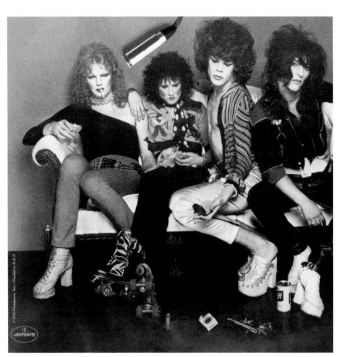

NEW YORK DOLLS

artist NEW YORK DOLLS
title NEW YORK DOLLS
year 1973
label MERCURY
design ALBUM GRAPHICS INC. (COVER COORDINATION)
photo TOSHI

When Mercury Records ushered the proto-punk, cross-dressing New York Dolls along to an antique shop, make-up free, to be photographed as "dolls among the antiques" for their first record cover they played along. However, proving that a little sleaze can go a long way, Sylvain Sylvain contacted *Vogue* magazine photographer Toshi to shoot the actual photo, which you see here. Mercury's image did get used—but on the back cover.

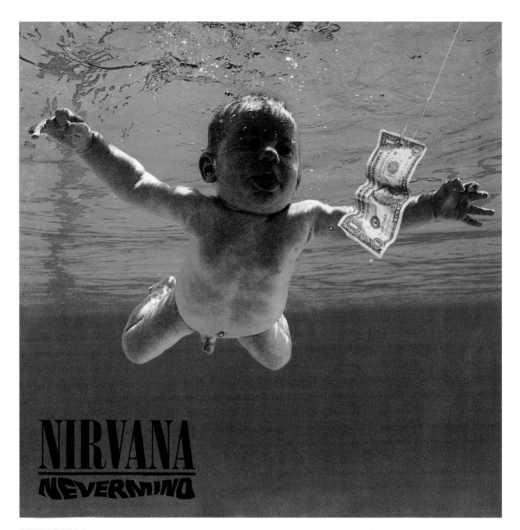

NIRVANA

artist NIRVANA
title NEVERMIND
year 1991
label DGC
ad ROBERT FISHER
photo KIRK WEDDLE
(COVER), KURDT
KOBAIN (MONEY
PHOTO)

The famous cover image for Nirvana's second LP owes its origins to a TV feature about water births, though when Kurt Cobain mentioned this idea to Robert Fisher, art director for Geffen, the stock images found during research proved to be too graphic. In the end he hired Kirk Weddle, who got the classic underwater shot of three-month-old Spencer Elden swimming toward the dollar bill on a fish-hook in a baby swimming pool. Geffen was worried about the cover causing trouble because the boy's penis could clearly be seen, but according to his biographer Michael Azerrad, Cobain refused any changes to the design, suggesting only that a sticker might be added saying, "If you're offended by this, you must be a closet pedophile."

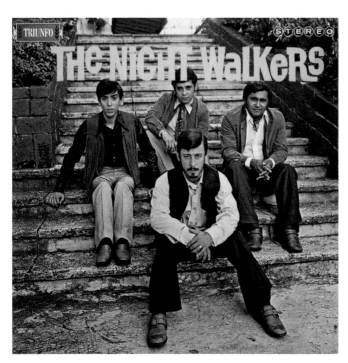

THE NIGHT WALKERS

artist THE NIGHT
WALKERS
title THE NIGHT
WALKERS
year 1968
label TRIUNFO

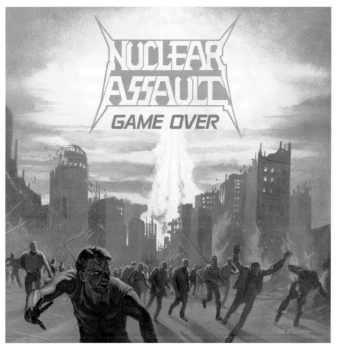

NUCLEAR ASSAULT

artist NUCLEAR ASSAULT
title GAME OVER
year 1986
label COMBAT
art EDWARD J. REPKA
design EDWARD J. REPKA

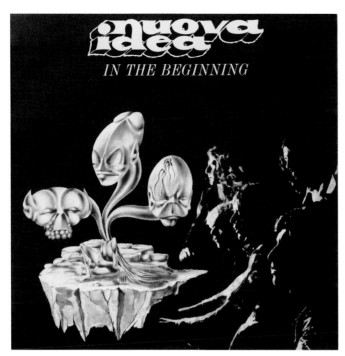

NUOVA IDEA

artist NUOVA IDEA
title IN THE BEGINNING
year 1971
label ARISTON

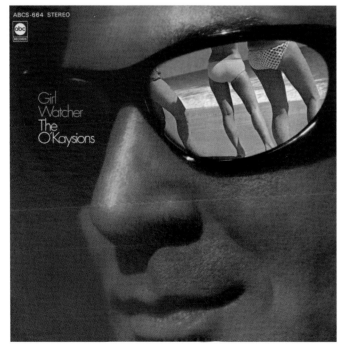

THE O'KAYSIONS

artist THE O'KAYSIONS
title GIRL WATCHER
year 1968
label ABC

"That was the album cover ABC decided on; we had very little input into it. If we had, it would've been different. I would have put a picture of the group on it. But see, a lot of people thought we were black. ABC did not want to lose the black market, so they wouldn't release photos of us for about six months."

Jim Hinnant

THORN OEHRIG

artist THORN OEHRIG
title CIRCUIT RIDER
year 1981
label CIRCUIT RIDER
art THORN OEHRIG
design THORN OEHRIG

"I went with Thorn to the pressing plant where he brought a real snake skin and threw it down on the desk of the art director saying, 'This is what I want on the back and on the front I want a snake nailed to a cross with a lizard lookin' up at it.'"

Jeff Jones

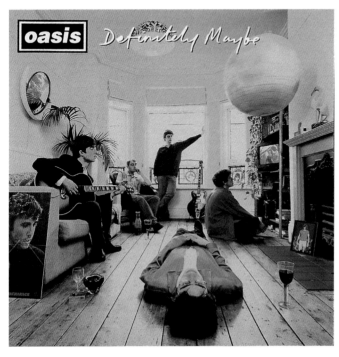

OASIS

artist OASIS
title DEFINITELY MAYBE
year 1994
label CREATION
design MICRODOT:
BRIAN CANNON
photo MICHAEL SPENCER
JONES

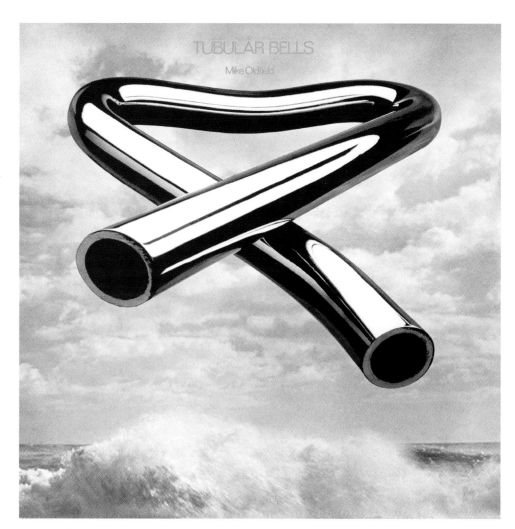

MIKE OLDFIELD

artist MIKE OLDFIELD
title TUBULAR BELLS
year 1973
label VIRGIN
art TREVOR KEY
design TREVOR KEY

Tubular Bells was the first album to be released on Richard Branson's Virgin Records label in 1973 and was also the debut of English multi-instrumentalist and composer Mike Oldfield, recorded when he was just 19. Album sales benefitted from the opening theme being used as part of the soundtrack to cult horror film, *The Exorcist*. Trevor Key, also co-designer of Virgin's logo, had dented a tubular bell while he was playing it and this inspired his now famous cover design.

DENNIS OLIVIERI

artist DENNIS OLIVIERI
title COME TO
THE PARTY
year 1968
label VMC

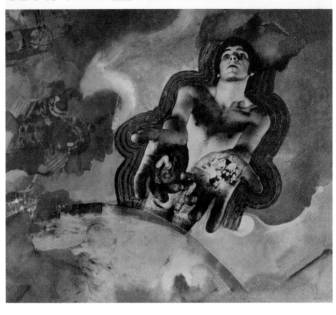

YOKO ONO/
PLASTIC ONO BAND

artist YOKO ONO/
PLASTIC ONO BAND
title FEELING THE
SPACE
year 1973
label APPLE
ad JOHN HOERNIE
design YOKO ONO
photo BOB GRUEN

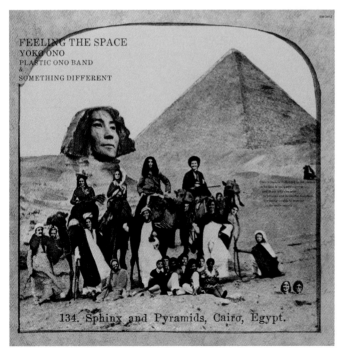

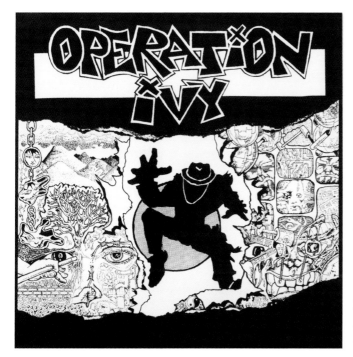

OPERATION IVY

artist OPERATION IVY
title ENERGY
year 1989
label LOOKOUT!
art JESSE MICHAELS

Though their logo is emblazoned on many a punk rock hoodie, Operation Ivy only put out one studio album and true punk spirit, lead singer Jesse Michaels, provided the now classic cover art. Though the band broke up just before the record came out, it made an indelible mark on the East Bay punk scene with its infectious fusing of punk and ska. Bassist Matt Freeman and guitarist Tim Armstrong would go on to form Rancid and help bring punk rock to malls across America.

ROY ORBISON

artist ROY ORBISON
title THE CLASSIC
ROY ORBISON
year 1966
label MGM
design ACY R. LEHMAN
photo JOHN ROSS

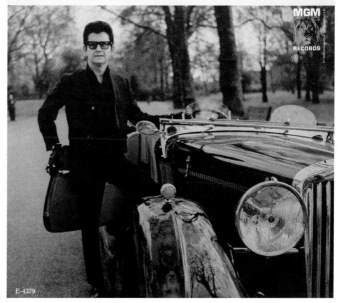

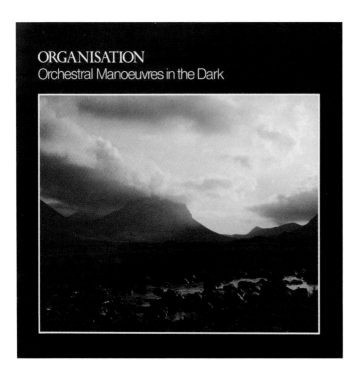

ORCHESTRAL MANOEUVRES IN THE DARK

artist ORCHESTRAL
 MANOEUVRES IN
 THE DARK
title ORGANISATION
year 1980
label DINDISC/VIRGIN
design PETER SAVILLE,
 TREVOR KEY
photo TREVOR KEY,
 INTERPHOTO

THE OSMONDS

artist THE OSMONDS
title CRAZY HORSES
year 1972
label MGM/KOLOB
design RON RAFFAELI
photo RON RAFFAELI

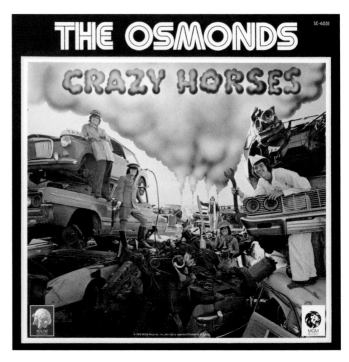

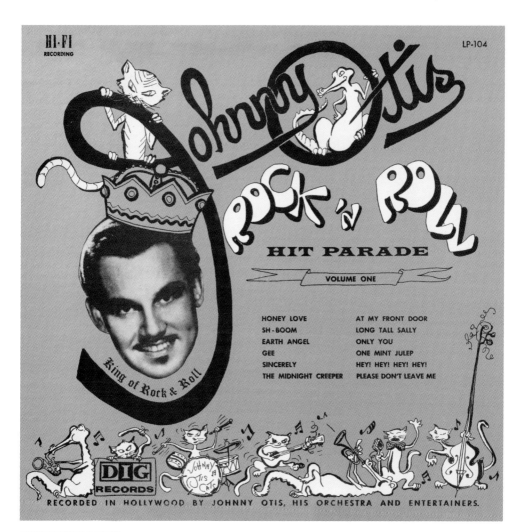

JOHNNY OTIS

artist JOHNNY OTIS
title ROCK 'N ROLL
HIT PARADE
VOLUME ONE
year 1957
label DIG
photo GEORGE MILLS

Born to Greek immigrants as Ioannis Alexandres Veliotes in Vallejo, California, Johnny Otis broke into the music industry first as a drummer and songwriter, then as an A&R scout, responsible for such signings as Etta James, Jackie Wilson and Hank Ballard. Perhaps his greatest discovery, however, came on *Cold Shot!* which marked the debut of his teenage son Shuggie Otis, himself responsible for a *sui generis* trio of introspective masterpieces, culminating with 1974's *Inspiration Information*.

VIVA LAST BLUES

PALACE MUSIC

artist PALACE MUSIC
title VIVA LAST BLUES
year 1995
label DRAG CITY
art DIANNE BELLINO

Will Oldham's voice cracks at just the right place during his tales of sexual meanderings steeped in a whiff of religious fervor. Throughout the mid '90s he used the Palace moniker for a slew of "anti-folk" projects, but this was his heaviest LP to date. The strong backbeat and broader range of instrumentations lend themselves well to his Flannery O'Connor-inflected tales, while the Terrence Malick-like magic-hour sunset of Oldham's glory keeps this indie high-water mark "always on my mind."

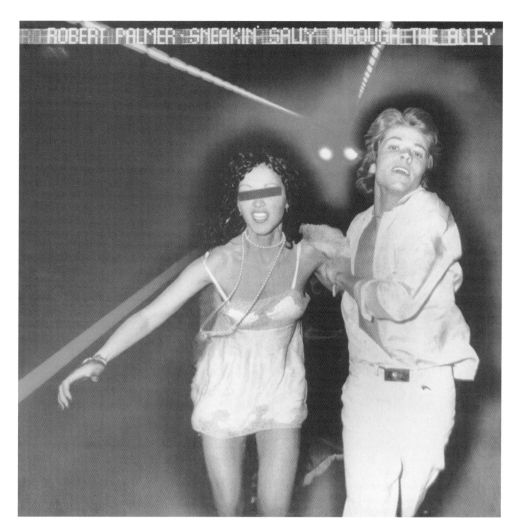

ROBERT PALMER

artist ROBERT PALMER
title SNEAKIN' SALLY
 THROUGH THE
 ALLEY
year 1974
label ISLAND
design GRAHAM HUGHES
 (CONCEPT)
photo GRAHAM HUGHES

Though best known for leisure-suit standards of the late '80s like "Simply Irresistible" and "Addicted to Love," the British-born vocalist laid deep roots in the blue-eyed soul movement with a string of low-slung '70s long-players. On his Island Records debut, he is backed alternately by Louisiana funk progenitors the Meters and Los Angeles's versatile Little Feat, striking a comfortable blend of yacht rock and danceable pop.

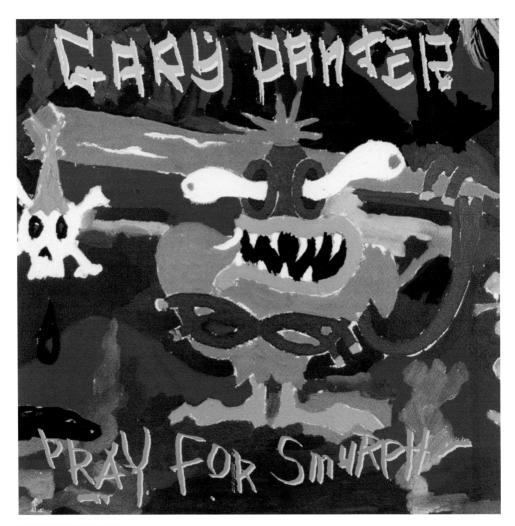

GARY PANTER

artist GARY PANTER
title PRAY FOR SMURPH
year 1983
label OVERHEAT
art GARY PANTER
design GARY PANTER

"I had done an album cover for Ian McLagan formerly of the Small Faces and got to know him and his band and the engineers at the recording studio, so he helped me trade a painting or two with the owners of the studio—Shangri-La Studios in Canaan Dune, owned by members of The Band. Phil Culp produced the rest of the album. We recorded in the off hours starting at two or three in the mornings and used the engineers who worked and lived there."

Gary Panter

PAUL PARRISH

artist PAUL PARRISH
title THE FOREST
OF MY MIND
year 1968
label MUSIC FACTORY
ad DICK SMITH
art VICTOR ATKINS

Sea monsters and ostriches
and sea planes, oh my! When
the forest of your mind is this
trippy, only the best artist
can captivatingly transform
it into an album cover. Victor
Atkins was the man for the
job, and shortly after the
Music Factory Records release
of Paul Parrish's happy-folky
debut, Atkins would go on
to win the 1969 Illustrator
Award from the Society of
Illustrators for his work on
Miles Davis's *Miles in the Sky*.

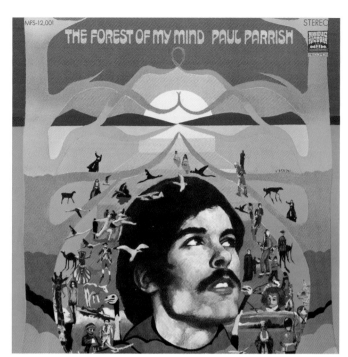

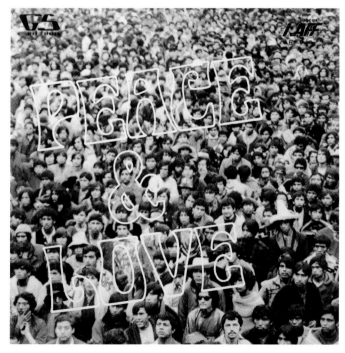

PEACE & LOVE

artist PEACE & LOVE
title PEACE & LOVE
year 1973
label RAFF
design ROJO JONES,
JOHNNY JACKSON
photo PABLO MUÑOZ

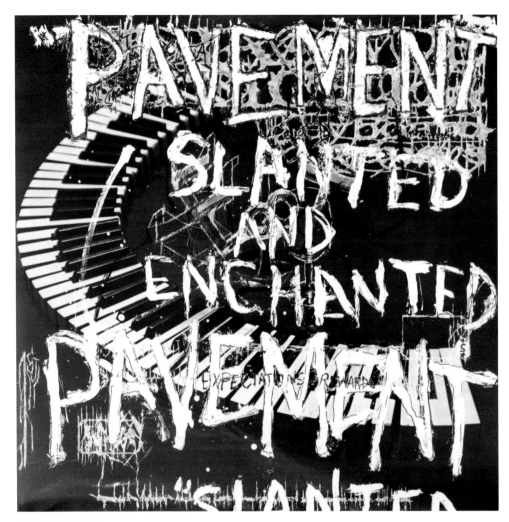

PAVEMENT

artist PAVEMENT
title SLANTED AND
ENCHANTED
year 1992
label MATADOR

Pavement didn't give birth to indie rock, but well, actually yes they did. In fact, when *Rolling Stone* compiled its 100 best debut rock albums of all time, *Slanted and Enchanted* sat pretty at number 25. According to them, "*Slanted and Enchanted* is one of the most influential rock albums of the 1990s; its fuzzy record-ing style can be heard in the music of Nirvana, Liz Phair, Beck, the Strokes and the White Stripes." Drawing on history was one of the group's strong points, and just as they turned familiar pop tropes on their heads, the cover art here was based on that used for *Keyboard Kapers* by piano duo Ferrante & Teicher. By dirtying up the playful classicism of the original image they announced their mission of low-fi absurdist humor and heart.

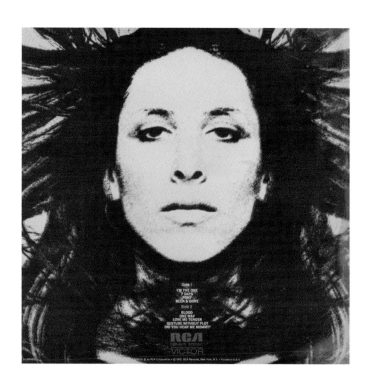

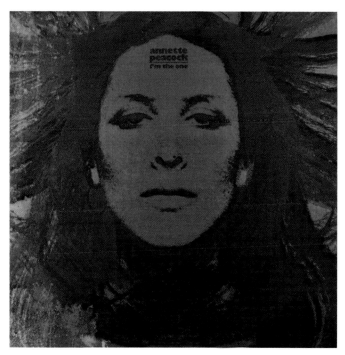

ANNETTE PEACOCK

artist ANNETTE PEACOCK
title I'M THE ONE
year 1972
label RCA VICTOR
design ANNETTE PEACOCK
photo RICHARD DAVIS

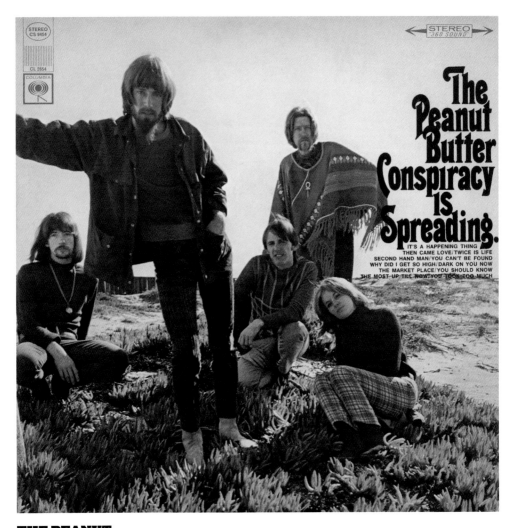

THE PEANUT BUTTER CONSPIRACY

artist THE PEANUT
BUTTER
CONSPIRACY
title THE PEANUT
BUTTER
CONSPIRACY
IS SPREADING
year 1967
label COLUMBIA
photo GUY WEBSTER

STEREO

Pearls Before Swine

PEARLS BEFORE SWINE

artist PEARLS BEFORE SWINE
title ONE NATION
 UNDERGROUND
year 1967
label ESP DISK
art HIERONYMUS BOSCH
 (DETAIL FROM *THE
 GARDEN OF EARTHLY
 DELIGHTS*)

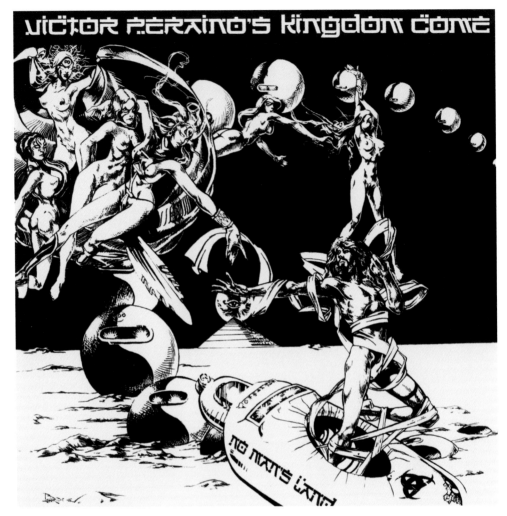

VICTOR PERAINO'S KINGDOM COME

artist VICTOR PERAINO'S
KINGDOM COME
title NO MAN'S LAND
year 1975
label NO MAN'S KINGDOM
COME
ad KARL NILSSON
art JIM BEVERIDGE
design VICTOR PERAINO
(COVER CONCEPT)

American keyboard wiz Victor Peraino was a member of the British prog rock group, Arthur Brown's Kingdom Come; his pioneering use of the mellotron (the first sample-playback keyboard) and Bentley Rhythm Ace drum machine were used with great effect on their last album *Journey*. When the band split up Peraino self-released *No Man's Land*, which continued his exploration of the spaced-out mellotron sound. Unable to find major label distribution, Peraino produced only 150 copies, making the original pressing of this album one of the most prized prog LPs in existence. The sci-fi cover art was an early piece by accomplished Canadian illustrator Jim Beveridge.

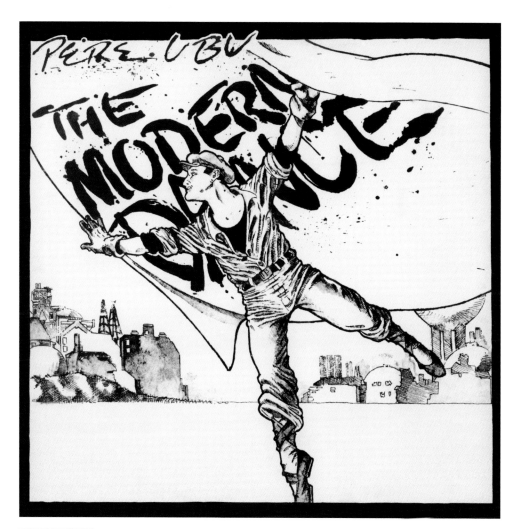

PERE UBU

artist PERE UBU
title THE MODERN
DANCE
year 1978
label BLANK
art STEVEN W. TAYLOR

"I had this idea based on the fact that it was called The Modern Dance *that I wanted to do something like the Chinese ballet—the people who are all dressed in uniforms—but I wanted more of an American worker, doing a modern dance. And of course I wanted a huge flag in the background, because they always had huge flags in the background, so that's what I did."*

Steven W. Taylor

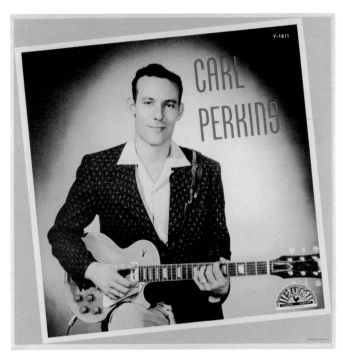

CARL PERKINS
artist CARL PERKINS
title CARL PERKINS
year 1957
label SUN/QUALITY

CAROLINE PEYTON
artist CAROLINE PEYTON
title MOCK UP
year 1972
label BAR-B-Q

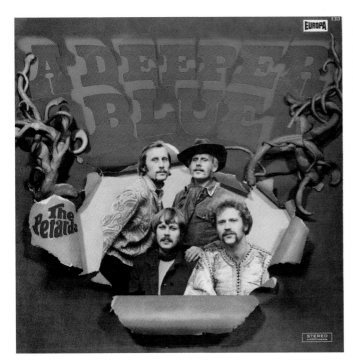

THE PETARDS

artist THE PETARDS
title A DEEPER BLUE
year 1968
label EUROPA

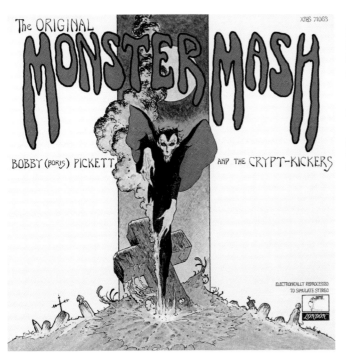

BOBBY "BORIS" PICKETT AND THE CRYPT-KICKERS

artist BOBBY "BORIS" PICKETT AND THE CRYPT-KICKERS
title THE ORIGINAL MONSTER MASH
year 1973
label PARROT (LONDON)
art MIKE KALUTA

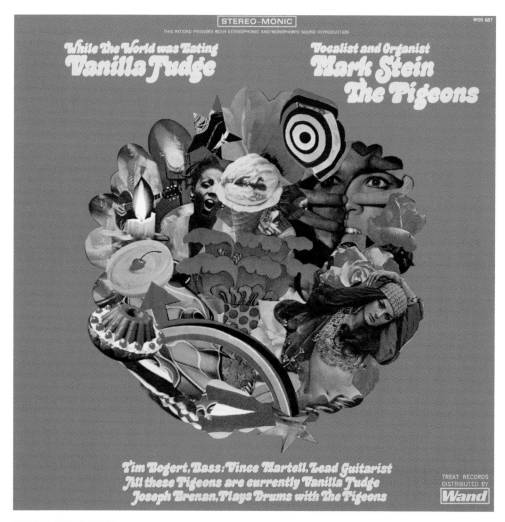

THE PIGEONS

artist THE PIGEONS
title WHILE THE WORLD
WAS EATING VANILLA
FUDGE
year 1970
label WAND
ad BURT GOLDBLATT
design BURT GOLDBLATT

Formed in 1965, initially as the Electric Pigeons, this R&B
covers band played bread-and-butter gigs on the East Coast
club circuit, providing backing for teen-girl groups such as the
Shangri-Las and their signature hit, "Leader of the Pack."
Purportedly recorded on a two-track tape recorder, this now
rare collection of songs was released at a later date in glorious
"Stereo-Monic." Shortly after the recording the band changed
their name to Vanilla Fudge and enjoyed a surprise hit with
a rearranged, slowed-down cover version of the Supremes'
"You Keep Me Hanging On." Cover designer Burt Goldblatt's
pioneering graphic techniques pushed the boundaries of jazz
cover design in the 1950s.

PHOENIX

artist PHOENIX
title CANTOFABULE
year 1975
label ELECTRECORD
art LILI, VALERIU SEPI
design LILI, VALERIU SEPI

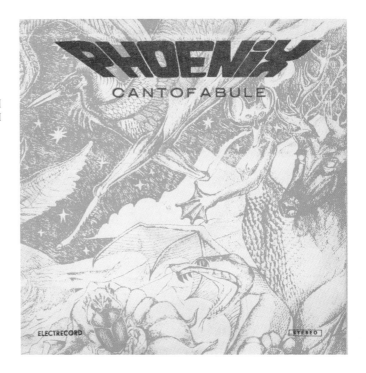

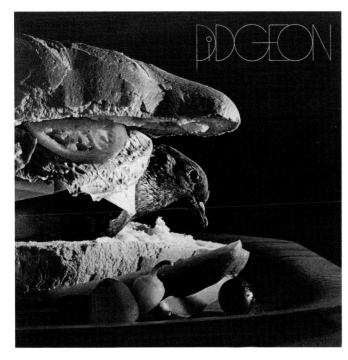

PIDGEON

artist PIDGEON
title PIDGEON
year 1969
label DECCA
photo GENE BROWNELL

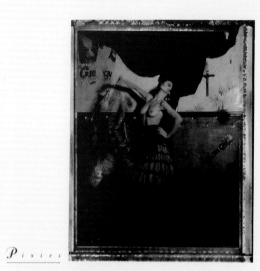

PIXIES

artist PIXIES
title SURFER ROSA
year 1988
label 4AD
design 23 ENVELOPE:
 VAUGHAN OLIVER,
 NIGEL GRIERSON
photo SIMON LARBALESTIER

Vaughan Oliver and Nigel Grierson's impeccable design coupled with Simon Larbalestier's evocative photo of a half-nude flamenco dancer key the listener in to the storm brewing within. The cover has a sense of polished decadence and begs us to take a breath before the rush of Black Francis's Dr. Jekyll devouring Kim Deal's Mr. Hyde. They do the punk pop tango so beautifully together as David Lovering and Joey Santiago keep the party moving with the frenetic power of a hopped-up chihuahua in a monster truck rally.

PIGBAG

artist PIGBAG
title SUNNY DAY
year 1981
label Y/STIFF

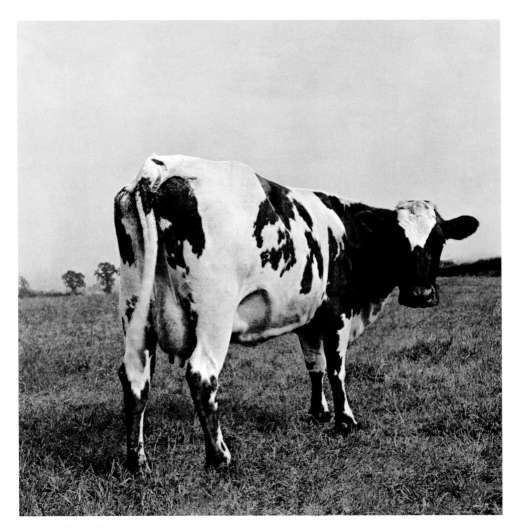

PINK FLOYD

artist PINK FLOYD
title ATOM HEART MOTHER
year 1970
label HARVEST
design HIPGNOSIS
photo STORM THORGERSON

As the music on their fifth studio album reached into different areas so too did the band feel that the cover should represent a plain but ambiguous image that would not be associated solely with their earlier brand of psychedelia. With this in mind, and also Warhol's cow wallpaper, Storm Thorgerson drove to a field just north of London to search for a suitable bovine model for *Atom Heart Mother*. He photographed the first one he saw and learned from its owner that the cow's name was Lulubelle III.

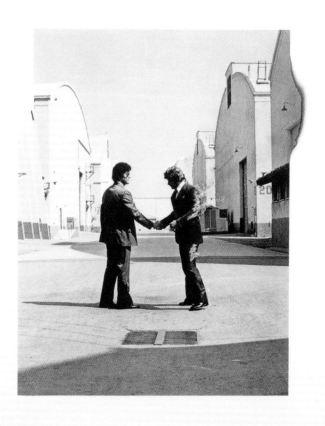

PINK FLOYD

artist PINK FLOYD
title WISH YOU WERE
HERE
year 1975
label HARVEST
design HIPGNOSIS
photo STORM
THORGERSON

The extraordinary success of *Dark Side of the Moon* (1973) forced Pink Floyd to retreat into a period of reflection, out of which came *Wish You Were Here* with its themes of absence and disillusionment, partly in reference to the soulless corporatism of the music industry, and also a tribute to Syd Barrett, the band's former guiding light whose drug use and mental decline had led to him leaving the band. Presented in an overall packaging that was riddled with visual metaphors, the front cover image can be seen to personify the feeling of "getting burned"—an industry phrase for being ripped off— whilst the faceless figure on the rear symbolizes the emptiness of business. Hipgnosis partner Storm Thorgerson further accentuated the impression of blankness by packaging the original album release in dark shrink-wrap.

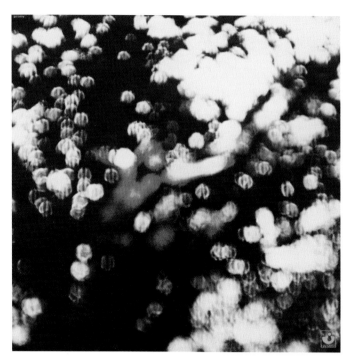

PINK FLOYD

artist PINK FLOYD
title OBSCURED BY
CLOUDS
year 1972
label HARVEST
design HIPGNOSIS
photo ANGUS MACRAY

Pink Floyd's seventh studio
release is taken from the
soundtrack they composed
for Barbet Schroeder's film
La Vallée. Apparently, whilst
Hipgnosis co-leads Aubrey 'Po'
Powell and Storm Thorgerson
were reviewing their selected
image for the sleeve—a film still
of a man in a tree—the 35mm
slide jammed in the projector.
The story then goes that the
band settled on this out-of-focus
shot as they didn't want the
cover of this release to upstage
their forthcoming album cover,
for *Dark Side of the Moon*.

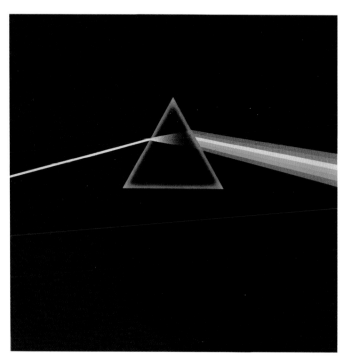

PINK FLOYD

artist PINK FLOYD
title DARK SIDE
OF THE MOON
year 1973
label HARVEST
art GEORGE HARDIE
design HIPGNOSIS
photo HIPGNOSIS

Drawing on the album's
lyrical approach and Pink
Floyd's light shows at con-
certs, Hipgnosis staffer Storm
Thorgerson concocted this
clean and elegant design for
the band's ambitious eighth
album. The resulting cover
image in black on white,
reversed and tinted during
the printing process, features
the airbrush work of George
Hardie's steady hand.

PITCH

artist PITCH
title WHAT AM I GONNA
DO FOR FUN
year 1982
label ON/OFF
design ARIANE, JIM
BOWLIN, PITCH

PLASMATICS

artist PLASMATICS
title BEYOND THE
VALLEY OF 1984
year 1981
label STIFF AMERICA
photo BUTCH STAR:
ROD SWENSON

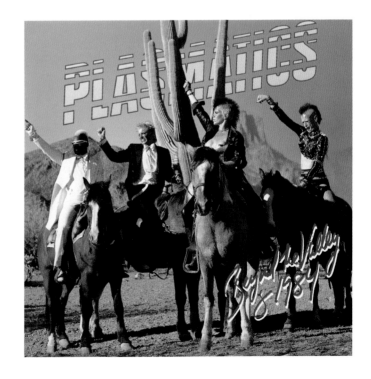

PLASTIC BERTRAND

artist PLASTIC BERTRAND
title ÇA PLANE POUR MOI (THIS LIFE'S FOR ME)
year 1977
label SIRE
photo RKM

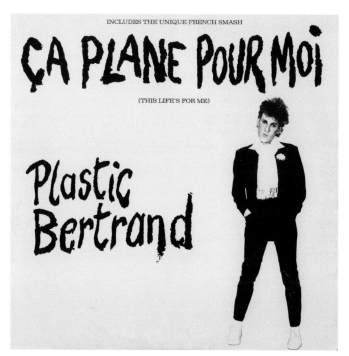

THE PLASTIC PEOPLE...PRAGUE

artist THE PLASTIC PEOPLE... PRAGUE
title EGON BONDY'S HAPPY HEARTS CLUB BANNED
year 1978
label SCOPA INVISIBLE
design PLASTIC PEOPLE DEFENSE FUND, FRANÇOIS

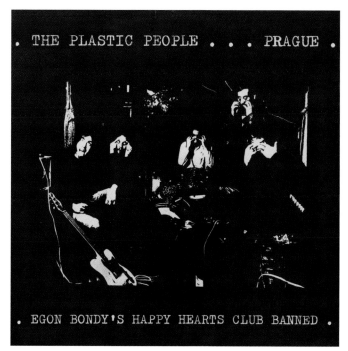

THE PLASTIC ONO BAND

artist THE PLASTIC ONO BAND
title LIVE PEACE IN
 TORONTO 1969
year 1969
label APPLE
design JOHN KOSH
photo IAIN MACMILLAN

John Lennon and Yoko Ono's artistic relationship had already begun to blossom in 1968, prior to the disbandment of the Beatles. *Live Peace in Toronto 1969* was recorded at the Toronto Rock and Roll Revival festival with a hurriedly put together line-up under the moniker of the Plastic Ono Band. Complete with a 13-month 1970 calendar insert, the album was released simultaneously in the UK and US in a bid to combat the proliferation of bootlegs, but record company executives soon launched a scathing attack on Ono for taking over side two with her experimental sounds and screaming vocals. For the cover, Lennon and Ono re-enlisted the design talents behind the iconic *Abbey Road* cover—John Kosh, Apple's creative lead, joining forces with Iain Macmillan, who produced the album's skyscapes.

THE POGUES

artist THE POGUES
title RED ROSES FOR ME
year 1984
label STIFF
photo STEVE TYNAN

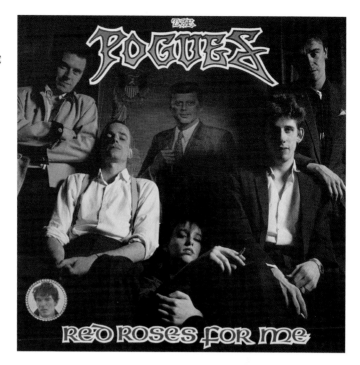

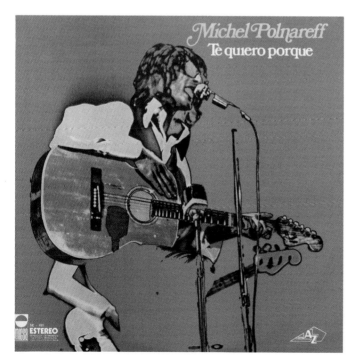

MICHEL POLNAREFF

artist MICHEL
POLNAREFF
title TE QUIERO PORQUE
year 1974
label DISC'AZ

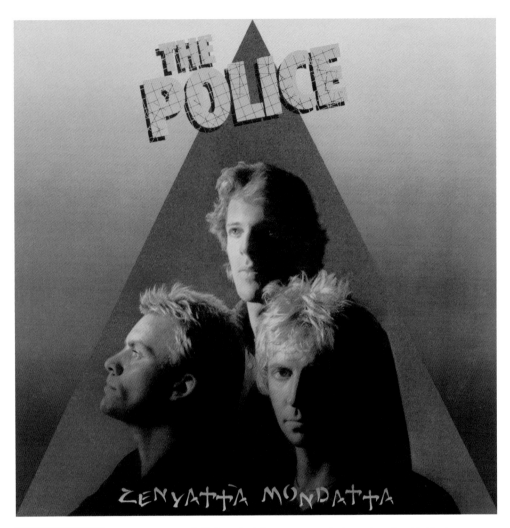

THE POLICE

artist THE POLICE
title ZENYATTA
MONDATTA
year 1980
label A&M
ad MICHAEL ROSS
design MICHAEL ROSS,
SIMON RYAN
photo JANETTE
BECKMANN

Self-described documentary photographer Janette Beckmann reputedly shot the cover portrait of the band on location in a Dutch forest. Following the releases of *Outlandos d'Amour* (1978) and *Reggatta de Blanc* (1979), this LP would be the third and last play on foreign-language titles by the British supergroup.

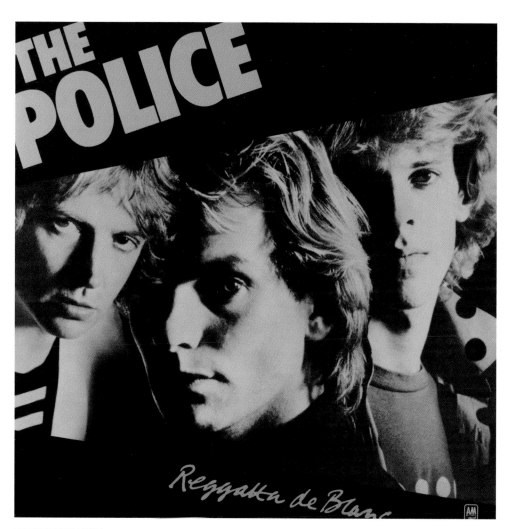

THE POLICE

artist THE POLICE
title REGGATTA DE
BLANC
year 1979
label A&M
ad MICHAEL ROSS
design MICHAEL ROSS
photo JAMES WEDGE

"Reggatta de Blanc *took us three weeks to record.
We just went into the studio and said 'right, who's
got the first song!' We hadn't even rehearsed them
before we went in.*"

Stewart Copeland

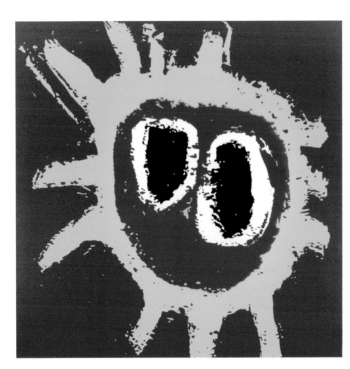

PRIMAL SCREAM

artist PRIMAL SCREAM
title SCREAMADELICA
year 1991
label CREATION
art PAUL CANNELL
design ES(P)

The late Paul Cannell painted the cover for Scotland's Primal Scream's first commercial hit. Cannell designed numerous albums for Creation Records as their in-house artist but *Screamadelica*'s simple art would be his most successful piece, even being featured amongst the "Classic Album Cover" stamps released in the UK by the post office in 2010.

ROGER POWELL

artist ROGER POWELL
title COSMIC FURNACE
year 1973
label ATLANTIC
design JULIA PEARL
photo MEL GOLDMAN

"There is a delicate method to this music," begins Roger Powell on his Atlantic Records debut. Whilst he had earlier worked with synthesizer pioneer Robert Moog, Powell instead pre-ferred ARP synthesizers to make the majority of the sounds heard on *Cosmic Furnace*. "The true and ori-ginal source of all this energy remains a general mystery," he concludes. "This is music for those who can see best with eyes closed."

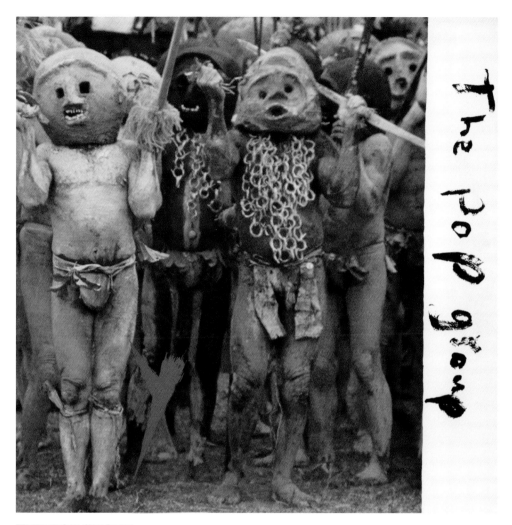

THE POP GROUP

artist THE POP GROUP
title Y
year 1979
label RADAR
design MALCOLM GARRETT,
RICH BEALE
photo DONALD MCCULLIN

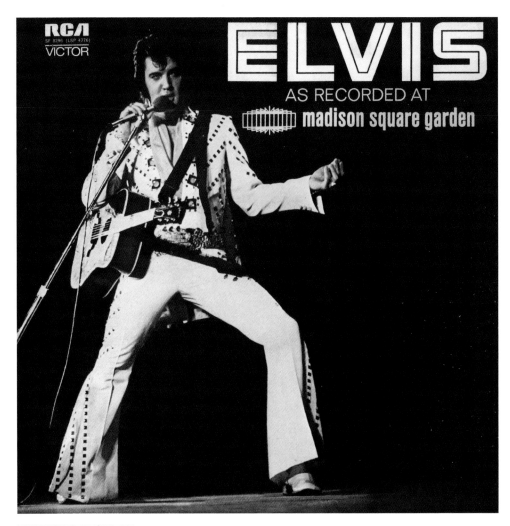

ELVIS PRESLEY

artist ELVIS PRESLEY
title ELVIS: AS RECORDED
AT MADISON
SQUARE GARDEN
year 1972
label RCA VICTOR
photo ED BONJA

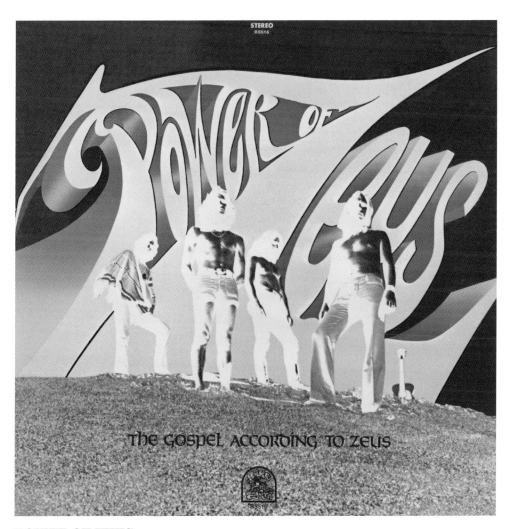

POWER OF ZEUS

artist POWER OF ZEUS
title THE GOSPEL
ACCORDING TO ZEUS
year 1970
label RARE EARTH
ad CURTIS MCNAIR
art EVELYN MYLES
design TOM SCHLESINGER
(GRAPHIC
SUPERVISION)
photo JIM WILSON

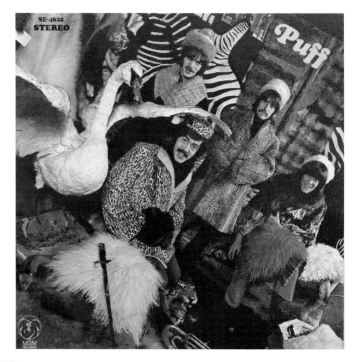

THE PRETENDERS

artist THE PRETENDERS
title PRETENDERS
year 1980
label SIRE
photo CHALKIE DAVIES

PUFF

artist PUFF
title PUFF
year 1969
label MGM
ad DAVID E. KRIEGER
photo JOEL BRODSKY

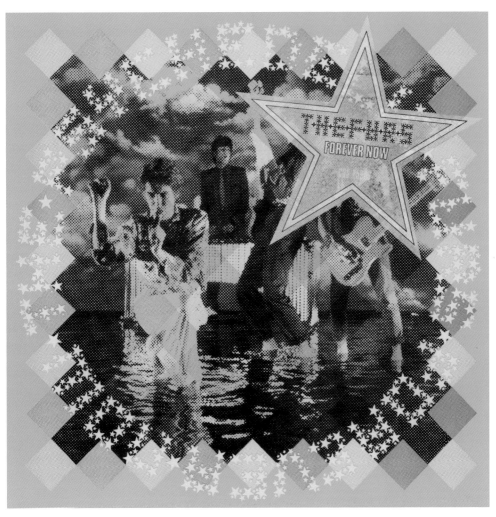

THE PSYCHEDELIC FURS

artist THE PSYCHEDELIC
FURS
title FOREVER NOW
year 1982
label CBS
photo GRAEME ATTWOOD

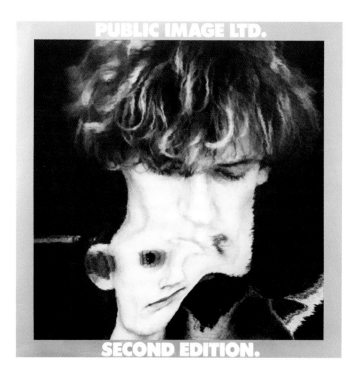

PUBLIC IMAGE LTD.

artist PUBLIC IMAGE LTD.
(PIL)
title SECOND EDITION
year 1979
label VIRGIN/ISLAND
photo TONY MCGEE

Originally titled *Metal Box*, this album was first released in 1979 by Virgin Records with its original packaging of a round, metal canister containing three 12" records. This innovative design was the work of Dennis Morris, but it proved to be a bitch to get into the box. Still, it was better than the original idea—a sandpaper record sleeve. The album was, however, re-released with a sigh of relief as *Second Edition* by Island Records, and this time in a traditional double-album sleeve.

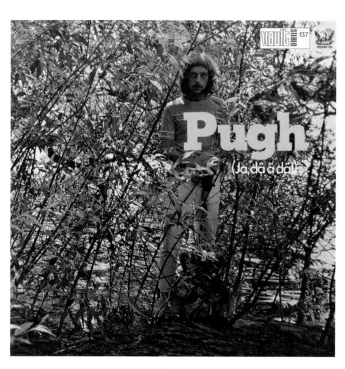

PUGH

artist PUGH
title JA, DÄ Ä DÄ!
year 1969
label VAULT
photo LENNART
WERNSTRÖM

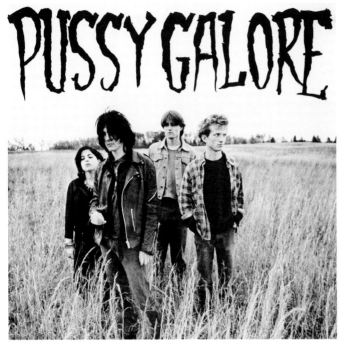

PUSSY GALORE

artist PUSSY GALORE
title GROOVY HATE FUCK
(FEEL GOOD ABOUT
YOUR BODY)
year 1987
label VINYL DRIP INT.
photo CRISTINA

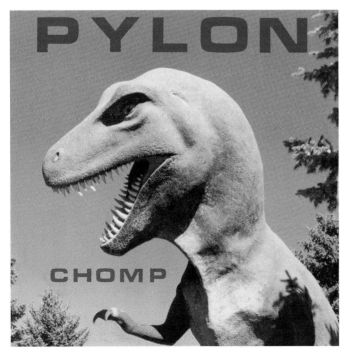

PYLON

artist PYLON
title CHOMP
year 1983
label DB
photo LOWELL T. SEAICH

"When Rolling Stone
called R.E.M. the
best rock band in
America, its coolest
member deferred to
this already-defunct
neighborhood quartet
[Pylon]."

Emerson Dameron

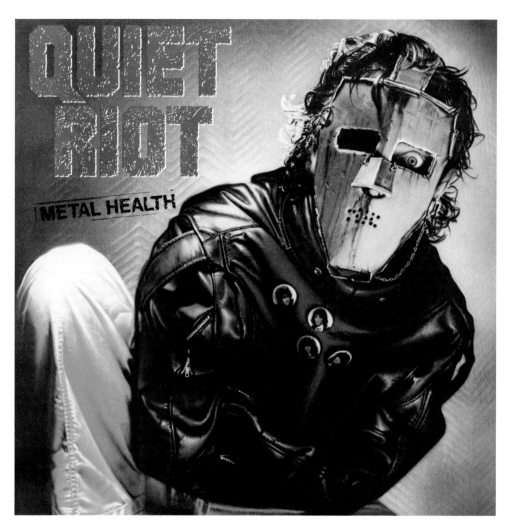

QUIET RIOT

artist QUIET RIOT
title METAL HEALTH
year 1983
label PASHA
ad JAY VIGON
art STAN WATTS
design QUIET RIOT
(CONCEPT),
JAY VIGON
photo RON SOBOL
(BUTTON PHOTOS)

*"You couldn't get away from the raucous
cover of Slade's 'Cum On Feel the Noize'
in 1983. It helped catapult Quiet Riot
to the top of the Metal heap and earned
them the distinction of having the first
Heavy Metal LP to reach number one
on Billboard's album chart."*

Frankie Banali

Q65

artist Q65
title REVOLUTION
year 1966
label DECCA
design BENNO PETERSSON
photo HERMAN BAAREN

It's all Dutch to you on Q65's
first hit release, *Revolution*.
The best of the Netherlands
combined forces to create a
visually and musically appeal-
ing album released on Decca.
Benno Petersson designed
several album covers, but this
one for Dutch powerhouse
Q65 may be his most creative.
Working with the band and
alongside Herman Baaren
for photography, Petersson's
finished package is complete
for a gritty, if not altogether
compelling R&B-laden psych-
rock album.

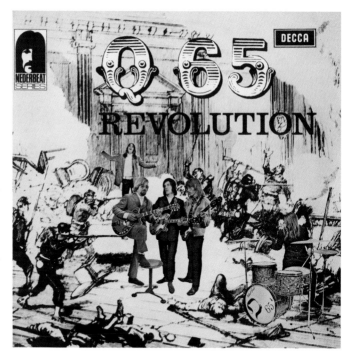

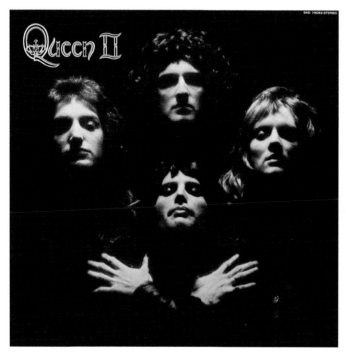

QUEEN

artist QUEEN
title QUEEN II
year 1974
label EMI/ELEKTRA
design MICK ROCK, QUEEN
(SLEEVE CONCEPT),
RIDGEWAY WATT
(TYPOGRAPHY)
photo MICK ROCK

For an entire generation, Queen
didn't mean a thing until the
sing-along car scene in *Wayne's
World*. For everyone else, Queen
has always been everything.
Instead of an A-side and a
B-side, *Queen II* features side
White and side Black, with
jacket images to match. Each
side features a variation of the
iconic diamond photograph by
Mick Rock that even the band
found ridiculously pretentious.

QUINTA FEIRA

artist QUINTA FEIRA
title QUINTA FEIRA
year 1974
label PDU
design L. TALLARINI,
G. RONCO
(COVER CONCEPT)

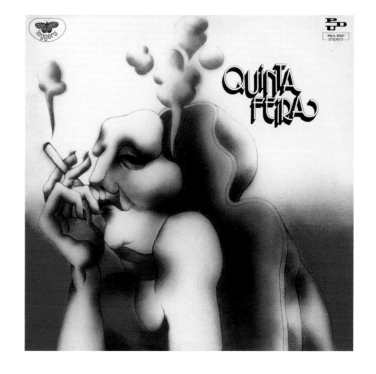

R.E.M.

artist R.E.M.
title RECKONING
year 1984
label I.R.S.
art HOWARD FINSTER

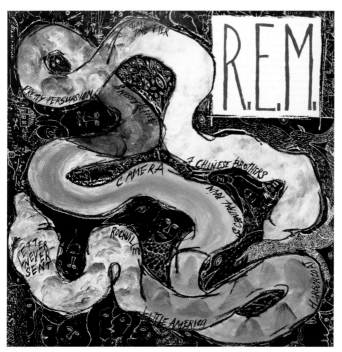

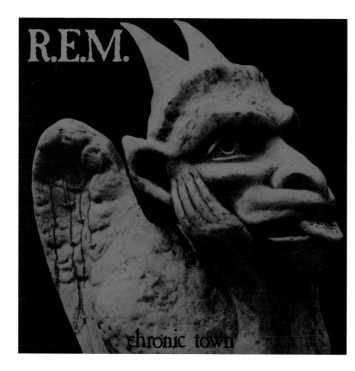

R.E.M.

artist R.E.M.
title CHRONIC TOWN
year 1982
label I.R.S.
design KAKO.N.
 (GRAPHICS),
 RON SCARSELLI
photo CURTIS KNAPP

New York illustrator and pho-
tographer Curtis Knapp was
already close with musicians
from the burgeoning Athens
scene when R.E.M. frontman
Michael Stipe asked him
about designing a cover for the
band. Stipe wanted a gargoyle
and blue background on the
front of the group's first EP;
Knapp complied, photograph-
ing a small statue purchased
from an antique shop on 32nd
Street in Manhattan.

RADIOHEAD

artist RADIOHEAD
title OK COMPUTER
year 1997
label PARLOPHONE
art MATT BALE, MR.
 BARRY, STANLEY
 DONWOOD, THE
 WHITE CHOCOLATE
 FACTORY

"*We did* OK Computer
*on a computer with a
tablet and a light pen.
We had this rule when
we couldn't erase any-
thing. It was great...*"

Stanley Donwood

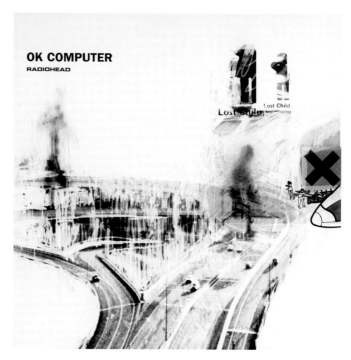

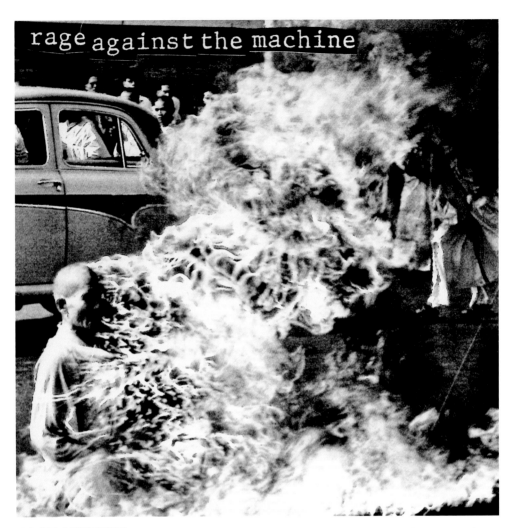

rage against the machine

RAGE AGAINST
THE MACHINE

artist RAGE AGAINST
THE MACHINE
title RAGE AGAINST
THE MACHINE
year 1992
label EPIC
ad NICKY LINDEMAN
photo MALCOLM BROWNE

Rap metal pioneers Rage Against the Machine burst on to the
LA music scene in 1991 and building on the legacy of such
cross-genre innovators as Afrika Bambaataa and the Beastie
Boys, grew to become anti-establishment icons renowned for
their explicit and left-wing lyrics. The band pulled no punches
in their shocking choice of debut album cover, which shows the
self-immolation of Thích Quang Duc in Saigon, a Vietnamese
Buddhist monk who killed himself in 1963 as a protest against
religious persecution by the Vietnamese regime.

THE RAINCOATS

artist THE RAINCOATS
title ODYSHAPE
year 1981
label ROUGH TRADE
design ANA DA SILVA,
GINA BIRCH

When Kurt Cobain and
Sonic Youth go to bat for the
re-release of your music, you
know you've done something
right. Riot girls far and wide
would agree, hailing the
Raincoats as the Godmothers
of Grunge. With *Odyshape*
the band gave a name to the
odyssey many women go on
in search of a perceived ideal
body shape. The group formed
while in art school in the
'70s, so it's fitting that two
of them are credited with the
artful design of the cover.

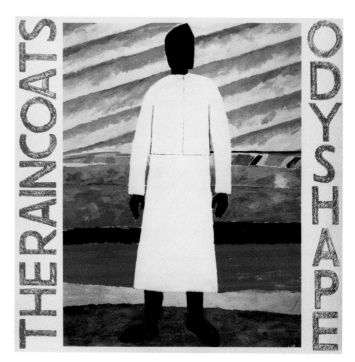

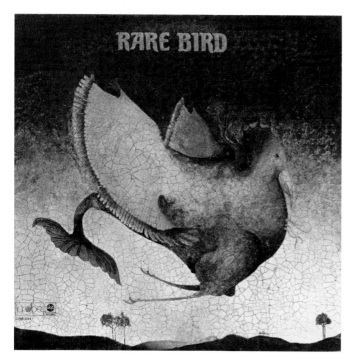

RARE BIRD

artist RARE BIRD
title RARE BIRD
year 1969
label PROBE
art ROBERT LO GRIPPO
design WILLIAM DUEVELL

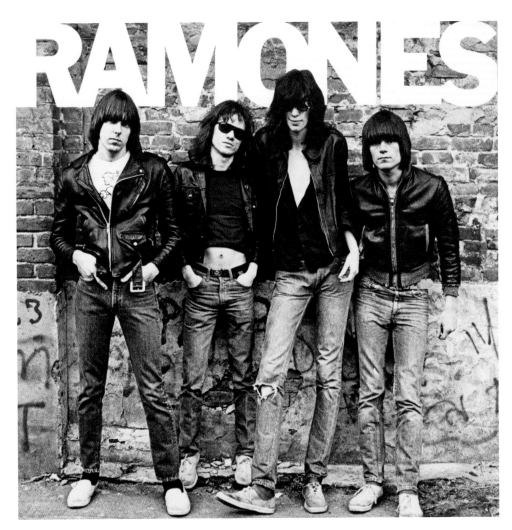

RAMONES

artist RAMONES
title RAMONES
year 1976
label SIRE
photo ROBERTA BAYLEY

The Ramones blew rock 'n' roll out of the sluggish waters it was treading with the release of their debut album. Full of machine-gun-fast songs with weirdo lyrics, the record clearly showed how the band was taking rock back to its roots while simultaneously propelling it into the future. The original cover design was to show the four band members in the same way as on the *Meet The Beatles!* cover, but despite a $2,000 photo shoot (the whole album only cost $6,400 to record) the pictures were not reckoned good enough by those in charge at the label. Instead they were taken by Roberta Bayley's raw black & white photo that was originally featured in *Punk* magazine and bought the rights, making that image into the iconic cover.

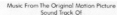

Music From The Original Motion Picture
Sound Track Of

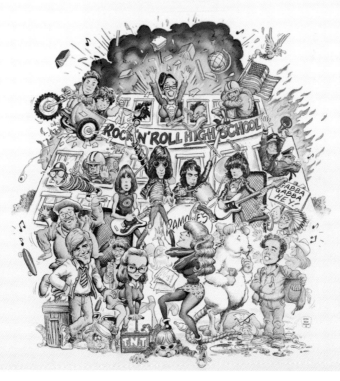

ROCK 'N' ROLL HIGH SCHOOL

A New World Pictures Release

RAMONES AND VARIOUS ARTISTS

artist RAMONES AND
 VARIOUS ARTISTS

title ROCK 'N' ROLL HIGH
 SCHOOL: MUSIC
 FROM THE ORIGINAL
 MOTION PICTURE
 SOUNDTRACK

year 1979

label SIRE

art WILLIAM STOUT

William Stout's intricate and versatile character and cartoon work can be seen in conjunction with the likes of the Yardbirds, Monty Python, countless natural history museums and Rhino Records, but his most recognizable work may be the film poster and cover art for *Rock 'n' Roll High School*. With more than 20 caricatures (and several more left off the final art), it's clear why Stout had received the 1978 Inkpot Award for Outstanding Achievement in Comic Arts from San Diego's Comic Con.

RATT

artist RATT
title OUT OF THE
CELLAR
year 1984
label ATLANTIC
ad BOB DEFRIN
photo BARRY LEVINE

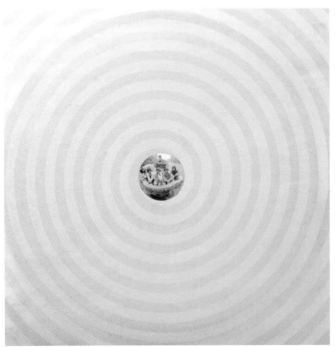

THE RATTLES

artist THE RATTLES
title RATTLES
PRODUCTION
year 1968
label FONTANA
ad SYNDICATE
KAI TORSTEN-
ELM RAABEN
design MICHAEL ROMPF
photo SYNDICATE
KAI TORSTEN-ELM
RAABEN

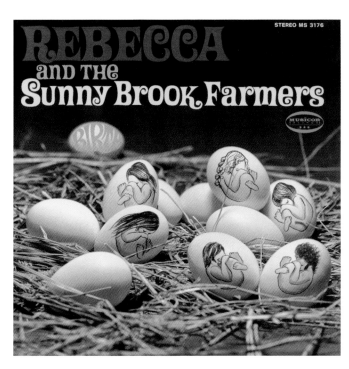

REBECCA AND THE SUNNY BROOK FARMERS

artist REBECCA AND THE
SUNNY BROOK
FARMERS
title BIRTH
year 1969
label MUSICOR

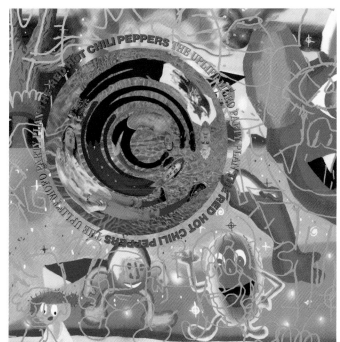

RED HOT CHILI PEPPERS

artist RED HOT CHILI
PEPPERS
title THE UPLIFT
MOFO PARTY PLAN
year 1987
label EMI/MANHATTAN
ad HENRY MARQUEZ
art GARY PANTER
photo NELS ISRAELSON

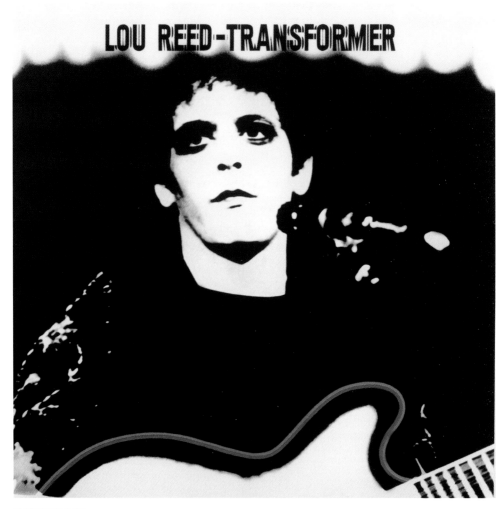
LOU REED-TRANSFORMER

LOU REED

artist LOU REED
title TRANSFORMER
year 1972
label RCA VICTOR
design ERNST THORMAHLEN
photo MICK ROCK

A blurring caused by a darkroom misprint caught the eye of photographer Mick Rock and this act of serendipity would result in one of the most recognizable cover images in rock history. On the back cover, by contrast, Reed's friend and designer Ernie Thormahlen appears very much in focus with a banana stuffed down his jeans. Co-produced by David Bowie and Spiders from Mars guitarist Mick Ronson, *Transformer* elevated the ex-Velvet Underground frontman from New York art-rocker to global superstar. This hit-laden second offering features such gems as "Satellite of Love," "Perfect Day" and "Walk on the Wild Side."

LOU REED

artist LOU REED
title ROCK N ROLL
ANIMAL
year 1974
label RCA
ad ACY R. LEHMAN
photo DEWAYNE
DALRYMPLE

A blast of brute force in the
wake of the commercial fail-
ure of Reed's high-falutin'
rock opera *Berlin*, the live
album *Rock N Roll Animal*
steers a primal course for
Reed's raw, street-sourced
lyricism and the arena-ready
guitar work of Dick Wagner
and Steve Hunter. A front-
and-center Reed in studs and
black lipstick leaves little to the
conceptual imagination, nor
does the record's hard-rock ap-
proach to Velvet Underground
classics such as "Heroin."

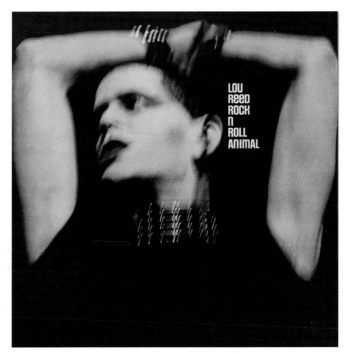

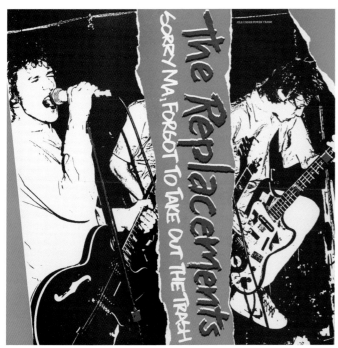

THE REPLACEMENTS

artist THE
REPLACEMENTS
title SORRY MA, FORGOT
TO TAKE OUT THE
TRASH
year 1981
label TWIN/TONE
design BRUCE C. ALLEN
photo GREG HELGESON

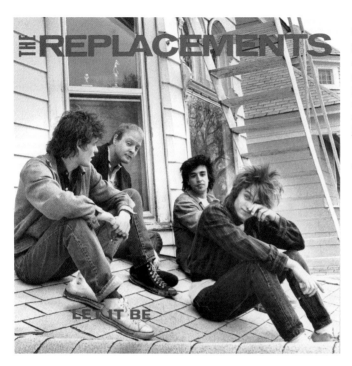

THE REPLACEMENTS

artist THE REPLACEMENTS
title LET IT BE
year 1984
label TWIN/TONE
design BRUCE C. ALLEN
photo DAN CORRIGAN

"They reminded me
personally of the early
Who—not musically, but
in your face. When I look
back at the negatives now,
I see that I didn't shoot
that much, which indicates
I was probably focused
on trying to figure them
out. I had photographed
countless bands, but this
was an eye-opener."

Greg Helgeson

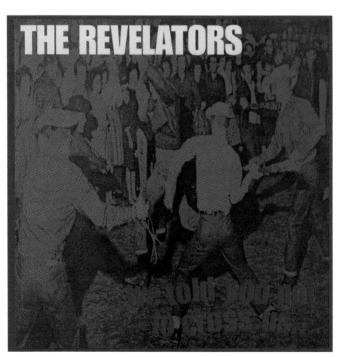

THE REVELATORS

artist THE REVELATORS
title WE TOLD YOU NOT
TO CROSS US
year 1997
label CRYPT

STEREO

JRLS-7004

PAUL REVERE & THE RAIDERS

artist PAUL REVERE
 & THE RAIDERS
title IN THE BEGINNING
year 1966
label JERDEN
art PETER WHORF
design PETER WHORF
 GRAPHICS

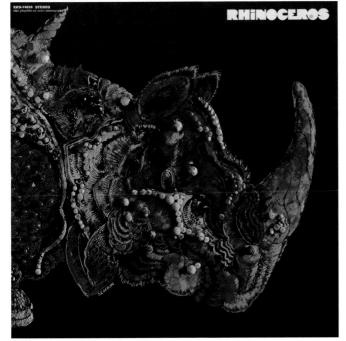

RHINOCEROS

artist RHINOCEROS
title RHINOCEROS
year 1968
label ELEKTRA
ad WILLIAM S.
 HARVEY
art GENE SZAFRAN

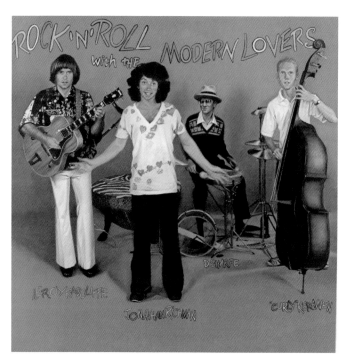

JONATHAN RICHMAN & THE MODERN LOVERS

artist JONATHAN RICHMAN & THE MODERN LOVERS
title ROCK 'N' ROLL WITH THE MODERN LOVERS
year 1977
label BESERKLEY
ad JIM BLODGETT
art WILLIAM SNYDER
photo CAROL FONDÉ

THE ROKES

artist THE ROKES
title I SUCCESSI DEI ROKES
year 1969
label ARC/KAN
design CORPOR ARTI GRAFICHE

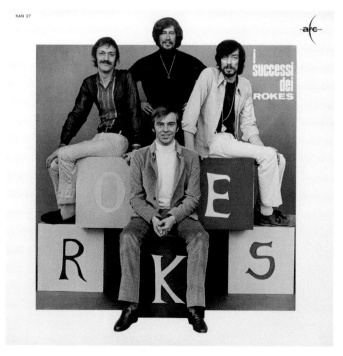

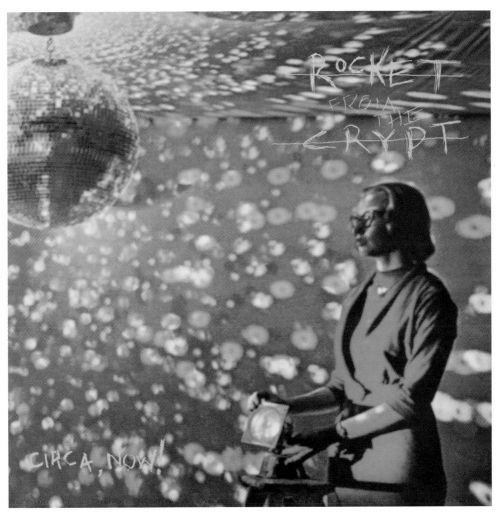

ROCKET FROM
THE CRYPT

artist ROCKET FROM
THE CRYPT
title CIRCA, NOW!
year 1992
label HEADHUNTER
design JONNY DONHOWE
photo JONNY DONHOWE

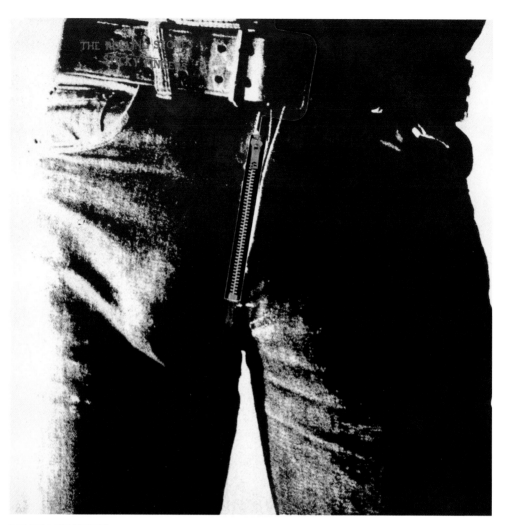

THE ROLLING STONES

artist THE ROLLING
 STONES
title STICKY FINGERS
year 1971
label ROLLING STONES
 RECORDS
design ANDY WARHOL
 (CONCEPT),
 CRAIG BRAUN
photo BILLY NAME

While rumors still swirl that the male, er, form on the cover is Mick Jagger's, rest assured, it isn't. Andy Warhol, who conceived the cover concept, had photographer Billy Name snap various men, but never revealed the identity of the model eventually selected (except that it wasn't Jagger). Craig Braun was responsible for the general design, which saw different functional transformations and once included a working zipper and belt.

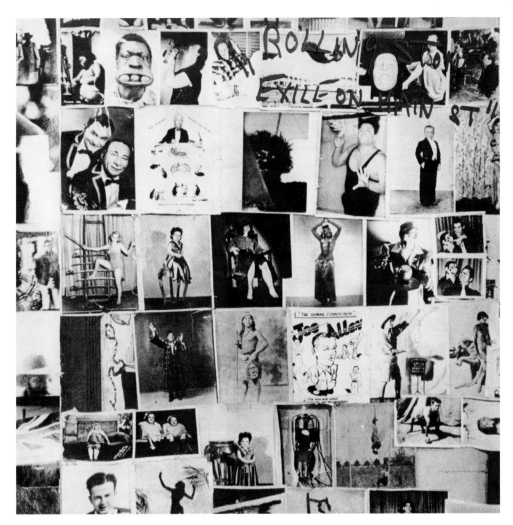

THE ROLLING STONES

artist THE ROLLING
STONES
title EXILE ON MAIN ST
year 1972
label ROLLING STONES
RECORDS
design JOHN VAN
HAMERSVELD
photo ROBERT FRANK

This disorienting collage was as confounding to 1972 audiences as the album's free-wheeling sonic pastiche, heralded later as one of the Stones' best. With drafting tape and torn paper, John Van Hamersveld fashioned Robert Frank's photographs into a prescient composition that foretold the later punk aesthetic in popular culture. Twelve perforated postcards of Norman Seeff's work were included as a peace offering from Keith Richards, whose heroin-fueled antics had derailed the photographer's earlier shoot for the album.

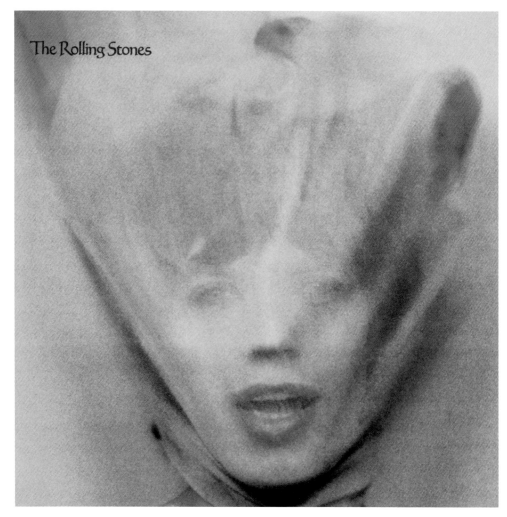

The Rolling Stones

THE ROLLING STONES

artist THE ROLLING STONES
title GOATS HEAD SOUP
year 1973
label ROLLING STONES RECORDS
design DAVID BAILEY, RAY LAWRENCE
photo DAVID BAILEY

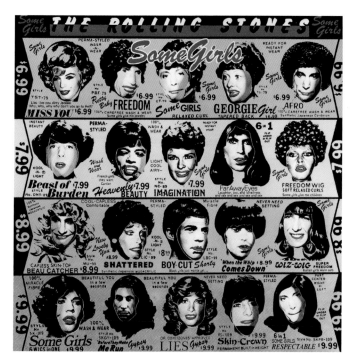

THE ROLLING STONES

artist THE ROLLING
STONES
title SOME GIRLS
year 1978
label ROLLING STONES
RECORDS
art HUBERT
KRETZSCHMAR
design PETER CORRISTON

ROYAL TRUX

artist ROYAL TRUX
title TWIN INFINITIVES
year 1990
label DRAG CITY

The resumés of Neil Hagerty
and Jennifer Herrema reflect
the birth of Drag City, several
bands, including Pussy Galore,
guest appearances, production
credits and numerous addic-
tions. While half the band—
Herrema—may be best recog-
nized for turning heroin chic
into an actual look for Calvin
Klein, their discography
includes more than a dozen
releases. All of Royal Trux's
cover art reflects their sound
flawlessly—echoing the lo-fi,
grungy pre-White Stripes
simplicity of their tunes.

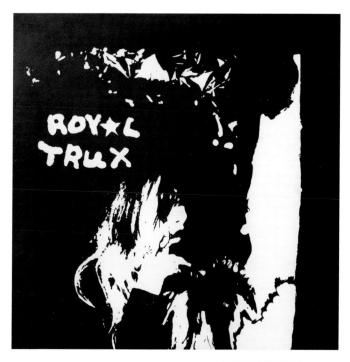

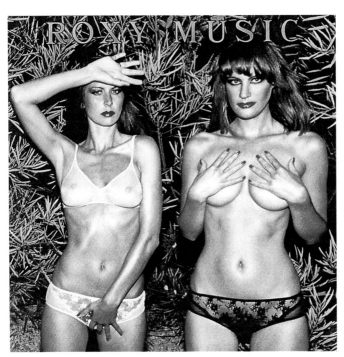

ROXY MUSIC

artist ROXY MUSIC
title COUNTRY LIFE
year 1974
label ISLAND/ATCO
ad BRYAN FERRY
design NICHOLAS
DE VILLE
photo ERIC BOMAN

THE RUNAWAYS

artist THE RUNAWAYS
title QUEENS OF NOISE
year 1977
label MERCURY
design DESMOND STROBEL
photo BARRY LEVINE

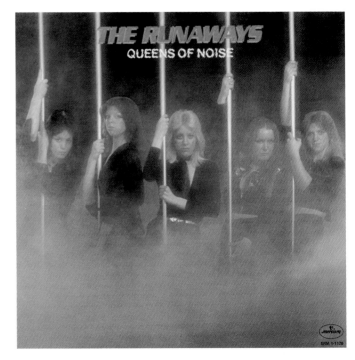

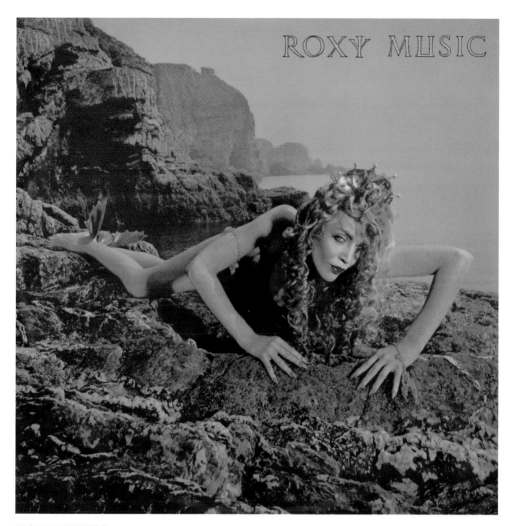

ROXY MUSIC

ROXY MUSIC
artist ROXY MUSIC
title SIREN
year 1975
label ATCO
art ANTONY PRICE
design JERRY HALL,
 BRYAN FERRY,
 GRAHAM HUGHES,
 ANTONY PRICE,
 NICHOLAS DE VILLE,
 BOB BOWKETT,
 CELINE, ADRIAN
 HUNTER
photo GRAHAM HUGHES

Many of Roxy Music's covers featured a current love interest of Bryan Ferry (that's one way to hook, line and sinker). Jerry Hall was posed seductively on the rocks of an island off the coast of Wales for the group's fifth cover. Conceptualized by Ferry, sketched by Antony Price and eventually photographed by Graham Hughes, the image shows Hall as the ideal *Siren* for this album. Apparently she wasn't too wooed by the modeling gig, however, as she left fiancé Ferry for Mick Jagger a couple of years later.

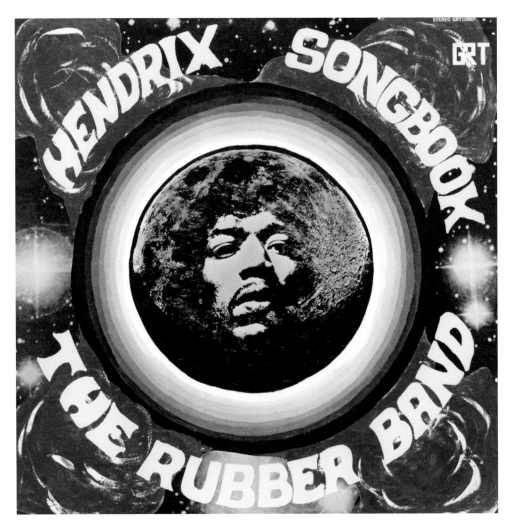

THE RUBBER BAND

artist THE RUBBER BAND
title HENDRIX SONGBOOK
year 1969
label GRT
art JOHN POWERS
design FITZPOW! GRAPHICS
COMPANY
photo JOHN PTAK

ED RUDY WITH THE BEATLES

artist ED RUDY WITH
THE BEATLES
title THE BEATLES –
THE AMERICAN
TOUR
year 1964
label I-N-S RADIO NEWS

ED RUDY WITH THE ROLLING STONES

artist ED RUDY WITH THE
ROLLING STONES
title IT'S HERE LUV!!!
STONES
year 1965
label I-N-S RADIO NEWS

MIKE RUSSO, JEANNE HAYES AND THE DELLWOODS

artist MIKE RUSSO,
JEANNE HAYES
AND THE
DELLWOODS
title MAD TWISTS
ROCK 'N' ROLL
year 1962
label BIG TOP
art MORT DRUCKER

S.O.D.

artist S.O.D.
STORMTROOPERS
OF DEATH
title SPEAK ENGLISH
OR DIE
year 1985
label MEGAFORCE
art CHARLIE BENANTE

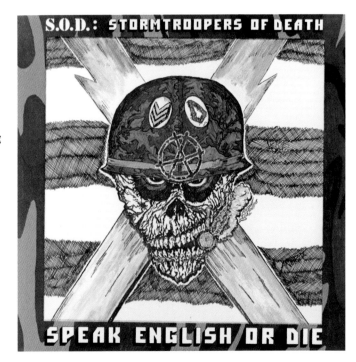

THE ORIGINAL SOUND-TRACK MUSIC FROM [1832]

BRUCE BROWN'S

The Endless Summer

THE SANDALS

THE SANDALS

artist THE SANDALS
title THE ORIGINAL SOUND-
TRACK MUSIC FROM
BRUCE BROWN'S THE
ENDLESS SUMMER
year 1966
label WORLD-PACIFIC
design JOHN VAN
HAMERSVELD

*"This album was recorded start to finish in 12 days.
This was my first involvement in a movie soundtrack.
We scored some of the music in the studio with
actual footage of the film on the screen in front of us.
Originally I was going to do one song for the film, but
after the director Bruce Brown heard some of my
demos, he hired me to do the whole score. Being a part
of such a classic film re-make was a thrill and a great
experience."* – Gary Hoey

THE SANDALS 359

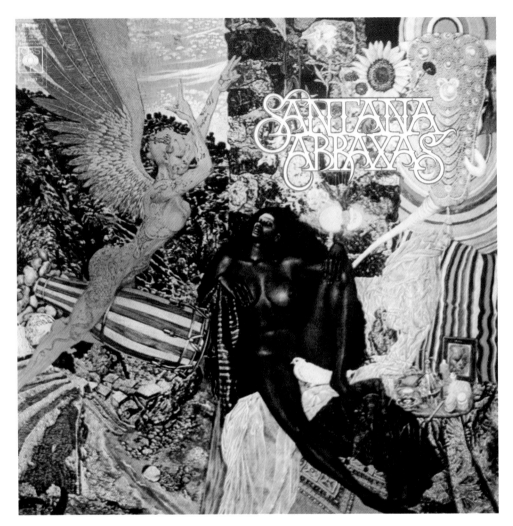

SANTANA

artist SANTANA
title ABRAXAS
year 1970
label CBS
art MATI KLARWEIN
design ROBERT VENOSA

"Years later Carlos Santana saw a reproduction of the Annunciation *in a magazine and wanted it for the cover of his all-time best-selling* Abraxas *album. It did me a world of good. I saw the album pinned to the wall in a shaman's mud hut in Niger and inside a Rastafarian's ganja-hauling truck in Jamaica. I was in good global company, muchissimas gracias, Carlito!"*

Mati Klarwein

SANTANA

artist SANTANA
title III
year 1971
label COLUMBIA
design HEAVY WATER
 LIGHT SHOW

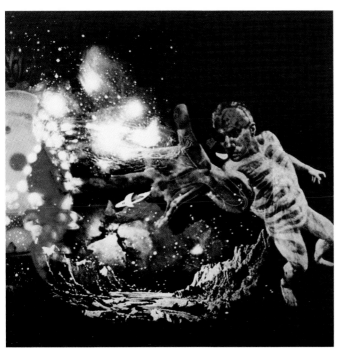

Comprising Mary Ann Mayer, Joan Chase and John Hardman, the San Francisco-based Heavy Water Light Show was a collective of visual artists, using modified light projectors to craft fluid, psychedelic imagery to accompany musical performances. They helped enhance concert experiences for Jefferson Airplane and the Grateful Dead, eventually touring planetariums throughout the United States.

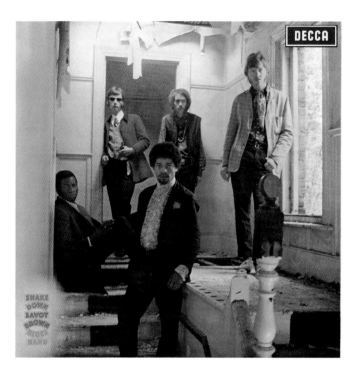

SAVOY BROWN BLUES BAND

artist SAVOY BROWN
 BLUES BAND
title SHAKE DOWN
year 1967
label DECCA

Never released in the US, this
first studio outing by British
blues rock band Savoy Brown
features a selection of covers
of blues legends Willie Dixon,
B.B. King and others. Found-
ing member and guitarist
Kim Simmonds was a key
figure in the British blues
movement in the '60s, whilst
the band's first vocalist Bryce
Portius was one of the UK's
first black rock musicians.

SBB

artist SBB
title SBB
year 1974
label POLSKIE NAGRANIA
 MUZA

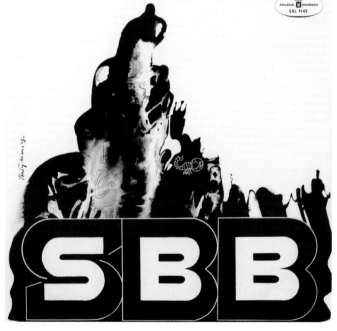

SCATMAN CROTHERS

artist SCATMAN
CROTHERS
title ROCK 'N ROLL
WITH "SCAT MAN"
year 1956
label TOPS

Although known primarily as
an actor, Benjamin Sherman
Crothers got his start as a
musician, nicknaming himself
"Scatman" in 1932 to stand
out at radio auditions. He
voiced animated characters
in Disney's *The Aristocats* and
Ralph Bakshi's *Coonskin*, and
appeared alongside famous
friend Jack Nicholson in *One
Flew Over the Cuckoo's Nest*
and *The Shining*.

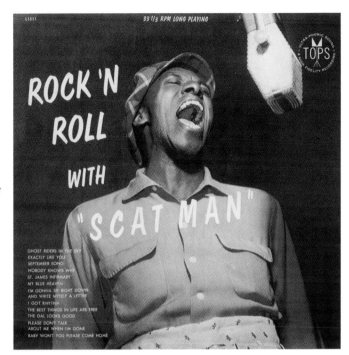

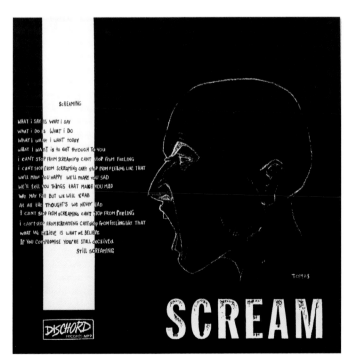

SCREAM

artist SCREAM
title STILL SCREAMING
year 1983
label DISCHORD
art TOMAS
design JEFF NELSON

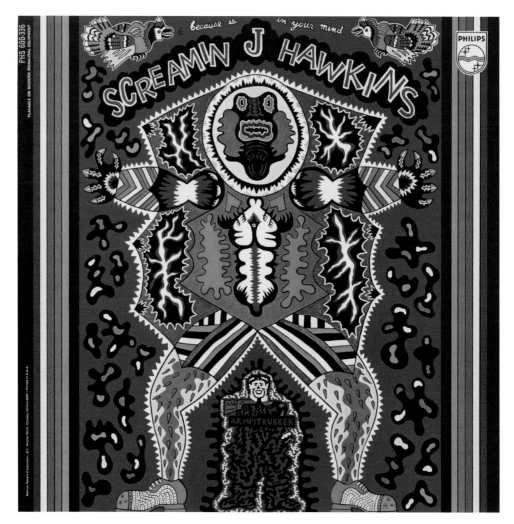

SCREAMIN' JAY HAWKINS

artist SCREAMIN' JAY
 HAWKINS
title BECAUSE IS IN
 YOUR MIND
year 1970
label PHILIPS
art KARL WIRSUM,
 THE ART INSTITUTE
 OF CHICAGO

SEBADOH

artist SEBADOH
title BAKESALE
year 1994
label SUB POP
design JEFF KLEINSMITH

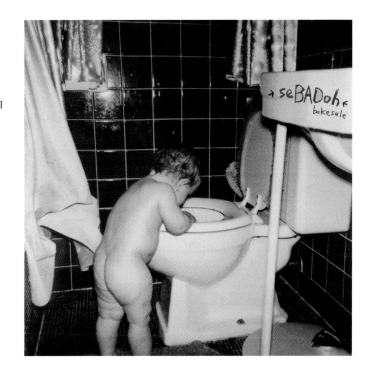

THE SEEDS

artist THE SEEDS
title FUTURE
year 1967
label GNP CRESCENDO
art SKY SAXON
design SKY SAXON

This delightfully unpredictable
and at times disparate psyche-
delic opus finds the garage-
punk forefathers borrowing
from the trippy orchestral
blueprint of *Sgt. Pepper* while
clinging to their buzz-saw
guitars with a death grip. The
gestural, puzzle-piece cover
drawing bubbled from the
mind-spring of Seeds boss
Sky Saxon, who made sure
to include "your imagination"
in the album credits.

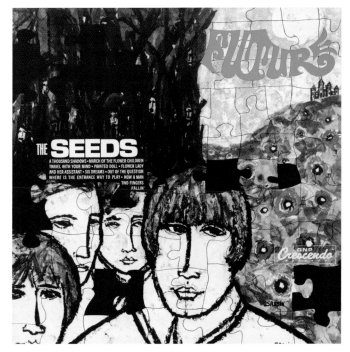

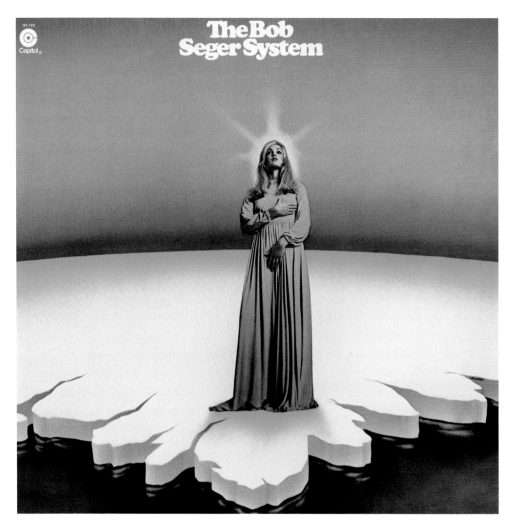

THE BOB SEGER
SYSTEM

artist THE BOB SEGER
 SYSTEM
title RAMBLIN'
 GAMBLIN' MAN
year 1969
label CAPITOL

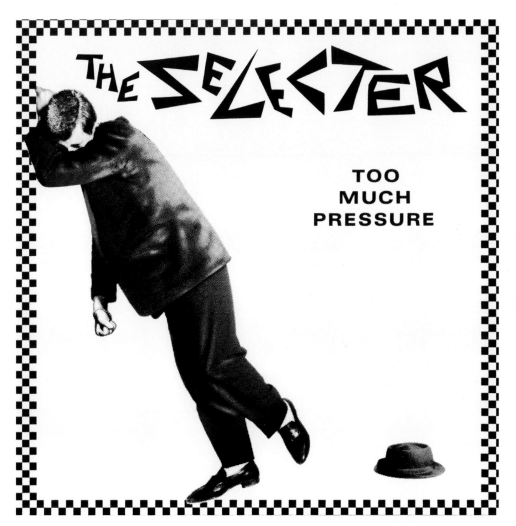

THE SELECTER

artist THE SELECTER
title TOO MUCH
PRESSURE
year 1980
label CHRYSALIS
design DAVID STOREY,
JOHN 'TEFLON'
SIMS
photo NICK MANN

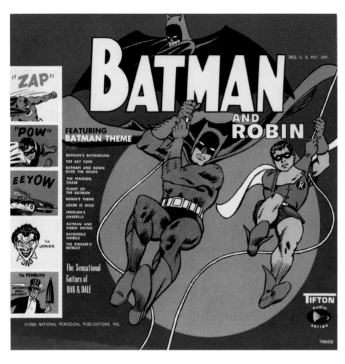

THE SENSATIONAL GUITARS OF DAN AND DALE

artist THE SENSATIONAL
GUITARS OF DAN
AND DALE
title BATMAN AND ROBIN
year 1966
label TIFTON

Tom Wilson produced this quick,
knock-off record to catch the
Batman fever that was sweeping
the USA after the TV show
became a hit in 1966. Luckily
he hired some of the most
interesting cats gigging in the
New York area to lay down the
groovy sessions, including Sun
Ra and members of his Arkestra
as well as Al Kooper's Blues
Project. Outside of Neal Hefti's
"Batman Theme" the tunes were
mostly in the public domain
(Chopin, Tchaikovsky and Bach)
or featured riffs on popular songs
by the Beatles and Booker T.

SEPTIC DEATH

artist SEPTIC DEATH
title TIME IS THE BOSS-
AAARRGGH IT'S
LIVE!
year 1985
label DELUXE
art BRIAN 'PUSHEAD'
SCHROEDER

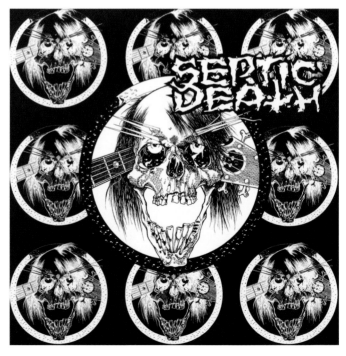

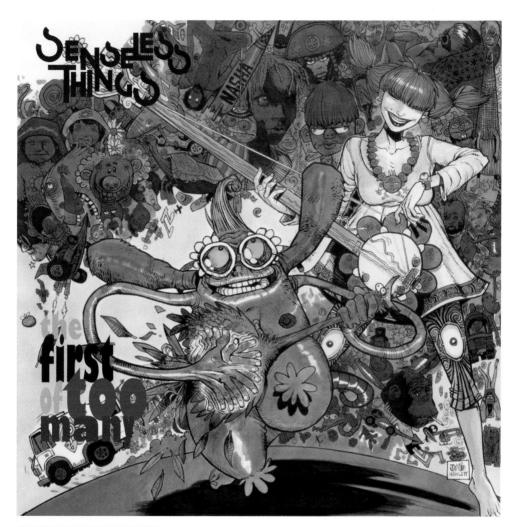

SENSELESS THINGS

artist SENSELESS THINGS
title THE FIRST
OF TOO MANY
year 1991
label EPIC
art JAMIE HEWLETT
design TOMCAT

Jamie Hewlett's journey from Note British beginnings to co-creator of super-group Gorillaz had many notable milestones, this album being one. With a solid career rooted in comic-book design, Hewlett was once best known for the creation of *Tank Girl*, a project that saw success second only to Gorillaz with the release of the 1995 film. Hewlett's distinct style and oddball caricatures fed perfectly into the album art for *The First of Too Many*, embodying the young, poppy sound of Senseless Things.

THE SEX PISTOLS

artist THE SEX PISTOLS
title NEVER MIND THE
BOLLOCKS, HERE'S
THE SEX PISTOLS
year 1977
label VIRGIN
ad MALCOLM MCLAREN
design JAMIE REID

A fortuitous alignment of anti-establishment attitudes, a bass-player who couldn't play, a wheeler-dealer manager, a wild, snarling frontman and an amazingly explicit cover: all the ingredients of pure, unadulterated punk. The album's title supposedly originated from a phrase picked up by guitarist Steve Jones who had overheard a couple of fans saying "never mind the bollocks" repeatedly to each other. It immediately rattled the censors and had police descending on record shops to confiscate the offending covers and advertising posters. In response, the musical press issued advertisements with the message, "The album will last. The sleeve may not." Several misprints appeared in different variations of the original pressing, with Reid purportedly having a direct hand in mis-spelling the black letters, which were corrected in their respective territories.

SHANGRI-LAS

artist SHANGRI-LAS
title SHANGRI-LAS – 65!
year 1965
label RED BIRD

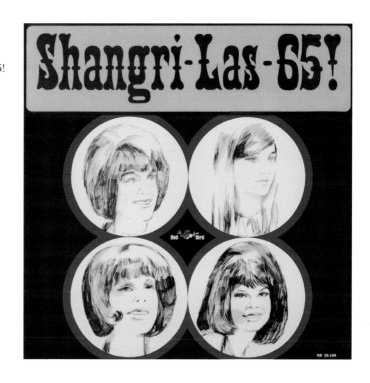

SHADOWS OF KNIGHT

artist SHADOWS OF
KNIGHT
title SHADOWS OF
KNIGHT
(FEATURING
FOLLOW/ALONE/
SHAKE)
year 1968
label SUPER K
photo JOEL BRODSKY

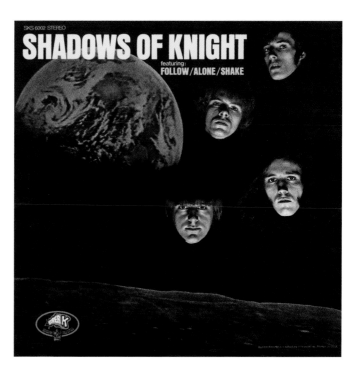

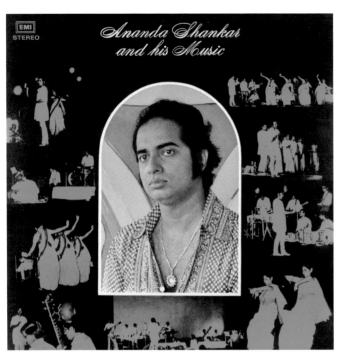

ANANDA SHANKAR

artist ANANDA SHANKAR
title ANANDA SHANKAR
AND HIS MUSIC
year 1975
label HIS MASTER'S
VOICE, THE
GRAMOPHONE
COMPANY OF INDIA
photo SOUMITRA SINHA,
SHUBHASH NANDY

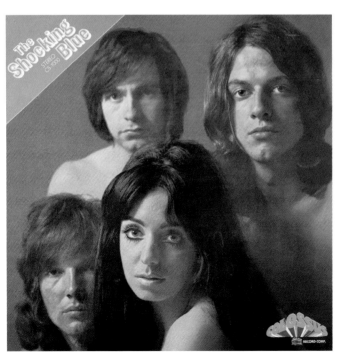

**THE
SHOCKING BLUE**

artist THE
SHOCKING BLUE
title THE
SHOCKING BLUE
year 1970
label COLOSSUS
design DAVID E. KRIEGER

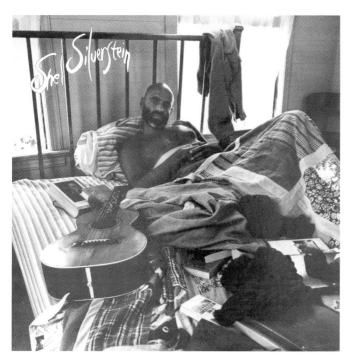

SHEL SILVERSTEIN

artist SHEL SILVERSTEIN
title SONGS AND STORIES
year 1978
label PARACHUTE
photo LAWSON LITTLE

Best known for writing and illustrating seminal children's books *The Giving Tree*, *Where the Sidewalk Ends* and *A Light in the Attic*, Silverstein first gained notoriety as a cartoonist for *Playboy*. Lawson Little spent the '70s and '80s photographing Key West's creative transplants, among them Jimmy Buffett, David Allan Coe and Tennessee Williams. His photos for *Songs and Stories* were taken in Silverstein's home on William Street.

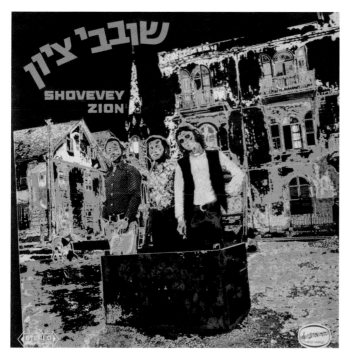

SHOVEVEY ZION

artist SHOVEVEY ZION
title SHOVEVEY ZION
year 1971
label HED-ARZI

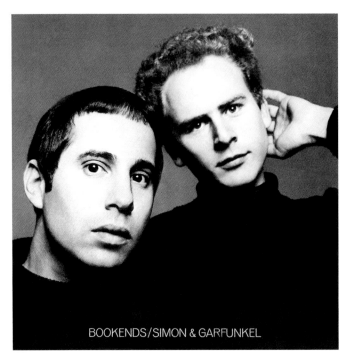

SIMON & GARFUNKEL

artist SIMON & GARFUNKEL
title BOOKENDS
year 1968
label COLUMBIA
photo RICHARD AVEDON

Richard Avedon was one of the best ever at creating iconic images. For Simon & Garfunkel's fourth release he set up an almost abstract design playing masterfully with the dark organic shapes of the boys' turtlenecks and the overblown whiteness of their skin. The crisp black and white portrait of quiet disquiet reflects the inquisitive, ethereal and succinct (clocking in at just under 30 minutes) view of American life the duo portrayed on the record.

NANCY SINATRA

artist NANCY SINATRA
title BOOTS
year 1966
label REPRISE
ad ED THRASHER
photo ED THRASHER

"When I die, I already know what my obituary will be, 'Frank's daughter died with her boots on!' Ha."

Nancy Sinatra

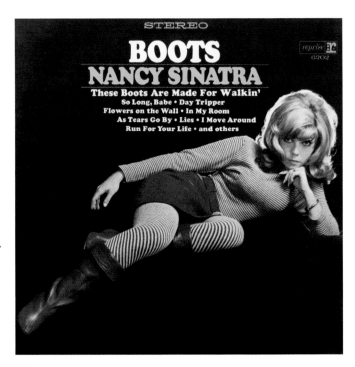

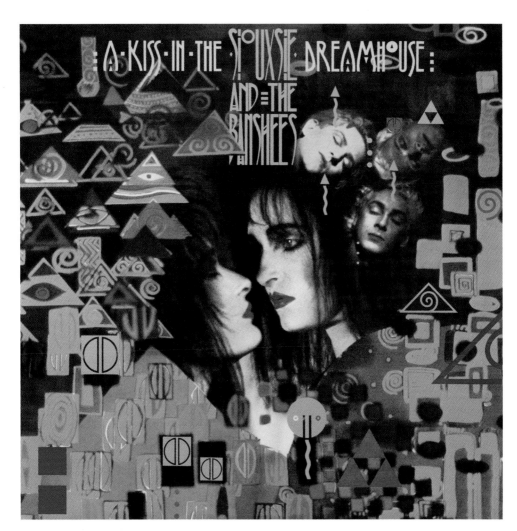

SIOUXSIE AND THE BANSHEES

artist SIOUXSIE AND THE
 BANSHEES
title A KISS IN THE
 DREAMHOUSE
year 1982
label POLYDOR
design SIOUXSIE (CONCEPT),
 ROCKING RUSSIAN
photo MICHAEL KOSTIFF

This sonic excursion by the post-punk goth pioneers heralded a
new direction in the band's sound into studio experimentation
using multiple instruments and effects. The Gustav Klimt-
inspired cover design added a deep lushness to reflect the
album's scintillating production. Bass-player Steven Severin took
the "Dreamhouse" in the title from a TV documentary he had
seen about an LA brothel in the 1940s where clients could meet
prostitutes who had undergone cosmetic surgery in order to
resemble Hollywood movie stars.

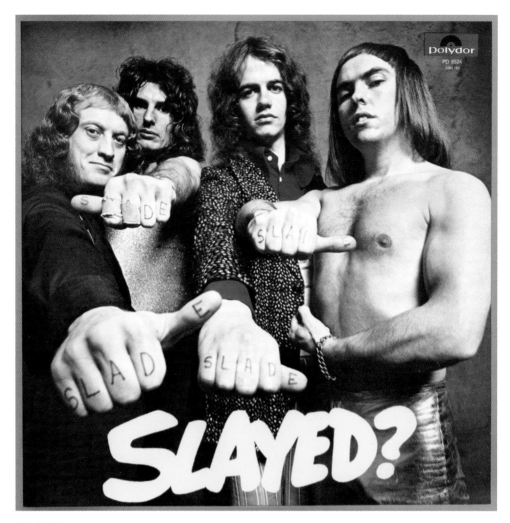

SLADE

artist SLADE
title SLAYED?
year 1972
label POLYDOR
photo GERED MANKOWITZ

Featuring such deliberately mis-spelled titles as "Gudbuy t'Jane" and "Mama Weer All Crazee Now," this second album release by Slade enjoyed a long transatlantic chart run in its first year of release. Hailing from a region in the English Midlands known as the Black Country, Slade went on to become a glam rock institution, with the writing partnership of screechy-voiced frontman Noddy Holder and bass-player Jim Lea producing a multitude of hits. Following an invitation to go on tour with the Rolling Stones in the '60s, young and upcoming photographer Gered Mankowitz found himself snapping the likes of Jimi Hendrix, Free and the Yardbirds.

THE SLITS

artist THE SLITS
title CUT
year 1979
label ISLAND
photo PENNIE SMITH

This predominantly female punk band asserted themselves on the UK scene with a line-up including such names as Ari Up, Palmolive, Kate Korus and Suzy Gutsy. During this time, the Slits toured with the Clash and featured in *The Punk Rock Movie* (1978), whilst among the personnel on *Cut* is future solo artist Neneh Cherry. The album's raunchy cover photo, which apparently influenced Palmolive to leave the band, was taken by *NME* staffer Pennie Smith, who spent her career photographing rock musicians from Led Zeppelin to Radiohead.

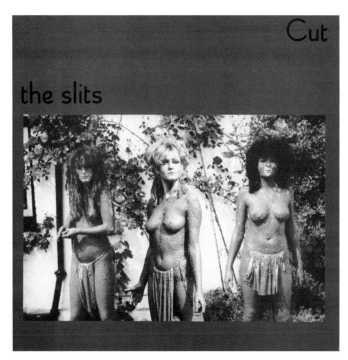

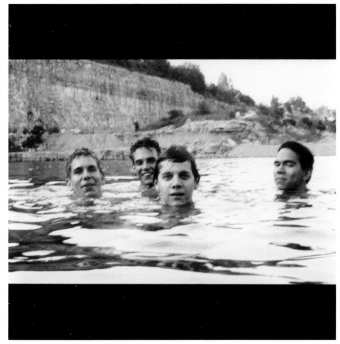

SLINT

artist SLINT
title SPIDERLAND
year 1991
label TOUCH AND GO
photo WILL OLDHAM

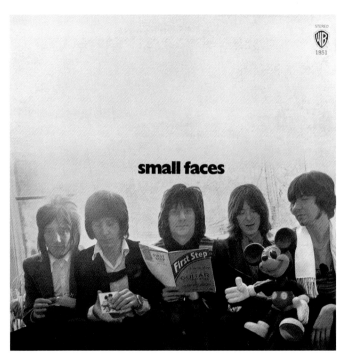

SMALL FACES

artist SMALL FACES
title FIRST STEP
year 1970
label WARNER BROS.
photo MIKE MCINNERNEY,
MARTIN COOK

After the band's second single, "I've Got Mine," failed to find favor with the British youth, the Small Faces' founding keyboardist and vocalist, Jimmy Winston, was replaced by career keyboardist Ian McLagan. It is the latter who appears on the cover of this album, along with credits for a couple of the songs.

HUEY 'PIANO' SMITH

artist HUEY 'PIANO' SMITH
title ROCKIN' PNEUMONIA AND THE BOOGIE WOOGIE FLU
year 1965
label SUE
design GUY STEVENS

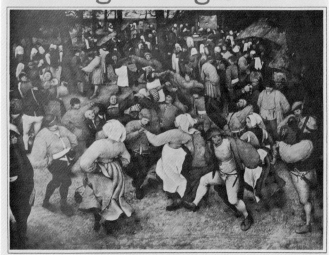

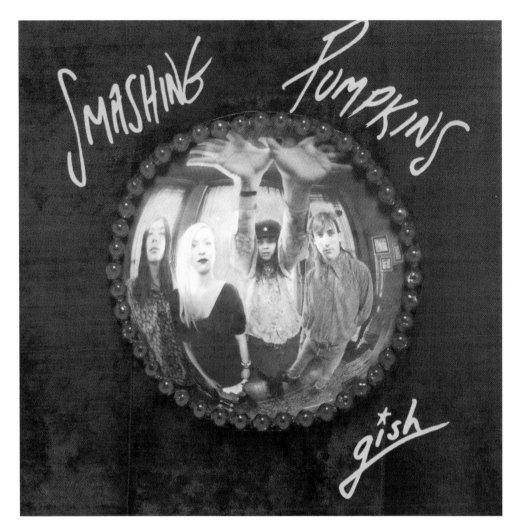

SMASHING PUMPKINS

artist SMASHING
PUMPKINS
title GISH
year 1991
label CAROLINE
design D'ARCY
photo ROBERT KNAPP

Billy Corgan told the *Chicago Tribune* in 1990 that: "My grand-mother used to tell me that one of the biggest things that ever happened was when Lillian Gish rode through town on a train. My grandmother lived in the middle of nowhere, so that was a big deal..." Hats off to "The First Lady of American Cinema," Lillian Gish, for giving her name to an album that skyrocketed the sound of the '90s. The Smashing Pumpkins' shift from their original psychedelic, new-wave leaning into the heavy alternative rock they're known for today was represented in every aspect of this album—from its songs to its edgy cover art.

THE SMITHS

artist THE SMITHS
title MEAT IS MURDER
year 1985
label ROUGH TRADE/SIRE
design MORRISSEY
(SLEEVE),
CARYN GOUGH

"Make War Not Love" were the words originally scrawled across Marine Cpl. Michael Wynn's helmet in Vietnam before the Smiths used it for their 1985 sophomore release. While the replacement wording is clearly a bugle call for vegetarianism, with the road the Smiths took to their ultimate demise perhaps they should have just kept the image's original message. Had the Smiths been a military unit, Morrissey would have been the sergeant, ordering his ranks not to be seen or photographed whilst eating meat and forcing them to cover '60s pop songs. No matter the reason, the band only made it for a couple more years—and aren't likely to see the light of day again: in 2006 Morrissey told *Gigwise* that he "would rather eat my own testicles than reform the Smiths, and that's saying something for a vegetarian."

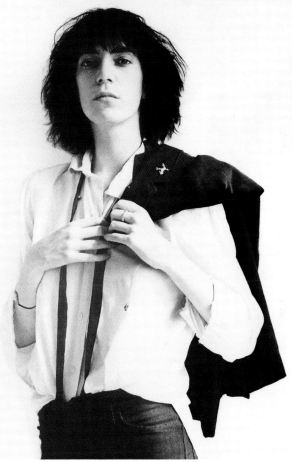

PATTI SMITH

artist PATTI SMITH
title HORSES
year 1975
label ARISTA
design BOB HEIMALL
photo ROBERT
 MAPPLETHORPE

Patti Smith created Patti Smith. As a young NYC transplant from New Jersey in 1967, she would try to get into the skin and head-space of her favorite artists by copying their gestures, whilst stealing art supplies or shacking up with her lover, Robert Mapplethorpe, at the Chelsea Hotel. He took the iconic cover photo for *Horses* as she struck her pose and imagined she was Anna Karina being filmed by Jean-Luc Godard. The same wild beauty he captured permeates this debut release and fills it with a dark, defiant romanticism that would herald punk and new wave.

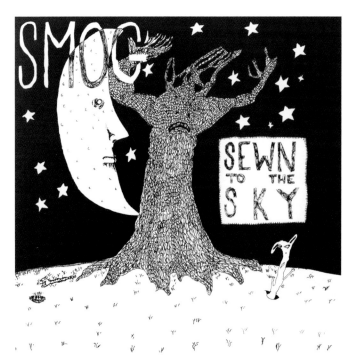

SMOG

artist SMOG
title SEWN TO THE SKY
year 1990
label DISASTER
art BILL SMOG
design BILL SMOG

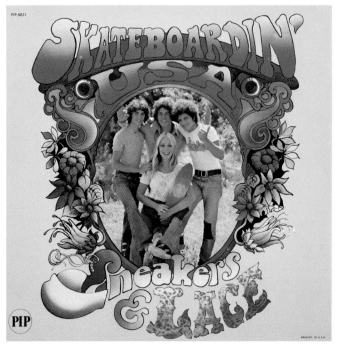

SNEAKERS & LACE

artist SNEAKERS & LACE
title SKATEBOARDIN'
USA
year 1976
label P.I.P.
ad FRANK DANIEL
art MICHAEL SEAN
WALSH
design PHYLLIS FEIL
photo SIMONE CHERPITEL

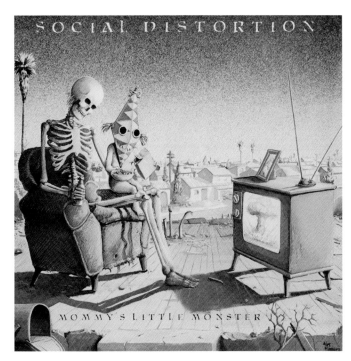

SOCIAL DISTORTION

artist SOCIAL DISTORTION
title MOMMY'S LITTLE
MONSTER
year 1983
label 13TH FLOOR
art ART MORALES

Recorded on Christmas Eve in
Fullerton, CA, this is the first
release for the seminal punk
band that would spawn drug
addiction, solo careers and a
rotating cast of characters.
That said, neither the young
West Coast punk rockers nor
artist Art Morales probably
ever imagined that any por-
tion of the art for this album
would eventually end up on
baby onesies, but even punk
has to grow up some time.

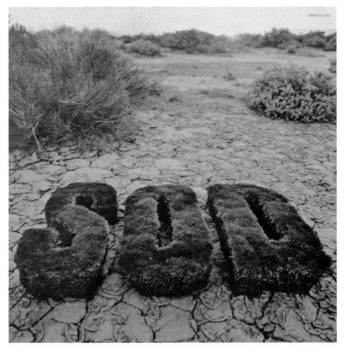

SOD

artist SOD
title SOD
year 1971
label DECCA/MCA
design JOHN C. LEPREVOST
photo JOHN C. LEPREVOST

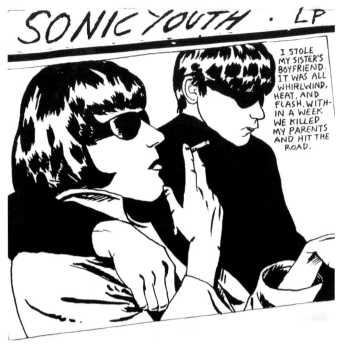

SONIC YOUTH

artist SONIC YOUTH
title GOO
year 1990
label DGC
ad KEVIN REAGAN
art RAYMOND PETTIBON

At the start of the 1990s the alternative nation was just gearing up for war with the status quo, when the status quo came to them. Leading the charge was Sonic Youth's major label debut, it was a kool thing for sure. A photo of Maureen Hindley and David Smith on their way to the murder trial of Maureen's sister Myra and Ian Brady inspired Raymond Pettibon's black and white cover art. The band had always flirted with delinquent chic and this coming-out party was just the kind of bloody mess the world needed.

SODOM

artist SODOM
title OBSESSED
 BY CRUELTY
year 1986
label METAL BLADE /
 RESTLESS
art REINHARD
 WIECZOREK
design WITCHHUNTER,
 ANGEL RIPPER

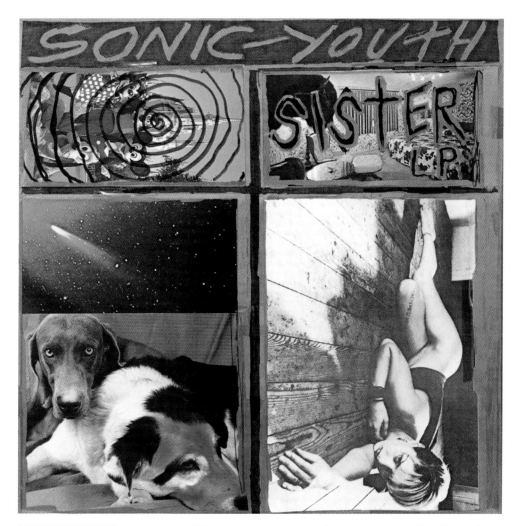

SONIC YOUTH

artist SONIC YOUTH
title SISTER
year 1987
label SST

The most interesting visual elements of Sonic Youth's fourth studio album aren't actually visible. The LP's original sleeve featured a photograph of a brooding 12-year-old girl in the upper-left corner, which was shot by controversial photographer Richard Avedon but blacked out after he threatened a lawsuit. Spooked by legal hang-ups, SST placed a bar code over an image of cartoon characters Mickey, Minnie, Goofy and Pluto in Disney's Magic Kingdom that appears on the flip side.

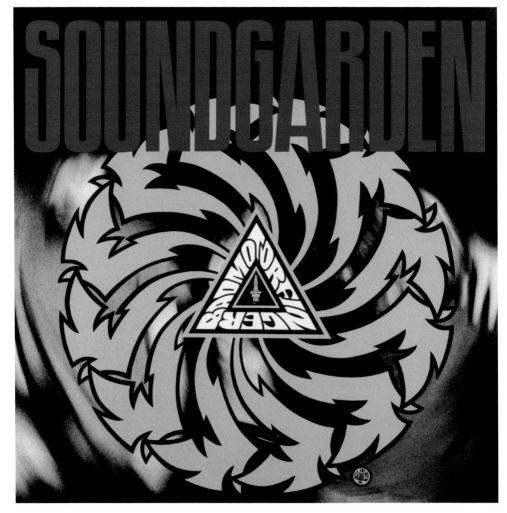

SOUNDGARDEN

artist SOUNDGARDEN
title BADMOTORFINGER
year 1991
label A&M
ad LEN PELTIER
art MARK DANCEY
design WALBERG DESIGN
photo MICHAEL LAVINE

With grunge songs flooding America like Seattle's rain, Soundgarden's third studio release had no problem finding a huge spot in music history and reaching number 39 on the *Billboard* charts. The cover, designed by Big Chief's guitarist Mark Dancey, was released in two versions with different coloring. While the name sounds like an inside joke with deeper meaning, it's really not: lead guitarist Kim Thayil simply liked that it "conjured up a lot of different images," although he has also joked that it's a play on the Montrose song "Bad Motor Scooter."

SOPWITH CAMEL

artist SOPWITH CAMEL
title SOPWITH CAMEL
year 1967
label KAMA SUTRA
ad GLEN CHRISTENSEN
art VICTOR MOSCOSO

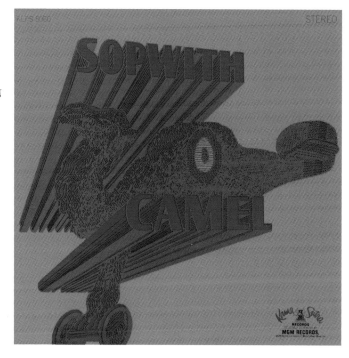

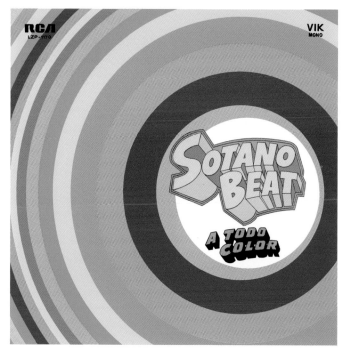

SOTANO BEAT

artist SOTANO BEAT
title A TODO COLOR
year 1970
label RCA VIK

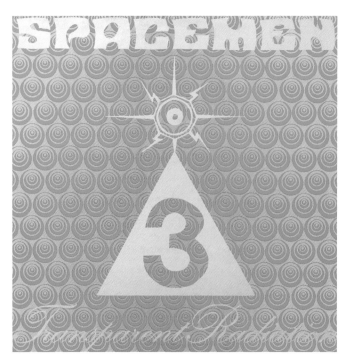

SPACEMEN 3

artist SPACEMEN 3
title TRANSPARENT
RADIATION
year 1987
label GLASS
design SPACEMEN 3

This long-running EP, which
tops out at nearly 40 minutes,
is an essential for followers of
J. Spaceman and Sonic Boom.
The five-song journey into the
British quartet's psychedelic
cosmos creeps to a start with
a hushed cover of the Red
Krayola track "Transparent
Radiation" and ends in a
meandering, psychotropic
take on the MC5's "Starship,"
based on a poem by free jazz
pioneer Sun Ra.

SPARKS

artist SPARKS
title BIG BEAT
year 1976
label COLUMBIA
ad RON CORO
design TOM STEELE
photo RICHARD AVEDON

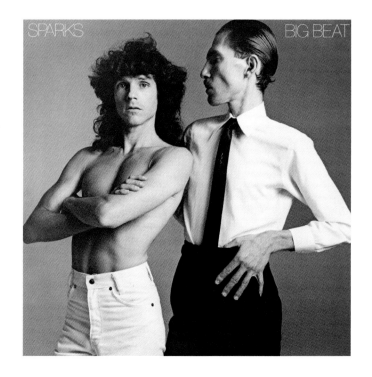

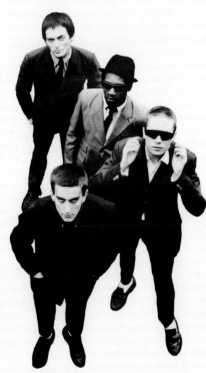

SPECIALS

A MESSAGE TO YOU RUDY

DO THE DOG

IT'S UP TO YOU

NITE KLUB

DOESN'T MAKE IT ALRIGHT

CONCRETE JUNGLE

TOO HOT

MONKEY MAN

(DAWNING OF A) NEW ERA

BLANK EXPRESSION

STUPID MARRIAGE

TOO MUCH TOO YOUNG

LITTLE BITCH

YOU'RE WONDERING NOW

2 TONE
RECORDS

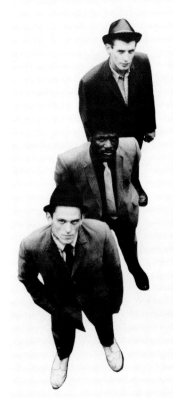

THE SPECIALS

artist THE SPECIALS
title SPECIALS
year 1979
label 2 TONE
design CAROL STARR,
CHALKIE DAVIES
photo CAROL STARR,
CHALKIE DAVIES

The Specials' debut defined the second-wave Ska revival and hit the UK like a ton of bricks, sending the band shooting into the music charts top ten. The newly formed creative team of Carol Starr and Chalkie Davies crafted the high-impact, yet simple graphics for the cover; they went on to help shape the look of rock record sleeves for about a decade before focusing on still-life photography, which required much less travel. Before they hung up their music hats, Davies+Starr shot the likes of Elvis Costello, Pink Floyd and Elton John, and in 2015 the National Museum of Wales will host an exhibition of the pair's iconic portraits in a much anticipated retrospective.

DUSTY
SPRINGFIELD

artist DUSTY SPRINGFIELD
title DUSTY IN MEMPHIS
year 1969
label ATLANTIC
photo DAVID REDFERN

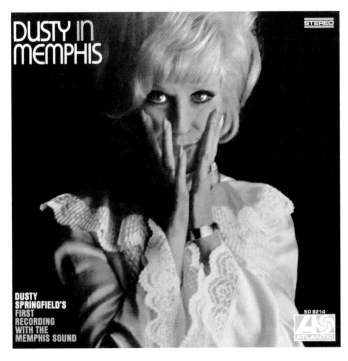

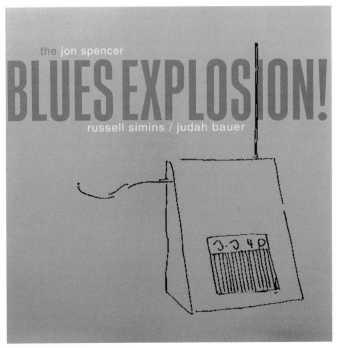

THE JON SPENCER
BLUES EXPLOSION

artist THE JON SPENCER
BLUES EXPLOSION
title ORANGE
year 1994
label MATADOR

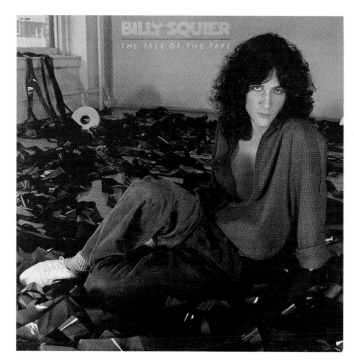

BILLY SQUIER

artist BILLY SQUIER
title THE TALE OF
THE TAPE
year 1980
label CAPITOL
design BOB HEIMALL (AGI)
photo DICK KRANZLER

SS DECONTROL

artist SS DECONTROL
title GET IT AWAY
year 1983
label XCLAIM!
art BRIAN 'PUSHEAD'
SCHROEDER
design BRIDGET BURPEE

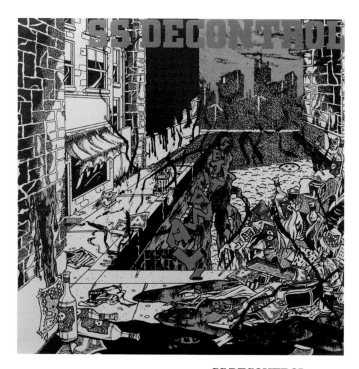

SS DECONTROL 391

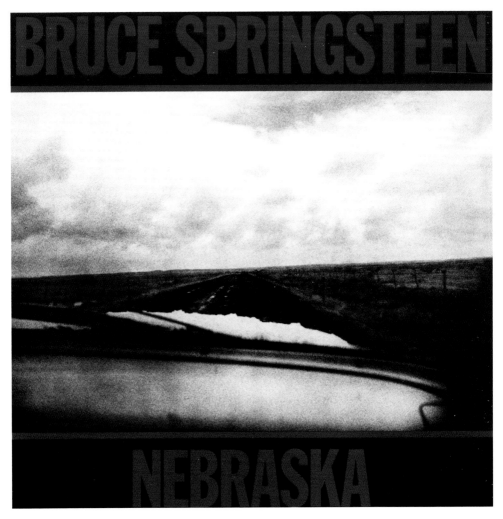

BRUCE SPRINGSTEEN

artist BRUCE
 SPRINGSTEEN
title NEBRASKA
year 1982
label COLUMBIA
ad ANDREA KLEIN
photo DAVID MICHAEL
 KENNEDY

In this collection of unplugged folk stories, Springsteen sings about isolation and the futility of the American Dream from the toil of the working class to the death penalty. The four-track Portastudio recording brings the listener closer to the raw and melancholic combination of voice, acoustic guitar and harmonica. Springsteen cited Howard Zinn's book *A People's History of the United States* (1980) as an inspiration, whilst David Michael Kennedy's cover photography pays homage to Robert Frank's 1958 photo essay, *The Americans*.

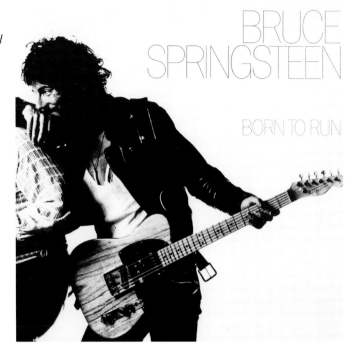

"*The mysteries of the Born to Run cover have assumed a mythical status that did not, of course, exist at the moment the album first appeared. The initial misspelling of Jon Landau's name, the alternate cover with its sepia blacks and jagged type, the mystery of where Bruce obtained a membership-only Elvis button, and the herculean effort on Bruce's part in the studio have long since magnified a sense that every last aspect of the album and its design were planned from the very beginning.*"

Eric Meola

BRUCE SPRINGSTEEN

BORN TO RUN

BRUCE SPRINGSTEEN

artist BRUCE SPRINGSTEEN
title BORN TO RUN
year 1975
label COLUMBIA
design ANDY ENGEL, JOHN BERG
photo ERIC MEOLA

BRUCE SPRINGSTEEN

artist BRUCE SPRINGSTEEN
title BORN IN THE U.S.A.
year 1984
label COLUMBIA
ad ANDREA KLEIN
photo ANNIE LEIBOVITZ

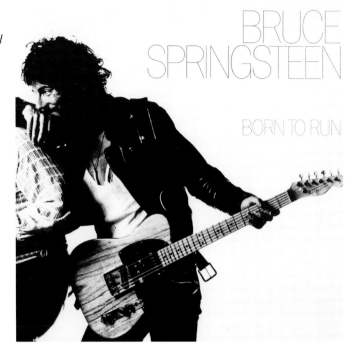

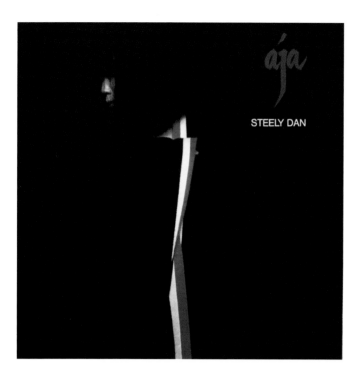

STEELY DAN

artist STEELY DAN
title AJA
year 1977
label ABC
design OZ STUDIO:
 GEOFF WESTEN,
 PATRICIA MITSUI
photo HIDEKI FUJII

Initially appearing as a model in the West in Paris in 1972, Sayoko Yamaguchi was one of the first Asians to cross over and become an international name in the fashion world. Hideki Fujii worked his way up to become a celebrated studio photographer through campaigns with Toyota and Nikon in the '60s, though come the '70s he was shooting Japanese females almost exclusively, making this cover engagement with Yamaguchi a perfect pairing.

THE STARLITERS

artist THE STARLITERS
title JOURNEY WITH
 THE STARLITERS
year 1966
label JUSTICE

Justice Records was perpetuated entirely by garage rock and beach music upstarts from North Carolina. Label boss Calvin Newton offered package deals to eager acts, requiring only that each signatory provide recording and manufacturing costs. Brothers Mike and Gary Rogers, Ken Wilkins and Larry Jones were underclassmen at South Stokes when their *Journey with the Starliters* became Justice catalog number 124.

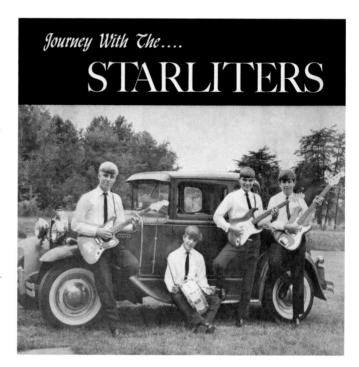

STEROID MAXIMUS

artist STEROID MAXIMUS
title QUILOMBO
year 1991
label BIG CAT
art PIZZ

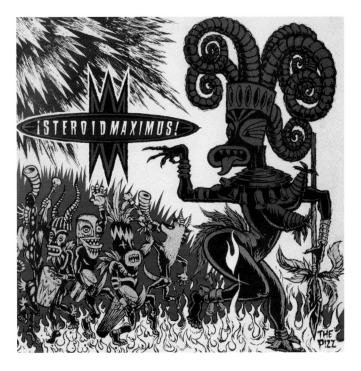

CAT STEVENS

artist CAT STEVENS
title MATTHEW & SON
year 1967
label DERAM

Cat Stevens's folk-meets-baroque-pop debut was a concerted effort to propel the teenaged Brit from self-conscious songwriter to heart-throb crooner, largely via the title track, which reached number 2 on the British charts in 1967. The cover photo featuring a clean-cut, fashionable Stevens in a dapper posture is further evidence of the attempted commercial catapulting on the part of parent label, Decca Records.

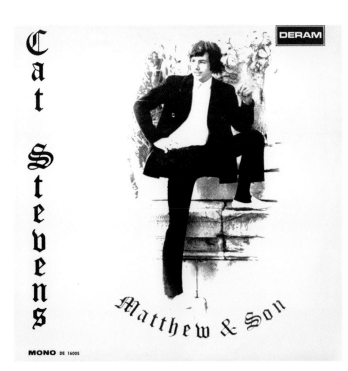

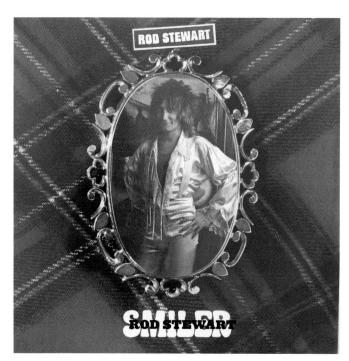

ROD STEWART

artist ROD STEWART
title SMILER
year 1974
label MERCURY
design KEEF
photo KEEF

THE STONE PONEYS

artist THE STONE PONEYS
title EVERGREEN VOL. 2
year 1967
label CAPITOL

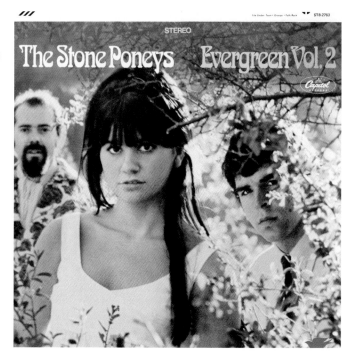

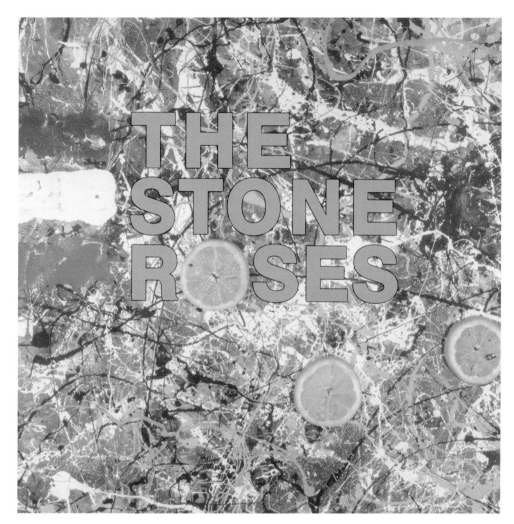

THE STONE ROSES

artist THE STONE ROSES
title THE STONE ROSES
year 1988
label SILVERTONE
art JOHN SQUIRE

Gaining prominence during the Madchester dance music and psychedelic revival movement of the late 1980s and early 1990s, the Stone Roses are widely cited as key influencers of the Britpop renaissance that emerged afterwards. Renowned for stonewalling the press, the band nevertheless maintained a cult profile throughout their active formation. The Jackson Pollock-inspired cover art, titled "Bye Bye Badman" (1988), was painted by the band's guitarist John Squire, and based on the Paris riots of May 1968.

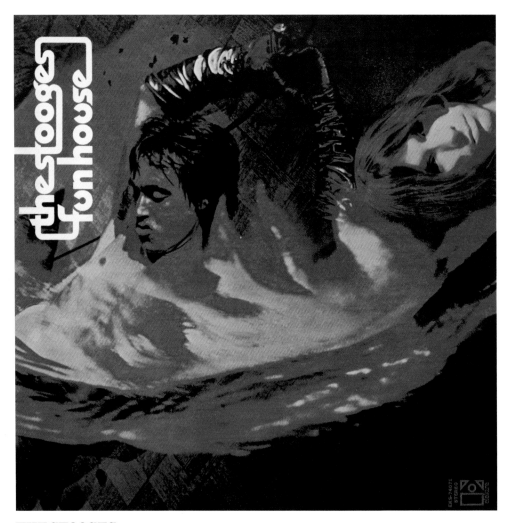

THE STOOGES

artist THE STOOGES
title FUN HOUSE
year 1970
label ELEKTRA
ad BOB HEIMALL
photo ED CARAEFF

A proto-punk maelstrom, the sheer aggression captured on the bleeding, imperfect recordings of *Fun House* is a prime example of art imitating life. As it goes, the seven-song LP was largely overlooked in its day but was later praised as a cacophonous blueprint for punk rock by no less than Henry Rollins, Lester Bangs and other seminal scene mouthpieces.

THE STOOGES

artist THE STOOGES
title RAW POWER
year 1970
label COLUMBIA
photo MICK ROCK

*"There is a certain
alien quality to him...
He was like he'd just
bloody landed.
That's for sure."*

Mick Rock

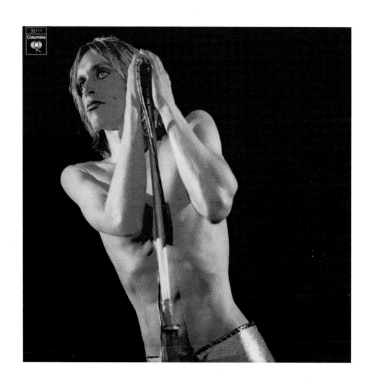

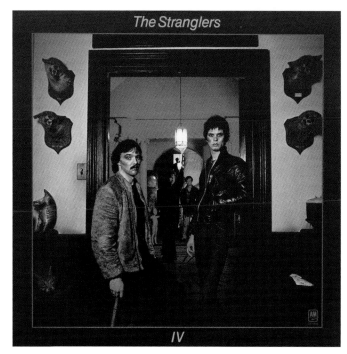

THE STRANGLERS

artist THE STRANGLERS
title THE STRANGLERS
IV/RATTUS
NORVEGICUS
year 1977
label A&M
design PAUL HENRY
photo TREVOR ROGERS

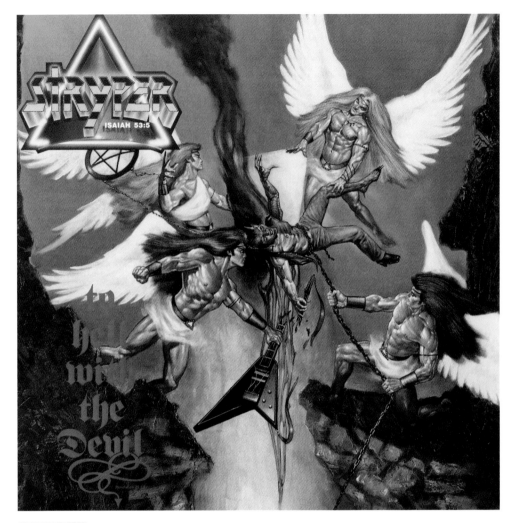

STRYPER

artist STRYPER
title TO HELL WITH
THE DEVIL
year 1986
label ENIGMA
ad BRIAN AYUSO
design ROBERT SWEET
(CONCEPT),
BRIAN AYUSO

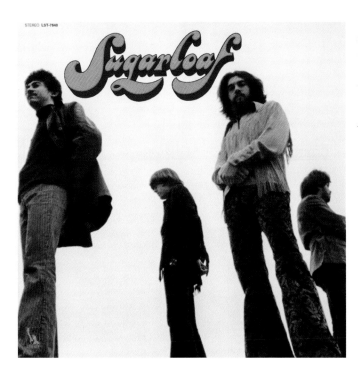

STEREO LST-7640

SUGARLOAF

artist SUGARLOAF
title SUGARLOAF
year 1970
label LIBERTY
design RON WOLIN
photo HOWARD RISK

SUICIDAL
TENDENCIES

artist SUICIDAL
TENDENCIES
title SUICIDAL
TENDENCIES
year 1983
label FRONTIER
art DEE ZEE
design GLEN E. FRIEDMAN
photo GLEN E. FRIEDMAN

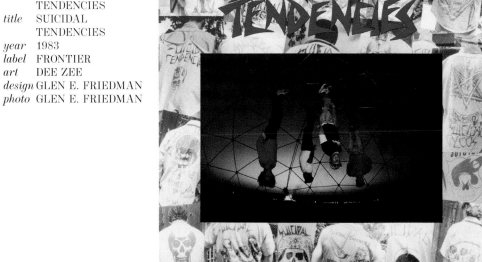

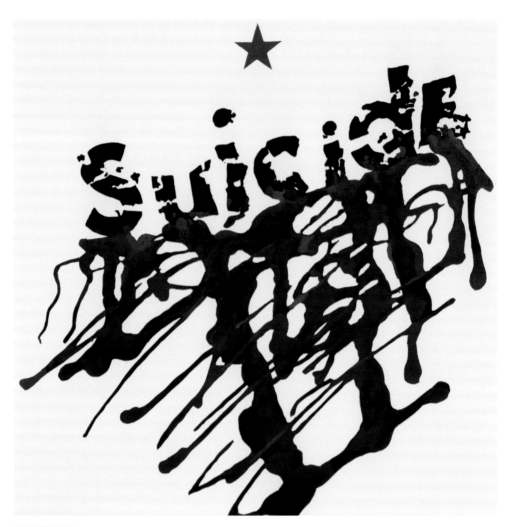

SUICIDE

artist SUICIDE
title SUICIDE
year 1977
label RED STAR
art TIMOTHY JACKSON

The 1950s crashed headfirst into a future that didn't exist yet, but Alan Vega and Martin Rev concocted a spooky, automated, amped-up version of that future with repetitive synth lines washing over the stabbing of the drum machine which together threatened to pulverize the listener. Vega's eerie vocal delivery pushed the boundaries of punk's disaffected teen rebellion, and this, coupled with the buzzsaw-like sounds that cut deeper with every listen, left in their wake a trail that would be followed by many a post-punk, synth popper and industrial rocker.

SUPERCHUNK

artist SUPERCHUNK
title NO POCKY FOR KITTY
year 1991
label MATADOR
art WOODCUT MAX
(MAC MCCAUGHAN)
design MERGE
photo LEXI, JENNIFER,
KRISTIN, MAC

"When we did the art for No Pocky For Kitty *we were still essentially working in Kinko's mode, that is, using the Xerox machines to blow up and stretch band photos and then layering a woodcut I did on top of that. We did this on the first album and produced possibly the ugliest album cover in the Matador catalog. With the help of Wayne Taylor at Barefoot Press in Raleigh we were more successful with this one. Silver ink behind the woodcut and the band logo helped."*

Mac McCaughan

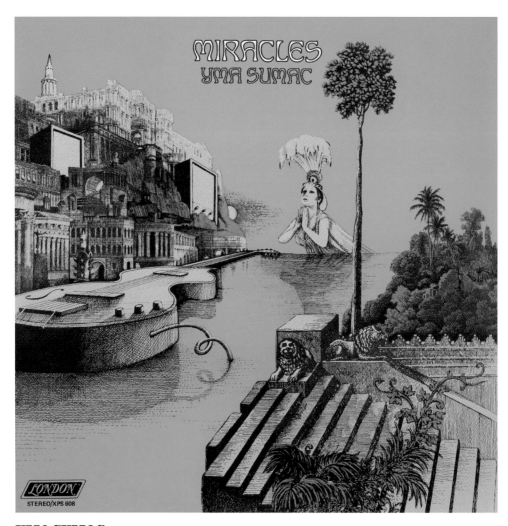

YMA SUMAC

artist YMA SUMAC
title MIRACLES
year 1972
label LONDON
art MARCELLINO
design MARCELLINO

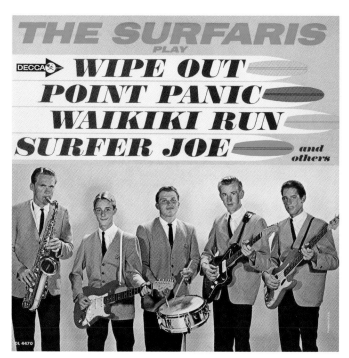

THE SURFARIS

artist THE SURFARIS
title THE SURFARIS
PLAY
year 1963
label DECCA

See those spots on the snare
drum front and center?
Those aren't stick marks—it's
blood, shed by drummer Ron
Wilson during a recent rowdy
concert. Who would have
guessed a bunch of powder-
blue-suited California high-
school boys had it in them?
But with an iconic jam like
"Wipe Out," and the ability to
usher in the surf genre, the
bloodshed suddenly seems like
a badge of honor.

SWEETWATER

artist SWEETWATER
title SWEETWATER
year 1968
label REPRISE
ad ED THRASHER
photo MARV LYONS

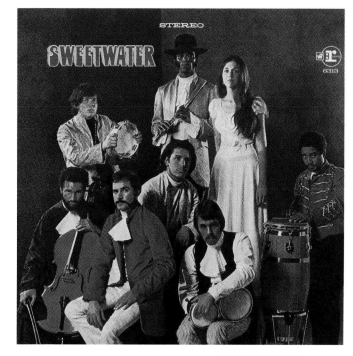

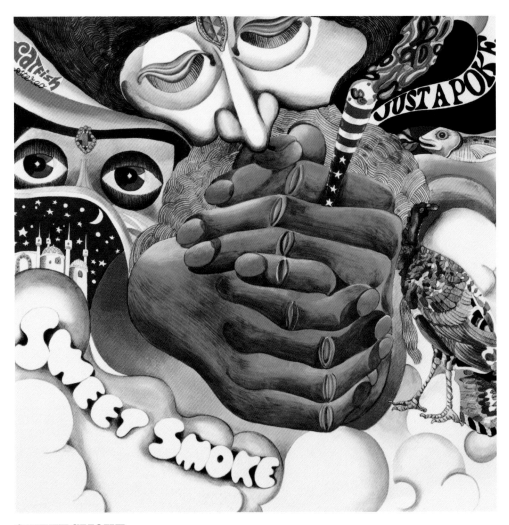

SWEET SMOKE
artist SWEET SMOKE
title JUST A POKE
year 1970
label CATFISH
art JAN FIJNHEER

THE T-BONES

artist THE T-BONES
title NO MATTER WHAT
SHAPE (YOUR
STOMACH'S IN)
year 1966
label LIBERTY
ad WOODY WOODWARD
design KEN KIM
photo MILES
LABORATORIES

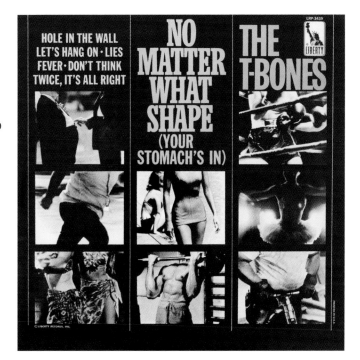

T.S.O.L.

artist T.S.O.L.
title T.S.O.L.
year 1981
label POSH BOY
photo ED COLVER

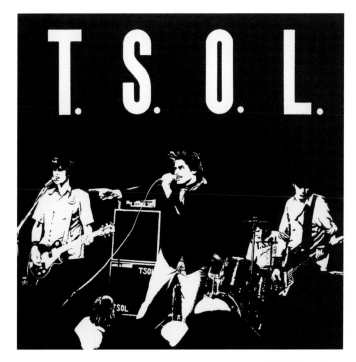

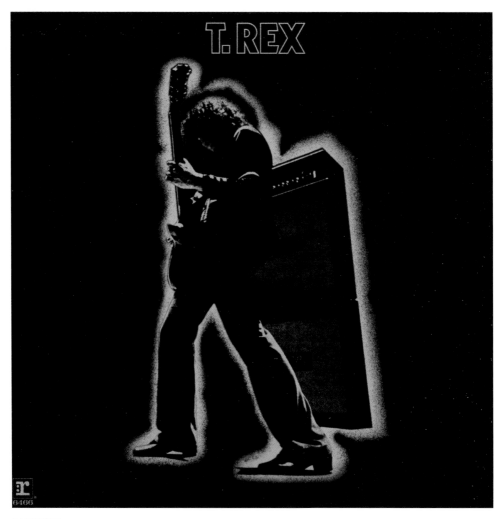

T. REX

artist T. REX
title ELECTRIC WARRIOR
year 1971
label REPRISE
design JUNE CHILD (CONCEPT),
 HIPGNOSIS
photo SPUD MURPHY

Marc Bolan gave birth to the glam-rock era on *Electric Warrior* with a hip-shaking wizardry that harked back to the roots of rock while looking forward to a sexualized theatrics that would inform many a future would-be rocker. Kieron "Spud" Murphy's iconic photo coupled with Hipgnosis's flair for the otherworldly design helped to solidify the juiced-up sensuality of a rock god in the making.

TALKING HEADS

artist TALKING HEADS
title STOP MAKING
 SENSE
year 1984
label SIRE
design DAVID BYRNE,
 MICHAEL HODGSON,
 JEFF AYEROFF
photo ADELLE LUTZ

This portrait of Talking
Heads—with tracks not
featured in the film of the
same name—gave listeners
a more in-depth experience
with their beloved band.
Initial copies included a
full-color brochure wrapped
around the jacket, the content
of which was transferred
to the inner sleeve for later
pressings.

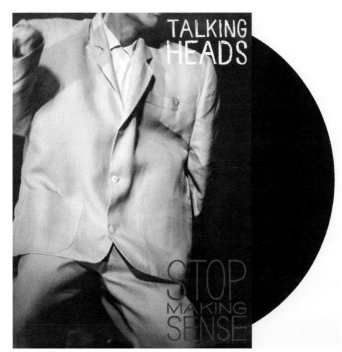

TALK TALK

artist TALK TALK
title THE COLOUR
 OF SPRING
year 1986
label EMI
art JAMES MARSH

THE TARRIERS

artist THE TARRIERS
title THE TARRIERS
year 1957
label GLORY
design GENE R. SMITH
photo LEO KARR

The Tarriers missed the folk
revival boat by just a year.
Their debut album was full
of energetic playing and
singing, and their choice of
material was spot on, but
"Tom Dooley" was to become
a smash hit for the Kingston
Trio the following year; and
although the Tarriers had
a hit with "The Banana
Boat Song" in 1956, Harry
Belafonte's rendition later
the same year would become
the standard. The group
performed their version in
the 1957 B-movie musical
Calypso Heat Wave, shortly
before founding member
Alan Arkin left to pursue
his acting career.

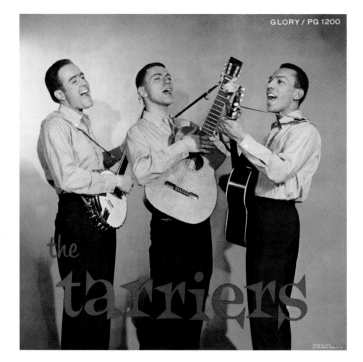

GLORY / PG 1200

JAMES TAYLOR

artist JAMES TAYLOR
title JAMES TAYLOR
year 1968
label APPLE
photo RICHARD IMRIE

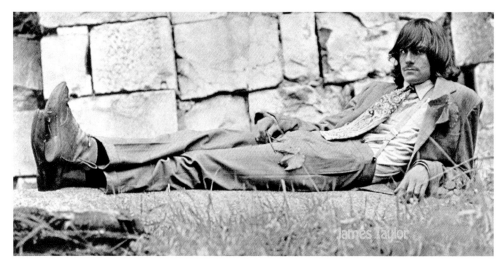

TEENAGE JESUS AND THE JERKS

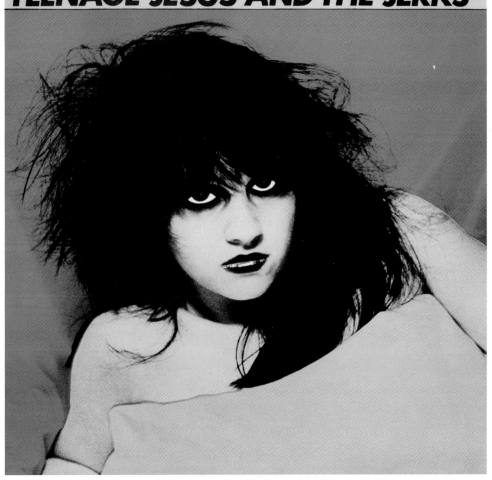

**TEENAGE JESUS
AND THE JERKS**

artist TEENAGE JESUS
AND THE JERKS
title TEENAGE JESUS
AND THE JERKS
year 1979
label ZE
photo JULIA GORTON

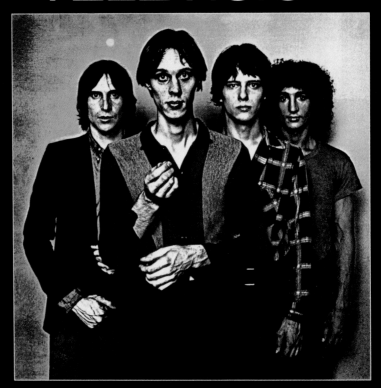

TELEVISION

artist TELEVISION
title MARQUEE MOON
year 1977
label ELEKTRA
ad TONY LANE
photo ROBERT
 MAPPLETHORPE

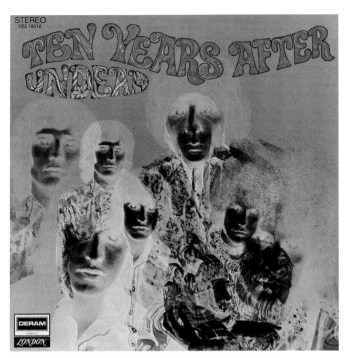

TEN YEARS AFTER

artist TEN YEARS AFTER
title UNDEAD
year 1968
label DERAM
photo JOHN FOWLEY

Like many bands, Ten Years After was a tough act to capture in the studio with accuracy. Their debut was a fine LP, but lacked the blood, sweat & boogie of their live performances. To rectify this situation they recorded their follow-up in London on May 14, 1968 at Klooks Kleek, a small jazz club. Alvin Lee led the charge with blistering guitar-work as the band tore through a combination of jazz- & blues-infused rock that would serve as a template for generations of guitar virtuosi.

THE TEMPOS

artist THE TEMPOS
title SPEAKING OF...
year 1966
label JUSTICE
design KINNARD A. MCKINSTRY
photo MIMS STUDIO

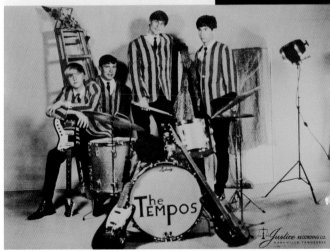

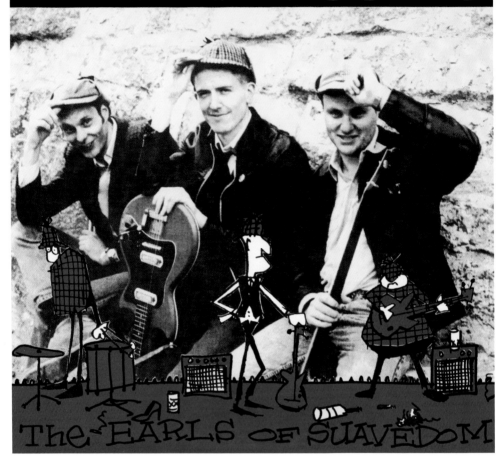

THEE HEADCOATS

artist THEE HEADCOATS
title THE EARLS OF
SUAVEDOM
year 1990
label CRYPT

THEM

artist THEM
title HERE COMES
THE NIGHT
year 1965
label PARROT

Emerging from Belfast in
1964, Them was a five-piece
garage band promoted in the
US as a contingent of the
British Invasion. Owing much
of their brief success to the
vocals and penmanship of
Van Morrison, the group had
chart hits with the album's
title song "Here Comes the
Night," as well as with "Baby
Please Don't Go" and "Mystic
Eyes." Morrison wrote seven
of the songs on the album,
including the garage classic,
"Gloria."

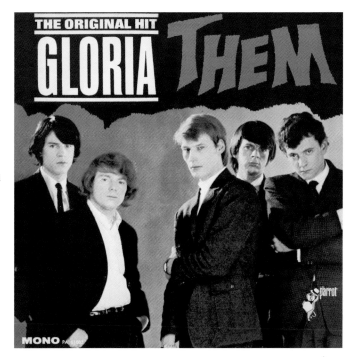

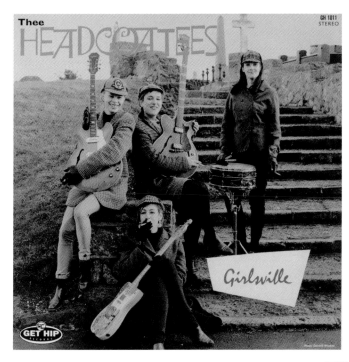

THEE
HEADCOATEES

artist THEE
HEADCOATEES
title GIRLSVILLE
year 1993
label GET HIP
photo DEVERILL WEEKES

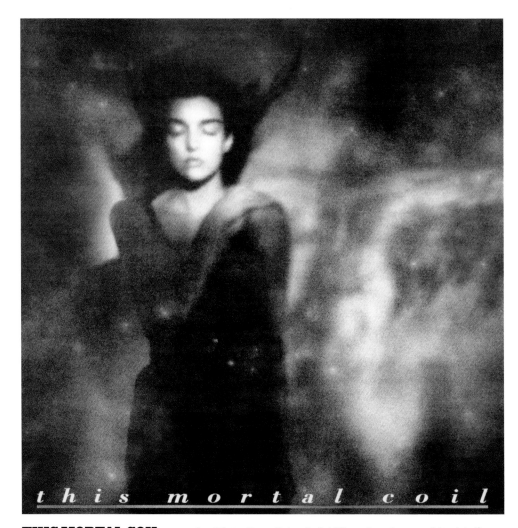

this mortal coil

THIS MORTAL COIL

artist THIS MORTAL COIL
title IT'LL END IN TEARS
year 1984
label 4AD
ad VAUGHAN OLIVER
design 23 ENVELOPE
photo NIGEL GRIERSON

Ivo Watts-Russell, head of 4AD, gathered some of his label's brightest stars, including Howard Devoto, and Elizabeth Fraser of Cocteau Twins, to record under the name This Mortal Coil. It was his declaration of change for the label. From the haunting covers of Big Star and Tim Buckley songs to the atmospheric package design by 23 Envelope, the new ethereal direction of the 4AD house sound would permeate British pop for the rest of the decade. 23 Envelope consisted of designer Vaughan Oliver and photographer/filmmaker Nigel Grierson. Their work for the label was a perfect storm of beauty and decay as the imagery and typography gave a distinct evocation of primal fears.

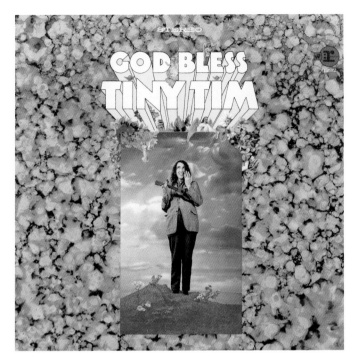

TINY TIM

artist TINY TIM
title GOD BLESS TINY TIM
year 1968
label REPRISE
ad ED THRASHER

If you dare look Tiny Tim up on the internet, prepare yourself to fall into a vortex of odd, hilarious, sad and joyous clips of performances and interviews. Included in the line-up is the first episode of *SpongeBob SquarePants*, appropriately featuring Tiny Tim's cover of the 1930s song "Livin' in the Sunlight, Lovin' in the Moonlight," also on this album. The vortex is strong, which is exactly what the late pop star—cartoonish persona, ukulele chops and all—would have wanted. Jazz and rock icon-maker Ed Thrasher took a chance and provided the purposefully cheesy art for this, Tiny Tim's first album.

T.I.M.E.

artist T.I.M.E.
title SMOOTH BALL
year 1969
label LIBERTY
ad WOODY WOODWARD
design WAYNE KIMBELL
photo GEORGE RODRIGUEZ

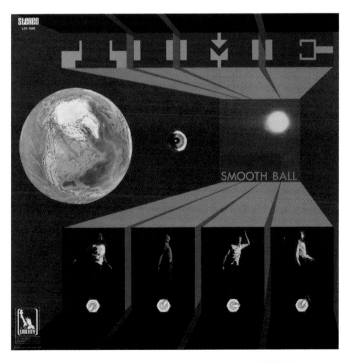

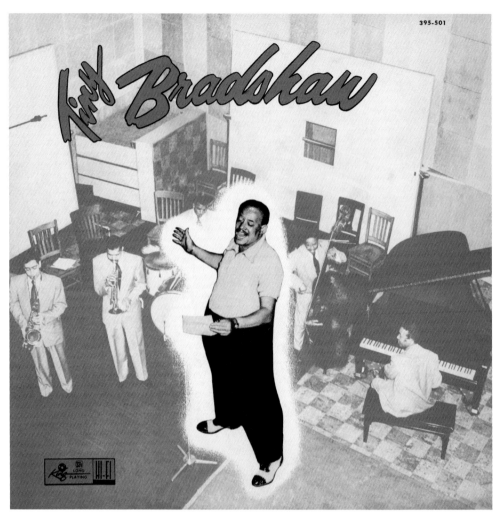

395-501

TINY BRADSHAW

artist TINY BRADSHAW
title TINY BRADSHAW
year 1955
label KING

Myron Carlton "Tiny" Bradshaw was a great jazz and R&B bandleader, as well as a composer, pianist, drummer and singer. His most memorable song was a jump blues nugget buried on side 2 of this LP, and "The Train Kept A-Rollin'" was turned on its head as a rockabilly classic by the Johnny Burnette Trio in 1956, their version including what many consider the first intentionally distorted guitar recording in rock history. The song has been covered by numerous artists over the years, including the Yardbirds, Aerosmith, Metallica and Motörhead.

TOE FAT

artist TOE FAT
title TOE FAT
year 1970
label RARE EARTH
ad CURTIS MCNAIR
design HIPGNOSIS,
TOM SCHLESINGER
(GRAPHIC
SUPERVISION)

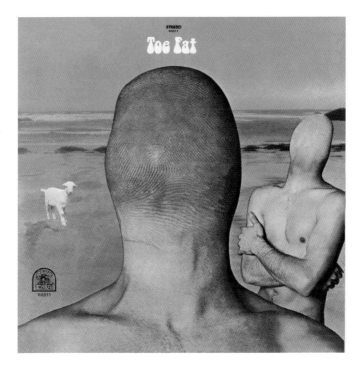

TITANIC

artist TITANIC
title MACUMBA!
year 1973
label COLUMBIA

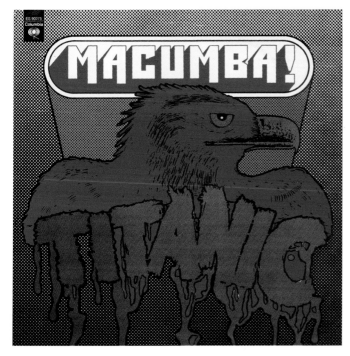

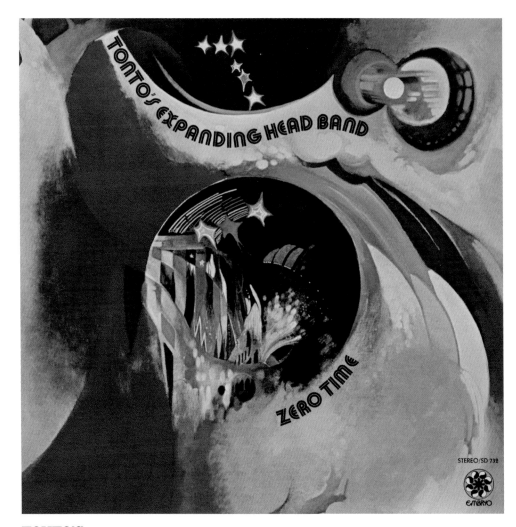

STEREO/SD 732

EMBRYO

TONTO'S EXPANDING HEAD BAND

artist TONTO'S EXPANDING
HEAD BAND
title ZERO TIME
year 1971
label EMBRYO
art CAROL HERTZER
(COVER PAINTING:
APOLLO ON MARS)
design HAIG ADISHIAN

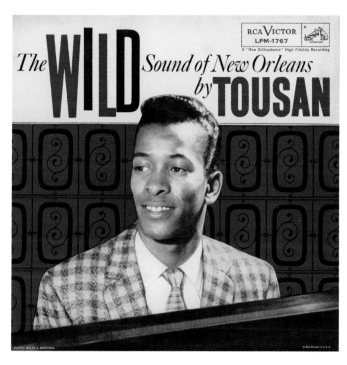

TOUSAN

artist TOUSAN
title THE WILD SOUND
OF NEW ORLEANS
year 1958
label RCA VICTOR
photo NOLAN A. MARSHALL

Allen Toussaint's debut LP was a
boogie-woogie shuffle of rockin'
piano-fueled NOLA spirit. He
once revealed to a reviewer that
he "had no involvement in the
titles of the songs. When I played
them, I referred to them as 'Song
Number One,' 'Song Number
Two' and so on. It wasn't until
the record came out that I was
informed [Danny] Kessler had
chosen to name each piece after
a different racehorse." The best
known of the instrumentals
from the session was "Java,"
which became a huge hit for
trumpeter Al Hirt years later.

THE TORQUÈS

artist THE TORQUÈS
title LIVE
year 1967
label LEMCO

Recorded on New Year's Eve
1966, this record by some
rambunctious students—
undergraduate, medical and
law—from the University
of Kentucky delivers upbeat
renditions of '60s pop hits
like "Black is Black" by Los
Bravos and "It's Not Unusual"
by Tom Jones. Released lo-
cally on the private Lemco
Records label, the primitive
cover photo collage approxi-
mates a page out of your
average yearbook, and renders
the ensemble in an array of
matching outfits.

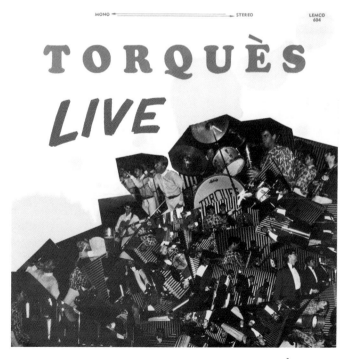

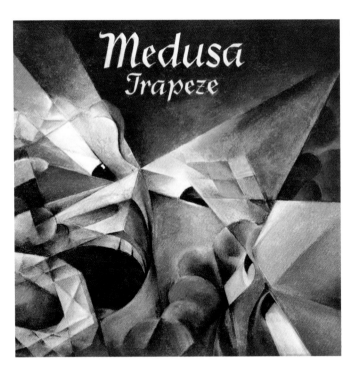

TRAPEZE
artist TRAPEZE
title MEDUSA
year 1970
label THRESHOLD
art PHIL TRAVERS

YAN TREGGER
artist YAN TREGGER
title STORIES
year 1973
label EDITIONS
MONTPARNASSE
2000
photo GUY ETIENNE

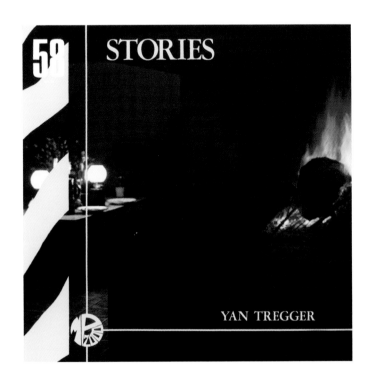

LN 24310

HERE COMES MY BABY · RUN BABY RUN · MY TOWN · WHAT A STATE I'M IN · LOVING YOU · GOOD DAY SUNSHINE · YOU · SHAKE HANDS · WHEN I'M WITH HER · EVEN THE BAD TIMES ARE GOOD

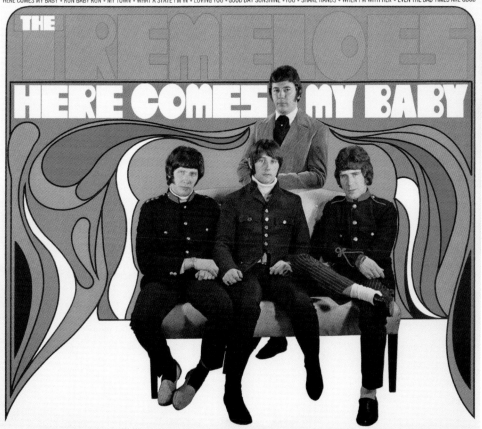

THE TREMELOES

artist THE TREMELOES
title HERE COMES
MY BABY
year 1967
label EPIC

THE TROGGS

artist THE TROGGS
title WILD THING
year 1966
label ATCO
design LORING EUTEMEY

IKE & TINA TURNER

artist IKE & TINA TURNER
title DYNAMITE!
year 1963
label SUE

An early release on New York's Sue label, *Dynamite!* nails the symbolic and interpersonal tension between these two performers. Tina, cocksure in a mink coat, hip thrust forward, turns away from a leering image of Ike, an almost spectral figure of surveillance on the cover. The label's logo, created by co-founder Juggy Murray, features a silhouette of his daughter, with a star replacing her birthmark.

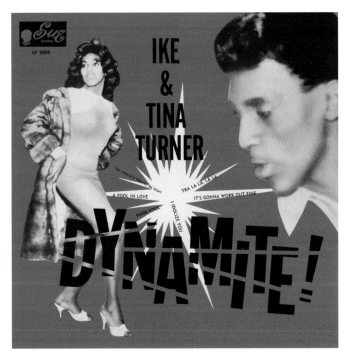

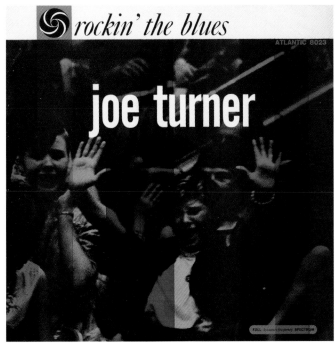

JOE TURNER

artist JOE TURNER
title ROCKIN' THE BLUES
year 1958
label ATLANTIC
design MARVIN ISRAEL
photo MARVIN ISRAEL

U2 OCTOBER

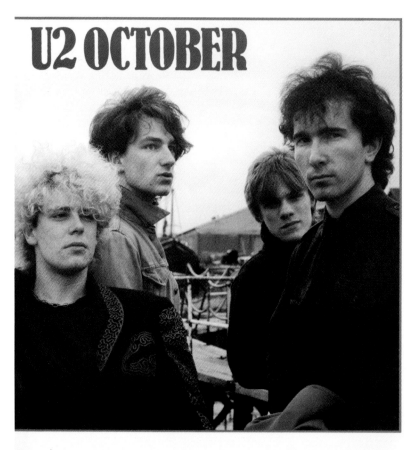

GLORIA
I FALL DOWN
I THREW A BRICK
THROUGH A WINDOW
REJOICE
FIRE

TOMORROW
OCTOBER
WITH A SHOUT
STRANGER IN
A STRANGE LAND
SCARLET
IS THAT ALL?

U2

artist U2
title OCTOBER
year 1981
label ISLAND
design RAPID EXTERIORS
photo IAN FINLAY

This album isn't considered U2's most successful (though it did go platinum in both the UK and the US), but it is their most spiritual. The contemplative look on the band's faces here may reflect their struggle between the juxtaposition of the Shalom Fellowship, a Christian group three of them were part of at the time, and a life of rock 'n' roll. Ian Finlay, who provided photography for their first release, followed up on this sophomore album and would also provide the iconic "war child" photo for U2's 1983 hit, *War*.

U2

artist U2
title WAR
year 1983
label ISLAND
design RAPID EXTERIORS
photo IAN FINLAY

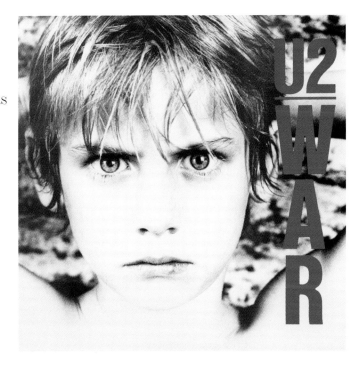

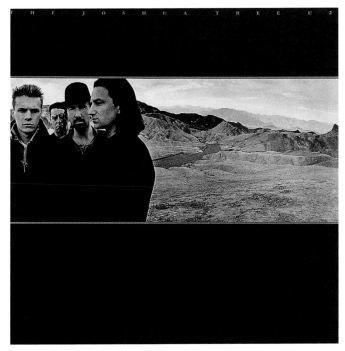

U2

artist U2
title THE JOSHUA TREE
year 1987
label ISLAND
design STEVE AVERILL
photo ANTON CORBIJN

THE UNDERTONES

artist THE UNDERTONES
title THE UNDERTONES
year 1979
label SIRE
design BUSH HOLLYHEAD
 N-T-A
photo JILL FURMANOVSKY

For the US release, Jill Furmanovsky captured the teenage attitude of the Northern Irish lads with her cover shots. Although standing still, their youthful punk jitters can be felt radiating right off the sleeve. Feargal Sharkey's quivering vocals were a perfect topper for the band's pop punk confections, and with their tales of teen angst and lust, like "Jimmy Jimmy," "Teenage Kicks" and "Get Over You," they tore into a "surf's up" style abandon with their own brand of anarchy.

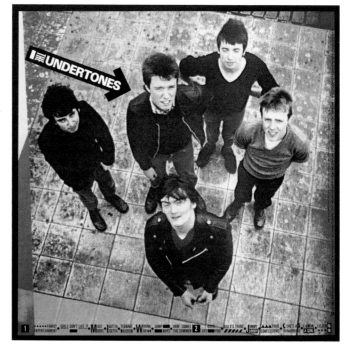

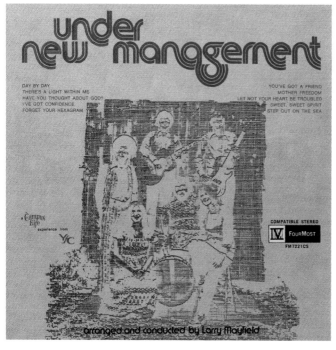

UNDER NEW MANAGEMENT

artist UNDER NEW
 MANAGEMENT
title UNDER NEW
 MANAGEMENT
year 1972
label FOURMOST

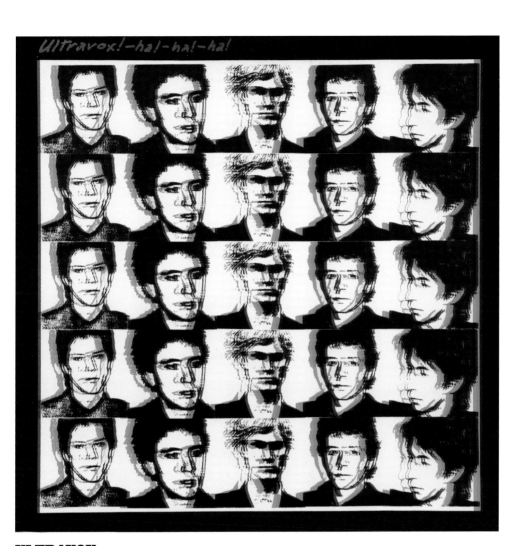

ULTRAVOX

artist ULTRAVOX!
title HA!-HA!-HA!
year 1977
label ISLAND
design DENNIS LEIGH (CONCEPT),
BLOOMFIELD/TRAVIS

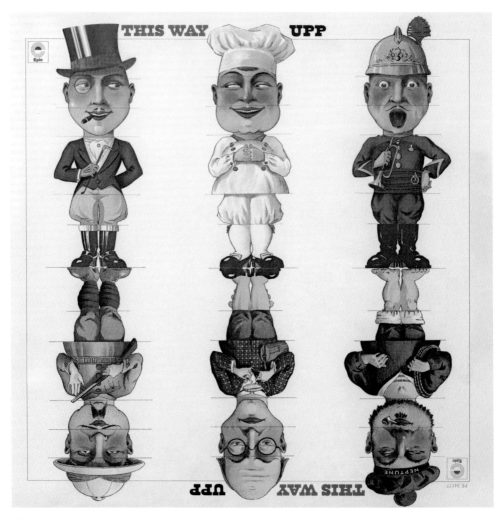

UPP

artist UPP
title THIS WAY UPP
year 1976
label EPIC
design PAULA SCHER

VARIOUS ARTISTS

artist VARIOUS ARTISTS
title ROCK AND ROLL
DANCE PARTY
year 1955
label SOMERSET

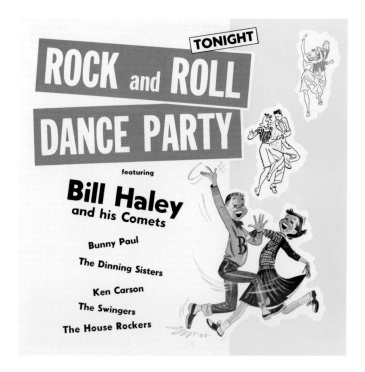

THE VARIATIONS

artist THE VARIATIONS
title DIG EM UP!
year 1966
label JUSTICE

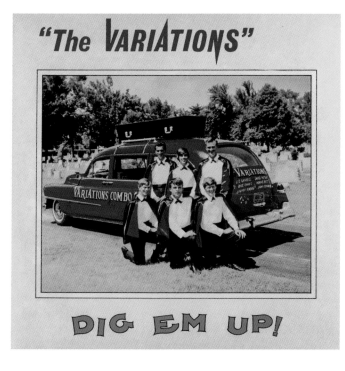

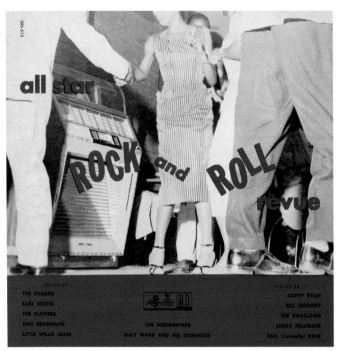

VARIOUS ARTISTS

artist VARIOUS ARTISTS
title ALL STAR ROCK
AND ROLL REVUE
year 1956
label KING

VARIOUS ARTISTS

artist VARIOUS ARTISTS
title HERE ARE
THE HITS!
year 1959
label FIRE

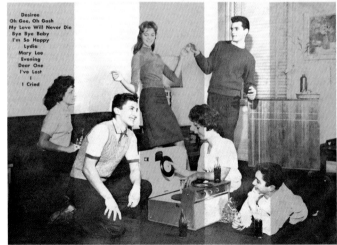

THE DAVE CLARK FIVE
NEIL SEDAKA
with the TOKENS
DICK DALE CHUCK JACKSON
THE MILLER SISTERS THE ANGELS
THE TOTTENHAMERS THE JADES

IN YOUR HEART
CHAQUITA
I WANT TO HOLD YOUR HAND
TEAR IT UP
MR. PRIDE
COME ON AND LOVE ME
FEEL GOOD
COON CHA

FAIREST OF THEM ALL
WE'LL NEVER HEAR THE END OF IT
UNKNOWN
FROM THE VERY FIRST DAY
THAT'S ALL I ASK OF YOU
CRY BABY CRY
I LOVE MY BABY
WHILE I DREAM

BEAT BATTLE OF THE WORLD
England Mersey Beat
vs.
United States Blue Beat

Groovemaster Records **ORIGINAL Chart Making Performances**

VARIOUS ARTISTS
artist VARIOUS ARTISTS
title BEAT BATTLE
OF THE WORLD
year 1964
label GROOVEMASTER

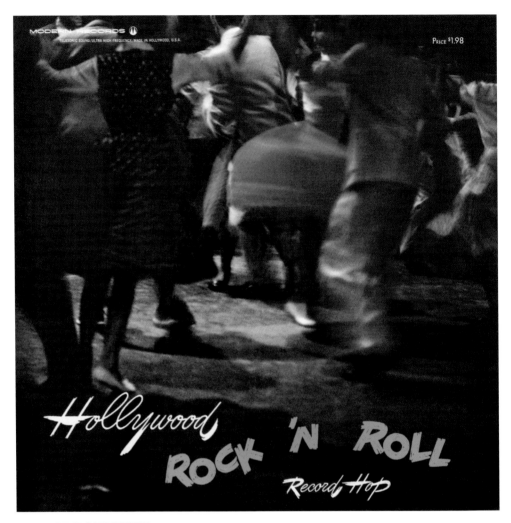

VARIOUS ARTISTS

artist VARIOUS ARTISTS
title HOLLYWOOD
 ROCK 'N ROLL
 RECORD HOP
year 1956
label MODERN
ad FLORETTE BIHARI
photo TODD WALKER

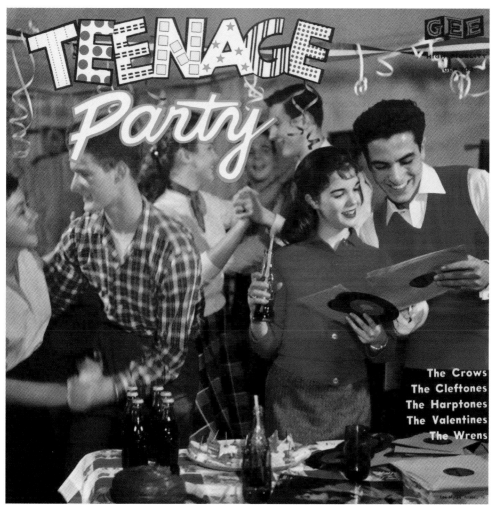

VARIOUS ARTISTS

artist VARIOUS ARTISTS
title TEENAGE PARTY
year 1958
label GEE
design LEE-MYLES ASSOC.

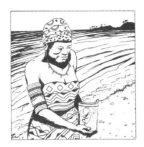
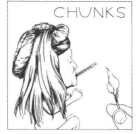
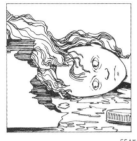
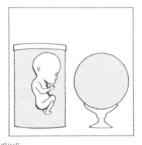

FEATURING

BLACK FLAG MINUTEMEN SACCHARINE TRUST STAINS DESCENDENTS
NIG-HEIST CHEIFS PEER GROUP ARTLESS ENTANGLEMENTS
SLIVERS KEN VOX POP

VARIOUS ARTISTS

artist VARIOUS ARTISTS
title CHUNKS
year 1981
label NEW ALLIANCE/
SST
art RAYMOND
PETTIBON

VARIOUS ARTISTS

artist VARIOUS ARTISTS
title ZENÉS KARAVÁN 1
year 1977
label ELECTRECORD
design CLARA TAMÁS,
JÓSEF KABÁN

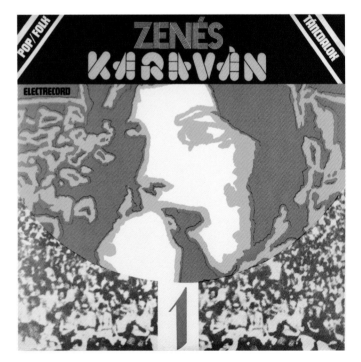

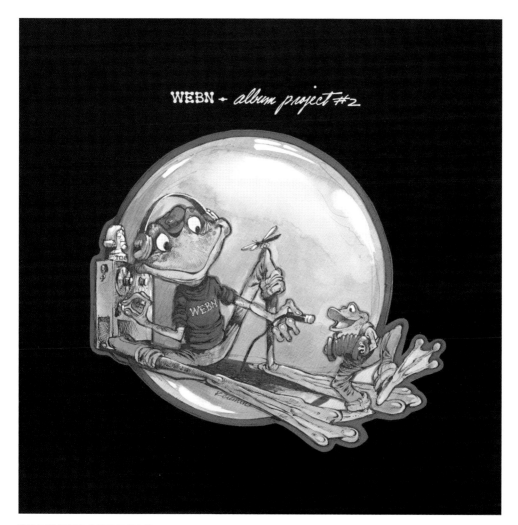

VARIOUS ARTISTS

artist VARIOUS ARTISTS
title WEBN – ALBUM
PROJECT #2
year 1977
label BRUTE FORCE
CYBERNETICS
art ROBERT CREMINS

"WEBN was a pretty wild affair. You'd go down there, and they'd be wearing T-shirts with painted-on bow ties. They had this idea for a frog logo, to represent the station. I was, at the time, doing cartoons, and I was doing a lot of frogs. Actually, I went on to use frogs for other rock groups once I got out to California. There was a frog I called Blind Staggers—a blues frog."

Robert Cremins

VARIOUS ARTISTS

artist VARIOUS ARTISTS
title NOTHING SHORT
OF TOTAL WAR
(PART ONE)
year 1989
label BLAST FIRST
art SAVAGE PENCIL
design DESIGNLAND

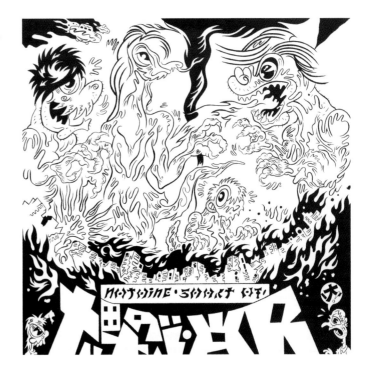

VARIOUS ARTISTS

artist VARIOUS ARTISTS
title BACK FROM THE
GRAVE
year 1984
label CRYPT
art MORT TODD

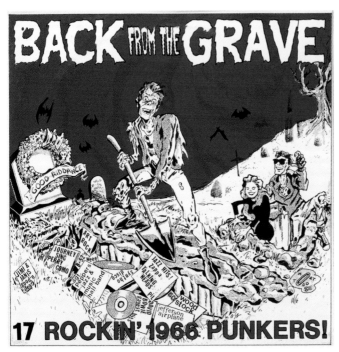

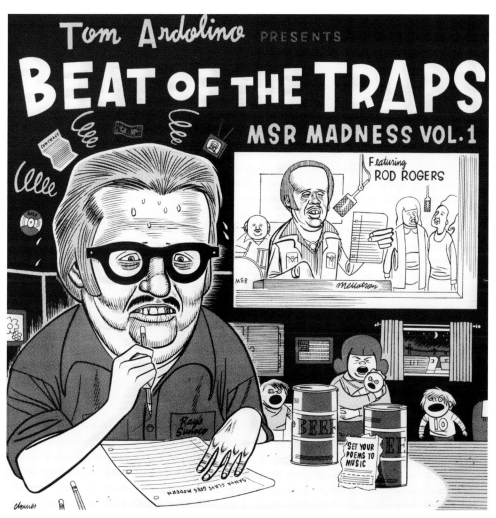

VARIOUS ARTISTS

artist VARIOUS ARTISTS
title THE BEAT OF THE
 TRAPS: MSR
 MADNESS VOL. 1
year 1992
label CARNAGE PRESS
art DAN CLOWES

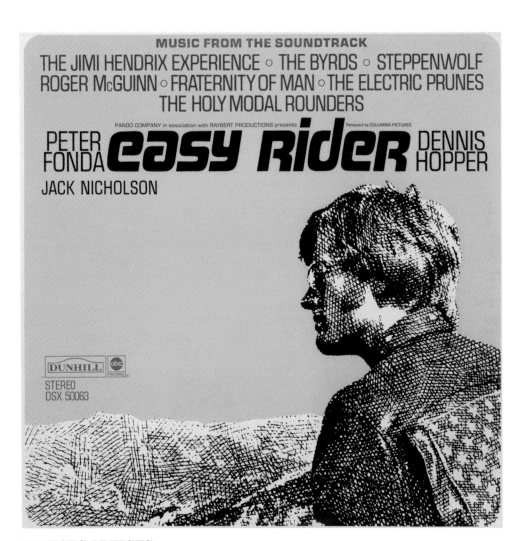

VARIOUS ARTISTS

artist VARIOUS ARTISTS
title EASY RIDER:
MUSIC FROM THE
SOUNDTRACK
year 1969
label ABC-DUNHILL

VARIOUS ARTISTS

artist VARIOUS ARTISTS
title THE DECLINE OF
WESTERN CIVILIZA-
TION: THE ORIGINAL
SOUNDTRACK FROM
THE FILM
year 1980
label SLASH
design J. RUBY
PRODUCTIONS

The cover of this seminal LA
punk compilation/soundtrack
shows one of the last photos
taken of Darby Crash. Pene-
lope Spheeris's camera caught
the Germs singer lying on
stage looking like he was
ready for his death mask to
be made. By the time the film
was released, Crash, at 22,
had overdosed on heroin.

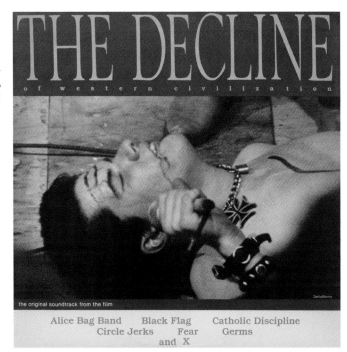

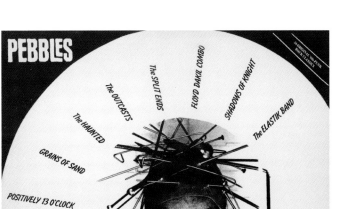

VARIOUS ARTISTS

artist VARIOUS ARTISTS
title PEBBLES, VOLUME
ONE
year 1979
label BFD

VARIOUS ARTISTS

artist VARIOUS ARTISTS
title SIGN OF AQUARIUS:
ORIGINAL MOVIE
SOUNDTRACK
year 1970
label ADELL
design T. NOVAK

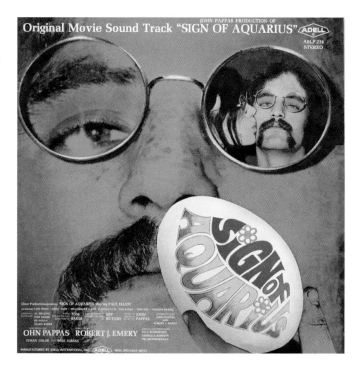

VARIOUS ARTISTS

artist VARIOUS ARTISTS
title THE CAPITOL DISC
JOCKEY ALBUM
JULY 1969
year 1969
label CAPITOL

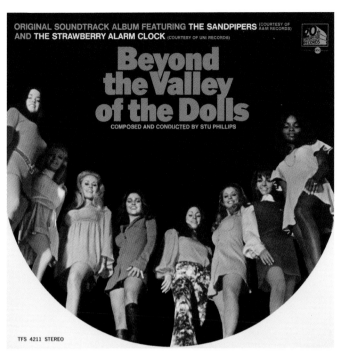

VARIOUS ARTISTS

artist VARIOUS ARTISTS
title BEYOND THE
VALLEY OF THE
DOLLS: ORIGINAL
SOUNDTRACK
ALBUM
year 1970
label 20TH CENTURY FOX

VARIOUS ARTISTS

artist VARIOUS ARTISTS
title ALL DAY THUMB
SUCKER
year 1970
label BLUE THUMB

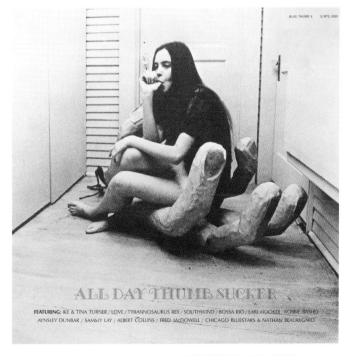

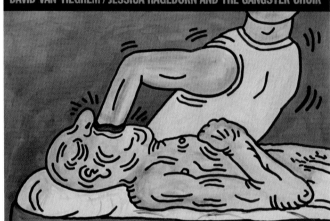

VARIOUS ARTISTS

artist VARIOUS ARTISTS
title A DIAMOND HIDDEN
IN THE MOUTH
OF A CORPSE
year 1985
label GIORNO POETRY
SYSTEMS
art KEITH HARING
design GEORGE
DELMERICO

VARIOUS ARTISTS

artist VARIOUS ARTISTS
title NUGGETS VOLUME
SIX: PUNK PART II
year 1985
label RHINO
ad ART D. REKSHUN
art DON BROWN,
GORILLA
COMMUNIGRAPHICS
photo MICHAEL OCHS
ARCHIVES

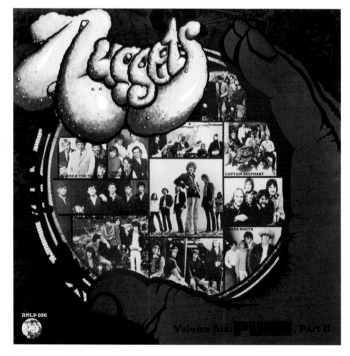

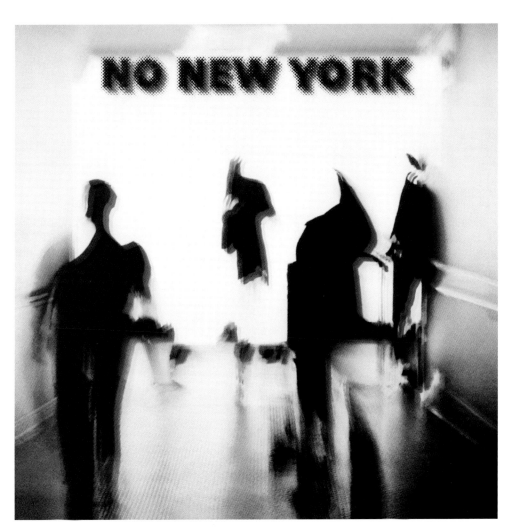

VARIOUS ARTISTS

artist VARIOUS ARTISTS
title NO NEW YORK
year 1978
label ANTILLES
design STEVEN KEISTER,
 BRIAN ENO
photo BRIAN ENO

Less of a compilation than a mixtape of Brian Eno's four favorite late '70s bands, *No New York* is one of the few true documentations of the brief No Wave movement, produced by Eno who also contributed to the acid-drenched, ethereal cover art and photography alongside artist Steven Keister. The album is also notable for having the song lyrics printed on the inside of the sleeve, so that the only way to read them was to open it up.

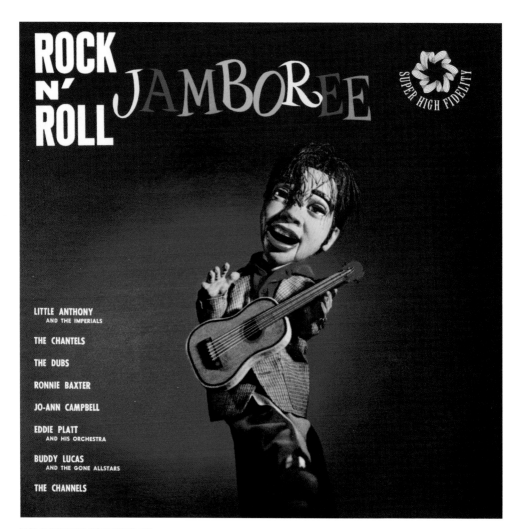

VARIOUS ARTISTS

artist VARIOUS ARTISTS
title ROCK N' ROLL
JAMBOREE
year 1959
label END

VARIOUS ARTISTS

artist VARIOUS ARTISTS
title THE ROCK AND
ROLL CIRCUS
year 1968
label BARKING MOOSE

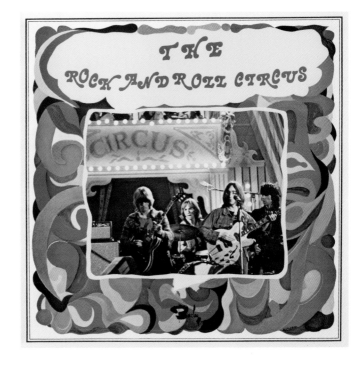

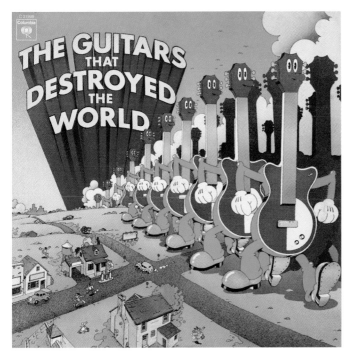

VARIOUS ARTISTS

artist VARIOUS ARTISTS
title THE GUITARS
THAT DESTROYED
THE WORLD
year 1973
label COLUMBIA
art W. WEBER

VARIOUS ARTISTS

artist VARIOUS ARTISTS
title SIN ALLEY
year 1986
label BIG DADDY

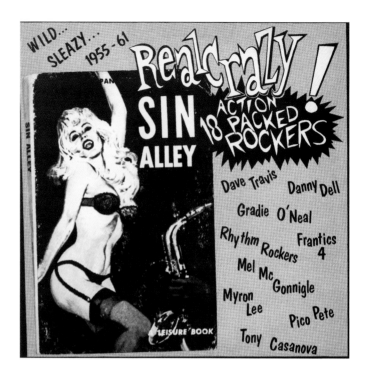

VARIOUS ARTISTS

artist VARIOUS ARTISTS
title PUNK AND
　　　 DISORDERLY
year 1982
label POSH BOY
design JOHN GORDON,
　　　 THE ACME ARTS
　　　 COMPANY
photo VIRGINIA TURBETT

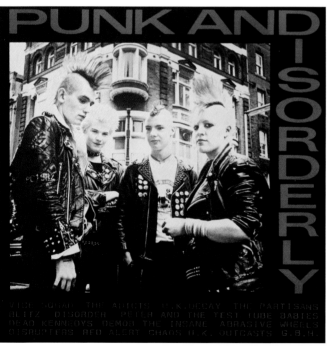

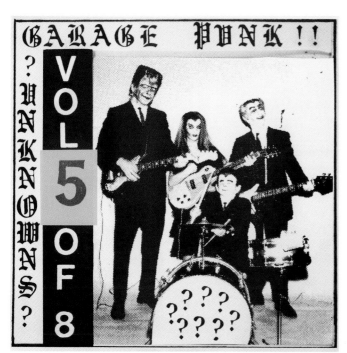

VARIOUS ARTISTS

artist VARIOUS ARTISTS
title GARAGE PUNK
UNKNOWNS:
VOL. 5 OF 8
year 1986
label STONE AGE

VARIOUS ARTISTS

artist VARIOUS ARTISTS
title RIOT ON SUNSET
STRIP: MUSIC
COMPOSED FOR
THE ORIGINAL
SOUNDTRACK
year 1967
label TOWER

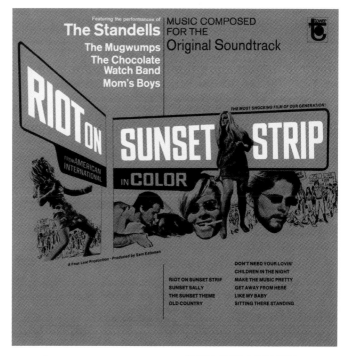

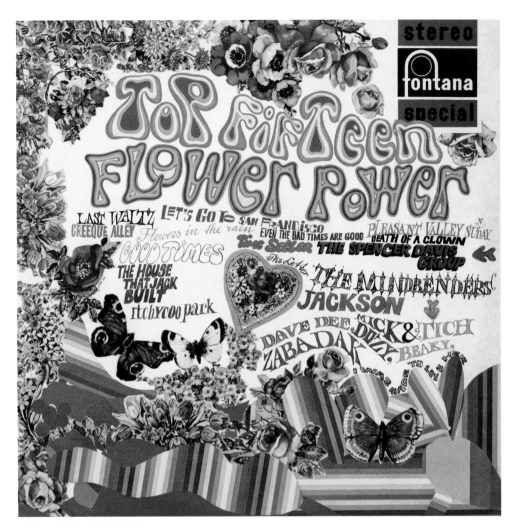

VARIOUS ARTISTS

artist VARIOUS ARTISTS
title TOP FIFTEEN
FLOWER POWER
year 1967
label FONTANA

VARIOUS ARTISTS

artist VARIOUS ARTISTS
title RESERVOIR DOGS
(ORIGINAL MOTION
PICTURE SOUND-
TRACK)
year 1992
label MCA SOUNDTRACKS
art VARTAN
photo LINDA R. CHEN

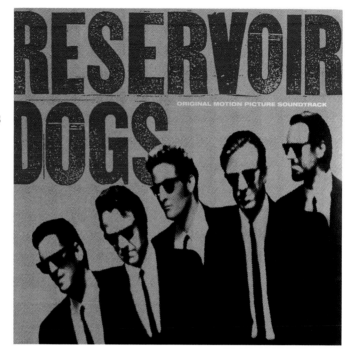

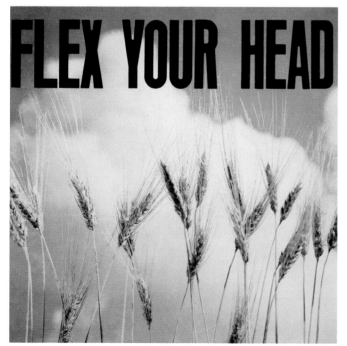

VARIOUS ARTISTS

artist VARIOUS ARTISTS
title FLEX YOUR HEAD
year 1982
label DISCHORD
design JEFF NELSON
photo SUSIE JOSEPHSON

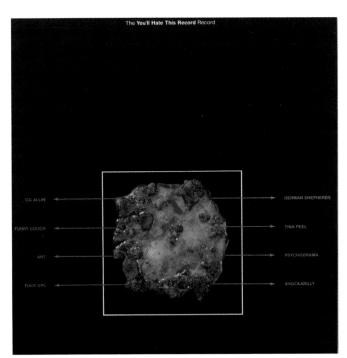

VARIOUS ARTISTS

artist VARIOUS ARTISTS
title THE YOU'LL HATE
THIS RECORD
RECORD
year 1983
label THE ONLY LABEL
IN THE WORLD
ad BILL "CRACKERS"
SHOR (CONCEPT)
design KENT MILLER

VARIOUS ARTISTS

artist VARIOUS ARTISTS
title WNBC – HOMETOWN
ALBUM II
year 1980
label WNBC RADIO 66
photo FRANK PUSKAS JR.

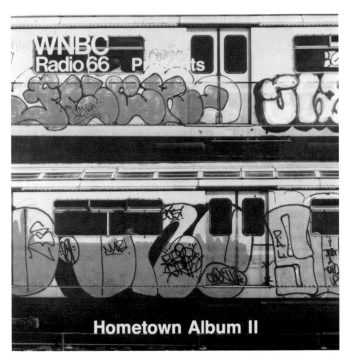

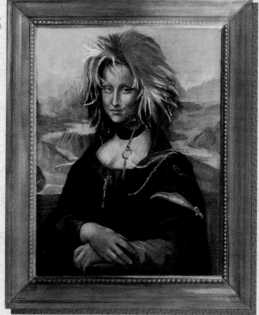

We do 'em OUR Way

MFP 50481
STEREO
MUSIC FOR
PLEASURE
(mfp)

SEX PISTOLS
Rock Around The Clock
(I'm Not Your)
Stepping Stone

THE STRANGLERS
Walk On By

hollywood BRATS
Then He Kissed Me

THOSE HELICOPTERS
World Without Love

THE GOLDEN ISLAND
Friday On My Mind

THE SLITS
I Heard It Through The Grapevine

THE FLYING LIZARDS
Money

DEVO
Satisfaction
(I Can't Get Me No)

She's Not There

THE DICKIES
Nights In White Satin

The HAMMERSMITH GORILLAS
You Really Got Me

VARIOUS ARTISTS

artist VARIOUS ARTISTS
title WE DO 'EM OUR
WAY
year 1980
label MUSIC FOR
PLEASURE

VARIOUS ARTISTS

artist VARIOUS ARTISTS
title SOME OF OUR BEST
 FRIENDS ARE
year 1968
label WARNER BROS/
 SEVEN ARTS
art RON COBB

This was a promotional sampler from Warner Bros. of some of the best psychedelic and folk rock of the day. It includes tracks by Jimi Hendrix, the Grateful Dead, the Electric Prunes, Joni Mitchell, the Fugs, Arlo Guthrie and Tiny Tim, among others. The cover design is by former Disney artist and counterculture political cartoonist Ron Cobb, who despite his lack of training in the field went on to contribute design work to a number of blockbuster films, including *Star Wars* and *Alien*.

VARIOUS ARTISTS

artist VARIOUS ARTISTS
title TOBACCO A-GO-GO:
NORTH CAROLINA
ROCK 'N' ROLL
IN THE SIXTIES
year 1984
label BLUE MOLD
art STEVE GAY,
KEN FRIEDMAN
design STEVE GAY,
KEN FRIEDMAN

This celebrated collection of red-clay rarities marks an early effort to retrace the steps of North Carolina's garage rock and beach music innovators. From the well known to the unknown, these 18 recordings range from James Taylor's 1962 studio debut with the Corsayers to the grim, rebellious rock of Arrogance.

SYLVIE VARTAN

artist SYLVIE VARTAN
title TWISTE ET
 CHANTE
year 1963
label RCA VICTOR
photo JEAN-MARIE
 PÉRIER

STEVIE RAY VAUGHAN AND DOUBLE TROUBLE

artist STEVIE RAY
 VAUGHAN AND
 DOUBLE TROUBLE
title TEXAS FLOOD
year 1983
label EPIC
ad JOHN BERG,
 ALLEN WEINBERG
art BRAD HOLLAND

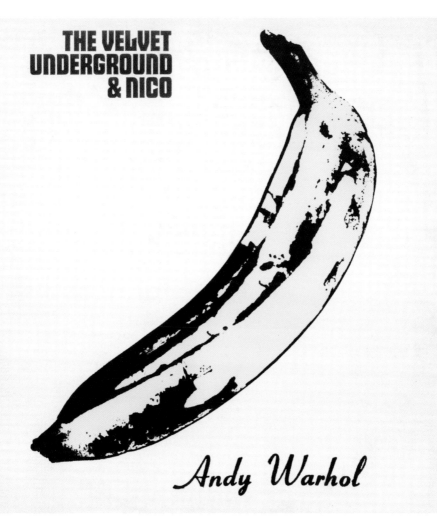

Andy Warhol

THE VELVET UNDERGROUND & NICO

artist THE VELVET UNDERGROUND & NICO
title THE VELVET UNDERGROUND & NICO
year 1967
label VERVE
art ANDY WARHOL
design ACY R. LEHMAN

Pop-art impresario Andy Warhol was a wizard at transforming the mundane into an indelible icon. And like all good magicians he was a master of manipulation. The mystery he shrouded himself in only served to shed a brighter light on the seemingly simplistic art he produced. When *The Velvet Underground & Nico* was released, the peelable banana design was not registered with the Copyright Office, leaving questions of creation and ownership up in the air ever since and which in turn have only led to more fascination with one of the most famous record covers in history.

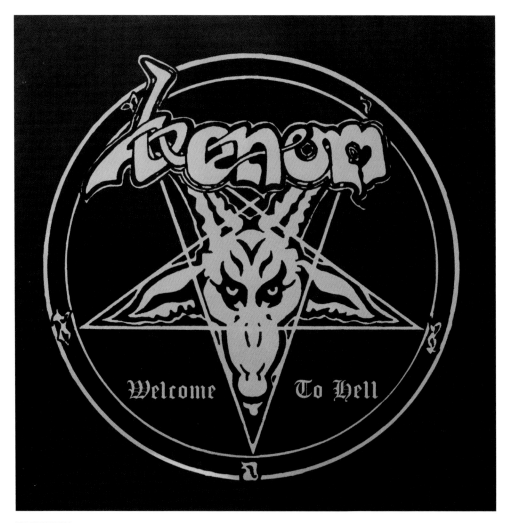

VENOM

artist VENOM
title WELCOME TO HELL
year 1981
label NEAT
art MAGDA

Venom's debut is perhaps one of the most influential and at the same time highly criticized LPs in heavy metal history. Released at the tail end of the new wave of British heavy metal, *Welcome to Hell* is a touchstone for the black metal movement that followed in its wake. Recorded and mixed in three days by the Newcastle trio of bassist/growler Cronos, guitarist Mantas and drummer Abaddon, they made an unholy mess of an album. The amateurish honesty of the sludge-filled tracks only adds to the overall satanic terror the lads inflict with every listen.

THE VICTIMS

artist THE VICTIMS
title REAL WILD CHILD
year 1979
label GOLDEN DISC
design BARBARA WOLF
photo NEW YORK ROCK
'N ROLL

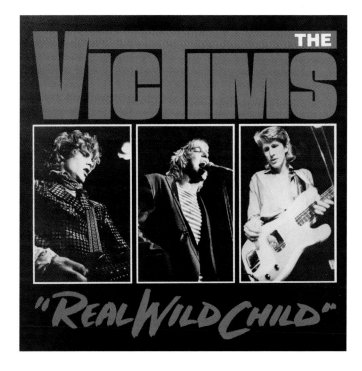

THE VELVET UNDERGROUND

artist THE VELVET
UNDERGROUND
title LOADED
year 1970
label COTILLION
ad HEATHER HARRIS
art STANISLAW
ZAGORSKI

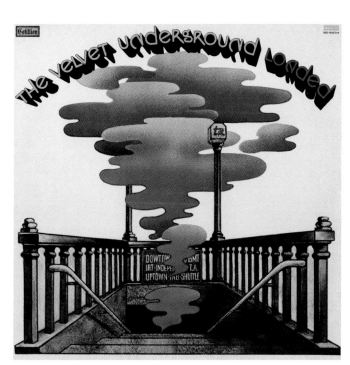

Loaded was the last studio album by the Velvet Underground to feature contributions from Lou Reed, who exited the group before this record's release date. Polish-born graphic artist Stanislaw Zagorski evidently interpreted the band's name in literal terms, concocting an image of an ominous subway emitting velvety clouds.

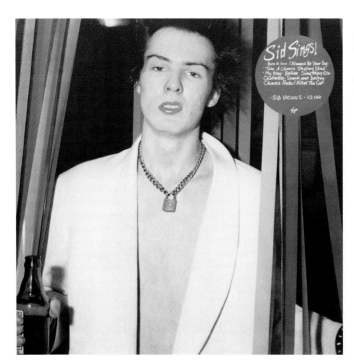

SID VICIOUS

artist SID VICIOUS
title SID SINGS
year 1979
label VIRGIN

GENE
VINCENT AND
THE BLUE CAPS

artist GENE VINCENT AND
 THE BLUE CAPS
title GENE VINCENT AND
 THE BLUE CAPS
year 1957
label CAPITOL

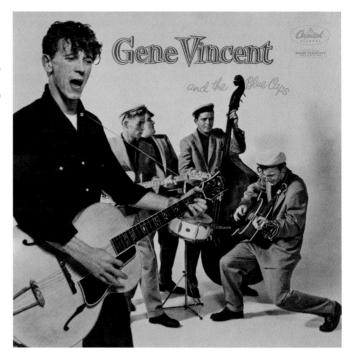

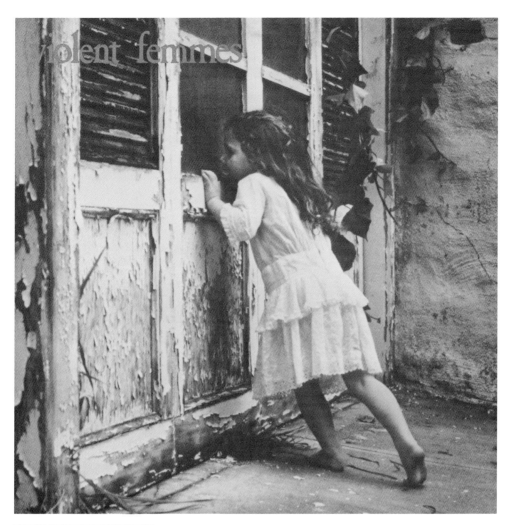

VIOLENT FEMMES

artist VIOLENT FEMMES
title VIOLENT FEMMES
year 1983
label SLASH
design JEFF PRICE
photo RON HUGO

"I remember looking into that building, and they kept telling me there were animals in there, and I was pissed off. I didn't know why they were making me look in this building. I had no idea there were photographers there. I was pissed off that I couldn't see the animals and I was all cranky by the end of it."

Billy Joe Campbell

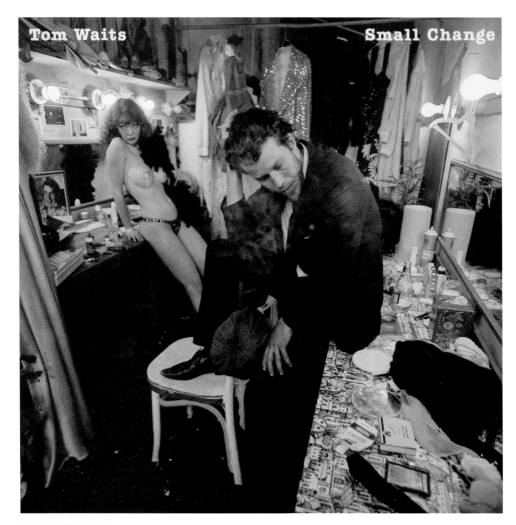

TOM WAITS

artist TOM WAITS
title SMALL CHANGE
year 1976
label ASYLUM
design CAL SCHENKEL
photo JOEL BRODSKY

Before she was Elvira, Mistress of the Dark, Cassandra Peterson was a working showgirl in Vegas, and although she says she doesn't remember shooting this cover, the buxom beauty in the background is pretty clearly her. Joel Brodsky was one of the premier commercial photographers, with the *Washington Post* stating in its obituary for him, "Mr. Brodsky was a meticulous craftsman, spending hours setting up lights, scenery and cameras. Even when his photographs looked like casual snapshots, such as the squalid backstage dressing room depicted on Tom Waits's *Small Change* (1976), they were always carefully composed."

TOM WAITS

artist TOM WAITS
title RAIN DOGS
year 1985
label ISLAND
design PETER CORRISTON
photo ANDERS PETERSEN

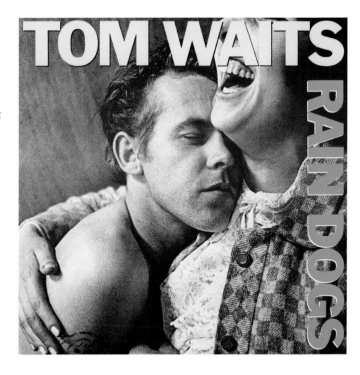

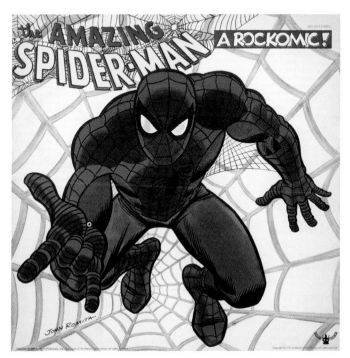

THE WEBSPINNERS

artist THE WEBSPINNERS
title THE AMAZING
SPIDER-MAN:
A ROCKOMIC!
year 1972
label BUDDAH
ad GLEN CHRISTENSEN
art JOHN ROMITA

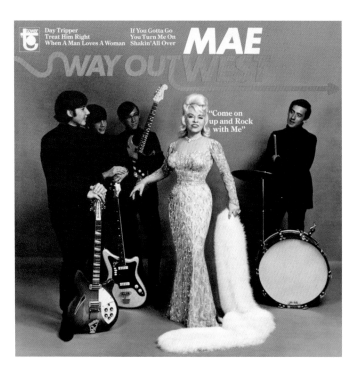

Day Tripper
Treat Him Right
When A Man Loves A Woman

If You Gotta Go
You Turn Me On
Shakin' All Over

MAE

WAY OUT WEST

"Come on up and Rock with Me"

MAE WEST

artist MAE WEST
title WAY OUT WEST
year 1966
label TOWER

WEEN

artist WEEN
title CHOCOLATE
AND CHEESE
year 1994
label GRAND ROYAL
design REINER DESIGN
CONSULTANTS
photo JOHN KUCZALA

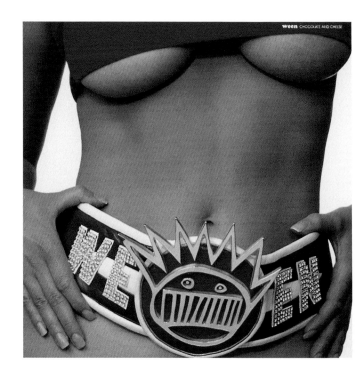

THE MIKE WESTBROOK CONCERT BAND

artist THE MIKE
WESTBROOK
CONCERT BAND
title MIKE WESTBROOK'S
LOVE SONGS
year 1970
label DERAM
art MOORE & MATTHES
design MOORE & MATTHES

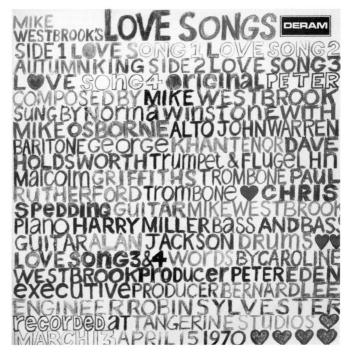

THE WHITE STRIPES

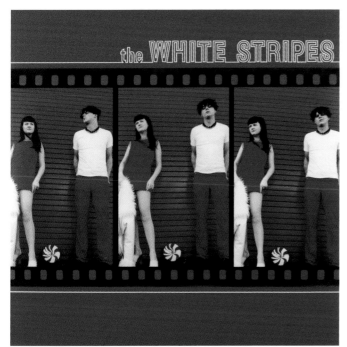

artist THE WHITE STRIPES
title THE WHITE STRIPES
year 1999
label SYMPATHY FOR THE
RECORD INDUSTRY
design BALLISTIC:
PATRICIA CLAYDON
photo KO MELINA ZYDECO

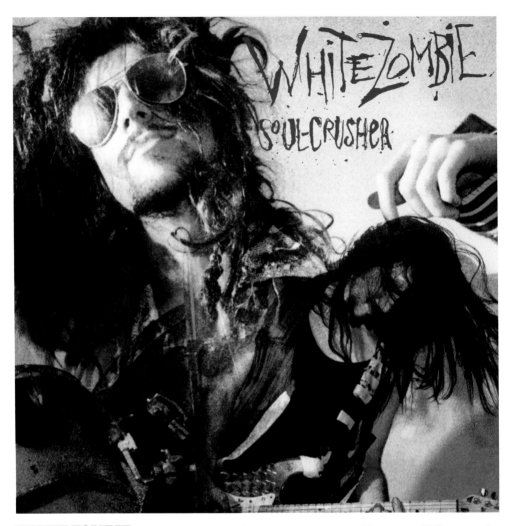

WHITE ZOMBIE

artist WHITE ZOMBIE
title SOUL-CRUSHER
year 1987
label SILENT EXPLOSION
art ROB STRAKER
design ROB STRAKER,
SEAN YSEULT
photo MICHAEL LAVINE

Steeped in horror movie imagery and Downtown NYC noise rock, Rob Straker aka Rob Zombie was the ringleader for the carnival of souls that was White Zombie. Photographer Michael Levine captured Zombie's penchant for psychedelic sludge beautifully with his cover shoot for their debut LP. Levine was a photo student at Parsons School of Design when he met the bass-player for the band, Sean Yseult, in the school's cafeteria. The young photographer would go on to be one of the most prominent of the grunge movement, as well as shooting some of the most memorable covers of the 1990s underground hip-hop era.

THE WHO

artist THE WHO
title THE WHO SINGS
MY GENERATION
year 1965
label DECCA
photo DAVID WEDGBURY

While the US release's cover photo of grey London with its air of mod distraction is drastically different from the original UK version and its bold-faced rebellion, the music is still the central focus of this powerhouse LP. Pete Townshend's lyrics gave a voice to a generation, just as his guitar tore through the fabric of rock. The band would go on to cover more sophisticated ground, but the sheer maelstrom of this debut would rocket them into the stratosphere of rock royalty.

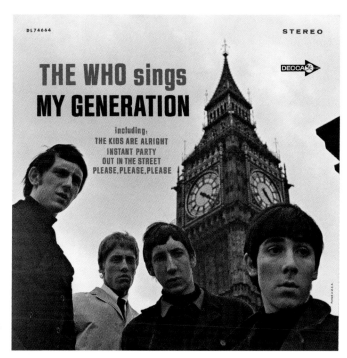

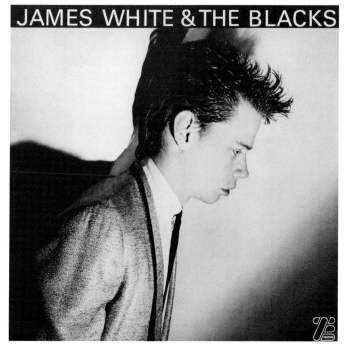

JAMES WHITE & THE BLACKS

artist JAMES WHITE
& THE BLACKS
title CONTORT
YOURSELF/
(TROPICAL)
HEATWAVE
year 1978
label ZE
design JIMMY DE SANA

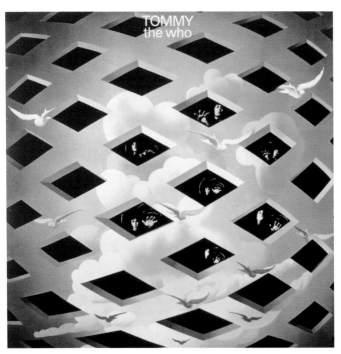

THE WHO

artist THE WHO
title TOMMY
year 1969
label TRACK/DECCA
design MIKE MCINNERNEY
photo BARRY MELLOR

Cited as the first rock opera, *Tommy* tells the traumatic story of a young "deaf, dumb and blind kid" who becomes a pinball genius. The original double-LP release was formed as a fold-out triptych that features a pop art painting by Mike McInnerney, who was also responsible for art direction at the counter-cultural *International Times*. In 1975 a film version of *Tommy* was made starring Roger Daltrey in the lead role, in turn spawning a new soundtrack LP and the single "Pinball Wizard," famously performed on screen by Elton John.

THE WHO

artist THE WHO
title WHO'S NEXT
year 1971
label POLYDOR
design JOHN KOSH
photo ETHAN RUSSELL

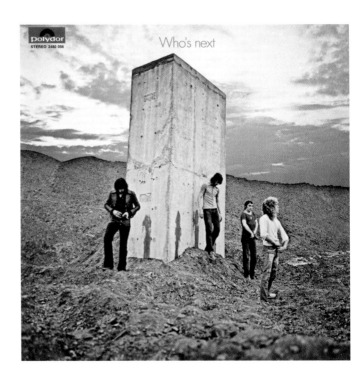

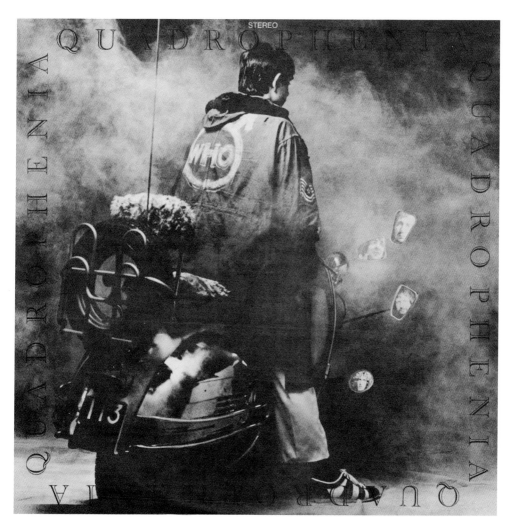

THE WHO

artist THE WHO
title QUADROPHENIA
year 1973
label TRACK/MCA
design GRAHAM HUGHES
photo GRAHAM HUGHES

Graham Hughes, Roger Daltrey's cousin, was tapped to shoot the cover for the Who's second rock opera album release. In trying to create an authentic mod look for the cover, the model and the Vespa had to look like they had just stepped out of London or Brighton a decade earlier. Terry "Chad" Kennett was found playing pool at a pub near the band's studio, and Roger Daltrey had the idea of painting the Who's logo on his parka. Graham thought the mood was great for the shot, but couldn't figure out how to get the band in the photo until he saw the wing mirrors and everything clicked.

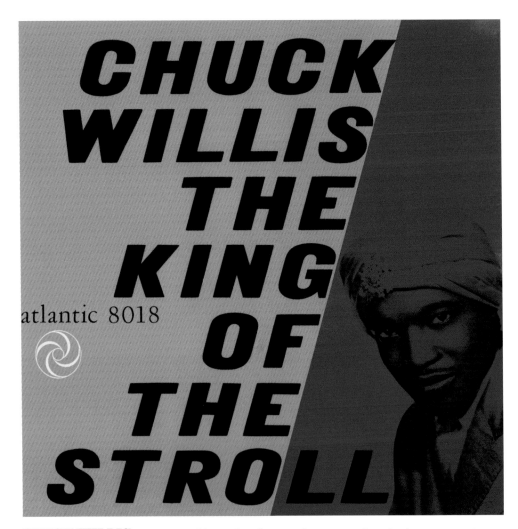

CHUCK WILLIS

artist CHUCK WILLIS
title CHUCK WILLIS,
THE KING OF
THE STROLL
year 1958
label ATLANTIC
design MARVIN ISRAEL

Marvin Israel was at this time working freelance as an art director for Atlantic Records, a post he held from 1957 to 1963. He had similar experience previously working for *Seventeen* magazine where he was sent out to photograph an up-and-coming musician named Elvis Presley right after his first LP came out; the magazine declined to print the gritty black and white photos, but they were later collected in a book. Israel went on to be a highly influential fashion editor for *Harper's Bazaar* where he introduced the world to a wealth of fresh photographers and artists including Richard Avedon, Diane Arbus and Andy Warhol.

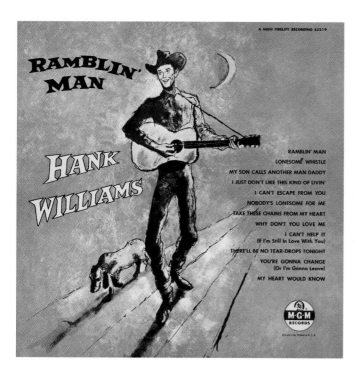

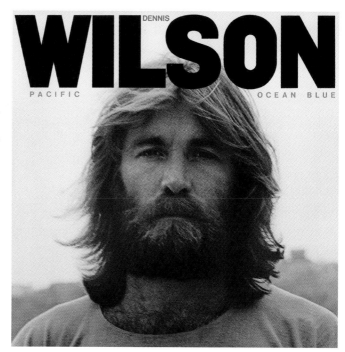

HANK WILLIAMS

artist HANK WILLIAMS
title RAMBLIN' MAN
year 1955
label MGM

While an undisputed pioneering force in country music, Hank Williams's impact on rock, specifically rockabilly, cannot be over- stated. Creating a more Western approach to rock tropes derived from rhythm and blues, Williams's song- writing, delivery and fashion sense would be acknowledged continually by rock and golf artists alike.

DENNIS WILSON

artist DENNIS WILSON
title PACIFIC OCEAN BLUE
year 1977
label CARIBOU
design DEAN O. TORRENCE, JOHN BERG
photo DEAN O. TORRENCE, KAREN LAMM-WILSON

The middle Wilson brother spent much of his solo debut exploring more introspective themes than his surf-savvy family band, the Beach Boys. Although a drummer by trade, Wilson played most of the instruments featured on *Pacific Ocean Blue*, recorded at the Santa Monica studio co-owned by Dennis and younger brother Carl.

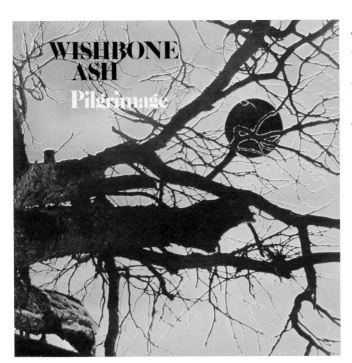

WISHBONE ASH
artist WISHBONE ASH
title PILGRIMAGE
year 1971
label MCA
design HIPGNOSIS
photo HIPGNOSIS

WOOL
artist WOOL
title WOOL
year 1969
label ABC
design BYRON GOTO,
HENRY EPSTEIN
photo NORMAN TRIGG

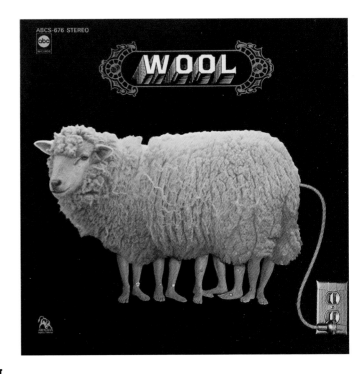

WIRE

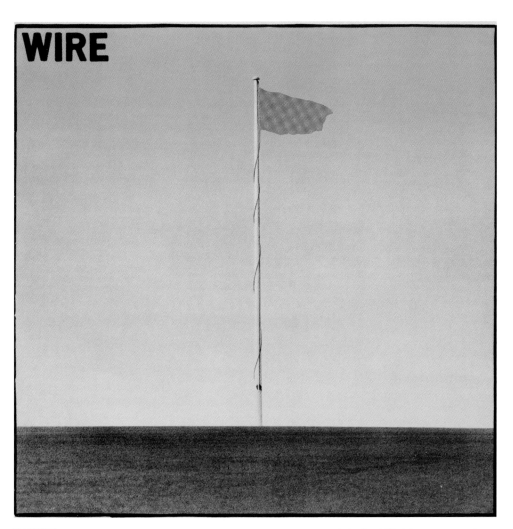

WIRE

artist WIRE
title PINK FLAG
year 1977
label HARVEST
art DAVID DRAGON
design B.C. GILBERT, GRAHAM
LEWIS
photo ANNETTE GREEN

The mysterious cover photo on Wire's 1977 debut mirrors the minimal, disquieting approach of the art-school punk that lives within. *Pink Flag* is widely regarded as one of the most influential records from punk's dawning, influencing a diverse cross-section of bands from R.E.M. to Minor Threat to Sonic Youth. Annette Green took the oddly serene cover photo, but the concept is credited to guitarist B.C. Gilbert and bassist Graham Lewis. Gilbert worked as an abstract painter after originally training as a graphic designer; the cover delivers an image that can be seen as a mixture of Andy Warhol/David Hockney-style pop art and the color field abstractions of Barnett Newman.

XTC

artist XTC
title DRUMS AND WIRES
year 1979
label VIRGIN
art JILL MUMFORD
design JILL MUMFORD

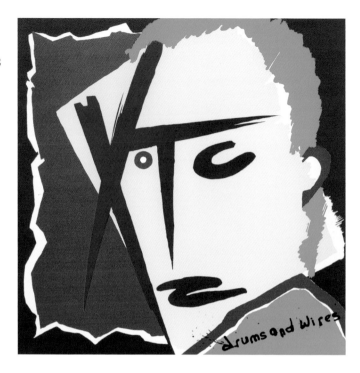

Y PANTS

artist Y PANTS
title BEAT IT DOWN
year 1982
label NEUTRAL
photo JUDITH WONG

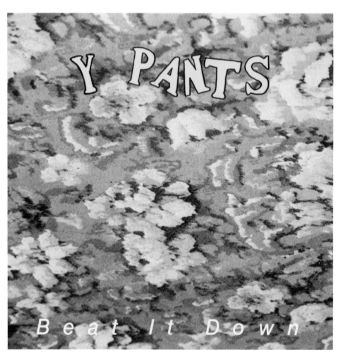

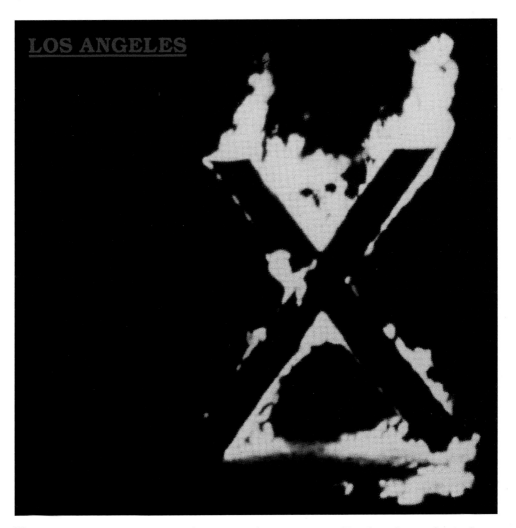

X

artist X
title LOS ANGELES
year 1980
label SLASH
design J. RUBY PRODUCTIONS
photo FRANK GARGANI

"Any time you're twenty years old and in a big city for the first time, you're going to be writing up a storm," front-woman Exene Cervenka told *Rolling Stone*, "you just feel like everybody's insane there. No one really has any values. They just make up a little story to act out, and that's their life." With the LP's tales of the seediness of the band's hometown coupled with some of the best musicianship in punkdom it only made sense that the Doors' Ray Manzarek would help launch this talented band on their way as their producer of choice. His ability to bridge the punk, rockabilly and hardcore sounds helped it to become one of the cornerstones of the LA punk scene of the '80s.

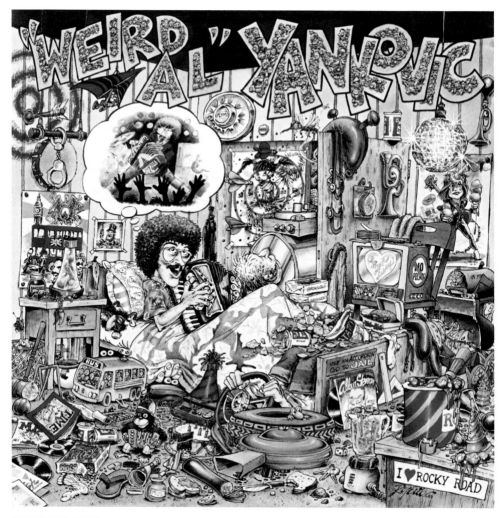

"WEIRD AL" YANKOVIC

artist "WEIRD AL" YANKOVIC
title "WEIRD AL" YANKOVIC
year 1983
label ROCK 'N' ROLL
art ROGERIO NOGUEIRA
design TOM DRENNON
(CONCEPT)

Once a performer's work is parodied by accordion wizard Alfred Matthew "Weird Al" Yankovic it will never be heard the same way again. On his self-titled debut an unsuspecting world was hit with an onslaught of pop and rock dissection. With a whirl of his ginsu-like tongue he was able to slice open the belly of self-aggrandizing rock pretense and lay the guts out as a smorgasbord of wacky humor. The Brazilian cartoonist Rogerio Nogueira perfectly captured "Weird Al"'s hysterically cluttered mind in his *Mad* magazine-like cover art.

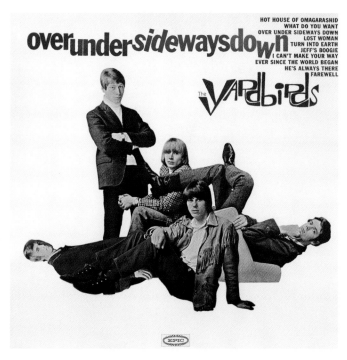

THE YARDBIRDS

artist THE YARDBIRDS
title OVER UNDER
SIDEWAYS DOWN
year 1966
label EPIC
photo HENRY PARKER

YEAH YEAH YEAHS

artist YEAH YEAH YEAHS
title YEAH YEAH YEAHS
year 2002
label TOUCH & GO
design YEAH YEAH YEAHS,
CRISPIN

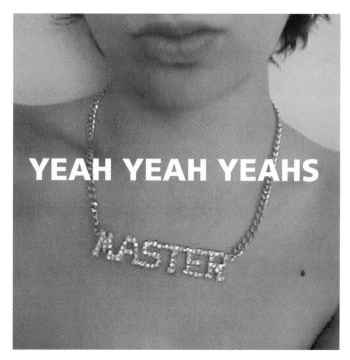

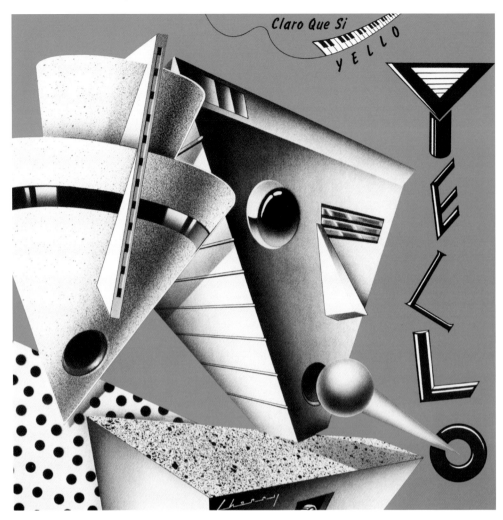

YELLO

artist YELLO
title CLARO QUE SI
year 1981
label VERTIGO
art JIM CHERRY
design JIM CHERRY

"When I was offered the Claro Que Si job, I realized that Yello's musique concrète suggested a literal match to my ambition. Frank Lloyd Wright's Guggenheim Museum of Art inspired the conical shape of the left figure, while the grainy spatter is meant to suggest the texture of concrete. I screwed up while painting the figure on the left and had to paste on a replacement. This happy accident subtly enhanced the overall 3D feel I was seeking."

Jim Cherry

YO LA TENGO

artist YO LA TENGO
title NEW WAVE HOT
DOGS
year 1987
label COYOTE
design GEORGIA HUBLEY,
PHIL MILSTEIN
(TYPE)
photo ROBERT SIETSEMA

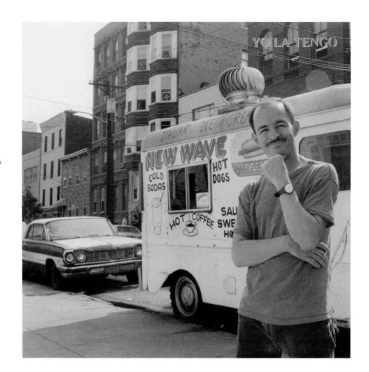

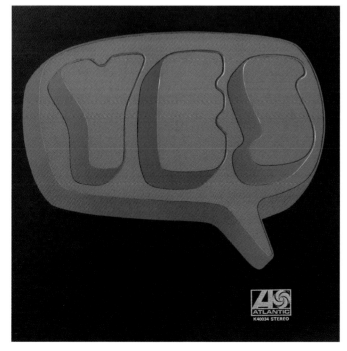

YES

artist YES
title YES
year 1969
label ATLANTIC
design ALAN FLETCHER
(LOGO)

Although surrealist illustra-
tor Roger Dean would become
intrinsically linked with Yes
by the mid-'70s, Alan Fletcher
of Crosby/Fletcher/Forbes
crafted this bold logo for the
progressive rock troupe's
debut. This distinct graphic
found its way on to the cover
of the UK pressing, rendered
Day-Glo on matt black to
create a three-dimensional
effect. The US version featured
a band portrait by American
photographer David Gahr.

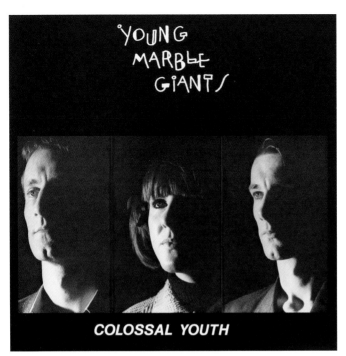

YOUNG MARBLE GIANTS

artist YOUNG MARBLE
GIANTS
title COLOSSAL YOUTH
year 1980
label ROUGH TRADE
photo PATRICK GRAHAM

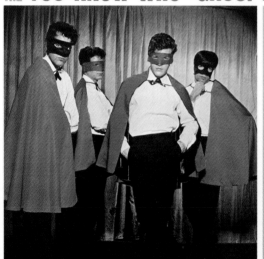

THE "YOU KNOW WHO" GROUP

artist THE "YOU KNOW
WHO" GROUP
title FIRST ALBUM
year 1965
label INTERNATIONAL
ALLIED

"We may have sounded
British, but were really
just four Italians from
Brooklyn... As for the
costumes we're wearing
on the cover, [rhythm
guitarist] Frank d'Avino's
mother, an experienced
seamstress, made those
capes and masks for us."

Frank Piemonte

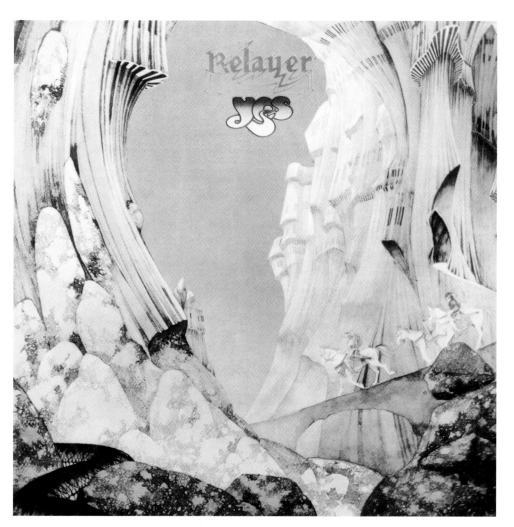

YES

artist YES
title RELAYER
year 1974
label ATLANTIC
ad BRIAN LANE
art ROGER DEAN
design ROGER DEAN,
MANSELL LITHO
(PLATES DESIGN)

From album sleeves to set designs, and the famous bubble logo for Yes, Roger Dean's work in designing the visual identity for these British prog pioneers is nigh legendary. Yes emerged on the London music scene in 1968, with a notable early formation congealed around bass-player Chris Squire and vocalist Jon Anderson. Seemingly inhabiting a Tolkienesque fantasy world, Yes became famous for their complex, symphonic compositions, technical wizardry and explosive stage performances.

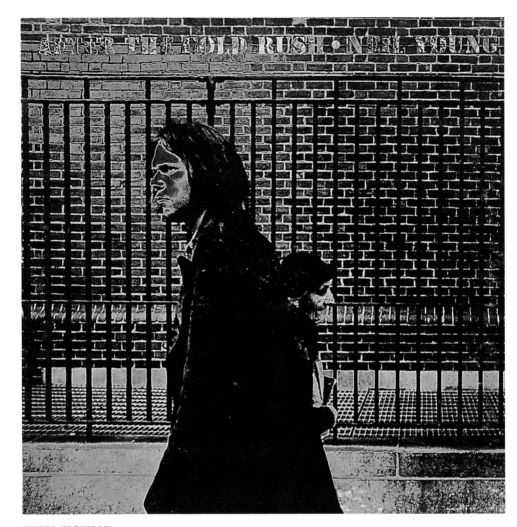

NEIL YOUNG

artist NEIL YOUNG
title AFTER THE
GOLD RUSH
year 1970
label REPRISE
ad GARY BURDEN
photo JOEL BERNSTEIN

"The photo was not 'a mistake.' I saw the small, old woman coming towards us down the sidewalk, was intrigued, and wanted to catch her passing Neil. The mistake, to me, was that I had in my haste focused the lens just past the two figures, closer to the fence than to Neil's face. That was the original reason why I made a small-sized print and solarized it; to help with the apparent sharpness. But the solarization in this case added a somewhat spooky dimension to the image, which Neil took to immediately."

Joel Bernstein

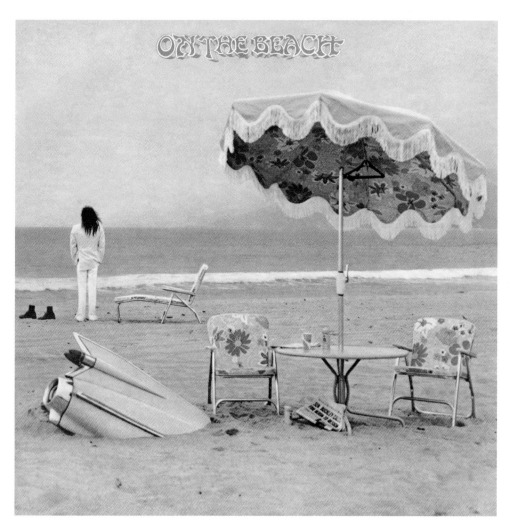

ON THE BEACH

NEIL YOUNG

artist NEIL YOUNG
title ON THE BEACH
year 1974
label REPRISE
art RICK GRIFFIN
(LETTERING)
design GARY BURDEN
photo BOB SEIDEMANN

The floral pattern upholstered on the folding chairs and beach umbrella is repeated inside the album's jacket, but nothing has engaged fans longer than Rusty Kershaw's hand-scribbled insert, a post-grammatical rant that details the fiddler's transformation into a python, consuming studio property, before offering the tangential guarantee, "I give you my word there is good music in this album."

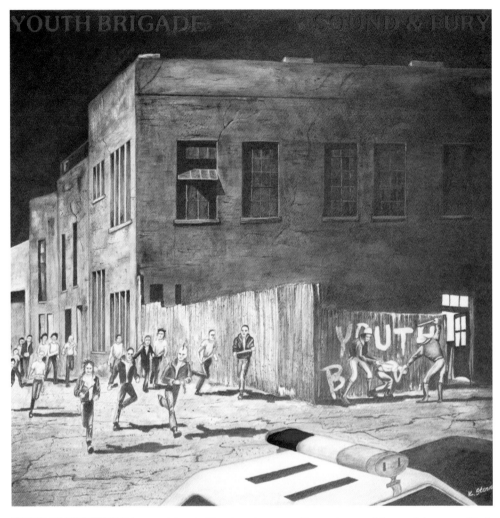

YOUTH BRIGADE

artist YOUTH BRIGADE
title SOUND & FURY
year 1982
label BETTER YOUTH
　　　　ORGANIZATION
art KANDY STERN
design MARK STERN

A band of brothers (guitarist Shawn, bassist Adam and drummer Mark Stern) infused their anthemic music with a keen sense of musicianship and in the process created what would be one of the cornerstones of California pop-punk. Kandy Stern, their step-mom, drew the cover.

"The first Youth Brigade album, Sound & Fury, was conceptualized by Mark Stern and illustrated by me. Punk rock subculture was intimidating and police brutality was rampant, hence the song 'Men In Blue.' Mark wanted to illustrate the inhumane treatment by the police, and depict the punk movement as a fearless brotherhood. The album was released before Youth Brigade's first tour in 1982; when they returned, not satisfied with the material, they recorded a new version and I created a new cover with the same theme. It was released in 1983 to rave reviews." – Kandy Stern

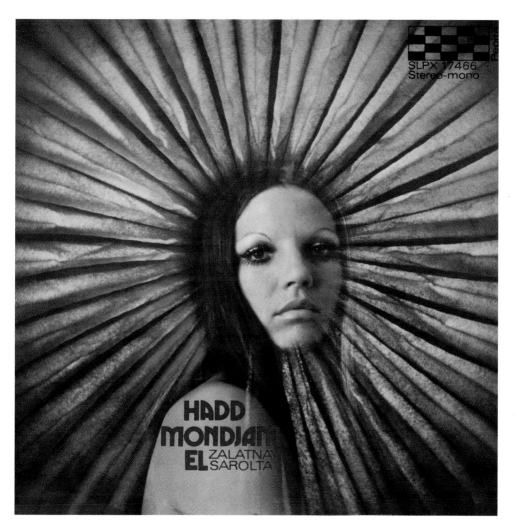

SAROLTA ZALATNAY

artist SAROLTA ZALATNAY
title HADD MONDJAM EL
year 1973
label PEPITA
design IMRE KOLMA
photo JÁNOS HUSCHIT

Hungary's most famous/infamous pop star is Sarolta Zalatnay. Born Charlotte Sacher and affectionately known as "Cini," she grew up in Budapest and came to the public's awareness in 1966 when she took second place in a national talent competition. She went on to front the Hungarian rock group Omega and in the late '60s moved to England before returning home in 1970 and starting a promising solo career. For *Hadd Mondjam El* she used Skorpio as her backing band and led by pianist Gyula Papp they brought a good dose of funk to her hard rock sound.

FRANK ZAPPA

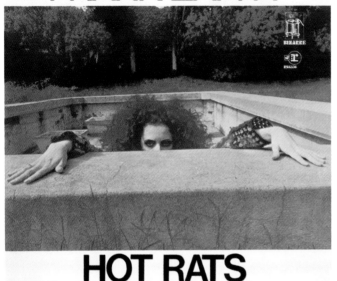

HOT RATS

FRANK ZAPPA

artist	FRANK ZAPPA
title	HOT RATS
year	1969
label	BIZARRE
design	CAL SCHENKEL
photo	ANDEE COHEN NATHANSON

Nathanson's toned photo made the creepy suggestion that freaks really were emerging after long incubation beneath a derelict Beverly Hills estate. Nathanson's model was her then-roommate "Miss Christine" Frka, governess to Frank Zappa's toddler daughter Moon Unit. Frka, a "junkshop harlequin" costumier and founding member of girl-freak group the GTOs, died in 1972 of a drug overdose.

FRANK ZAPPA

artist	FRANK ZAPPA
title	ORCHESTRAL FAVORITES
year	1979
label	DISCREET
ad	RICK SERRINI
art	GARY PANTER

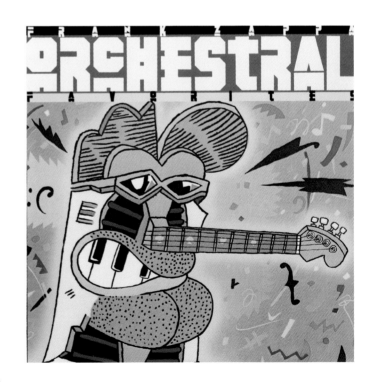

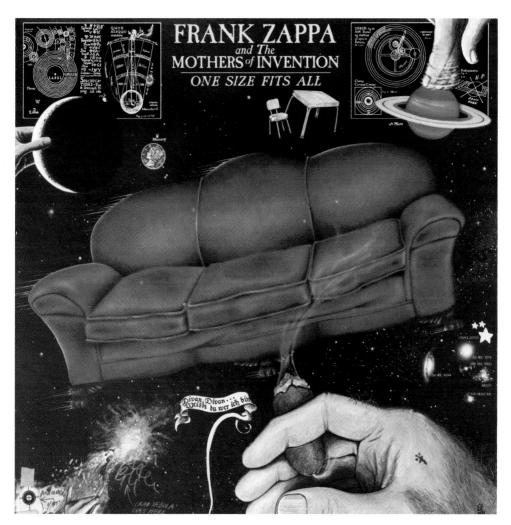

FRANK ZAPPA AND THE MOTHERS OF INVENTION

artist FRANK ZAPPA
AND THE MOTHERS
OF INVENTION
title ONE SIZE FITS ALL
year 1975
label DISCREET
art CAL SCHENKEL,
LYNN LASCARO
design CAL SCHENKEL

Cal Schenkel's first cover for Frank Zappa was 1968's *We're Only in It for the Money*, on which the *Sgt. Pepper* parody fell closely on the heels of the Beatles' original. Raised in the suburbs of Philadelphia, Schenkel was responsible for Zappa's most iconic album covers, and would go on to design posthumous releases by the eccentric composer, who passed away in 1993.

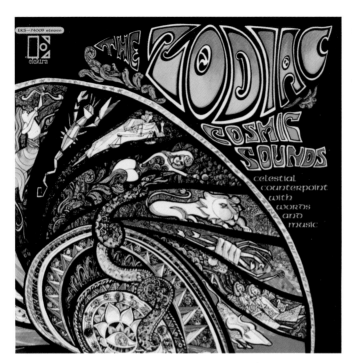

THE ZODIAC

artist THE ZODIAC
title COSMIC SOUNDS
year 1967
label ELEKTRA
ad WILLIAM S.
HARVEY
design ABE GURVIN

JOHN ZORN

artist JOHN ZORN
title NAKED CITY
year 1989
label ELEKTRA/
NONESUCH
design TANAKA TOMOYO,
TAKAHASHI
YUKIHIRO (PHOTO-
TYPE SETTING)
photo WEEGEE
(CORPSE WITH
REVOLVER)

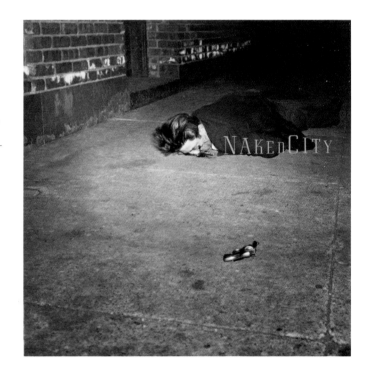

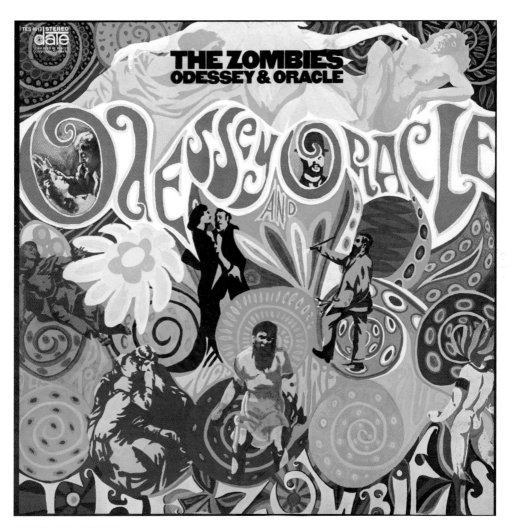

THE ZOMBIES

artist THE ZOMBIES
title ODESSEY AND
ORACLE
year 1968
label DATE/CBS
art TERRY QUIRK

Before the zombies of *The Walking Dead* and *World War Z*, there were The Zombies. These Zombies probably wouldn't eat your heart, but they could definitely make you eat your heart out with tear-jerking psych ballads like "A Rose for Emily" and "Hung up on a Dream." Just as upsetting to some is the fact that "Odessey" is mis-spelled on the cover, for which we have sleeve designer and bassist Chris White's roommate, Terry Quirk to thank. As frontman Colin Blunstone told *Word* magazine in 2008: "Rod [Argent] told this story for nearly 40 years of how it was deliberate and a play on the word 'ode,' hence 'odessey' when it should be spelled 'odyssey'. So I was as astounded as anyone when he finally admitted about a year ago that it had been a simple spelling mistake. Too late to change by the time anyone noticed it. A bit embarrassing, but it's history now."

COLLECTORS' TOP-10 LISTS

Every record collection is different, and each one says something profound about its owner. As music fans, collectors strive to create and sustain a musical utopia with each new entry, the culmination of which defines their unique musical identity. What record collections lurk in the libraries, spare-bedrooms and crates of rock's greatest advocates? A diverse cross-section of rocking/rolling collectors have been asked to gather their ten favorite album covers of all time. With no strings attached. They delivered a smorgasbord of delicacies that speak to the way they each live and breathe the music and art of the Rock LP.

Jede Schallplattensammlung ist einzigartig, und jede sagt etwas Profundes über ihren Eigentümer aus. Als Musikfans wollen Sammler mit jeder neuen Platte, die sie ihrem Bestand einverleiben, ein musikalisches Utopia schaffen und daran weiterbauen – als Krönung ihrer einzigartigen musikalischen Identität. Welche umfangreichen Plattensammlungen mögen die größten Anhänger des Rock in ihren Bibliotheken, Gästezimmern und Plattenkisten versteckt halten? Wir haben einen vielfältigen Querschnitt von Sammlern jeglicher Rockcouleur gebeten, ihre zehn besten Albumcover aller Zeiten zusammenzustellen. Weitere Bedingungen dazu gab es keine. Zurück kam dieses bunte Sammelsurium an Leckerbissen; sie alle lassen uns fühlen, wie die Musik und Kunst der Rock-LP in ihnen lebt und atmet.

Chaque collection de disques est différente, et chacune trahit quelque chose de profond à propos de son propriétaire. En tant qu'amateurs de musique, les collectionneurs s'efforcent de créer et entretenir une utopie musicale avec chaque nouvel ajout, dont l'accumulation définit leur identité musicale unique. Quelles collections de disques se tapissent dans les bibliothèques, les chambres d'amis et les malles des plus grands défenseurs du rock ? Nous avons demandé à un échantillon représentatif de collectionneurs de rock de rassembler leurs dix couvertures d'album préférées de tous les temps. En toute liberté. Ils ont concocté un smörgåsbord de morceaux de choix qui révèle leur façon de vivre la musique et l'art de l'album de rock.

NEVER MIND THE BOLLOCKS

HERE'S THE

SeX PiSTOLS

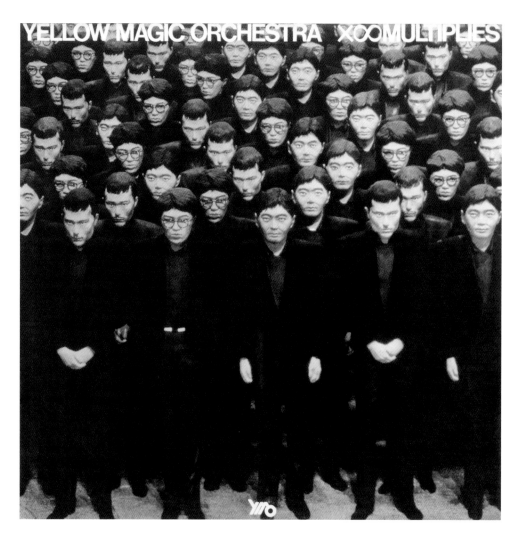

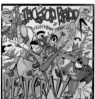
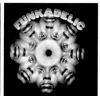

This is a COMPACT DISC COVER. This writing is the DESIGN upon the cover. The DESIGN is to help SELL the compact disc. We hope is from your attention to it and encourage you to pick it up. When you have done that maybe you'll be persuaded to listen to the music - in this case YMO's So I allude. Then we want you to BUY it. The idea being that the more of you that buy this compact disc the more money Virgin Records, the manager for Ryo and XYZ will get. We intend however this is shown as PLEASURE. A good cover DESIGN is one that attracts more buyers and more money. This writing is trying to pull you in that like an eye catching picture. It is designed to get you to READ IT. This is called buying the VICTIM, and you are the VICTIM. But if you have a free mind you should STOP READING NOW because all we are attempting to do is to get you to read on. Now truly is a DOUBLE BIND because it you instead stop you'll be doing what we tell you, and if you read on you'll be doing what we wanted all along. And the more you read the more may be telling for this simple deceive of telling you exactly how a good commercial design works. Now by TRYING and this is the most IRONIC of all since by describing the TRICK and is trying it TRICK YOU, and it in, we read rain for that you're TRICKED but you wouldn't have known this unless you'd read this far. At least you're telling us here for this sentence would you with a beautiful or amazing cobaler that may never tell you. We're telling you thing that you might to buy this compact disc because it contains a PRODUCT and PRODUCTS are to be consumed and you're a consumer and this is a good PRODUCT. We could have written the hand's name in special lettering or they'll pound our and you'd end in perform you'd do most likely if this will do well in the music business. Most of us are really suggesting is that you our FEELING to buy or not buy a compact disc merely as a consequence of sober though do you cover. This is a run because if you agree than you'll probably like this writing, which is the cover design - and hence the disc inside. Now we've just as been you just to be and. A good cover design could be considered as one that gets you to buy the record. But that never actually happens to SOD because YOU know it's just a design for the cover. And this is the COMPACT DISC COVER.

"HEROES" DAVID BOWIE
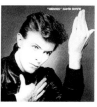

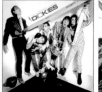
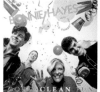
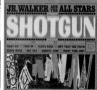

MICK COLLINS

Mick Collins is largely responsible for sustaining Detroit's role as a rock incubator, helping to bridge the gap between the MC5 and the White Stripes. Formed in 1986 by Collins, guitarist Dan Kroha and drummer Peggy O'Neill, the Gories used '60s garage rock to fuel and inform their raw, rebellious output. After disbanding in the early '90s, Collins formed the Dirtbombs, which blended Detroit disciplines of rock and soul. Determined from the outset to issue only singles that conformed to specific styles, the Dirtbombs went on to put out an enormous catalog of 7-inches and full-lengths, boasting a broad spectrum of *sui generis* output. With a rotating line-up boasting two bass-players and two drummers at any given time, the Dirtbombs have given and continue to offer sanctuary to Motor City musicians of all stripes.

Mick Collins hat sich besonders dafür ins Zeug gelegt, Detroits Rolle als Brutstätte des Rock zu fördern, und er half dabei, die Lücke zwischen MC5 und den White Stripes zu überbrücken. Collins gründete 1986 die Gories zusammen mit dem Gitarristen Dan Kroha und der Schlagzeugerin Peggy O'Neill. Prägend für den rauen, rebellischen Gories-Sound war der Garage Rock der Sixties. Als sich die Band Anfang der 1990er auflöste, formierte Collins die Dirtbombs, um die Detroiter Disziplinen Rock und Soul zu verschmelzen. Von Anfang an entschlossen, nur Singles in bestimmten Stilen zu veröffentlichen, brachten die Dirtbombs einen enormen Katalog an Singles wie auch LPs auf den Markt und können sich ihres breiten und einzigartigen Spektrums rühmen. Stets waren zwei Bassisten und zwei Schlagzeuger in der Truppe, und mit ihrem wechselnden Line-up bieten die Dirtbombs Musikern aller Couleur aus der Motor City jederzeit eine Zuflucht.

C'est en grande partie grâce à Mick Collins que Detroit a pu conserver son rôle d'incubateur du rock, car il a comblé l'écart entre les MC5 et les White Stripes. Groupe formé en 1986 par Collins, le guitariste Dan Kroha et la batteuse Peggy O'Neill, les Gories utilisaient le garage rock des années 1960 pour nourrir et informer leur production brute et rebelle. Après leur dissolution au début des années 1990, Collins forma les Dirtbombs, qui alliaient le rock et la soul de Detroit. Déterminés dès le départ à ne sortir que des singles suivant des styles bien spécifiques, les Dirtbombs allaient produire un énorme catalogue de 45 tours et d'albums embrassant un large spectre de musique unique en son genre. Avec des effectifs changeants mais comportant toujours deux bassistes et deux batteurs, les Dirtbombs ont offert et continuent d'offrir refuge aux musiciens de tous poils de Motor City.

1. **YELLOW MAGIC ORCHESTRA** x∞Multiplies *Alfa, 1980*

2. **QUEEN** News of the World *EMI/Elektra, 1977*

3. **JOE JACKSON BAND** Beat Crazy *A&M, 1980*

4. **FUNKADELIC** Funkadelic *Westbound, 1970*

5. **XTC** Go 2 *Virgin, 1978*

6. **DAVID BOWIE** "Heroes" *RCA, 1977*

7. **YES** Yessongs *Atlantic, 1973*

8. **THE DICKIES** The Incredible Shrinking Dickies • *A&M, 1979*

9. **BONNIE HAYES WITH THE WILD COMBO** Good Clean Fun *Slash, 1982*

10. **JR. WALKER AND THE ALL STARS** Shotgun *Soul, 1965*

STEREO SKAO-422

EMI

HARVEST

RECORDED IN
ENGLAND

MANTLE-PIECE

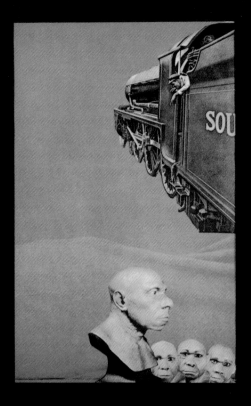

SOU

THE BATTERED ORNAMENTS

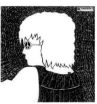

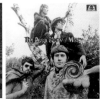

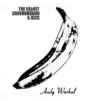

EDAN

A student at Boston's prestigious Berklee College of Music, Edan Portnoy found a way to combine his musical abilities with his love of hip-hop and his obsession with obscure records. Billing himself simply as Edan, the Rockville, Maryland native used a string of independent releases to establish himself within the hip-hop community, effortlessly blending elements of psychedelic rock and old-school rap into one accessible mash. Although a proven lyricist, Edan's musical outreach more often materializes during in-demand DJ sets internationally and in his adopted New York City.

Edan Portnoy studiert am angesehenen Berklee College of Music in Boston. Seine musikalischen Fähigkeiten verbindet er mit seiner Liebe zu Hip-Hop und einer Obsession für obskure Platten. Er stammt aus Rockville, Maryland, und nennt sich selbst nur Edan. In der Hip-Hop-Community etablierte er sich über seine Serie von Independent-Releases. Dabei vermischt er mühelos Elemente von Psychedelic Rock und Old School Rap zu einer erstaunlich verträglichen Mischung. Edan ist auch als Lyriker anerkannt, aber seine musikalische Wirkung manifestiert sich natürlich stärker bei Engagements als DJ in seiner Wahlheimat New York City und weltweit.

Étudiant au prestigieux Berklee College of Music de Boston, Edan Portnoy a trouvé une façon de combiner ses talents musicaux, sa passion du hip-hop et son obsession pour les disques obscurs. Se présentant simplement sous son prénom Edan, ce natif de Rockville, dans le Maryland, s'est fait une place dans la communauté du hip-hop avec une série de productions indépendantes qui mêlaient avec une facilité déconcertante le rock psychédélique et le rap de la vieille école. Bien que ses talents de parolier soient amplement démontrés, le rayonnement musical d'Edan se matérialise plus souvent lors de ses sessions de DJ très demandées dans le monde entier et dans sa ville d'adoption, New York.

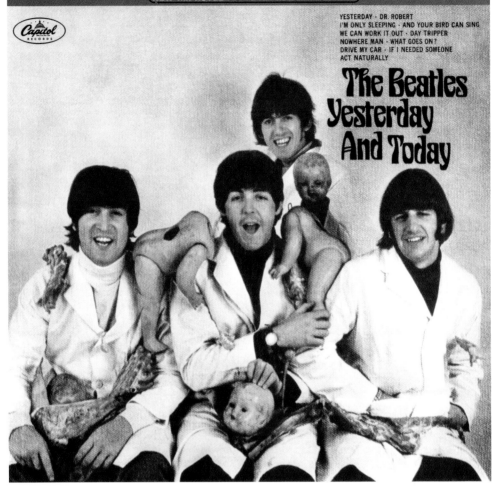

YESTERDAY · DR. ROBERT
I'M ONLY SLEEPING · AND YOUR BIRD CAN SING
WE CAN WORK IT OUT · DAY TRIPPER
NOWHERE MAN · WHAT GOES ON?
DRIVE MY CAR · IF I NEEDED SOMEONE
ACT NATURALLY

The Beatles
Yesterday
And Today

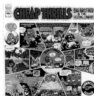
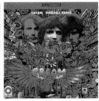

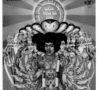
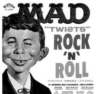
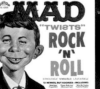

JOHN HOLMSTROM

In 1975 John Holmstrom co-founded *Punk* magazine along with Ged Dunn and "resident punk" Legs McNeil. With their popularizing of the term "punk" they helped define the movement that was brewing in NYC clubs like CBGB. Holmstrom did the sleeve illustrations for the Ramones albums *Rocket to Russia* and *Road to Ruin*. As he said, "I was always resentful of most record covers, especially those featuring photos or plain graphics because I always thought that a cartoon or illustration would have been better. Back in the day, photos often reproduced as a blurry, unfocused image, while illustrations looked sharp."

1975 gründete John Holmstrom zusammen mit Ged Dunn und dem „Resident Punk" Legs McNeil das Magazin *Punk*. Weil sie den Begriff „Punk" populär machten, definierten sie nebenbei auch jene Bewegung, die sich damals in New Yorker Clubs wie dem CBGB zusammenbraute. Holmstrom schuf die Coverillustration der Ramones-Alben *Rocket to Russia* und *Road to Ruin*. Dazu meint er: „Über die meisten Plattencover ärgere ich mich, vor allem solche mit Fotos oder in rein grafischer Gestaltung. Ich finde einfach, dass ein Cartoon oder eine Illustration viel besser passt. Damals wurden Fotos oft als verschwommene, unklare Bilder reproduziert, aber Illustrationen waren immer scharf."

En 1975, John Holmstrom cofonda le magazine *Punk* avec Ged Dunn et Legs McNeil, «punk à demeure». En popularisant le terme «punk» ils contribuèrent à définir le mouvement qui se préparait dans les clubs new-yorkais tels que CBGB. Holmstrom réalisa les illustrations des pochettes pour les albums *Rocket to Russia* et *Road to Ruin* des Ramones. Il a déclaré: «Je détestais la plupart des couvertures de disque, surtout celles qui avaient des photos ou un graphisme simple, parce que j'ai toujours pensé qu'un dessin ou une illustration aurait été préférable. À l'époque, les photos donnaient souvent une image floue, tandis que les illustrations étaient toujours impeccables.»

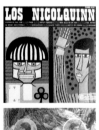
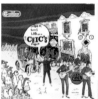
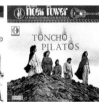

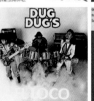
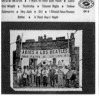

CARLOS ICAZA

Carlos Icaza doesn't consider himself a record collector, despite maintaining one of the most comprehensive libraries of Mexican music in existence. Using the moniker Tropicaza, Icaza proactively seeks DJ opportunities and parcels of radio time as a means of evangelizing the diverse array of music issued by his native country's recording industry during the '60s, '70s and '80s. An in-demand drummer among Mexico City's most prominent acts, Icaza has toured much of Latin America and Europe as an agent of Mexico's contemporary music scene as well.

Carlos Icaza betrachtet sich nicht als Plattensammler, obwohl seine Kollektion mexikanischer Musik zu den umfangreichsten überhaupt zählt. Unter seinem Alias Tropicaza ist Icaza proaktiv als DJ unterwegs und bringt die musikalische Vielfalt seines Heimatlandes aus den 60er- bis 80er-Jahren auch im Radio unter. Icaza ist bei den wichtigsten Acts von Mexico City als Drummer sehr gefragt und unternahm als Botschafter der zeitgenössischen mexikanischen Musikszene auch viele Tourneen in Lateinamerika und Europa.

Carlos Icaza ne se considère pas comme un collectionneur de disques, bien qu'il possède l'une des discothèques de musique mexicaine les plus complètes au monde. Sous le pseudonyme de Tropicaza, Icaza recherche activement des opportunités d'exercer comme DJ et des créneaux de temps radio pour faire connaître le large éventail de musique produit par son pays natal dans les années 1960, 1970 et 1980. Batteur très recherché par les plus grands groupes de Mexico, Icaza a également voyagé partout en Amérique latine et en Europe pour diffuser la musique mexicaine contemporaine.

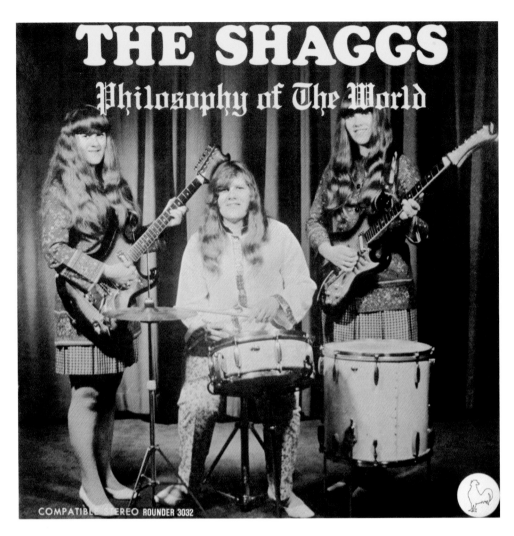

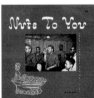
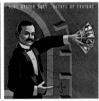

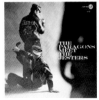
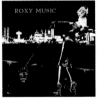
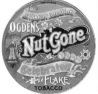
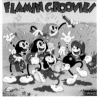

LENNY KAYE

Lenny Kaye is a musician, record producer, writer and record collector, responsible for the hugely influential compilation series *Nuggets: Original Artyfacts from the First Psychedelic Era*. Kaye was a foundational component of the Patti Smith Group, with whom the guitarist has continued to collaborate for over 30 years. Kaye's first recording, a mature garage rock suite attributed to Link Cromwell, was issued by Hollywood Records in 1966. He continues to serve as a guiding light and consultant regarding the evolution of rock music at large, and has authored books on the far-flung topics of guitars, crooners, and Waylon Jennings.

Lenny Kaye ist Musiker, Plattenproduzent, Autor und Plattensammler. Verantwortlich zeichnet er für die außerordentlich einflussreiche Compilation-Serie *Nuggets: Original Artyfacts from the First Psychedelic Era*. Kaye ist ein fundamentaler Baustein der Patti Smith Group, in der er seit über 30 Jahren als Gitarrist spielt. Als Maßstab und Richtschnur treibt er die Evolution der Rockmusik insgesamt voran und hat Bücher über breit gefächerte Themen wie Gitarren, Crooner und Waylon Jennings geschrieben.

Lenny Kaye est musicien, producteur, écrivain et collectionneur de disques. Il est également responsable de la très influente série de compilations *Nuggets: Original Artyfacts from the First Psychedelic Era*. Kaye fut un membre fondateur du groupe de Patti Smith, avec qui ce guitariste a continué de collaborer pendant plus de 30 ans. Le premier enregistrement de Kaye, une suite de rock garage pleine de maturité attribuée à Link Cromwell, est sorti chez Hollywood Records en 1966. Aujourd'hui encore il remplit un rôle de guide et de consultant sur l'évolution du rock dans son ensemble, et il a écrit des livres sur des sujets aussi éclectiques que les guitares, les crooners et Waylon Jennings.

1. **THE SHAGGS** Philosophy of the World
Third World Recordings, 1969

2. **STEVE MILLER** Children of the Future
BAND *Capitol, 1968*

3. **THE ROLLING STONES** Their Satanic
Majesties Request
Decca, 1967

4. **DOUG CLARK** Nuts to You Vol. 1
AND THE HOT NUTS *Gross, 1961*

5. **BLUE ÖYSTER CULT** ... Agents of Fortune
Columbia, 1976

6. **TODD RUNDGREN** A Wizard,
A True Star • *Bearsville, 1973*

7. **THE PARAGONS** The Paragons
& THE JESTERS Meet the Jesters
Jubilee, 1959

8. **ROXY MUSIC** For Your Pleasure
Warner Bros., 1973

9. **SMALL FACES** Ogdens' Nut Gone Flake
Immediate, 1968

10. **FLAMIN'** Supersnazz
GROOVIES *Epic, 1969*

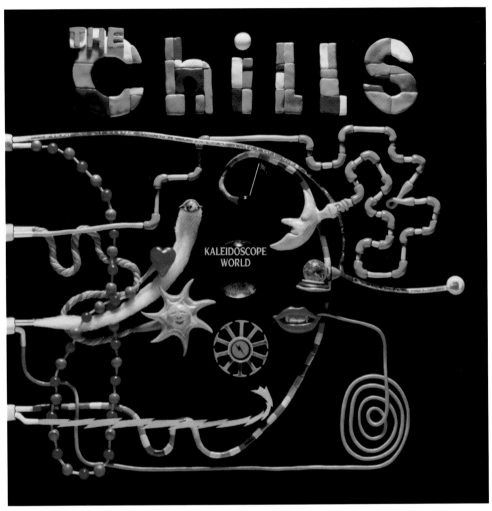

gal costa

MAC MCCAUGHAN

When Mac McCaughan's band Chunk encountered an agitated band with the same name, McCaughan's mother suggested adding a superlative to the disputed handle and Superchunk was born. As a means of circulating the music being made by his band, McCaughan formed Merge Records in 1989 with bandmate and then-girlfriend Laura Ballance. Merge has since released hundreds of albums by influential acts like Spoon, the Magnetic Fields and Arcade Fire, becoming a prototype for the American indie scene in the process. McCaughan was a contributing author for *Our Noise: The Story of Merge Records, the Indie Label That Got Big and Stayed Small*, published in 2009.

Als Mac McCaughhans Band Chunk einer verärgerten Band gleichen Namens begegnete, schlug seine Mutter vor, zur Beilegung des Disputs einen Superlativ einzufügen, und Superchunk ward geboren. Um die Musik seiner Gruppe unters Volk zu bringen, gründete McCaughan 1989 zusammen mit seiner Bandkollegin und damaligen Freundin Laura Ballance das Label Merge Records. Merge veröffentlichte seitdem Hunderte von Alben einflussreicher Gruppen wie Spoon, Magnetic Fields oder Arcade Fire. Gleichzeitig entwickelte sich das Label zum Prototyp der amerikanischen Indieszene. McCaughan war Mitautor des 2009 erschienenen Buchs *Our Noise: The Story of Merge Records, the Indie Label That Got Big and Stayed Small*.

Lorsque Chunk, le groupe de Mac McCaughan, tomba sur un autre groupe agité qui portait le même nom, la mère de McCaughan lui suggéra d'ajouter un superlatif devant le vocable disputé, et c'est ainsi que naquit Superchunk. McCaughan créa Merge Records pour disposer d'un moyen de distribuer la musique de son groupe en 1989 avec Laura Ballance, qui faisait partie du groupe et était sa petite amie à l'époque. Merge a depuis sorti des centaines d'albums de groupes influents tels que Spoon, les Magnetic Fields et Arcade Fire, ce qui l'a converti en prototype de la scène indé américaine. McCaughan a contribué à la rédaction du livre *Our Noise: The Story of Merge Records, the Indie Label That Got Big and Stayed Small*, paru en 2009.

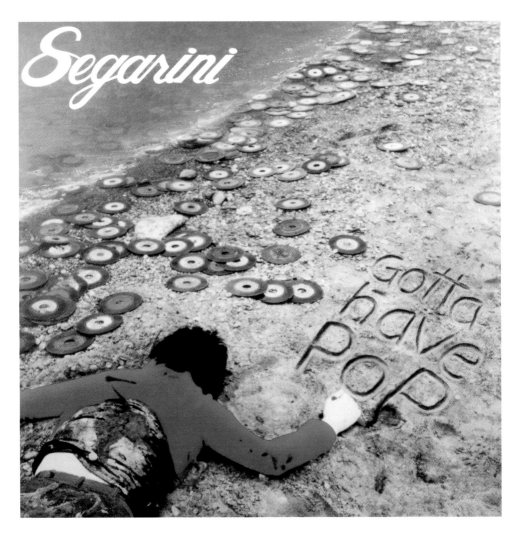

Segarini

Gotta have Pop

FOOLS FACE

here to observe

THE HEATS

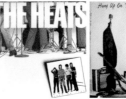

Hang Up On Top

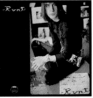

Sorrows

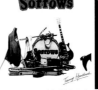

Dwight On White

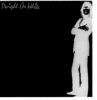

TOM SORRELLS

Tom Sorrells's music career began behind the drum set of Omaha, Nebraska's Yellow Hair, who issued one single in 1969 on the Pacific Avenue label. In 1976 he met Mark Prellberg in Kansas City and upon establishing that they had a shared enthusiasm for the Midwest's underground rock acts, they began drafting a fanzine called *Teen Titans*, which quickly mutated into the record label Titan. Between 1977 and 1981, Titan issued just six singles, one EP and one LP, each a financially irresponsible masterpiece, and each a commercial failure. In 2008, Numero Group released *Titan: It's All Pop*, expanding Titan's diminutive catalog with unreleased material and yielding a 49-track trove of hook-laden power pop made possible by Sorrells and Prellberg's devotion to the Midwest's modern rockers of yore.

Tom Sorrells begann seine musikalische Karriere als Schlagzeuger von Yellow Hair aus Omaha (Nebraska). Die Band brachte 1969 eine Single bei Pacific Avenue heraus. In Kansas City lernte Tom 1976 Mark Prellberg kennen; sie teilten die Begeisterung für den Rock Underground des Mittleren Westens und brachten ein Fanzine namens *Teen Titans* heraus; binnen Kurzem mutierte es zum Plattenlabel Titan. Zwischen 1977 und 1981 veröffentlichte Titan nur sechs Singles, eine EP und eine LP, alles finanziell verantwortungslose Meisterwerke und definitiv kommerzielle Misserfolge. *Titan: It's All Pop* erschien 2008 bei Numero Group und erweiterte den schmalen Katalog des Labels um bisher unveröffentlichtes Material. In diesen 49 Tracks – einer Schatzkiste voller Power Pop mit höchst eingängigen Hooks – spürt man die Begeisterung von Sorrells und Prellberg für die damals modernen Midwest-Rocker.

La carrière musicale de Tom Sorrells commença derrière la batterie de Yellow Hair, groupe issu d'Omaha, Nebraska, qui sortit un single en 1969 chez le label Pacific Avenue. En 1976 il rencontra Mark Prellberg à Kansas City et, lorsqu'ils se rendirent compte qu'ils partageaient une passion pour les groupes de rock underground du Midwest, ils commencèrent à créer un fanzine intitulé *Teen Titans*, qui devint vite le label Titan. Entre 1977 et 1981, Titan sortit seulement six singles, un maxi et un album, tous des chefs-d'œuvre financièrement irresponsables, et tous des échecs commerciaux. En 2008, Numero Group a sorti *Titan: It's All Pop*, qui ajoute au minuscule catalogue de Titan des morceaux qui n'avaient jamais vu la lumière du jour, et produit un trésor de 49 pistes de power pop infectieuse né de la dévotion de Sorrells et Prellberg pour les rockeurs modernes du Midwest d'antan.

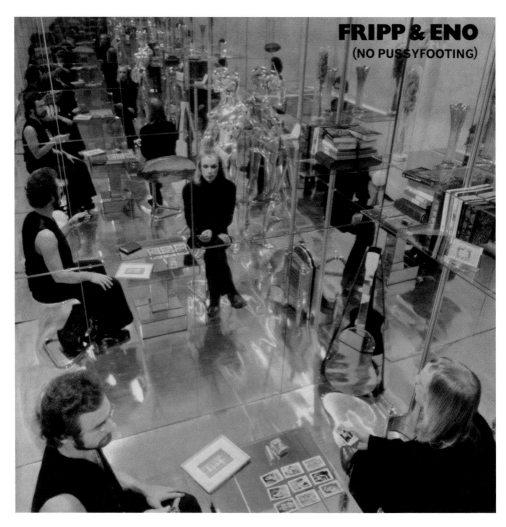

J.G. THIRLWELL

J.G. Thirlwell is an Australian songwriter and performer whose prolific career spans several decades. Thirlwell has a penchant for adopting different identities (e.g. Clint Ruin, Frank Want and Foetus), which has led to collaborations with such underground rock luminaries as Nick Cave, Lydia Lunch, Thurston Moore, Nine Inch Nails, Pantera and Jon Spencer Blues Explosion. His spectral recordings tend to incorporate elements of the classical and experimental, yet render a product which is decidedly rock. In addition to his many dalliances in the tragically unmarketable and overtly meta-musical universes, Thirlwell also scores the Cartoon Network series *The Venture Bros.*

J.G. Thirlwell ist ein australischer Songwriter und Interpret, dessen produktive Karriere mehrere Jahrzehnte überspannt. Thirlwell versetzt sich gerne in verschiedene Identitäten (und wird dann z. B. Clint Ruin, Frank Want oder Foetus). So arbeitete er mit Rocklegenden wie Nick Cave, Lydia Lunch, Thurston Moore, den Nine Inch Nails, Pantera und der Jon Spencer Blues Explosion zusammen. Seine breit gefächerten Aufnahmen greifen Elemente klassischer und experimenteller Musik auf, produzieren aber letztlich doch eindeutig Rock. Neben vielen Eskapaden in tragisch unverkäufliche und außerordentlich metamusikalische Universen sorgte Thirlwell etwa aber auch für den Soundtrack der Trickfilmserie *The Venture Bros.* von Cartoon Network.

J.G. Thirlwell est un compositeur et interprète australien dont la carrière prolifique embrasse plusieurs décennies. Thirlwell aime adopter différentes identités (par ex. Clint Ruin, Frank Want et Foetus), ce qui l'a mené à collaborer avec des sommités du rock underground telles que Nick Cave, Lydia Lunch, Thurston Moore, Nine Inch Nails, Pantera et Jon Spencer Blues Explosion. Ses enregistrements fantomatiques tendent à incorporer des éléments classiques et expérimentaux, et pourtant le produit fini est résolument rock. Parallèlement à ses nombreux batifolages dans des univers ouvertement méta-musicaux et manquant tragiquement de tirant commercial, Thirlwell signe également la bande originale de la série de Cartoon Network *The Venture Bros.*

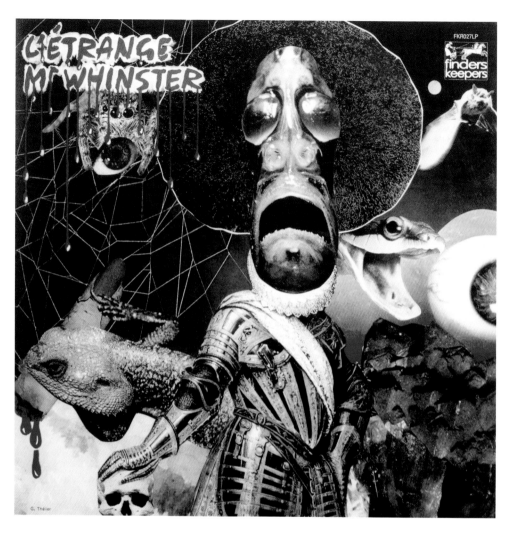

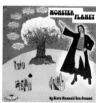

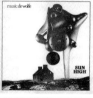

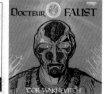

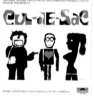

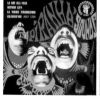

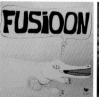

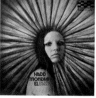

ANDY VOTEL

Drawn to hip-hop music through the exercise of sampling old records to make new ones, Andy Shallcross's first vehicle for music output was with the Violators of the English Language, from which his pseudonym is derived. He co-founded Twisted Nerve Records with Badly Drawn Boy and along with his production duties he served as chief cover designer for the label. Through his reissue label Finders Keepers, Votel has mined the unlikely musical reservoirs of over 40 countries, helping introduce a new generation to world music and otherworldly music, and making his personal record collection a United Nations of exotic rock gems.

Zum Hip-Hop kam Andy Shallcross über das Sampeln alter Platten, aus denen er neue mischte. Das erste Vehikel seiner Musikproduktionen waren die Violators of the English Language, von denen er auch sein Pseudonym ableitet. Gemeinsam mit Badly Drawn Boy gründete er die Twisted Nerve Records. Votel arbeitete als Produzent und als Chefdesigner für die Cover des Labels. Auf seinem Label Finders Keepers bringt er Wiederauflagen heraus. Dazu gräbt er sich durch die Musik-archive in über 40 Ländern. So half er, neue Generationen mit Musik aus dieser und anderen Welten vertraut zu machen. Seine eigene Platten-sammlung bildet eine Art Vereinte Nationen der exoti-schen Rockjuwelen.

Andy Shallcross est arrivé au hip-hop alors qu'il samplait de vieux disques pour en faire de nouveaux. Le premier groupe avec lequel il a commencé sa production musicale s'appe-lait Violators of the English Language, dont son pseudonyme est dérivé. Il a cofondé Twisted Nerve Records avec Badly Drawn Boy et, parallèlement à ses fonctions de producteur, il a également été le principal responsable des couvertures pour ce label. À travers son label de rééditions Finders Keepers, Votel a fouillé les réservoirs musicaux impro-bables de plus de 40 pays. Il a contribué à diffuser la musique du monde et même la musique d'autres mondes auprès d'une nouvelle génération, et sa collection personnelle de disques est une véritable assemblée de l'ONU, remplie de joyaux exotiques du rock.

1. **JEAN-PIERRE MASSIERA & HORRIFIC CHILD** L'Etrange Mr Whinster
 Eurodisc, 1976

2. **AMON DÜÜL** Disaster/Lüüd Noma
 BASF, 1972

3. **VARIOUS** From Czech Electronic Music Studios • *Supraphon, 1974*

4. **STEVE MAXWELL VON BRAUND** Monster Planet
 Clear Light of Jupiter, 1975

5. **BLUE WING CONSOLE** Sun High
 De Wolfe, 1976

6. **IGOR WAKHÉVITCH** Docteur Faust
 Pathé, 1971

7. **KRZYSZTOF KOMEDA** Cul-de-Sac
 Polydor, 1966

8. **THE PIRANHA' SOUNDS** The Piranha' Sounds
 SEM, 1968

9. **FUSIOON** Fusioon
 Belter, 1974

10. **SAROLTA ZALATNAY** Hadd Mondjam El
 Pepita, 1973 (see p.485)

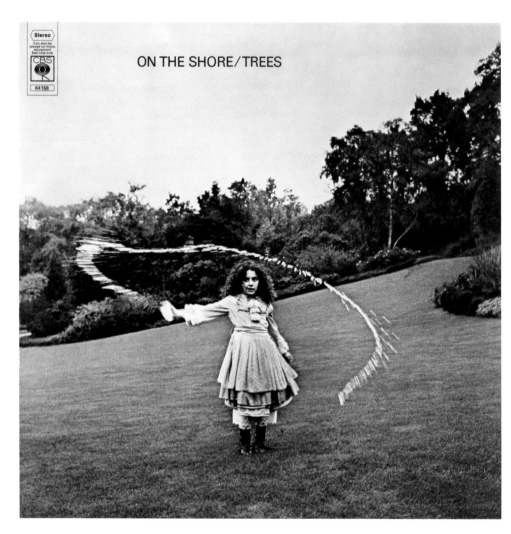

ON THE SHORE/TREES

Stereo
Can also be
played on mono
equipment
See note over

CBS

64168

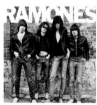

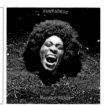

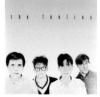

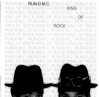

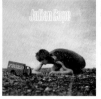

GEOFFREY WEISS

Geoffrey Weiss is one of the most knowledgeable, dedicated and enthusiastic music fans to have worked within the industry's corporate structure (A&M, Warner Bros., Hollywood). He has worked with My Bloody Valentine, Green Day, Sir Mix-A-Lot, Dinosaur Jr., Ministry, Soundgarden, the Polyphonic Spree, DJ Z-Trip, Patrick Park, Atreyu, Grace Potter and the Nocturnals, and many more in his career, while his meticulously catalogued record collection includes over 30,000 LPs and 45s, ensnaring some of rock's most obscure and unique artifacts from across the globe. He currently manages Dylan Gardner.

Geoffrey Weiss ist einer der sachkundigsten, engagiertesten und leidenschaftlichsten Musikfans, der in vielen Firmen der Branche tätig war (A&M, Warner Bros., Hollywood). Während seiner Laufbahn hat er u. a. mit My Bloody Valentine, Green Day, Sir Mix-A-Lot, Dinosaur Jr., Ministry, Soundgarden, den Polyphonic Spree, DJ Z-Trip, Patrick Park, Atreyu und Grace Potter and the Nocturnals. Zu seiner akribisch katalogisierten Plattensammlung gehören über 30 000 LPs und Singles. Darin finden sich so manche außerordentlich obskure und einzigartige Artefakte des Rock aus aller Welt. Aktuell ist er Manager von Dylan Gardner.

Geoffrey Weiss est l'un des amateurs de musique les plus cultivés et enthousiastes qui aient officié au sein des entreprises du secteur (A&M, Warner Bros., Hollywood). Au cours de sa carrière, il a travaillé avec My Bloody Valentine, Green Day, Sir Mix-A-Lot, Dinosaur Jr., Ministry, Soundgarden, Polyphonic Spree, DJ Z-Trip, Patrick Park, Atreyu, Grace Potter et les Nocturnals, entre de nombreux autres, et sa collection de disques méticuleusement cataloguée comprend plus de 30 000 albums et 45 tours, dont certains des artefacts les plus uniques et obscurs du rock planétaire. Il est actuellement le manager de Dylan Gardner.

IMPRINT

© 2020 TASCHEN GmbH
Hohenzollernring 53, D-50672 Köln
www.taschen.com

Original edition © 2014 TASCHEN GmbH

To stay informed about TASCHEN and our
upcoming titles, please subscribe to our free
magazine at www.taschen.com/magazine, follow
us on Twitter, Instagram, and Facebook, or
e-mail your questions to contact@taschen.com.

EACH AND EVERY TASCHEN
BOOK PLANTS A SEED!
TASCHEN is a carbon neutral publisher.
Each year, we offset our annual carbon emis-
sions with carbon credits at the Instituto Terra,
a reforestation program in Minas Gerais, Brazil,
founded by Lélia and Sebastião Salgado. To find
out more about this ecological partnership,
please check: www.taschen.com/zerocarbon
Inspiration: unlimited. Carbon footprint: zero.

Printed in Slovenia
ISBN 978-3-8365-7643-7
Editor in charge: Julius Wiedemann
Editorial coordination: Daniel Siciliano Brêtas
and Hanna Kirsch
Editorial assistant: Nora Dohrmann

Design: Andy Disl and Birgit Eichwede
Layout: Jörg Schwellnus
Cover design: Josh Baker

Production: Tina Ciborowius
Photographer: Jennifer Patrick
Assistant to photographer: Erik Freer

Authors' assistants:
Patrick Sisson, Erin Osmon (to Jonathan Kirby)
Brandee Castle, Matt Rivera (to Robbie Busch)

Additional research: Chris Mizsak
Additional record collectors: Joaquim Paulo,
Chris Mizsak and Tony Gimbert

English revision: Chris Allen
German translation: Jürgen Dubau
German editing: Eva Henle
French translation: Aurélie Daniel
for Delivering iBooks & Design